THE INSU

BUYING GUIDE

A Practical Method for Figuring Out How Much--and What Kind of--Insurance You Need

by the Silver Lake Editors

SILVER LAKE PUBLISHING
LOS ANGELES, CALIFORNIA

The Insurance Buying Guide
A Practical Method for Figuring Out How Much—and What Kind of—Insurance
You Need
First edition, 1999
Copyright © 1999 by Silver Lake Publishing

Silver Lake Publishing
2025 Hyperion Avenue
Los Angeles, CA 90027

For a list of other publications or for more information from Silver Lake Publishing, please
call (888) 663-3091.

Library of Congress Catalog Number: pending

The Silver Lake Editors
The Insurance Buying Guide
A Practical Method for Figuring Out How Much—and What Kind of—Insurance
You Need
Includes index
Pages: 392

ISBN: 1-56343-145-9
Printed in the United States of America.

Acknowledgments

The Silver Lake Editors would like to thank the following organizations for assistance offered in researching information that appears this book: The Insurance Information Institute, the National Consumers' League, the Risk and Insurance Management Society and MetLife. The Offices of Insurance Commissioner in several states—California, Indiana, New Jersey, Texas and Washington—also helped considerably. Finally, we would also like to thank Sue Elliott Sink for her critical contribution to the project.

The Insurance Buying Guide is part of Silver Lake Publishing's consumer insurance reference series. This book, used with *What Do You Mean It's Not Covered?* and *Get Your Claim Paid*, takes the smart consumer through the entire process of buying and using personal-lines insurance.

While the information and statistics in this book will help you understand how to buy personal-lines insurance in a cost-effective manner, no book can analyze a person's specific legal position and insurance needs. This book should not be used in place of qualified professional advice.

The Silver Lake Editors welcome feedback from our readers. If you have a comment or suggestion on the content and delivery you see in this book, please feel free to call Silver Lake Publishing at 888.663.3091 or e-mail at editors@silverlakepub.com. We look forward to hearing from you.

James Walsh, Publisher
Silver Lake Publishing
January, 1999

Table of Contents

Introduction

What You Need to Know

Reading this book can make you popular. In a narrow kind of way.

Tell someone you know that you're reading a book about the different kinds of insurance you need—and how to get the best coverage for your money. That person will probably start asking you questions as if you're some long-lost expert. "Do I have the right kind of car insurance?" "You know, I got a call last week from this guy trying to sell me term life...."

You'll know how doctors and lawyers feel at bad cocktail parties—when they're swarmed by people who want free advice.

People know they need insurance. They just aren't sure what kind to buy, or how much, or from whom. And they don't want to become experts. They want to know what it's going to cover and what it isn't—and how much it's going to cost.

And they *don't* want to call an insurance agent or salesperson to ask for advice. This is because many people trust insurance agents only slightly more than they trust used car dealers. With so much media attention in the early 1990s focused on unfair sales practices, it's no wonder.

This is not to say that all agents are out to rip you off. But insurance is a business driven by information. The insurance companies and their agents have plenty of information on *you*—both specifics about who you are from the information that you provide in your application, and general trends about the kind of person you are that they keep in their databases. You need to level the playing field by knowing a little about *them*.

The right kind of insurance will protect you—and your finances—if you get into a car accident, if someone falls and is hurt at your home, if you need emergency surgery or if you're disabled and out of work for an extended pe-

riod of time. Insurance also can protect you if you misjudge a dock when you're out on your boat, if you need to stay in a nursing home or if you die young, leaving your spouse with small children to raise and a mortgage to pay.

The important thing is to get the right kind of insurance to suit your needs—and to get the right amount of it. This book will help you figure out these things for yourself, thanks to plenty of easy-to-understand descriptions of the kinds of coverage insurance companies offer and worksheets that will help you calculate your insurance needs.

The book will also give you the tools to make sure you're dealing with a solid company—one that will be around when you need to make a claim and collect money.

It will help you save money too, with tips for cutting your premium costs and charts to help you compare insurance companies.

A Few Basic Concepts

Before you dive into the details of homeowners or personal umbrella liability coverage, let's establish a few basics.

First, insurance is designed to **make a loss whole**. In the simplest terms, **a loss** occurs when things you own are **destroyed or reduced in value**. If your house burns to the ground, insurance will pay to rebuild it. The idea is to pay for your actual losses without allowing you to *make* money. This is what an insurer means by making the loss whole.

In addition, it's important to note that an insurance policy is a legally binding contract between **two parties**. One party is the insured person—you—and the other is the insurance company.

As is true with all contracts, an insurance policy describes the rights and obligations of each party. In addition, the policy identifies how much you must pay to receive those rights. This amount is known as the **premium**. The policy identifies how much the insurance company is obligated to pay, if certain events should occur. The maximum amount an insurance company will have to pay is the **limit of insurance**.

The Details of Comparison Shopping

Insurance is complicated. It mixes some standard, regulated factors with some completely *un*regulated ones. The results can be....interesting. Prices for the same kind of insurance coverage can vary widely from company to

company. And different companies may offer slightly—or radically—different coverage. So, it's important to shop around before you buy insurance.

But just saying "shop around" isn't enough. Not only is insurance—as a product—complicated, the ways in which it's sold are also complicated.

When you purchase insurance, you can buy it from a **captive agent**, who works for only one insurance company. You also can buy it **directly from the insurance company**. Or you can buy it from an **independent agent**—that is, an agent who sells policies for several different companies. Often, working with an independent agent can make the shopping process easier, by allowing you to compare several different companies' policies at one time. Working with more than one independent agent can give you access to even more policies—and allow you to compare the agents, as well.

Using more than one agent is the same as getting quotes directly from more than one insurance company. Virtually all agents work on commission, so they can be quite persistent. But don't buy insurance for the wrong reasons—like to make a salesperson shut up and go away.

The best way to find a good agent—and a good insurance company—is by asking around. If your friends, family and co-workers are satisfied with their insurance, they'll tell you. If they're not, they'll tell you even more. A growing number of user groups on the Internet focus on insurance pros and cons.

Asking around before you start calling agents and direct-sale insurance companies can save you a lot of time and aggravation. It also will help you find an insurance company that charges fair rates, processes claims quickly and pays when you expect it to.

A good insurance agent or customer service representative should:

- answer your questions quickly and courteously;

- explain your policy thoroughly before you pay for it;

- contact you periodically to see if you need to change or update your coverage; and

- help you whenever you need to file a claim.

FYI: **Brokers** also sell insurance. They are slightly different from agents, though. Agents have an agreement with one or more insurance companies to sell their products. Brokers are not appointed by insurance companies. They shop for—or *broker*—insurance among many companies. They still receive a commission for each sale, but they can be more attuned to your needs because

they do not work for a particular insurance company. However, some brokers also may charge you a fee for services rendered. For this reason, you may not want to work with them, except for large policies and special situations.

Words of Wisdom from the Front Lines

Most of us want to trust other people. But a lot of otherwise smart people have gotten burned by being too trusting when it comes to insurance.

No matter how much you trust your agent or broker, you probably don't know everyone who works in his or her office. So, never sign a **blank insurance application**—or a blank insurance form. This is like signing a blank check. And it's a more common problem than most people...including most insurance people...realize.

Don't expect your agent to fill in the application for you—or to fill it in correctly. Read over the application carefully before it is submitted to the insurance company. Incorrect information on the application can mean more than just a simple mistake. It can be a way for the insurance company to avoid having to pay a claim down the line.

Be sure to get any promises an agent makes **in writing**—especially if they have to do with how much something will cost or earn in the future. If an agent won't put a statement about future costs, benefits or value in writing, it may be time to find another agent. If an agent shows you a proposal, get a copy of it, as well, so you can study it at home at your leisure—and keep it for your records if you decide to purchase the coverage.

Also, get copies of everything you sign and receipts for any payment you make. Even if you're not the most organized person in the wolrd, make a folder or file...or box...that contains all of your insurance information—applications, policies, back-up information. It's critical to have the stuff. Hang onto your old policies for at least three to four years. Sometimes, a claim or other issue may come up long after the underlying incident occurred or long after a policy has expired. Also, try to pay by check or credit card. If you pay in cash, you may not have proof that a payment was made.

Most people would rather sit in a dentist's chair than read an insurance policy. But it is very important to read a policy thoroughly, to be sure that you got the amount of coverage you want, without any surprise exclusions or limitations.

This book will tell you exactly what to look for—and what to *look out* for—so *Insurance Speak* won't read like legal mumbo-jumbo.

It is also important to read the policy as soon as it arrives. Many policies include a **free look** period (ranging from 10 to 30 days after delivery), during which you can cancel the policy without paying a penalty.

Remember to check your coverage regularly—once a year is usually sufficient—to be sure it still meets your needs. If the cost of building a home in your neighborhood has gone up, you probably need to increase your homeowners coverage. If you've bought a new car, you will need to update your auto policy. And if your children are grown and your house is paid off, you probably don't need to carry as much life insurance as you did before.

> **Example:** You sell a used car to someone, who sells it to someone else. The current owner sues you, years later, claiming that you illegally disconnected an air bag. You'll need to have your liability insurance policy handy, so that you can get back in touch with the insurance company.

Insurance Is a Business

It's important to remember that insurance is a business. Some people may think of insurance as a service that helps people in times of need, insurance companies operate to produce a profit. Therefore, they want to collect more in premiums than they pay out in claims.

If all of an insurance company's "insureds" filed claims at the same time, the company would go bankrupt. Fortunately, the odds of this happening are incredibly slim. To improve their odds, insurers will make some kinds of insurance (such as earthquake insurance in California and homeowners insurance in parts of Florida and other hurricane-prone areas) very hard to get—or very expensive.

If you file a lot of claims, your insurance company is going to raise your rates—not to punish you, but to make sure it can still earn a profit. Because claims often lead to higher rates, it is important to avoid filing small claims.

We'll show you more ways to save money in the following chapters. And we'll show you how to decipher the jargon insurance agents love to use. Even though insurance is complicated, a few basic tools and guidelines can cut through most of the difficulty.

Chapter 1

What's Covered by
Personal Auto Policies

Every state in the U.S. has a law requiring people who drive to have a minimum level of auto insurance. But, even if the law didn't require it, you'd probably still want to have some auto coverage. Driving a car or truck is risky business. (And that doesn't even touch on the danger of driving a motorcycle.) Each year, more than 21 million motor vehicle accidents occur on our nation's roadways, according to the National Safety Council.

Even the safest car or truck driver runs some risk of getting in an accident. This means you'll need some form of insurance to cover the cost of repairs to your car—as well as the other person's car and injuries, if you were at fault. Then there are medical bills. There's also the chance that you'll be sued for causing pain and suffering if someone is injured in an accident and you are at fault.

Another issue to consider: It's likely that you or someone you know has had a car stolen. According to the Insurance Information Institute, nearly 1.5 million vehicles were reported stolen in the United States in 1995.

The fact that you aren't wild about your car doesn't mean that thieves aren't. So-called "chop shops" have a particular penchant for commonplace vehicles that are several years old, since they can resell the parts to repair shops at a tidy profit. And then there are the "exporters," who steal cars and resell them in other countries.

In other words, your vehicle is at risk, even when it's parked. When it's moving, all of your possessions are also at risk. The key to protecting yourself from these risks is to "transfer" them to someone else—and the way to do that is to buy insurance. It transfers the risk from you to the insurance company—for a small fee, of course.

The Basics

What kind of car insurance is there? There's the kind you're required by law to have in your state. And there's the kind you're probably going to want, even though it isn't mandatory.

To start things off with the simplest matters, the mandatory auto insurance coverages in most states include:

- **Bodily injury liability**. If you injure someone in a car accident, this coverage pays that person's medical and rehabilitation expenses, and any damages for which he or she may sue you. In most states, you must buy coverage of at least $15,000/$30,000 (the $15,000 pays for injuries to one person; the $30,000 is the total available per accident).

A caveat: Legally mandated coverage minimums don't always...don't usually...provide enough protection to shield a middle-class person adequately from auto-related liabilities. Limits as high as $100,000/$300,000 are easily available from most insurance companies—and make the most sense for most people with assets to protect.

- **Property damage liability**. If you're at fault in an accident and you damage someone's property, this coverage pays to fix it. In most states, you must buy $5,000 worth of coverage. Many standard policies include a higher limit—often $25,000. (Of course, if you total a new Mercedes, you'll need more.)

- **Medical benefits**. This coverage pays medical bills for you and others covered on your policy, no matter who was at fault in the accident. In most states, you must buy at least $5,000 worth of coverage. The typical driver buys $10,000. However, if you have health insurance, you may not need it.

In addition to the mandatory coverages, there are various coverages that are not mandated by law...but which protect you from common risks. These coverages, which most people buy without thinking much about, include:

- **Collision**. It's all well and good to pay to fix someone else's car, but this coverage will pay to fix yours. Like medical benefits, it's a **no-fault** coverage. (In other words, it pays—regardless of who was at fault.)

> If you're financing a car purchase, most lenders will require you to buy collision coverage. Insurance companies usually will give you a $500 deductible, unless you request another amount. The higher your deductible, the lower your premium.

- **Comprehensive**. This coverage pays for theft, as well as damage to your car from "hazards," including fire, flood, vandalism or striking an animal. Again, most lenders require you to buy this coverage if you're financing your car, and you also can set your deductible for this coverage.

- **Uninsured/underinsured motorist**. If you're injured in an accident and the person who hits you doesn't have enough insurance—or any insurance—you'll be glad you have this coverage. It will pay for your losses and damages, including your medical bills, lost wages and pain and suffering. It usually makes sense to purchase the same level of this coverage that you have for bodily injury liability.

But Wait, There's More

In addition to these typical components of a car insurance policy, there are a few special options that you may want to add—to customize your insurance to suit your needs, but not all insurance companies offer them, so be sure to ask. These include:

- **Extraordinary medical benefits**. If your medical and rehabilitation expenses exceed the limits on your policy, this coverage kicks in and pays—up to $1 million.

- **Funeral benefit**. If you or a family member die in an auto accident, this coverage pays up to $2,500. The cost is nominal. Nationwide, for instance, charges 40 cents per year for $1,500 worth of coverage (although it costs considerably more to be buried in most parts of the United States).

- **Gap insurance**. This coverage pays the difference between what you owe on a car and what the actual values is in the event that the value is lower than the pay off if the car is stolen or totalled. This coverage has become more common since leasing cars has become more popular.

- **Income loss**. If injuries from an accident keep you from working, this coverage pays the amount of your take-home pay.

Payments will usually last only a limited time. But they are made without regard to whether you have other disability insurance coverage—although any other disability insurance you have will probably not kick in until this coverage ends.

- **Rental car replacement**. This coverage pays a set amount (usually about $15 per day, to a maximum of $450) for a rental car if your car is being repaired because of an accident.

- **Towing and labor costs**. This coverage pays for towing and road service, such as jump-starting your car or changing a flat tire. It can be used any time your car breaks down, not just when it's involved in an accident. This coverage shouldn't cost very much—usually less than $5 a year.

- **Stacking**. This coverage allows you to multiply the amount of uninsured or underinsured motorist coverage you have by the number of vehicles on your policy—or by the number of vehicles in your household, if they are covered under separate policies. Because people sometimes abuse stacking to inflate claims, some states don't allow this practice—and even the ones that do add a number of provisions.

Throughout this chapter, we will consider the various types of auto insurance in detail.

What They Say, What They Mean

As we've seen before, insurance companies are notoriously fond of jargon. Here's what they really mean, starting at the beginning of an insurance policy, with the **Declarations Page**.

The Declarations Page contains a lot of the specific information relating to a particular policy—and policyholder. It includes the names of the people covered by the policy, the dates it's in effect and the vehicles covered.

A policy is in effect beginning on the **effective date**. When coverage under a policy stops, the policy has expired—thus, the date on which coverage ends is called the expiration date.

A key thing to note: The time of day that appears along with the effective date and expiration date. This pinpoints the exact time at which coverage begins and ends. (If your policy starts at midnight, and you get in an accident at 11:55 p.m. you won't be covered.)

The Declarations Page also will mention any specific kinds of coverage added to or dropped from a standard policy. These are called **endorsements**. However, more detail on the endorsements usually will appear elsewhere in your policy.

After the Declarations Page, the next place to look for basic information is the **definitions** section of the standard policy. Here's a quick translation of the most important terms found there.

- **Loss**, as used in an insurance policy, does not generally mean *misplacement*. Loss means a direct financial loss of value as a result of situations that are covered by the policy.

- **Covered auto** is used throughout the policy to refer to the specific car or cars listed on the Declarations Page. A car has to be listed—usually by vehicle identification number—in order to be considered a "covered auto." (This is why it's important to actually read the Declarations Page—to be sure all the autos you think are covered really are.)

- The phrase **non-owned auto** is a new addition to some policy forms written. It relates to coverage for cars you've borrowed or rented. (Leased cars usually are treated as if you own them.)

- A **collision** does not have to involve smashing into something— damage caused by the upset or overturn of a covered auto is considered collision damage. And collisions don't necessarily involve multiple cars—if you hit a bridge or a tree or a mailbox, that's considered a collision, too.

- However, hitting an animal or bird is not considered a collision, according to standard policies, and the damage would be covered only if **other than collision** (OTC, also known as comprehensive) coverage has been purchased.

There are a few other key phrases you'll need to know, to be able to speak the language of car insurance fluently.

For starters, you'll need to know that the phrase *covered auto* applies to several sets of circumstances. If you sell a car and buy a replacement vehicle during the policy period, the replacement is automatically a covered auto for liability purposes until the end of the policy period. However, **physical damage coverage** will apply to newly acquired vehicles (whether they are replacement cars or additional vehicles) only if you request the coverage within 30 days. The reason: Physical damage rates and premiums are more depen-

dent upon the value of the vehicle than are rates and premiums for other coverages—like, say, liability. (While you may think a beat-up 1977 Toyota poses a greater liability threat than a new Bentley, insurance companies don't see it quite that way.)

Another good term to know is **liberalization**. The liberalization clause states that if the insurance company makes a change to its standard policy form that provides broader coverage without a premium charge (for example, if it drops a policy exclusion), that change automatically will apply to your policy on the date the change goes into effect in your state. This clause is good for you, and it's good for insurance companies, too, since it eliminates the need to mail out endorsements to every single policyholder when there is no change in premiums.

And then there's the C-word: **cancellation**. In most states, the reasons for which an insurance company is permitted to cancel a policy are limited by the state's insurance department and the law—but only if the policy has been in effect for at least 60 days or is a renewal.

Another good insurance vocabulary word is **subrogation**. To be subrogated means to be substituted in the place of another. In insurance policies, a subrogation provision says that if the insurance company has made a payment under the policy to you or to a third party on your behalf—and if you have a legal right to recover that loss from yet another party—the insurance company is subrogated to your right. This is an important protection for the insurance company: It means the company can recoup what it has paid out to protect you, if someone else is at fault.

Most people do not pay cash for their cars—instead, they borrow money from a bank or auto finance company to make the purchase. Until the loan is paid off, both the purchaser and the lender have a **financial interest** in the car, which insurance companies have determined is an insurable interest. Thus, virtually all banks and lending companies can make some stipulations as to the type of insurance you carry (most require that coverage for damage to your car be carried on a financed vehicle)—and they can insist that they (as the lender) be listed on the policy as having an insurable interest in the car.

Humongous Trucks Need Not Apply

Not every vehicle is eligible for coverage under a Personal Auto Policy. There are ownership rules, usage rules and rules that have to do with the size and shape of the vehicle.

Let's begin with the **ownership rules**. To be eligible, a vehicle must be owned by one of the following:

- an individual;

- a husband and wife who are residents of the same household;

- two or more relatives other than a husband and wife, or two or more unrelated people in the same household—as long as both names are listed on the registration (and some insurers may refuse to offer this type of coverage.);

- a farm family co-partnership or farm family corporation.

> **A leased auto usually is treated as if it were owned, and may be covered under a Personal Auto Policy.**

In addition, only **private passenger vehicles** are eligible for coverage under the Personal Auto Policy. To be considered a private passenger auto, the vehicle must, have four wheels. (Three-wheeled Morgans would be an exception to this rule, but they'd probably be covered by a classic car policy, anyway.)

Coupes, convertibles, sedans and station wagons qualify as *private passenger autos* for coverage under a Personal Auto Policy. Pickup trucks, panel trucks and vans also may be considered *private passenger autos* and may be eligible for coverage if they satisfy the following requirements:

- they must be **owned by insured persons**;

- they must have a Gross Vehicle Weight of **less than 10,000 pounds**; and

- they must **not** be used in a **freight or delivery** business.

So, vans, pickups and panel trucks are eligible when they're used only for personal transportation, or used in farming and ranching, or used in any business except a freight or delivery business.

However, the same restriction does not apply to other private passenger autos. **Coupes, convertibles, sedans and station wagons** are eligible for coverage as long as they are not:

- used as a public or livery conveyance for passengers for a fee (such as a taxi or limousine service); or

- rented to others.

In other words, cars can be used in a freight or delivery business, but only if they are transporting cargo (products, materials or packages)—not humans—for a fee. This is a **loophole** that's likely to be closed at some point.

You can extend your liability, medical payments, uninsured motorists, collision and other-than-collision coverage to motorhomes, motorcycles, golf carts, etc. To do so, you must add on a *Miscellaneous Type Vehicle Endorsement.*

Insuring Against Liability

Liability is probably the most important kind of automobile insurance. It covers money owed when you cause **bodily injury** to another person or **damage to another person's property**.

Technically, liability coverage applies only when you are legally liable for injury or damage. The fact that injury or damage has occurred does not necessarily mean that you're legally liable. (However, proving who is either completely or partially liable can be one of the most time-consuming—and legal fee-generating—parts of the insurance claims process.)

If one driver is liable for a two-car accident, the other party may be entitled to compensation for injuries or damage or both. Compensation may be in the form of money paid to the injured party for **tangible damages** (such as a medical bill or the cost to repair a damaged vehicle) and/or money paid for **intangible damages** (such as pain and suffering).

The intangibles are the ones that get you, financially speaking. When you damage another car, your liability is usually limited to the value of that vehicle. But, if you injure a person in that car, causing a permanent disability or pain and suffering that prevents that person from earning a living, courts can award millions of dollars. That's why you need liability insurance.

State insurance laws generally specify **split limits**. For example, a state might require that automobile owners maintain liability insurance in the following amounts:

- $15,000 per person and $30,000 per accident for claims stemming from bodily injury; and

- $10,000 per accident for claims stemming from property damage.

Examine the chart that follows to determine the minimum liability limits required in your state.

Minimum Levels of Required Auto Liability Insurance

The figures listed are in thousands of dollars. (Insurance companies generally abbreviate the coverage amounts in this way.) The first number is the bodily injury liability maximum for one person injured in an accident. The second number is the bodily injury liability maximum for all injuries in one accident. And the third number is the property damage liability maximum for one accident.

State	Liability Limits	State	Liability Limits
Alabama	20/40/10	Missouri	25/50/10
Alaska	50/100/25	Montana	25/50/10
Arizona	15/30/10	Nebraska	25/50/25
Arkansas	25/50/15	Nevada	15/30/10
California	15/30/5	New Hampshire	25/50/25
Colorado	25/50/15	New Jersey	15/30/5
Connecticut	20/40/10	New Mexico	25/50/10
Delaware	15/30/10	New York	25/50/10
D.C.	25/50/10	North Carolina	25/50/15
Florida	10/20/10	North Dakota	25/50/25
Georgia	15/30/10	Ohio	12.5/25/7.5
Hawaii	35/15/10	Oklahoma	10/20/10
Idaho	25/50/15	Oregon	25/50/10
Illinois	20/40/15	Pennsylvania	15/30/5
Indiana	25/50/10	Rhode Island	25/50/25
Iowa	20/40/15	South Carolina	15/30/5
Kansas	25/50/10	South Dakota	25/50/25
Kentucky	25/50/10	Tennessee	20/50/10
Louisiana	10/20/10	Texas	20/40/15
Maine	20/40/10	Utah	25/50/15
Maryland	20/40/10	Vermont	20/40/10
Massachusetts	20/40/8	Virginia	25/50/20
Michigan	20/40/10	Washington	25/50/10
Minnesota	30/60/10	West Virginia	20/40/10
Mississippi	10/20/5	Wisconsin	25/50/10
		Wyoming	25/50/20

Source: *1997 Property/Casualty Fact Book*, published by the Insurance Information Institute

It's good to know the minimum required by law, but it probably won't make much of a difference in your selection of coverage—because you'll probably want substantially more.

As we've noted before, most experts recommend buying bodily injury coverage of at least $100,000 per person and $300,000 per accident, and property damage coverage of at least $25,000. These higher limits are important: If a court awards someone more money than your auto insurance limits, you are **personally responsible** for the difference.

> If you want to protect your assets—a house, investments, a killer stamp collection—in the event that you cause an accident, you'll probably want coverage of at least $100,000/$300,000.

As part of your property damage liability coverage, if you damage another vehicle, the insurance company also will pay for **a rental car for the other driver**—which is considered a loss of use expense. (Of course, your insurance company is not so generous with you. Loss of use is not part of *your* physical damage coverage; however, you can add on rental car coverage—if you don't have a spare car—for a small fee.)

The other big liability concept is **vicarious liability**. Like *vicarious pleasure*, it's not something in which you participated...but it still affects you. In the case of your car insurance, it means liability that applies to a person or organization that did not actually cause damage or injury but is responsible for the actions of the person who did cause the damage or injury. A classic example: a member of your family causes a multi-car accident that results in claims against your insurance policy from the other drivers.

Liability coverage also might apply to injuries to a passenger in your car—but only if you were legally responsible for the passenger's injuries and the passenger is not a member of your household.

Defense Costs

Because defending a lawsuit in court can be very expensive, payment of legal defense costs is an important part of liability insurance coverage. In some cases, the cost of defense can be as much as—or more than—the amount ultimately awarded as damages.

It's important to remember that the insurance company pays unlimited defense costs in an automotive liability suit—and these defense costs are paid **in addition to the limit of liability**.

If defense costs were included within the limit of liability, most of us

would have to purchase much higher limits of insurance to be adequately protected. For example, if you had a $50,000 limit of liability and the insurer defended a claim for which your liability was questionable, but lost the case anyway and incurred $38,000 of expenses for defense costs, there would be only $12,000 of coverage left to pay for damages. If the damage award was $40,000, you would then have to pay $28,000 out of your own pocket.

Fortunately, car insurance doesn't work that way. This is vital for you, because the cost of replacing a car, however expensive, is finite; the potential liability risk is not.

If the insurance company defends against a liability suit and the court reaches a verdict against you, and if the insurance company delays making the payment, the court might require that interest be paid on the amount of the judgment from the time it is entered until it is paid or an offer of payment is made. This interest is **post-judgment interest**—and it does count toward the policy's overall limit of liability.

Another factor in the limits of liability: Most policies will pay up to $50 a day for loss of earnings (but not other income) you incur because of attendance at hearings and trials at the insurance company's request. But this nominal coverage doesn't impact most lability limits significantly.

Bear in mind that the insurance company is only obligated to defend claims that are— or may be—covered by the policy. It has no duty to defend or settle a claim for injury or damage that is not covered by the policy.

For example, if you are being charged with drunk driving, the insurance company will not pay for your criminal defense.

Medical Payments

Medical payments coverage is an optional part of auto insurance. The coverage pays **reasonable medical expenses** incurred by you, members of your family and passengers for bodily injuries sustained while riding in your car. (The insurance company will have its own ideas about what is or isn't *reasonable*.)

This coverage also applies to you and your family members when you're riding in **another automobile**, or if you're injured as pedestrians by an automobile.

Medical payments coverage allows **immediate payment** to you or other covered persons, regardless of who was at fault in the accident. Both you and the insurance company benefit from this aspect of the coverage. A quick settle-

ment of a claim for medical expenses resulting from an injury is a big help if you're paying the bills out of pocket, since you don't have to wait around until all the finger-pointing (and lawyer-calling) is done. The insurance company likes this quick-pay plan, too, because it hopes paying you right away will prevent you from filing a liability claim later for additional damages.

> **There is one major problem with settling medical claims immediately: You may not know right away what medical expenses you will incur as a result of an accident. Sometimes, one treatment is rendered immediately (such as the setting of a broken bone) and another treatment comes later (such as surgery to put a pin in the broken bone or physical therapy to follow). There may be a long delay between the first treatment and the final treatment for an injury.**

The **Insuring Agreement** section in many standard auto policies includes a time limitation on expenses covered by the medical payments insurance. So, it's good to know how long this is—especially if you're the kind of person who would put off surgery for as long as possible.

While no one would dispute the usefulness of medical payments coverage, it is one of the reasons car insurance is so expensive today. That's because medical costs have been rising dramatically in the United States.

> **One way insurance companies have been able to control costs in the health insurance arena is by using managed-care plans or health maintenance organizations (HMOs) to administer care. These plans save the insurer money, essentially by limiting policyholders' choices and by making certain expensive procedures more difficult—or even impossible—to obtain under the insurance policy.**

Not surprisingly, insurance companies have begun applying these same cost-saving techniques to auto insurance medical payments coverage.

Damage to Your Car

You have to carry insurance to cover damage to somebody else's car. But you don't have to carry insurance to cover damage to *your* car. However, most people with newer vehicles choose to get it—and all people who "co-own" their cars with a bank or leasing company are usually contractually required to have it.

Coverage for damage to your car is divided into two categories.

Collision coverage refers to direct or accidental physical damage to your car as the result of upset (flipping over) or impact with another vehicle or object (other than an animal).

The second loss category for damage to your car is called, aptly enough, **other than collision** or OTC. Historically, this has also been known as **comprehensive** coverage. It is a broad category that includes many types of loss. In fact, most types of auto insurance claims fall under OTC coverage.

> Collision pays for traffic accident damages, and comprehensive pays for other types of damage, such as from hail or a tree falling on your car. Collision coverage typically accounts for about 30 percent of the annual cost of an auto insurance policy, and comprehensive accounts for about 15 percent.

Auto policies are almost always written with **higher deductibles** for collision than for comprehensive losses. So, by treating an accident with an animal as a non-collision loss, the insurance company has done you a favor: It allows the lower deductible to apply. Why? Because insurance companies know that you will have greater opportunities to avoid contact with other cars or objects than with free-moving creatures that react unpredictably to lights, motion and sound.

Theft Coverage

If your car is stolen and it isn't recovered—and you have other-than-collision coverage—the insurance company will pay you the actual cash value of the car, less your deductible.

> This *actual cash value* is an important term that we will see throughout this book. In short, it means the amount paid for a thing minus the depreciation which has occurred during the term of ownership. In the case of cars, it is often used interchangibly with the term *Blue Book value*. Whatever the term, this is a conservative way to value an asset—and one that doesn't guarrantee the asset can be replaced.

If your car is recovered and it wasn't totaled, the insurance company will pay to fix the damages caused by the theft.

However, OTC coverage will not pay for things that were in—but not of—your car. This includes cellular phones, tapes and CDs, suitcases, cameras, purses and hundreds of other items. The good news is that these items probably will be covered by your homeowners (or renters) insurance policy.

Endorsements and Changes

Since an insurance policy is a legal contract, you or your insurance company can't just take a pen and make changes to the policy. To change any portion of the policy (whether it is the information on the Declarations Page

or any of the policy terms and conditions), the insurance company must issue a form that identifies the change being made. The form is then attached to the policy, and the change becomes binding on both parties.

Forms such as this—and changes such as this—are called **endorsements**.

Additional forms also are attached to a policy to add optional coverages that are not included in the standard policy form. These forms may be attached when a policy is first issued, or at a later date.

A variety of endorsements may be used in connection with an auto policy. Endorsements may do something as simple as correcting the misspelling of your name—or something more complex, such as changing the insured vehicles or adding a coverage that is not mentioned in the original policy.

One endorsement that has become popular in recent years is **towing and labor cost** coverage. When the coverage is written, a limit of insurance and a premium for such an addition will be shown on the Declarations Page.

Obviously, this coverage applies toward towing and labor costs when a covered auto is disabled. However, the labor costs are covered only when the labor is performed at the **place of disablement** (such as on the side of the road where the car stopped running—not later at a garage). This coverage usually is written for a prearranged, limited amount.

Based on their names, you might think that when you purchase both collision and other-than-collision coverage, any possible loss situation would be covered. But you'd be wrong. There are a few exclusions in the policy, which we'll get into later. Nonetheless, purchasing both does give you extremely broad coverage for direct and accidental loss to insured vehicles.

Limits of Liability

The term **limit of liability** is used all the time in insurance matters. It has the same meaning as limit of insurance or limit of coverage. Your agent or insurance company may use any of these terms interchangeably.

Insurance companies use the term *limit of liability* because when a loss occurs that is covered by the policy, they become legally responsible for honoring their contractual agreements to pay damages to you or to a third party on your behalf.

In other words, the liability in question belongs to the insurance company—and, together, you and the company set limits on it.

The limit of liability for any coverage is simply the **maximum amount of money** that the insurance company is legally obligated to pay if a covered

loss occurs. If a covered loss occurs for less than the limit of liability, the insurance company will pay the amount of the loss, minus any deductible that may apply. If the amount of a covered loss is more than the limit of liability, the insurance company will pay the limit of its coverage and *you* are responsible for paying any additional costs.

> **If, for some reason, you choose to purchase or renew an insurance policy that does not satisfy the financial responsibility law of your state, that policy must come with a clear, written warning that it does not meet the law.**

You don't get to choose the limit of liability for physical damage coverage directly, because it is based on the actual cash value of the covered car, minus any deductible.

An important point: **Most cars depreciate in value rapidly**. If you paid $20,000 for a new car five years ago and it is totally destroyed today, it would not be worth its original cost—nor would it be worth the current cost for a new car. Instead, your insurance company would pay the actual cash value, and you might receive $10,000 as a settlement.

Generally, the actual cash value of a five-year-old car should be enough for you to purchase another five-year-old car of the same (or similar) make and model.

If your car was not a total loss, the company would pay what it cost to repair the car with materials of like kind and quality (which may mean used or substitute parts). However, the insurance company does have the option of keeping all or part of any damaged or stolen property—and giving you a check for an agreed or appraised amount.

> **This is what people mean when they say a car has been "totaled." The insurance company pays out the total Actual Cash Value (ACV) of the car and takes possession of the title. It will then sell the wrecked car to an auto salvage company.**

Also bear in mind that if the shop doing the repair work does additional damage to your car (say, if it falls off the lift or someone backs into it), the insurance company will not pay. You'll have to get the money for those repairs from the shop.

A standard auto policy will usually include **specific liability limits** for certain kinds of coverage. One example: If you own a trailer, on most policies, the maximum coverage is limited to $500.

Interstate Travel

The odds are that you're going to drive into another state at some point. You may even work across state lines. Because liability laws vary from state to state, settling a claim can be complicated if an accident occurs when you are outside your home state.

That's why insurance companies have **out-of-state coverage provisions** in a standard auto policy. The standard Personal Auto Policy will automatically provide the minimum amounts and types of coverage needed in the other state. For example, suppose your home state does not have a no-fault auto insurance law, but you vacation in another state that requires no-fault coverage. If you have an accident in the no-fault state, your Personal Auto Policy will provide the required no-fault benefits.

However, most personal auto policies do place some restrictions on where you drive. Generally, the policy territory is limited to the United States, its territories and possessions, Puerto Rico and Canada. If you drive into Mexico, you must have valid liability insurance from a Mexican insurer. (If you don't and you're involved in an accident, you could wind up doing jail time, having your car impounded and suffering other penalties.)

It's a Rental

One of the most common questions people ask about auto insurance is "Do I need to buy the insurance that car rental companies offer?"

The answer used to be simple: No. But standard auto coverage has started to change in the last few years—limiting the coverage available when you're driving a car you don't own. Now, the answer is not so simple: Usually not, but in some situations, maybe.

In the 1990s, standard auto insurance policies were modified slightly to limit coverage for **non-owned vehicles** (this is the jargon term that includes rental cars in its definition). Essentially, the standard policy used to provide blanket coverage for an insured person driving a non-owned vehicle. These days, some policies limit the coverage to certain types of non-business use—and then only if there is no other insurance coverage available.

To be sure about your coverage for rental cars, read the non-owned vehicle section of your policy. If it includes weasel words, find out if your employer covers you for business travel under a corporate liability policy. If not, call your insurance company and ask for an endorsement broadening coverage for non-owned vehicles. This will add a few dollars to your premium—but it will be much more cost-effective than paying for the insurance that

rental car companies offer.

When you rent a car, you usually will be offered several kinds of coverage. The most common is a **collision damage waiver**, or CDW. Some rental companies use the term loss damage waiver, or LDW, instead of CDW—but the protection is the same.

This kind of waiver releases you from responsibility for damage to the rental car, provided you comply with the rental contract terms. If you decline the coverage and have an accident, you may be held responsible for the entire value of the car. (A technical point: CDW isn't, strictly speaking, insurance. It's an indemnification agreement between you and the car rental company.)

> One common problem is that CDW agreements often contain limitations and loopholes that renters can unwittingly violate, voiding the coverage. For example, CDW can be voided if you drive on an unpaved road, or if you engage in "negligent" driving—and the rental company defines *negligent*.

CDW usually is overpriced. It added about $11 a day to the cost of renting a car in 1995. However, in states where rental companies have to bundle collision coverage into the advertised rental rate, average rates are only about $2.50 a day higher than in the rest of the country. (Illinois used to be one of the states that bundled coverage in rental car rates. However, in 1997, it changed its laws to allow car rental companies to sell the coverage again. This change was made because of the move among auto insurers to limit coverage for damage to rental cars.)

CDW isn't the only additional insurance car rental companies may try to sell you. Other kinds include:

- **Supplemental liability insurance**. Unlike the CDW/LDW, this option protects the renter against property damage or personal-injury claims over and above the basic liability limits provided in the rental agreement—usually the minimum required by state law.

- **Personal-effects coverage**. This provides limited reimbursement for loss of baggage and other personal property during the rental period. (These items probably are covered by your homeowners policy.)

- **Personal accident insurance**. This provides limited accidental death benefits for the renter and—often—passengers.

Of these, supplemental liability is the coverage most people should con-

sider. Whether or not you should buy it has a lot to do with where you're renting the car. In some states, major car rental companies are beginning to **shift primary liability** responsibility to renters who have personal insurance. That means, without supplementary coverage, you could be faced with financial disaster if you are sued.

A useful rule of thumb: If the clerk at the rental desk asks for the name of your insurance company and you haven't secured broad non-owned auto coverage, you should consider taking the supplemental liability coverage.

Coverage also may depend on whether you use the car for business or pleasure, or whether your vehicle at home is being used in your absence. Some personal policies limit the number of rental days covered each year. Others apply deductibles and lower liability limits to collision coverage—and, therefore, rental car coverage.

Even when your personal auto insurance does cover you in the event of a physical damage loss to a rental car, it will usually be treated as excess over the insurance or other coverage purchased from the car rental company. This means that if you bought the CDW, your insurance company won't pay until the rental car company's obligation is tapped out.

And if you think the credit card you use to rent the car provides all the coverage you need, think again. Insurance offered by credit card companies is treated as **excess over all other forms of coverage**—even your personal policy.

Uninsured Motorist Coverage

Uninsured motorist (UM) coverage is designed to protect you for bodily injuries when those injuries are caused by another driver who either has no liability insurance or has coverage that is less than the minimum requirements of state law. UM coverage also protects you for bodily injury when caused by a hit-and-run driver who cannot be identified.

Uninsured motorists are a bigger risk than many people think. According to the California Department of Insurance, in certain parts of Los Angeles County, fewer than seven in 10 drivers have auto insurance. The same study found that almost 28 percent of all California drivers are uninsured—a number that seems to apply to the states with the biggest populations.

Even in states that strictly enforce auto insurance rules, uninsured motorists go to great lengths to stay on the road. Some purchase temporary insurance to obtain license and inspection seals, then discontinue their payments. Others use counterfeit insurance cards.

UM coverage was conceived as a partial solution to the problem created by drivers who would not or could not obtain liability insurance. It benefits those who are covered by a Personal Auto Policy and who purchased UM coverage. It does *not* benefit the uninsured motorist who is responsible for an accident.

In most states, UM coverage applies only to bodily injury. Only a handful of states allow this coverage to apply to property damage. (In many states, property damage caused by an uninsured motorist or a hit-and-run driver comes under the domain of your collision coverage—an important point to consider before you turn down collision coverage.)

Underinsured motorists coverage is slightly different. It applies when another driver who causes an accident has liability insurance, but the insurance is inadequate to cover resulting injuries.

For example: You carry $50,000 of underinsured motorists coverage. Another driver swerves onto the wrong side of the street and hits your car head-on. You need $45,000 to cover your injuries. The other driver only has $30,000 of bodily injury liability coverage and cannot personally pay the additional damages. The other driver's insurance company would pay you $30,000, and the underinsured motorists component of your coverage would pay the additional $15,000.

Underinsured motorists coverage is often linked directly with uninsured motorists coverage in a standard policy. Whether or not they're linked, it's usually a good idea to purchase coverage limits in line with the other personal property coverage in the policy.

UM coverage is susceptible to some strange legal rulings and regulatory interpretations. But, if anything, this only makes it all the more important to have.

An example: In 1994, insurance companies in Ohio were increasing their cash reserves (money stockpiled to pay claims) in response to a decision from 1993 that increased the awards for injuries suffered in auto accidents.

This decision eliminated the per person liability limits for bodily injury and uninsured/underinsured motorists coverage in wrongful death cases. It also expanded underinsured motorists coverage to apply to situations where it didn't previously.

The Ohio Insurance Institute estimated that the change would result in rates doubling on uninsured and underinsured motorists coverage. Many people in the insurance industry worried that such a spike would convince some drivers to drop the coverage.

Exclusions

Every insurance policy will have a section devoted to exclusions. They help shape the coverage—and narrow its scope—by specifying losses that the policy won't pay.

Exclusions generally are included in insurance policies to accomplish these four broad purposes:

- to **clarify the intent** of coverage;

- to remove coverage for losses that should be covered by **other forms of insurance**;

- to remove coverage for losses that result from **above-average risk factors**, which are not anticipated in average rates and premiums (usually this type of excluded coverage is available at an additional charge); and

- to remove coverage for **catastrophic losses** that generally are not insurable (although coverage for these losses may be available through special insurance policies or government programs).

Exclusions form the basis of most of the legal disputes that occur between policyholders and insurance companies.

The C-Word

One of the most common complaints about car insurance companies is how quick they are to cancel your policy if you have an accident or get too many tickets. Fortunately, state regulators have taken a great interest in how, when and why insurance companies **cancel** policies.

In 1995, Washington state Insurance Commissioner Deborah Senn announced a package of changes in procedure and consumer education programs intended to help people make sense of their auto insurance. The centerpiece of the Washington package was a proposed law that would prevent insurance companies from **cancelling or denying auto coverage** based on a single accident per insured driver—or because of accidents that weren't the fault of the policyholder.

> Insurance regulators hear many consumer complaints that insurance companies arbitrarily assign partial blame to policyholders when accidents aren't their fault. After assigning blame without consulting the policyholder, some companies then cancel the coverage.

Another Washington proposal would prohibit insurance companies from denying people auto coverage because their **coverage was previously cancelled** or denied by another company. Consumer groups call the practice **"blacklisting."**

Of course, even the most progressive states must allow insurance companies to cancel policies in some instances (after all, insurance is a business, and insurers should be allowed to make a fair profit). But state insurance regulations do provide guidelines concerning when and why policies may be cancelled, and how. They usually require the insurer to use **specific language**—and provide explanations and information—to the policyholder as part of the cancellation notice. If they don't comply, insurance companies often get far more than a slap on the hand.

> If your car insurance is cancelled—or not renewed when it expires—make sure that the company gives you a clear, written explanation of *why* this is happening. If the explanation doesn't come promptly...or doesn't make sense when it does come...contact the consumer protection branch of your state Insurance Commissioner's office. Have the cancelled or non-renewed policy ready. Regulators like to pursue these cases.

State insurance departments also have heard a growing number of policyholders complain that, if they make even a small claim, insurance companies will threaten to cancel their coverage unless they buy other insurance policies—such as homeowners or umbrella liability insurance.

In April 1994, the Prudential Insurance Company of America told its New Jersey agents that it would not cancel the auto insurance policies of policyholders who didn't buy other types of insurance or have clean driving records. Prudential spokesman Robert DeFillippo said the directive to the agents was a reiteration of current policy. But some agents—and policyholders—claimed the statement flew in the face of their own experiences with the company.

The agents claimed that the company was not renewing the auto policies of hundreds of customers, including ones with good records, but was willing to reconsider if they purchased other insurance from the firm. Their claims were buttressed a few months later, when a Prudential agent went public with what he said was a list of 97 clients that the company had identified as candidates for cancellation unless they bought additional policies.

Some states require that an insurance company offer **alternative coverage**—which usually comes at a higher cost—whenever it cancels a policy. The insurance company has to refund part of whatever premium you've already paid, too. The refund typically is calculated on a **pro rata basis**, which means the refund is based on the time coverage was in effect.

However, there are situations in which a return premium computation is not based on an even division of the premium, and the insurance company is allowed to retain slightly more than a pro rata share in order to recover the expenses of issuing the policy. When a policy is issued, the insurance company expects to recover its **administrative expenses**—for generating the policy and keeping policy records over its term.

> When a policy is cancelled, the exposure to loss terminates but some of the insurance company's fixed expenses remain the same. It can recover these expenses by deducting a slight penalty from the return premium. Return premium calculations that include this penalty often are referred to as short-rate cancellations. Look carefully at the cancellation language in any auto policy you buy...short-rate cancellations are something to avoid. Some companies will take out the language if ask them to do so.

If you decide to cancel a policy, the insurance company usually will return only 90 percent of the pro rata portion of the unearned premium for the first policy year (thus, the penalty is 10 percent). This applies to annual policies, and to policies having a shorter term, such as three or six months.

If a two- or three-year policy is cancelled after the first year, the first-year premium is fully earned, the initial expenses have been recovered, and the insurer should return the full unearned premium for the unexpired term.

Having mentioned blacklisting, we should also mention **redlining**—the practice some insurance companies used to make of cancelling, non-renewing or increasing premiums excessively for car insurance in some neighborhoods. The idea was that, by increasing the cost of insurance beyond what was economically defensible, the company could **chase away unwanted business**. (In the bad old days, some companies would literally draw red lines on maps around neighborhoods they wanted to avoid. And, frankly, the neighborhoods were often selected because of the color of the residents' skin.)

Redlining is illegal. Insurance companies have to defend their rates to state regulators. But some consumer advocates insist illegal discriminatory practices still go on in the insurance industry. That possibility—however remote—is yet one more reason to check with at least three companies when shopping for auto insurance.

Assigned Risk

In most states, if no insurance company will sell you car insurance, you can buy coverage from a state-run company or an assigned risk plan. Insurance policies written by these **alternative markets** tend to be expensive and offer more limited coverage than standard policies.

A state-run insurance company is exactly what it sounds like.

An assigned risk plan is a **cooperative enterprise** that all insurance companies doing business in the state must participate in. The plan constructs a policy (again, usually expensive and limited) that it will sell to people whose driving records or location disqualify them from standard coverage. It then forces participating insurance companies to take a number of assigned risk policies—typically **a number proportional to their market share** in the state. (Big companies have to take more, small companies fewer.)

State-run companies and assigned risk plans serve the same purpose, have similar structures and share common problems—including fairly frequent financial problems.

In New York, drivers in the mainstream market (sometimes called the voluntary or commercial market) **subsidize the assigned risk pool**. Insurance companies fear that the premiums they collect from drivers in the assigned risk pool won't offset the claims they'll have to pay because of rising coverage minimums.

Michigan drivers also are forced to subsidize insurance sold through the Michigan Automobile Insurance Placement Facility (MAIPF). MAIPF writes this insurance at a loss (averaging about 1 percent or 2 percent of total premiums), which is then passed on to private insurance companies, who charge it to customers as a cost of doing business.

A more troubling example:

In early 1995, R. Terry Haskins, chief operating officer of New Jersey's Market Transition Facility (MTF), and Marshall Selikoff, trustee of the state's Joint Underwriting Association (JUA), resigned.

The MTF was a state-run insurance company. The JUA was an assigned risk plan. Most states don't have both forms—but New Jersey had had so many problems that it needed all the alternative markets it could find.

A few weeks before Haskins and Selikoff resigned, former Deputy Insurance Commissioner Jasper Jackson charged that the deficit-ridden insurance pools were poorly run, and said that former Insurance Commissioner Samuel Fortunato had recommended in 1993 that both men be fired.

Jackson said the men did not properly oversee the payment of medical bills and settlements for accident victims insured by the pools, resulting in millions of dollars in unnecessary losses for the state-run operations. He also said that medical payments to accident victims were only part of the problem. He said the MTF saved about $80 million in 1993 alone, after he and Fortunato insisted that Haskins and his staff review all claims for more than $5,000.

The companies administering claims filed against the MTF often were paying accident settlements without attempting to negotiate lower awards with plaintiffs' insurance companies.

The JUA had been founded in 1984 to cover motorists who were unable to obtain auto insurance in the private market. At the time, insurance companies said they could not make money in densely populated New Jersey and refused to write policies for many residents. The JUA grew to insure 2 million policyholders and ran up a debt of $3.6 billion.

In 1990, Governor Jim Florio abolished the JUA and mandated that auto insurance companies write policies for all motorists with eight or fewer motor vehicle points. To ease the transition of drivers into the private market, Florio created the MTF to serve as a temporary insurance company. Like the JUA, the MTF developed a debt, which officials said reached $1.3 billion in 1994.

The last JUA policy expired in 1990, and the last MTF policy expired in 1993. But the pools were still paying claims filed by accident victims. In 1994, state officials had to stop paying claims for MTF accident victims because the reserves in the pool had dropped below $50 million.

In general, it's best to stay away from assigned risk insurance. If you have no choice, call the state agency that runs the program—or a local insurance agent—and find out why you have to use the plan. Ask the state agency what you can do to improve your application. Then get out of the assigned risk plan as soon as you can. This one move will save you money and get you better coverage at the same time.

No-Fault Insurance

Another choice you may have in your state is whether or not to purchase no-fault insurance.

In most states, blame is assigned in an accident. The person who is deemed at fault—or that person's insurance company—is responsible for paying the costs incurred by the other party.

However, in 1995, 13 states used some form of **no-fault insurance system**. These systems all have similar goals, but they tend to differ widely in

practice.

If you opt for no-fault insurance, you agree to **give up certain rights** to sue if you are in an accident. In return, you receive a state-mandated premium discount (usually at least 15 percent).

Before you choose no-fault coverage, you should understand what that decision could mean. Under the option, you agree to relinquish your right to sue for **pain and suffering** in the case of a minor injury. But there are some exceptions:

- You keep the right to sue, if you are **injured seriously**.
- You're allowed to sue for damages, regardless of the type of injury, if you are hit by a **drunk driver or an uninsured or out-of-state motorist**.
- You retain your right to sue for **unpaid medical bills, lost wages and out-of-pocket expenses**.

Supporters of these programs say that no-fault promises quicker payment of insurance claims, because there's no wait for insurance companies—or courts—to decide who is at fault. A growing number of insurance companies agree, saying that no-fault systems reduce their costs—and the resulting higher auto insurance premiums—by limiting the number of lawsuits. That's a big plus for an insurance sector, in which legal fees account for as much as 12 percent of premium costs.

The basic factors that shape no-fault programs include:

- **Thresholds**. Designers of a no-fault system must decide when injuries are so severe that a person should be allowed to sue the driver who was responsible. Make the threshold too low and most people will go to court; make them too high and some may not be fairly compensated. Most no-fault proponents favor a **verbal threshold** that spells out which specific injuries permit an insured to sue. The alternative is a **monetary threshold**, which allows lawsuits for damages above a specified amount.

- **Benefit (or liability) limits**. A no-fault designer also must decide what maximum benefits an injured motorist can receive

under a no-fault policy. While some suggest a limit as high as $250,000, the industry proposal puts the cap on benefits at $50,000, which insurance officials say covers 97 percent of all auto claims.

- **Lost coverage allowances**. No-fault can mean that drivers pay more to maintain their current level of coverage. For instance, since no-fault only covers insured motorists and their passengers, a driver might have to buy a separate liability policy to cover such things as hitting a parked car.

- **Cost containment**. Low-cost policies also could require medical treatment from a managed-care provider. (Medical expenses typically account for 15 percent of insurance premium costs.)

"Pure" No-Fault

One reason proponents of no-fault defend it so staunchly is that when they say "no-fault," they generally mean **pure no-fault**.

Under a pure no-fault system, virtually all lawsuits related to auto accidents are eliminated. The right to sue and a shot at a damage award are replaced by the right to **guaranteed benefits**. Lawsuits are retained only to punish convicted drunk drivers and others guilty of criminal conduct. Policyholders pay premiums to protect themselves. If they (or their passengers) are injured, they are compensated by their own insurers—no matter who is to blame for any part of an accident.

That's unlike a **liability system**, which requires the responsible party's insurer to pay for medical bills and car repairs.

As yet, there is no pure no-fault system in the United States.

In 1995, the Hawaiian state legislature adopted what would have been the first pure no-fault program. Consumer advocate Ralph Nader visited Hawaii to lend his support to the program. He said that a limited reform plan being considered, which would allow lawsuits after damages exceeded $20,000 and offer consumers a choice of policies, was too complex. "And complexity always works to the benefit of the auto insurance company against the consumer," Nader said.

He and other supporters argued that, under pure no-fault, consumers would no longer have to hope that the person who hit them was rich or well-insured. They also wouldn't have to split the settlements with lawyers. Most importantly, they wouldn't have to subsidize uninsured motorists with UM cover-

age. (Getting rid of the need for UM coverage is one benefit of pure no-fault.)

The California-based RAND Institute estimated that the Hawaiian pure no-fault initiative would have provided drivers with $1 million in medical and wage loss coverage for **an average of half what they paid** for less injury coverage under the liability system. But governor Ben Cayetano said it would cost victims their chance to sue for pain and suffering. He unveiled his own plan, which would provide every car owner with $25,000 worth of liability insurance and let health insurance pay for traffic-related injuries.

Partial No-Fault

The 1995 Hawaii proposal came pretty close to pure no-fault. But most of the no-fault programs currently in place can best be called **partial no-fault**. They allow you to make a claim up to a certain dollar limit without having to determine who caused an accident.

About the same time Hawaii's no-fault proposal was getting bogged down in politics, California's insurance commissioner and a number of consumer advocacy groups proposed a partial no-fault plan. The program that Commissioner Chuck Quackenbush supported would require all drivers to purchase **a basic policy** with $15,000 in medical and lost-wage benefits—for an annual premium of $220 for most drivers. People injured in an automobile accident would be entitled to compensation for medical bills and lost wages up to the $15,000 limit, regardless of who caused an accident. If damages went beyond that threshold, they could sue.

The minimum policy would be mandatory for all Californians, with proof of insurance required for vehicle registration. Modeled after New York's no-fault law, it also used a verbal threshold—"serious or permanent injury"—to determine in which cases litigation could be pursued.

> In New York, all auto insurance policies must contain $50,000 in no-fault coverage for medical expenses and lost wages. Policies still have liability coverage, but that only begins after the $50,000 no-fault limit has been used up.

Michigan and New York often are cited as having good experiences with no-fault. Georgia and Connecticut, which repealed no-fault in the 1990s, often are cited as having had bad experiences with the system.

> Some consumer advocates who support no-fault reforms argue that trial lawyer groups spend a lot of money to oppose any form of no-fault. And, even in states that have stuck with no-fault plans, regulators have tended to lower liability limits—which lawyers like.

Under New Jersey's no-fault auto insurance law, all drivers must buy **personal injury protection** (PIP) coverage. If an accident occurs, it pays for all medical bills and lost wages for the insured up to $250,000. Drivers have to buy PIP as part of every automobile insurance policy. This coverage is a substitute for the indemnification typically handled through civil lawsuits.

In Michigan, legislators consider modifications to the state's expensive no-fault system on what seems like an ongoing basis. That state's PIP coverage also has **no liability limit**—although the financial model on which it's based assumes an average limit of $250,000. No other no-fault state requires unlimited PIP coverage.

The troubling trend for Michigan auto insurance costs is that the total value of so-called "PIP catastrophic" claims, those exceeding $250,000, exploded in the late 1980s and early 1990s. The cost of paid claims rose by more than 1,500 percent between 1984 and 1994, while the number of claims reported rose by only about 200 percent.

In insurance industry jargon, this kind of increase is called a **deterioration in claims experience**. As a result of Michigan's deterioration, the annual cost of PIP coverage rose from $3 in 1978 to $23.60 in 1988 and to $96.95 in 1995. And this is a surcharge added to the premium of every driver in the state.

Insurers blame Michigan's unlimited benefits for driving up the cost of total premiums by more than 50 percent between 1990 and 1995. "If you're going to have a Michigan-style system, you might as well not have no-fault at all," said a spokesman for one of the biggest auto insurance companies in the country.

In 1993, Connecticut abandoned its no-fault system to return to a traditional liability system. Repealing the no-fault system wasn't easy but, "considering the alternatives, it was the least Draconian, the least intrusive, the least traumatic impact on the consumers," said Garrett Moore, president of the Connecticut Trial Lawyers Association.

Savings came primarily from no longer requiring the partial no-fault coverage, which paid up to $5,000 for medical bills and lost wages. Connecticut Insurance Commissioner Robert Googins noted that rates on policies dropped 7.7 percent on average—but the effect on individual consumers varied widely. At some companies, rising costs of liability claims **offset the cost reductions** from the return to the traditional liability system.

In short, the experience of no-fault systems has been mixed. By trim-

ming the thresholds of the things, politicians neutralize their effectiveness. (We'll see some similar issues in our discussion of HMOs in Chapter 11.)

If you are in a no-fault state, make sure that your policy covers damages that go **above the no-fault threshold**. If your policy doesn't do this, get supplemental coverage that does. If you are in a state which allows the option of selecting a partial no-fault, it's probably worth taking—because it does make resolving small damages relatively easy. But you still need to make sure that you have the above-threshold coverage. That's where things can get ugly.

Conclusion

Many people only buy auto insurance because the law says they have to—and often make their choice of a policy based on cost alone.

Insurance companies react to trends like this by accomodating consumer needs and preferences. They make auto insurance cheaper by limiting the amounts and kinds of coverage the policies offer. As a result, to use one example, standard policies that used to cover rental car losses begin to limit this coverage.

For this reason, you need to pay attention to the details of any auto policy you consider buying—even if you're buying on price. Two policies that cost the same amount may offer significantly different levels and types of coverage. When it comes to car insurance, the policy you choose makes a big difference.

Key Questions

Questions to answer for yourself before you call an insurance company, agent or salesperson about auto coverage.

1) Which cars do you need to insure? List the year, make, model and vehicle identification number.

	Year	Make	Model	VIN
Car #1	____	____	____	____
Car #2	____	____	____	____
Car #3	____	____	____	____
Car #4	____	____	____	____

2) Do all of these vehicles qualify for a Personal Auto Policy, or do some need to be covered by a commercial policy (e.g., vans that are used to deliver merchandise)? _____

3) Who are the licensed drivers in your household? Anyone driving the cars listed above needs to be listed on the insurance policy. The insurance company will want their age and drivers license number.

	Name	Age	License Number
Driver #1	_____	___	_____
Driver #2	_____	___	_____
Driver #3	_____	___	_____
Driver #4	_____	___	_____

(We'll consider some of the details of who drives in your household in the next chapter.)

4) What is the minimum liability coverage required in your state? It may be a split limit, with several numbers.

5) Do you want collision and other-than-collision (a.k.a. comprehensive) coverage on some or all of your cars?

Yes No

If yes, which ones? _____

6) Do you want towing and labor cost coverage? (If you are a AAA member or belong to another roadside assistance program, you probably don't need it.)

Yes No

7) Do you want uninsured and underinsured motorist coverage? (This, you probably do need.)

Yes No

Questions to ask an insurance company, agent or salesperson. (You may want to photocopy these questions and use them for each policy or company you consider.)

1) How much—in dollars—of the estimated premium cover each type of auto coverage? What are the liability limits of each?

	Premium $	Liability Limit
Liability	_____	_____
Collision	_____	_____
Other-than-Collision	_____	_____
Medical Payments	_____	_____
Rental Replacement	_____	_____
Towing, etc.	_____	_____
Other	_____	_____

2) Are there any unusual exceptions or exclusions to the Collision or Other-than-Collision coverage?

Collision _____

Other-than-Collision _____

3) Does the policy include any unusual language in its cancellation section? If so, what is it?

4) What does the insurance company consider grounds for cancellation or nonrenewal of a policy? _____

5) What kind of complaint record does the company have with the state insurance commissioner's office? If it has had problems, is there a good explanation?

Good Some Complaints Bad

6) What kind of coverage for rental cars does the policy you're considering offer? _____

7) Would you need to purchase the CDW or supplemental liability insurance?

CDW Supplemental

Chapter 2

How to Calculate Your Needs

Now you know how auto insurance works. But how much will you have to pay for it—and why?

One major factor that will determine the amount and cost of the auto insurance you buy is **where you live**—or, more accurately, where you keep the car that you're insuring. Different areas pay different rates because of a number of factors: **state insurance requirements**, local population, weather conditions, collision damage repair costs, **auto theft rates** and hospital costs. Also, insurance companies charge customers in a particular area for the cost of nearby accidents involving **uninsured drivers**.

Premium ranges vary from state to state. In the 1990s, drivers in Hawaii paid the highest premiums in the country, an average of nearly $1,000 a year—thanks to liberal liability laws and an abundance of uninsured drivers. Drivers in North Dakota paid the lowest, an average of less than $350 a year.

The Ideas Behind Rating

Within the insurance industry, professionals refer to pricing insurance coverage as **rating**. A rate is the cost for a unit of insurance. As you might guess, some means had to be devised for charging individual policyholders equitably for different amounts of insurance protection.

If you call several insurance companies and get very different quotes for coverage, it may seem that prices are set arbitrarily. But, actually, insurance companies use a consistent set of factors to determine the premiums you pay for auto insurance; different companies just apply those factors somewhat differently. For example, some companies consider certain characteristics—such as your age or your driving record—more important when setting rates than other companies do.

Insurers' **claims-processing** costs, **sales** costs and other overhead costs also can account for the differences in rates. Plus, insurance companies use your premiums to generate income through **investments**—so companies that have a good investment record may offer lower rates than those whose investments have been faring poorly.

Each insurance company will set a **base rate** for each specific coverage, such as bodily injury and property damage liability. For example, a base rate might be $300 a year for $100,000 of liability coverage. A driver with a good driving record might qualify for this base rate, while a driver with a poor driving record would be charged more. This higher amount is computed by multiplying the base rate by a **rating factor**.

> Rating is an important function in the insurance industry. For insurance companies to be financially stable, rates must be adequate to cover costs. For insurance companies to remain competitive in the marketplace, rates must be fair and reasonable in relation to the risk of loss.

The **primary factors** that affect rates—other than the state in which you live and drive—include:

- **who you are** (for example, your age, sex and marital status);

- your **driving record**;

- **where you live** within the state;

- **how you use your car**;

- the **model, mileage and year** of your car; and

- the **type of coverage** you select.

Each of these factors reflects some aspect of your particular **insurance needs**. Each is also quantified by the insurance company. Together, they add up to a **total rating factor**, which is then multiplied by the base rate for all major coverages—except uninsured motorists coverage.

> Rating factors do not apply to UM coverage—or to towing or other minor coverages that may be added by endorsement. The purpose of the factors is to analyze and categorize the major coverages.

We'll consider each of these rating factors—and what they mean in terms of your insurance needs—in turn.

Who Are You?

This is the most important factor in determining both your insurance needs and **the price you'll pay**. It's not a philosophical question, but rather one of how an insurance company perceives you. Are you a major risk or a minor risk? Are you likely to get in an accident...or not?

To determine your **risk profile**, insurance companies rely heavily on information concerning your **age, sex and marital status**—what insurance companies refer to as primary factors when computing premiums.

First, the insurance company will consider your age.

If you're young and you're insuring yourself, you'll pay more than any other age group. Depending on where you live, you also may have very few choices as to what kind of insurance you can buy. If you're a parent or guardian who has a young driver in your family, he or she likely will be the single biggest cost-driver in your insurance premium.

Most insurance companies categorize drivers in **age brackets**. These are age ranges, usually between seven and 15 years. For example, the youngest age bracket for most drivers is 16 to 25 years old. Within the age brackets, **sex and marital status** are factored in—and they have more of an impact on the bottom line if you fall into the youthful operator category. When it comes to young drivers, insurance companies pay particular attention to your marital status, **driver training credit** and whether you're a **good student**.

As dated a concept as it may seem, **marital status** does mean a great deal to insurance companies. Most insurance companies have actuarial tables that show that married people are less likely to be involved in car accidents.

For example, all males under age 25 qualify as youthful operators with most insurance companies—but only unmarried females automatically qualify. Generally, single men younger than 25 will pay the highest premiums. So, when you're buying auto insurance, remember that getting married moves you into a better risk profile. (Now there's a romantic reason to tie the knot. Maybe you can save on taxes, too.)

Once you've aged a bit or gotten hitched, you're considered an **adult operator**. There are only three classifications based on age and sex for this group—all other classifications relate to **use of the vehicle**.

For most men and women, auto premiums actually drop while they're in their forties and fifties. The rate of **accidents per miles driven** is lower for people in this age group than for any other group. Insurance companies know this and price their coverage accordingly.

Young operators are not the only people who pay high premiums. Since **retirement-age adults** tend to drive less and usually avoid driving in the most dangerous conditions (at night, during rush hour and in bad weather), fewer older adults than teenagers die on the roads.

However, accident rates—and premiums—begin creeping up again when drivers reach 65. For people over age 75, the rate of fatal crashes per miles driven is even **higher than it is for teenagers**.

> The accident numbers for the oldest drivers skew perceptions among auto insurance risk analysts. They tend to characterize the entire population of over-65 drivers as high risk. This means that drivers between 65 and 75, whose accident rates remain relatively close to drivers in the middle-age categories, subsidize the drivers over age 75. This becomes a political issue.

"A logical step would be to **adjust premiums** so that the oldest drivers paid much higher rates," says one risk analyst for a big multi-line insurance company, who requested anonymity for his comments on this subject. "But that would effectively force people over 70—certainly over 75—off the roads. The political fallout from that would be huge. There wouldn't be an elected official in Florida who still had a job."

Proposed plans for reducing older drivers' accident rates include **tighter relicensing rules** to ensure that their vision or other relevant capabilities haven't fallen below minimum levels. In 1994, 16 states had **age-based license renewal** regulations. But some advocacy groups, such as the American Association of Retired Persons (AARP), consider them discriminatory. "As a general rule," said Ted Bobrow, an AARP auto insurance specialist, "we oppose age-based testing. It may be a good idea to test all drivers every year or every four years."

> Senior citizens usually can get discounts on their auto insurance if they successfully complete driver safety courses. Also, senior discounts for keeping other lines of insurance—for instance, homeowners and personal liability—with the same company sometimes are greater than for other age groups.

Your Driving Record

While who you are is the primary factor that influences how insurance companies look at you as an auto risk, there are **secondary rating factors** based on some specific variables unique to each individual. These secondary factors also determine the cost of coverage.

Your **driving record** (what insurance companies call a **sub-class**) is the most important of these secondary factors. Insurance company statistics say:

The more accidents that you have, the more likely it is that you will be involved in another accident.

Normally, companies divide auto policies into three categories: **preferred**, for the best drivers presenting the least risk; **standard**, for people with good but less-than-perfect records; and **nonstandard**, for high-risk drivers.

If you've had several tickets or accidents, you will get lumped into the high-risk, nonstandard category. You also may wind up in this category if you've had a lapse of insurance coverage in the past or you've never had insurance before.

If you or someone in your family has a bad driving record, you need to consider two things. First, you may be limited in terms of the kind of insurance you can buy. Second, you may have different needs than you thought you had. While a high-risk driver increases your insurance costs, he or she also increases your need for liability, medical payments, collision and other-than-collision coverages.

At some point, you may need to take the keys away from a risky driver. In the insurance context, you can do this by making that person a **named exclusion** from coverage under your policy. However, reserve this course of action only for a truly dire situation. The insurance company will write this kind of exclusion, but you will be left effectively **self-insuring** that high-risk driver. **If you exclude someone by name from your coverage, make sure that person doesn't drive.**

In practical terms, excluding family members from an insurance policy doesn't work well. It doesn't solve *your* problem—only the insurance company's. When this does work, it usually involves older family members whose driving skills have been eroded by age. Exclude a teenager only if you're certain you can keep him or her from driving.

Nonstandard Auto Policies

A typical nonstandard policyholder seeks the minimum limits of liability required by law, has an undesirable or unverifiable driving record, poor credit history, poor claims experience or minimal net worth.

Sadly, this segment of the insurance market is **rapidly growing**. "Nonstandard is growing at a 14 percent to 15 percent rate, while the overall market is growing at 6 percent to 7 percent," says Charles Gray, president and chief operating officer of Tennessee-based Midland Financial Co.

Midland Financial sells nonstandard auto insurance in 16 states, primarily in the South and West. The company also provides car insurance to people in personal bankruptcy proceedings.

Why would bankruptcy be an issue? If a company thinks you're **not financially stable**, you might be rejected for coverage or pushed into a high-risk pool, even if you've never had an auto accident or a ticket. It might even cancel a policy you recently bought.

> Why does your credit rating matter? Insurance companies say there's a clear connection between good credit risks and good insurance risks. They claim that people who don't pay their bills are more likely to file a theft, fire or accident claim. Most large insurance companies will use personal credit ratings as a secondary factor if a policy applicant meets some predetermined risk profile.

More than 100 insurance companies use a credit test developed by Fair, Isaac & Co., a California-based statistical risk-evaluation firm (and developer of the nearly ubiquitous FICO credit scoring system). Other big companies—including Allstate Insurance—use their own credit tests.

Fair, Isaac evaluates at least 35 pieces of credit information. No single one makes **a bad insurance risk**, says Wendell Larson, director of marketing for the insurance division. What matters is your total score. It includes how long you've had a credit card, the number of accounts that are 60 days past due, and any liens, judgments or bankruptcy filings.

The test covers general credit information for the past five years and late-pay information for the past two years.

Allstate screens for several major credit blemishes incurred in the past five years, including foreclosures, judgments, bankruptcies and liens. It also looks for whether you have had a second occurrence of garnishment or repossession or left a bill of $100 or more unpaid for at least three months.

Just one of these problems can tip you into Allstate's **high-risk category**, where charges are 50 percent to 100 percent more for coverage. It's not a place you want to be.

How You Use Your Car

Your insurance needs and the insurance company's risk analysis coincide when it comes to the question of **how you use your car** or cars.

Among the insurance company's primary rating factors are the automobile use classifications. These include **pleasure use, business use, farm use** and **driving to work**.

If you only use the car for pleasure (this is sometimes called **occasional use**), your premium will be lower than if you drive it every day to work. Cars that you claim for business use tend to be even more expensive to insure. The other categories fall in between.

The number of cars you have also impacts the kind of insurance you buy. A Personal Auto Policy will be rated as either a single-car risk or a multi-car risk. In most cases, insuring your cars as a multi-car risk will be more cost-effective—since many companies give multi-car discounts—than insuring cars separately. But this issue is worth exploring with your insurance company or agent—especially if you have a high-risk driver in your household.

Generally, the use issue comes into play when you're insuring **more than one car**. If your household has two or three cars, you probably shouldn't insure them all as work- or business-related. Try to insure at least one of the cars that you don't drive every day as a **pleasure** or occasional-use vehicle.

Also, let your insurance company know if you won't be using a car for more than 30 days. You might be able to suspend your collision coverage.

Your Neighborhood

The state you live in has an effect on your insurance rates—and so does your neighborhood. This is another secondary factor.

If you live in a large metropolitan area, you will pay more for auto insurance than if you live in the country. And if you live in **certain ZIP codes** or areas within a big city, your insurance may be even more expensive still.

While some insurance reform plans have done away with it, most states still allow insurance companies to adjust insurance rates according to neighborhood. This practice penalizes people who live in high-crime and high-accident areas. Critics argue that this quickly becomes a mechanism for unfairly discriminating against certain groups of people—red-lining in the most extreme cases.

Candid insurance companies argue that this is a process of discriminating bad risks from good ones. They argue that **claims histories** support their premium structures. In your particular case, **higher local rates** may mean more people may be driving without insurance in your area. They also mean a greater risk of hit-and-run accidents.

In terms of your insurance needs, these factors make **uninsured and underinsured motorists** coverage particularly important. If you live in a big city and drive a new car, you should make sure you have UM that covers the car's value—and your own.

In most states, UM applies only to bodily injury. In a few states, it also applies to property damage—or property damage UM coverage may be available as an option. Rates for UM coverage often apply to $50,000 single limit coverage or $25,000/ $50,000 split limits of coverage. If you want higher limits, an additional flat-dollar premium charge is added to the base rate.

Insurance companies also are interested in whether you keep your car in a **garage**. Garaged cars are less likely to be stolen or sideswiped by errant drivers. If you keep your car in a garage in a low-risk area, you'll get a break on your premium—in a high-risk area, that break will be even bigger.

You also may keep one or more cars at another address. For instance, you might live in Washington, D.C., but keep a car at a vacation home on the Delaware shore. If you do, you'll want to let the insurance company know. It will use the **garaging address** for each vehicle when determining the premium you'll pay—and the rates in Delaware will be much lower than for your home neighborhood.

The Make, Model and Age of Your Car

The final—and, to some people, the most important—secondary risk factor is the kind of car or cars you are insuring. This factor considers the **make, model and age** of your car. This is the reason a 1969 Corvette may cost more to insure than a 1995 Cavalier. Or, more commonly, why a one-year-old BMW will cost more than a three-year-old Mercedes.

To set rates for **collision** and **other-than-collision** coverage—if you choose to purchase these coverages—an insurance company has to calculate how much your car is worth and then calculate how much it will charge in premiums. To avoid inconsistencies, the insurance industry uses standard formulas for calculating premiums.

Four factors influence auto insurance premiums:

- the **age** of the vehicle;

- the **value** of the vehicle;

- the **deductible** amount you've chosen; and

- the **territory** in which the vehicle is located.

If all other factors are equal, **the older the vehicle, the less the cost for collision coverage**. Most vehicles wear out with use, and the **replacement value** declines over time. (Especially the first minute after you drive a new car off of the sales lot—but car depreciation schedules are a rant for another book.)

The **age of a vehicle** is derived from the model year. This can be a flexible thing. Historically, auto manufacturers traditionally started selling their new models in the fall of the previous year—for example, 1994 models would be introduced in the fall of 1993. However, in the last few years, car makers have been known to introduce 1997 models as early as the spring of 1996.

Not surprisingly, insurers use a somewhat different method for calculating the current model year. They follow an **age group rule**, which means that the model year for insurance purposes changes each October 1, regardless of when manufacturers actually introduce new models. For example, after October 1, 1997, all 1998 models would be classified as age group one, 1997 autos would be age group two, and 1996 vehicles would be age group three.

> The maximum age is six, so all vehicles that are more than five years old are classified as age group six.

The second factor that affects collision and other-than-collision rates is the **value** of the vehicle. Insurers assign cars to various **symbol groups**. The symbol groups make up a rating system developed by adjusting an automobile's value when it moves up or down to reflect the physical damage loss experience for that particular model. So, two 1998 cars of different makes and models might have the same market value, but they would be assigned to different symbol groups if one model suffers **greater damage in a crash** or is more expensive to repair. The higher the symbol group code, the higher the rate.

Shown below is a section of a sample **rate table** used by insurance companies to calculate the risk factors that influence the insured value of a car. The base rate for collision coverage for a particular automobile is where the appropriate territory, age group and symbol columns intersect.

AUTO NO.	CLASSIFICATION CODE	PRIMARY FACTOR +	SECONDARY FACTOR =	TOTAL FACTOR	SYMBOL	AGE GROUP	TERRI- TORY
1	___	___ +	___ =	___			
2	___	___ +	___ =	___			
3	___	___ +	___ =				

COVERAGE	AUTO 1			AUTO 2			AUTO 3		
	BASE RATE x	TOTAL FACTOR =	PREMIUM	BASE RATE x	TOTAL FACTOR =	PREMIUM	BASE RATE x	TOTAL FACTOR =	PREMIUM
$ BI ___	___	___	___	___	___	___	___	___	___
$ PD ___	___	___	___	___	___	___	___	___	___
$ BI/PD SL	___	___	___	___	___	___	___	___	___
$ MP ___	___	___	___	___	___	___	___	___	___
$ UM ___			___			___			___
$ COMP ___	___		___	___		___	___		___
$ COLL ___	___	___	___	___	___	___	___	___	___
$ TOWING ___			___			___			___
	TOTAL	$___		TOTAL	$___		TOTAL	$___	

Sports and luxury cars cost more to insure than your average sedan. Even if you're not driving a Ferrari or a Lamborghini, a sports car can cost a lot to insure. Most insurance companies classify car models in one of four groups:

- **standard**,
- **high performance**,
- **sports** and
- **high performance sports**.

The last three classifications all include higher premiums.

Many people find out, once they've bought their first high-performance sports car, that the insurance can cost as much as the monthly payment on the car. Even when the cost isn't that dramatic, it will be significant. If you want to indulge a taste for exotic or high-performance cars, factor in between 50 percent and 100 percent of the annual cost of buying and keeping the car for insurance.

Conclusion

In the previous chapter, we considered the mechanics of how car insurance works in general. In this one, weve considered the rating factors that reflect the particulars of individuals, families, makes and models of insured cars and financial needs.

These factors, which are categorized as either primary or secondary influences, are based on loss histories that various insurance companies have tracked for many years.

As you compare coverages and shop for cost-effective insurance, you should keep the rating factors that apply to your situation at hand in a reviewable format. You may find that insurance companies will be quite willing to lower premiums if you can adjust the rating factors. If you know what these factors are, you can speak knowledgeably with the insurance company or its representatives.

Key Questions

An insurance agent or salesperson is going to want to gather some information from you before giving you a quote on coverage. Here's what the agent is most likely to ask.

Questions to ask for each driver to be covered by the insurance policy.

1) How old are you? _____

2) What is your gender? _____

3) Are you married? _____

4) Do you have any points on your driving record (from being in an accident or getting a ticket)? Yes No

 If yes, how many points? _____

5) Where do you live? (Most likely, the insurance company will ask for your ZIP code.) _____

Questions which apply to the cars covered by the insurance policy.

1) What model category (standard, high performance, sports or high performance sports) applies to each car?

 Car #1 _____

 Car #2 _____

 Car #3 _____

 Car #4 _____

2) What is the mileage of each car?

Car #1 _____

Car #2 _____

Car #3 _____

Car #4 _____

3) How do you use each car you are seeking to insure (business, pleasure, farm, drive to work)?

Car #1 _____

Car #2 _____

Car #3 _____

Car #4 _____

Chapter 3

Comparison Shopping for Car Insurance

Shopping for auto insurance isn't easy. You want to get the best rates possible. But you also want to go with a company that will treat you well in the event of a claim—and one that will be around when you need it.

The best way to find a good insurance company is to ask people you trust about their experiences. Most will be happy to tell you their tales of woe. But they'll also usually recommend a company they've had good experiences with. Then you can call those companies and ask for quotes.

It's also a good idea to check with your state's **insurance department** or **insurance commissioner** to see if a company you are considering attracts an unusual number of complaints.

In 1994, approximately 200,000 people filed some form of complaint against their auto insurance companies—ranging from unfairly rejected policy applications and excessive premiums to insufficient settlements.

Many states publish brochures that rank insurance companies according to the number of complaints filed against them, compared with the total number of policies that each company wrote in the state. (A list of state insurance departments appears in the Appendix at the end of this book.)

And, as with any important purchase, you'll want to comparison shop. Rates for auto insurance can vary widely. So, you'll want to call **at least three different companies** to check premiums.

However, before you pick up the phone, it's a good idea to make a chart that will help you compare apples with apples. You'll also want to consider several **strategies for reducing premiums**.

Getting Going

As an auto insurance consumer, your choice of which coverage to purchase will be influenced by the following questions:

- What coverage do you have to buy because of **state law**?

- What **additional coverage** do you need or want?

- **How much** will the required and optional coverages cost? (The more coverages being purchased, the higher the premium, of course.)

Several different elements add up to the premium. You can pick and choose coverages and, in some cases, manipulate the menu to get more protection for less money.

Let's start by **charting your needs**, then take a look at a number of ways to save your hard-earned dollars.

How Many Assets Do You Have to Protect?

Your **net worth** defines how much liability coverage you should buy. If you're not worth much, the state minimums probably will cover any liability you might face. But you don't have to be rich to be concerned about protecting your assets. In states with a liability minimum of $50,000, even the equity in a modest suburban house may be worth protecting with a higher liability limit. That's why most companies offer standard insurance packages that include $100,000, $300,000 and even $1 million in liability coverage. (Bear in mind that a two-car accident involving four people can easily generate several million dollars in losses.)

Most financial advisers generally recommend that you carry bodily injury coverage of at least $100,000 per person and $300,000 per accident, as well as property damage coverage of at least $100,000. If you have substantial net worth that you want to protect against potential lawsuits, you'll want to increase your bodily injury coverage.

A simple way to calculate how much liability coverage you need is to add up the equity value you have in **your house**, any **other property** you own, major **personal possessions** (such as cars, jewelry or collectibles), and any savings or liquid investments you have. (In the cases of real estate and possessions, you don't even have to own them outright. Calculate the current market value, minus whatever debts you owe.)

Some experts also say you should add in any pension or retirement ben-

efits you have or investments you've made. Although these usually can't be seized in a legal judgment, their benefits can be attached over time.

The total value of all these things—even if you couldn't raise it by selling everything tomorrow—is what you need to protect. You should have liability coverage equal to at least this amount.

Assets Inventory

You may not even realize how much you have to protect. Here's a quick checklist to jog your memory.

Asset Category	Description	Value
Home	——————	——————
Second home	——————	——————
Income property	——————	——————
Savings	——————	——————
Stocks or bonds	——————	——————
Mutual funds	——————	——————
Alimony income	——————	——————
Pension benefits	——————	——————
Cars	——————	——————
Boats	——————	——————
Airplanes	——————	——————
RVs	——————	——————
Art	——————	——————
Collections (e.g., stamps, dolls)	——————	——————
Computer equipment	——————	——————
Jewelry	——————	——————
Stereo equipment	——————	——————
Other	——————	——————
Total value		——————

If you have assets worth more than $300,000, you should consider buying a $1 million **umbrella liability policy**, in addition to your auto insurance. An umbrella policy will pay off if damages exceed the limits of either your auto or homeowners policies.

A $1 million umbrella policy generally costs $200 to $300 a year. This is less than increasing the liability limits on your auto policy, plus you get broader coverage for your money.

The biggest mistake most people make on their auto insurance is that they are **underinsured on liability** coverage and **overinsured on collision** and comprehensive coverage.

Medical Payments Coverage

Liability coverage isn't the only part of the auto insurance package that you can adjust. The **medical payments** section also can include greater or lesser levels of coverage.

Medical payments coverage always is written with a **single basic limit** that applies per person in each accident—but that limit can be adjusted, usually in $5,000 increments. So, you can pick the coverage you want, and the insurance company will add a **flat dollar amount** to the published rate for each additional $5,000 of coverage.

> Generally, if you have a health insurance plan for you and your family that you're happy with, you can keep the medical payments coverage to the state minimum. But if you're in a managed-care health system that sometimes resists paying for experimental or high-risk treatments, you might consider higher medical payments limits.

In some cases, your insurance company or agent might say that **higher liability limits** and **lower medical payments limits** are tough to combine. Don't take this as an absolute. While some insurance companies prefer to keep liability limits consistent in high, middle and low packages, they can and do mix coverage levels.

Collision Coverage

One of the major factors affecting the price of collision coverage is the **deductible**. And, fortunately, this is something you can control.

A deductible is simply a risk that is "self-insured." With a $1,000 deductible, you pay for (or self-insure) the first $1,000 of each loss.

Obviously, how much you can afford to pay is going to be one of the deciding factors when you choose a deductible—but this doesn't just mean how much you can pay in the event of a loss. Most people want to pay as little as possible if they're in a collision. But they pick **higher deductibles** because they want **lower insurance premiums**.

> If all other factors are equal, the greater the deductible amount, the lower the premium for collision insurance. This is because higher deductibles reduce the insurance company's exposure. Small losses that do not exceed the deductible do not require a claim settlement (lowering the insurance company's costs of doing business), and large losses that exceed the deductible result in (a smaller settlement).

Deductibles typically are set at $500 to $1,000 per claim. However, deductibles ranging from as low as $100 to as high as $5,000 are available for

collision coverage. In picking your deductible, you need to ask yourself **how frequent such losses might be**, how many cars are being insured and how many loss-free years you will need to live through before the premium savings equal the extra risk being taken.

> To play it safe, assume that if you choose a deductible, you'll have to pay it once a year. This assumption budgets in the deductible as a cost of coverage.

To determine whether a deductible works for you, compare **a year's premiums** without a particular deductible to a year's premiums with that deductible plus the amount of the deductible. The **deductible total** will be higher. But if you go through the year without making a claim, you get to keep the deductible amount.

> In most cases, insurance companies will structure premiums to encourage high deductibles. For example, the cost of collision coverage with a $500 deductible can be as much as 45 percent less than the cost with a $100 deductible. In this scenario, a $500 deductible will pay for itself in premium savings in as little as three years. And a $1,000 deductible can pay for itself in just a little longer than that. But both of these scenarios assume that you don't make any claims during that period.

A caveat: If you finance your car, the finance company may not let you have a high deductible.

In the case of collectible or antique cars, you can opt to insure the vehicle for a predetermined replacement value called the **stated value**. Insurance companies usually offer this in the form of a premium per $100 of declared value.

For example, a 1957 Chevy in mint condition would be worth far more than a "restorable" '57 Chevy. It might cost many thousands of dollars to obtain a replacement vehicle and restore it to the same mint condition after a total loss. So, you'd want to insure it for an amount that you determine.

But this coverage is expensive. The cherry 1957 Chevy that you declare to be worth $40,000 may cost more to insure than a new Mercedes that sold for the same amount. Also, the insurance company has to agree to your determined amount.

Ways to Reduce Your Rates

When shopping for insurance, don't forget to ask about **special discounts**. Many companies offer price breaks to people who drive **fewer miles** than the annual average. Most also offer lower rates to motorists who haven't had an accident or moving violation for **three years**.

Also ask about **safety-feature discounts**: You may get a break if your car has air bags, anti-lock brakes, and an alarm or anti-theft system. For instance, The Auto Club offers approximately 10 percent off comprehensive coverage premium if you have a qualifying **anti-theft system**—and 15 percent savings on your medical payments, uninsured motorist and bodily injury coverages if you have an **air bag**.

If you have two cars, you also may be able to cut your costs by insuring them both on the same policy. Discounts for **multiple-car households** can range from 15 percent to 20 percent.

Also, look into insuring your house with the same company. **Multi-policy discounts** shave a few percentage points off the price of both your homeowners and your auto insurance policies.

There are several other ways to reduce your car insurance premiums. These include:

- **Dropping the rental-reimbursement** coverage. Rental coverage pays for renting a car when your own auto is in the repair shop. If you have two cars, you may be able to get along without a rental.

- **Dropping towing** and labor costs coverage. If you already have coverage—through an automobile club, for example—you're just duplicating your costs.

- **Dropping loss of income** benefits. You may want to skip this coverage if you have a good disability plan at work.

- Cancelling coverage if your **car won't be used** for a long period. If you're flying out of the country on vacation for a month or longer, see if you can cancel your coverage for collision and liability while you're gone.

- Joining **a car pool or taking public transit** to work. Insurers base your premiums, in part, on how much time you're driving. If you can lower your annual mileage sufficiently, you can lower your rates. Some companies offer a 10 percent to 20 percent discount for regular car pool drivers.

- Checking out insurance costs before you move. Insurance companies base their rates partly on where you live. People living in big cities will pay more than those in small towns, all other things being equal. Rates can even vary from one block or ZIP code to another, because of lower accident or theft rates.

- **Get older**. Drivers aged 50 or 55 qualify for a mature driver discount—usually in the 10 percent to 20 percent range.

- Buy **cars with better insurance records**. Generally, expensive cars cost more to insure than economy cars; sports cars carry heftier premiums than family sedans. Cars that are more popular targets of thieves also can cost more to insure. And cars that cost more to repair or sustain more damage in an accident than average also cost more to insure.

- Install an **alarm or fuel cut-off**. Most companies give discounts for anti-theft devices—many of which will deter all but the most determined thieves.

We'll consider even more tips and techniques to help you save on your insurance in a few pages. But first, a few words about the buying process.

Considering Insurance Companies

The kind of insurance company you choose can make a big difference, especially when you have to make a claim. Different companies offer different benefits—some stress low prices, others stress excellent service.

Companies also **target different groups** of drivers for their policies. For instance, if a company only writes policies for squeaky-clean drivers, its rates are going to be lower than one that accepts a broader range of drivers, hoping to make money on higher volume—and the extra investment income it can generate by charging higher premiums. Generally, insurance companies with lower loss records charge less for insurance.

Some companies charge more so that they can provide quicker service. If a company has more claims adjusters in your area, it probably will settle cases faster. But it also is likely to charge higher premiums. Only you can decide if the tradeoff is worth the money.

Bargain-basement insurers, in contrast, may be making their money by keeping **a tight fist on expenses**. To keep costs down and profits up, they may offer poor or **minimal customer service**, avoid paying claims whenever possible and process claims at a snail's pace, so their reserves can keep earning investment income as long as possible.

Some insurance companies also offer discounts if you agree to have accident repairs done at **preapproved body shops**. Insurers say that they can

save millions on the costs of processing accident claims by virtually eliminating the insurance appraiser. They compare these cost-containment plans to managed-care systems in the health insurance market.

Under **cost-containment plans** (also called preferred provider option plans), repair shops appraise cars and send the estimates to the insurance company via computer. That cuts the typical time it takes to get a damaged vehicle repaired from 14 days to seven. Because the shop gets a steady stream of business, it gives the insurance company reduced labor rates and parts discounts—usually in the neighborhood of 5 percent to 10 percent.

Preferred provider option is an outgrowth of another type of plan—called **direct repair programs**—that insurance companies began offering in the late 1980s. Direct repair programs encourage owners to choose a body shop recommended by the insurance company, although the owner also can go to a shop that's not on the list.

> In Pennsylvania, state-approved auto insurance rates dropped between 1993 and 1995, largely due to a cost-containment provision in a 1990 reform law.

Although only a handful of accident claims fell under cost-containment options during the mid-1990s, insurance industry officials predict that 25 percent of claims will use these systems by the year 2000.

Direct Purchases

Increasingly, smart consumers are buying their auto insurance **directly from insurance companies**. You can do this through the mail, on the telephone or—the most recent development—via on-line computer services and the Internet.

> The online services are an area in which most insurance companies see marketing potential. They predict a day when you can tap into a computer and see a comparative list of auto-insurance rates offered by each company.

Armed with this information, you could set the agenda when it comes time to bargain for the policy that will cover a prized car or trusty family wagon—or at least keep you on the road legally. This will require a greater level of consumer sophistication. You'll need to know more about what coverages you need and what you're buying with your premium dollars.

A number of companies also have begun using **direct marketing** as their main method of selling coverage. Direct marketers don't use agents or bro-

kers to sell their insurance; they sell through direct mail and telemarketing. Since they eliminate a sales staff—and a commission structure—these companies usually offer **cheaper premiums**. The problem is: Some of these companies handle claims the same way they sell policies. In other words, the price break usually comes at the cost of service. Nonetheless, direct marketing sales have become one of the fastest-growing parts of the auto insurance market.

Single- vs. Multiple-Car Policies

As we mentioned in the last chapter, insurance companies use rating tables to set premium prices. These tables often are divided into two sections—one for **single-car risks** and one for **multi-car risks**. The multi-car rating factors—and therefore the rates—are lower, because they include a discount for insuring two or more cars.

In fact, if there are no points against insured drivers, the rating factor for the second car actually can be zero—or even a negative number.

> Insurance experience points are not the same as the points the Department of Motor Vehicles issues, but they're similar. Insurance companies assign points for tickets and accidents, then add those points to your rating factor—based on your age, sex, location, etc. The total rating factor is what they multiply the standard rate by to come up with your price.

So, theoretically, insuring a second car on the same policy will be much less expensive than insuring two cars separately. However, in practice, multi-car risks often include **multiple drivers**. And one of these drivers might have a poor record or be young. This is what can drive up costs.

Insurance companies apply **secondary rating factors** to multi-car risks very simply. There are two key elements to remember:

- When rating more than one car, **driving record points** are applied to a maximum of two cars. When rating three or more cars, the driving record points are assigned to the two cars with the highest base premium. All additional cars don't have to have points, so their rates will be lower.

- When there are no youthful operators, the primary factor for the principal operator of a car is applied to that car. If you add **youthful operators** to your policy, the primary factors for youthful operators will apply to all vehicles those drivers use.

In all cases, if a **youthful operator** is the **principal operator** of a car, the primary factor for the young driver applies to that car.

Although youthful operators who are not principal operators are assigned to cars that have the highest base premiums, it is possible for two or more cars to have the **same base premium**. There is a rating rule to resolve this potential conflict when it arises.

> If the total base premium is the same for two or more cars, a youthful operator who is not a principal operator will be assigned to the car with the lowest rated-use classification (the "pleasure" versus "business" distinction).

There are several reasons why young drivers are expensive. Auto accidents were the most frequent cause of death among people ages 6 to 33 years old in 1992. In 1993, more than 5,400 teenagers died on American roads, and half of the deaths were alcohol-related.

Family Risks

Here are some effective ways to save money on family auto insurance:

- **Stay with a company**. The longer you're a good customer, the better the rates.

- Make sure your kids take **driver's ed**. Adding a teenager to a two-driver, two-car policy can boost a family's premiums by 50 percent. However, most major insurance carriers reduce premiums for drivers up to age 21 by 10 percent to 15 percent if they take a certified driver education course. If their school has no program, a course at a certified privately run driving school also will qualify you for the discount.

- Encourage your kids to get **good grades**. Most insurance companies provide a discount for students with a B average or better—or with a 3.0 grade point average in college. The typical discount is 10 percent. (Some companies ask for copies of report cards or transcripts each time you renew your policy.)

- Talk your teen into driving a nice, big, safe **station wagon**. Intermediate-size cars, sedans and other "low-profile" vehicles will carry lower premiums than high-performance cars, sport utility vehicles and sports cars. If your teenager wants to drive a sports car, you will have to go to a company specializing in high-risk policies—and the premium can be double the normal rates.

- **Raise the deductible** amounts—or drop—collision, fire and theft coverage for the cars the teenager drives. Many agents suggest getting a deductible of $500 for collision and $250 for theft and other damage, and dropping towing and labor coverage. This approach is especially appropriate if your child drives an older car.

- Put your teenage driver on **your policy**. This usually is cheaper than buying separate insurance. Even if your son has his own car, including his coverage on the family policy will help get the multi-car discount.

- If a teenage driver is in an accident that is not judged another driver's fault—or if the teenager gets a traffic ticket—the cost of your policy will rise, often dramatically. In this case, you may want to put your teenager on a **separate policy**. If your teenager has his own car and doesn't qualify for a good student or driver education discount, it may be better for him to have his own policy—especially if he has a bad driving record.

What Is a Safe Driver?

Safe drivers typically save as much as 20 percent off insurance companies' standard rates. But different insurance companies will have slightly different definitions of a safe driver.

The "Safety Pays" program from American Express's insurance divisions (AMEX Assurance Co. and IDS Property Casualty Insurance Co.) will give an idea of what they have in mind. The Safety Pays program looks for drivers with:

- No more than **one minor violation** or at-fault accident in the last three years per household.

- No more than one **comprehensive loss** or not-at-fault accident in the last three years per household.

- No **major violations**, such as driving while intoxicated, in the last five years (three years in Arizona, California, Delaware, Florida, Maryland, Michigan, Oklahoma, Oregon, Pennsylvania and Virginia).

- No **revocation or suspension** of driver's license(s).

- No Financial Responsibility Filings required in the last three years.

- Five years' **driving experience** in the United States for principal drivers.

- No **lapse** in insurance coverage.

- No accidents or tickets if under age 21.

In addition, some **high-performance cars will disqualify** you from the discount program. Classic, antique and customized vehicles typically are not eligible, and neither are commercial vehicles.

Wanna Make a Bet?

Insurance could be considered a gamble. You're either betting that you will have an accident or betting you won't.

If you feel lucky—in other words, if you are willing to assume some additional risk—you may wish to implement one or more of the following risk-related suggestions for **trimming auto insurance costs**.

Weigh the **cost of comprehensive and collision** coverage against the value of the car. On a car that is financed, banks require collision, which pays for damage to a driver's own car if he or she is involved in a wreck, and comprehensive, which pays for theft, fire and other losses. But once the loan is paid off and the car gets to be five or six years old, a driver may want to drop one or both coverages.

> Whenever your car's value gets below $3,000, it's a good time to reconsider these coverages. Insurers won't pay for damage that is more than your car is worth on the open market. That means that an 8- or 10-year-old car that suffers several thousand dollars in damage may not get repaired. Instead, it will just be totaled—i.e., declared an unrepairable loss. You'll get only the book value of the car—which could be less than $1,000, depending on the model and year.

However, if your car is still worth some money, you may want to keep these coverages.

If you do drop them and you cause an accident that damages your car— or if your car is stolen—you will not be reimbursed at all. So, drop comprehensive and collision only if you are willing to pay the **entire cost** of repairing or replacing your car.

Consider **raising your deductibles**. If you don't want to pay for the whole cost of the car in the event of a collision or theft, you may be able to lower the cost of collision and comprehensive coverages enough to make them worthwhile simply by increasing the size of the deductibles.

The National Insurance Consumer Organization, a nonprofit consumer group, says that increasing your collision deductible from $100 to $250 will knock an average of 20 percent off the cost of that coverage. Boosting the deductible to $500 could save another 30 percent. Even paying $1,000 in the event of an accident can be more cost effective than paying higher premiums.

Obviously, if you have an older car, it's important to know what it's worth before you buy insurance. A good way to determine your car's market or "book" value is to use the book many insurance companies use: the National Automobile Dealers Association's *Official Used Car Guide*, which is updated each month. Some companies also use the more consumer-oriented *Kelley Blue Book*. Most public libraries have copies of both books.

More Ways to Save

There are a number of other ways you can cut your insurance costs. Some involve assuming more risk. Others involve transferring risk to a different type of insurance policy.

For instance, if your state's laws allow it, you may want to drop your auto **medical payments** coverage. If you do most of your driving alone or with family members and you have good health insurance coverage, you might decide to skip the medical payments coverage and avoid paying twice for similar insurance.

However, if you often have people other than family members in your car, you should keep your medical payments coverage—so, in the event of an accident, injuries to all passengers would be covered. (Passengers who are family members could collect under your health insurance policy, but non-family members would have to sue you for negligence to collect under your automobile liability insurance.)

Other tips:

- Consider buying **last year's model**. If you're in the market for a new car and it's the end of the model year, you're probably considering the advantages and disadvantages of buying last year's model on sale. Last year's model is not only cheaper to buy, it's cheaper to insure. That's because rates are based on model year. However, the car also will have a reduced resale value (compared with a car of the next model year purchased on the exact same day) and a reduced actual cash value for insurance purposes. If you're leasing and plan to turn in the car

at the end of the term anyway, the financial benefits of leasing the older model clearly outweigh the disadvantages.

- Don't get tickets or have accidents. Good drivers can receive as much as 20 percent off the standard premium from some companies. In contrast, **a driver with more than five experience points** on his or her record can pay double—and sometimes even triple—the standard premium.

- Always **wear a seat belt**. Whether the accident is your fault or not, we all bear a responsibility to keep the costs to our medical and legal systems down. This, in turn, keeps insurance rates down. Besides, it's the law.

- Look ahead. What happens if you get in an accident? What if you're in two accidents in a year? It's worth knowing how accidents and claims might affect your future rates—and how the insurance company you choose **handles claims**.

- **Don't make small claims.** Use your insurance as a last resort. Carry higher deductibles and don't make small claims to your insurer. Statistics show that people who have a history of making small claims eventually tend to make larger ones, as well—and insurance companies base their rates on these statistics.

- **Don't smoke.** Several companies offer lower rates for liability, no-fault (medical benefits) and collision coverage to nonsmokers than to smokers. The reason: Smoking is thought of as a high-risk behavior.

- **Stay married.** Loss histories show that married people are less likely to be involved in accidents than single folks—and so they get better rates. Rates are especially improved for men in their twenties and thirties.

- If you're a senior citizen, check out **driver safety course discounts**. Some companies offer 10 percent or more off their standard policies for drivers who are age 50 or older and take a safe-driving class. (However, those discounts may not apply to drivers who are over 65.)

- **Retire early**. In their search for mature drivers who pay premiums promptly and don't spend much time on the road, insurance companies are offering big discounts to early retirees.

Don't assume an association's rates are the best available. For example: In 1994, National Insurance Consumer Organization President Robert Hunter said older drivers probably would pay less in their state's assigned risk insurance plan than they would for AARP's heavily promoted auto insurance. "Guaranteed renewability at inaffordable prices is no guarantee at all," said Hunter—referring to the primary reason older people buy AARP insurance.

You also can save money in some states by selecting a **no-fault insurance** policy. As we saw in Chapter 1, by giving up certain rights to sue in the event of an accident, you receive a state-mandated premium discount (usually at least 15 percent).

Ask insurers if they have any **unique or promotional discounts**. Different companies do have different loss experiences and different target markets, and they may provide a reward if you're their kind of customer.

Find out whether an agent can get you a better deal. After you've done your own shopping and comparing, you can go to an independent insurance agent—someone who sells policies from several different insurance companies—and see if he or she can find a lower price.

In some states, you also can ask your agent for a commission rebate. For instance, in California, Proposition 103 authorizes agents to rebate part of their commission to you. They may not like doing it, but it never hurts to ask.

Don't Skimp on the Liability

While it's tempting to cut liability coverage to save money, the risk of injuring or killing another person is the largest risk you face when driving. And, in fact, you save very little by purchasing lower liability limits, because the cost per $1,000 for liability decreases sharply as your limits increase. Don't risk the loss of your home or other assets just to save a few bucks.

The average person usually carries $25,000 per person per accident in liability coverage. Many experts recommend that you raise your comprehensive and collision deductibles and spend some of the money you save to pay for more liability coverage.

If you do a lot of driving—particularly in high-risk areas—you might consider increasing your **third-party liability**. Court awards in excess of $1 million are increasingly common. The additional cost of raising this coverage from $1 million to $2 million can be as little as $10 to $50 a year, on average. If you're over 25 and have a good driving record, it's even cheaper.

Another approach, if you live in a high-cost market—which includes almost every big city—and you need more than minimum amounts of liability insurance, is to lower the liability limits on your auto insurance and purchase a personal umbrella policy—called a "pup" in that fun insurance industry lingo. In some areas, this can slash your auto insurance bill by hundreds of dollars—and you won't be paying that much for the same amount of liability coverage under a plup.

I Didn't Want That

Sometimes, you can save money simply by reading your policy.

It's a reality of the modern insurance market that unwitting consumers get ripped off. In many markets, the rip-offs focus on selling multiple, redundant policies. In auto insurance, **the two biggest scams** are selling policies written by insurance companies that are bankrupt or don't exist and adding bogus surcharges to premium bills.

In August 1995, the owner of a south Florida insurance agency was arrested and charged criminally with bilking more than 1,000 customers out of nearly $100,000 by slipping **unneeded or unwanted charges** into their auto policies.

Months later in north Florida, four agents working for another insurance agency in its Tallahassee and Pensacola offices were charged with administrative complaints in what investigators said was a similar scheme.

In each instance, the agents allegedly ripped off consumers through a deceptive sales scheme known in industry jargon as **sliding**.

"Sliding—or **charging customers for insurance products without their knowledge** or consent—is a statewide problem," said Florida Insurance Commissioner Bill Nelson. "We are receiving complaints from people in different parts of Florida, and each is being thoroughly investigated. Where warranted, charges will be brought."

Besides the cases resulting in charges, investigators with the Florida Department of Insurance had a number of other sliding allegations under active investigation.

> Insurance department investigators in other heavily populated states—including California, Texas, New Jersey and New York—have begun campaigns to stamp out sliding.

You can remedy sliding problems quickly by reading your policy when it arrives and reporting any coverages you didn't want to your insurance agent

or company. If you don't get satisfaction right away, call your state insurance department.

Collector Car Insurance

We've talked about '69 Corvettes and '57 Chevys. But this isn't just loose automotive speculation. People collect cars they love—and love is a tough thing to insure.

If you have a street rod, classic car or other collectible vehicle, there is one other way you can lower your basic auto insurance rates: by putting that collector car on a separate insurance policy. However, these policies typically have a **low annual mileage limit**—around 2,500 miles—so they're only appropriate for cars that are driven only on weekends or to car shows.

The premiums for these policies usually are reasonable—possibly as low as **a third of the price** for a daily-driver—because the insurance companies know you'll take particularly good care of this car.

There are several other reasons why the premiums are so low. One is the mileage limit. Another is the typical restrictions on where and when you may drive, and what sort of storage facility you must use. (These cars must be garaged, and some policies require additional theft and fire protection.) Also, youthful drivers may not take these cars out for a spin.

However, to qualify for one of these collector car policies, your car often must be at least 25 years old. If you don't qualify for one of these policies (perhaps because of your car's age or that it isn't garaged), you can save some money on your Personal Auto Policy by letting the insurance company know that this vehicle is a **pleasure car**. This will qualify it for lower rates.

Optional Coverages

When you're assessing your auto insurance needs, you should consider all the optional coverages that aren't required in your state. These optional packages can answer many specific insurance needs.

In many states, **uninsured motorists** coverage must be included in automobile liability policies, although some states permit an insured to reject the coverage in writing. In some states, underinsured motorists coverage is a separate optional coverage that applies only when an additional endorsement is attached to the policy, in which case a separate premium also is charged. If the value of your car is higher than the state-required property damage liability minimum, you definitely will want underinsured motorists coverage. (You

also should buy this coverage if your area is noted for the number of uninsured drivers on the road.)

Some states allow benefit **stacking** as an optional coverage. This coverage means that you can add the uninsured motorists limits from insurance on several different cars to apply to a single claim. But be careful about stacking—you obviously shouldn't buy it if you only have one car, and some states have been accused of allowing stacking charges to be applied to all insurance policies.

Towing and labor cost coverage is a minor physical damage coverage. It covers charges for towing and labor when a covered auto is disabled due to a breakdown or accident. Covered labor must be performed at the place of disablement—labor performed after an automobile is towed to a garage is not covered.

Conclusion

Armed with this book, you should be able to shave a significant chunk off the price of your auto insurance. Just be sure to compare quotes from at least three companies, and don't forget to check their records with your state's insurance department. A bargain isn't a good deal if the company is notorious for delaying payment on claims—sometimes permanently.

Key Questions

1) Before you contact an agent or insurance company, you'll want to decide how much coverage you need, as well as what deductibles you would consider. The following chart will help you keep all this information straight.

Coverage	Limit desired	Deductible
Bodily injury liability	_____	NA
Property damage liability	_____	NA
Medical benefits	_____	NA
Uninsured motorist	_____	NA
Underinsured motorist	_____	NA
Collision	_____	_____
Comprehensive	_____	_____

2) Would you like any of the following optional coverages?

Rental-car reimbursement	Yes	No
Towing and labor costs	Yes	No
Loss of income	Yes	No
Funeral benefit	Yes	No
Stacking	Yes	No

3) When comparing companies, you'll want to find out which discounts you can qualify for, and how much those discounts are. The following are some of the more common discounts:

Discount	How much?		
	Company A	Company B	Company C
Safe driver	_____	_____	_____
Non-smoker	_____	_____	_____
Retired driver	_____	_____	_____

Driver age 50-64 _____ _____ _____

Senior safe-driving
course _____ _____ _____

Young adult driver's
ed. course _____ _____ _____

Good grades for
students _____ _____ _____

College student(s)
away from home
without a car _____ _____ _____

Anti-theft device _____ _____ _____

Car kept in a garage _____ _____ _____

Automatic seat belts _____ _____ _____

Air bags _____ _____ _____

Anti-lock brakes _____ _____ _____

Low annual mileage _____ _____ _____

Car pool (or taking
public transportation
to work) _____ _____ _____

Pleasure use only _____ _____ _____

Multi-car discount _____ _____ _____

Multi-policy discount
(e.g., homeowners and
auto with the same
company) _____ _____ _____

Legend: Company A is _____.

Company B is _____.

Company C is _____.

4) Will the agent give you a commission rebate? Yes No

5) If you are getting collision and comprehensive coverage, you'll
 also want to compare premiums with different deductibles.

Raising the amount of the deductible can lower your premiums substantially.

	Company A	Company B	Company C
Deductible 1 for collision ($____)	_____	_____	_____
Deductible 2 for collision ($____)	_____	_____	_____
Deductible 1 for comprehensive ($____)	_____	_____	_____
Deductible 2 for comprehensive ($____)	_____	_____	_____

6) If you own a collector car, it's worth inquiring about declared value coverage, as well as occasional-use discounts. It's also worth it to compare these rates with those for a special collector car insurance policy. (Companies that offer collector car insurance usually advertise in car magazines.)

Type of car: _____

Declared value: _____

Will this car qualify for coverage? Yes No

Does the insurance company agree to insure the car for this declared value? Yes No

How much will the premiums be? _____

What restrictions, if any, are placed on the vehicle? _____

What about an occasional-use discount? _____

Premium for a collector car policy: _____

What restrictions, if any, are placed on the vehicle? _____

Chapter 4

Insuring Boats and Personal Watercraft

As society has become more affluent and more mobile, unprecedented numbers of American families have purchased boats and personal watercraft. Of course, the fact that people are marrying later in life also has contributed to the upsurge in sales, too—since single people tend to have more disposable income.

If you're one of those people who is headed for the great outdoors every chance you get—along with your boat or personal watercraft—here's what you need to know about insurance.

The Basics

First of all, don't expect a **standard homeowners** insurance policy to meet your coverage needs. Most people who rely on their homeowners insurance to cover a boat or Jet Ski wind up with **gaps in coverage** that they don't know about until it's too late.

The kind of coverage that you need is similar to personal auto insurance. At a minimum, boats and jet skis need **liability** and **comprehensive** coverage. Liability protects you if your vessel injures someone or damages his property, and comprehensive insurance protects your property in case of vandalism, damage or destruction caused by theft or fire. Depending on the **age and value** of your craft, you also may want to purchase **collision** insurance, which provides coverage for damage you cause to your own property.

Boat insurance prices depend on the value of the boat and your boating equipment, the engine's horsepower whether it has an in-board or out-board motor, and the length of the boat, according to the Independent Insurance Agents of America (IIAA). You also can add coverage for such things as:

- fuel and other **spillage liability**;

- a boat **trailer**;

- **medical payments**;

- **personal effects**; and

- liability to protect you from an **uninsured boater**.

As with auto insurance, it is possible to get some price breaks on boat policies. Typically, **discounts** are offered for having **safety equipment** on board, or for providing **protective storage** for your boat when it's not in use. In addition, you may be eligible to receive lower rates if you hold a **captain's license**—or if you complete one of the safety courses offered by the U.S. Coast Guard Auxiliary or Power Squadron.

Pleasure Boats

In some respects, owning a boat is a lot like owning a car. For one thing, you'll face the same sorts of exposures to loss. These include:

- **Bodily injury** and **property damage** to others, such as injury to passengers, skiers, swimmers, occupants of other craft and damage to other craft.

- **Physical damage** to the craft itself because of collision with other boats or objects, fire, and theft (as well as many of the other comprehensive-type losses to which cars are exposed); and losses due to "perils of the seas," including wave action, stranding, sinking, or capsizing).

- Injury to the boat operator and other guests onboard the craft because of the actions of another boater who is **uninsured**.

- Liability imposed because of the responsibility for removing a **wrecked craft** from the waterway.

You can insure most boats as part of your homeowners policy or with a separate boatowners' package policy or an ocean marine policy. Yachts have their own type of coverage, since there are a few additional concerns.

Regardless of the type of coverage you buy, certain **conditions and exclusions** are almost always part of a pleasure boat insurance contract. Policies stipulate that the craft must be used "solely for private pleasure purposes,"

and that coverage **will not apply** if the boat is hired out, chartered, or used to transport people or property for a fee. Another common exclusion removes coverage while the watercraft is being used in an official **race or speed contest** (unofficial events are not excluded).

Your Homeowners Policy

If you have a homeowners policy, it will provide very **limited watercraft coverage**. For instance, coverage for physical damage to watercraft, trailers, furnishings, accessories, equipment and motors is limited to just $1,000 per occurrence. Not only is this a relatively low dollar amount, but this coverage applies only to the named perils in the homeowners policy. So, even if you get the broadest homeowners coverage available, it still won't protect your boat for "perils of the seas" (including wave action, stranding, sinking or capsizing).

> Even when coverage does apply to watercraft, it is often quite limited. For example, under the windstorm and hail perils, a homeowners policy will cover watercraft and related equipment only when they are inside a fully enclosed building. Since many boat owners store their boats outside, they wouldn't be covered under a typical homeowners policy.

Theft coverage for watercraft also is **restricted** under a homeowners policy. It applies only to theft that occurs at your home. If your boat and/or trailer were stolen from a lakeside vacation spot, a parking lot in a national park or any place else other than your home, there would be no coverage.

Liability coverage under a homeowners policy is limited, too. A homeowners policy offers coverage only to a very few types of vessels. For the kinds of vessels that are covered, it includes coverage for ownership, maintenance, use, entrustment of the watercraft by an insured to anyone else and vicarious parental liability for the actions of a child or minor using the watercraft. Excluded watercraft, obviously, are not covered.

The following chart illustrates some of the restrictions that affect the coverage of certain types of boats.

Power and Length Restrictions for Covered Watercraft			
	Owned by the insured	Rented to the insured	Borrowed by the insured
Outboard	Total 25 hp or less	No limit	No limit
Inboard and inboard-outdrive	Total 50 hp or less	Total 50 hp or less	No limit
Sailboats	26 feet or less	26 feet or less	No limit

Even if you own a small boat that falls within the **permitted range** for homeowners liability coverage, the odds are you'll want to look elsewhere for coverage—thanks to the $1,000 limit on property coverage. In most cases, $1,000 wouldn't even begin to cover your losses.

However, you may be able to take up some of the slack in terms of liability coverage via an endorsement to your homeowners policy. The **watercraft endorsement** provides the range of normally excluded liability coverage (related to ownership, maintenance, use, entrustment and vicarious liability) for boats that exceed the power and length limitations outlined above.

A caveat: You still wouldn't be covered if you were in an official race or practicing for a race (unless your craft is a sailboat). In addition, sailboats and inboard and inboard-outdrive-powered boats wouldn't be covered for bodily injury to any employee if that employee's main duties pertain to the maintenance or use of the watercraft—and there is no coverage while the watercraft is used to carry people for a fee or while it is rented to others.

The watercraft endorsement may solve some of your problems with homeowners insurance coverage. However, it doesn't help alleviate the **physical damage** exposures you face.

Boatowners Policies

Instead of trying to adapt a homeowners policy to meet only some of your needs, you'll probably be better off getting a **boatowners policy**, which is designed to provide all of the coverages necessary to meet a boatowner's needs. Some of these policies are designed to cover small to mid-sized boats, while others are designed specifically to cover larger craft, including high-value **houseboats** and even **luxury yachts**.

It's important to point out that insurance companies use different terms from the rest of us when they describe these policies. While most people use the phrase *personal watercraft* as the generic name for Jet Ski or Wave Runner-type crafts, insurers call boat policies **personal watercraft policies**. We'll call them *boatowners policies*, to be clear. To make things even more confusing, insurance companies also offer policies specifically for Jet Ski-style personal watercraft. Obviously, when you get quotes for a boatowners policy, you'll need to be sure you and your agent are on the same wavelength.

So, what do you get on a boatowners policy? Again, boatowners policies are a lot like car insurance policies. A typical policy will include:

- **physical damage** coverage for the boat and its equipment (on either a replacement cost or actual cash value basis);

- **liability** coverage for bodily injury or property damage to others;

- **medical payments** coverage for occupants of the boat; and

- **uninsured boater** coverage to cover injuries that may be caused by an uninsured or hit-and-run boater.

Policies designed for larger vessels often also include coverage for personal property on board the craft, and special coverage for injuries to crew members.

Definitions

Boatowners policies use a variety of terms that may be familiar to you. These include:

- Your **insured property**—meaning the boat or boats scheduled on the Declarations Page, along with related equipment. Policies designed to cover higher-value vessels will include furniture and dinghies, while policies designed for lower-value craft usually limit coverage for related equipment to that which is necessary to the operation or maintenance of the boat.

- **Covered person**—meaning you or any person or legal entity operating the covered boat for private pleasure use with the insured's direct and prior permission. (Business use is not allowed, because this is a personal watercraft policy.) Any of your family members or anyone else operating the boat with permission would be a "covered person." However, the definition of "covered person" does not include paid crew, or any person or entity operating or employed by a marina, boat repair yard, boat sales agency, boat service station or yacht club. (This is similar to the "auto business" exclusions found in a Personal Auto Policy, which state that if a shop damages your car, it is liable for the repairs—your insurance company isn't.)

- **Horsepower**—meaning the amount stated by the manufacturer as peak horsepower (at the flywheel).

- **Latent defect**—meaning a flaw in material or machinery that existed at the time the boat was built, but was not discovered by ordinary methods of testing.

A typical policy also provides coverage for **newly acquired watercraft**, as long as you notify the insurance company within the prescribed time period (usually 15 days) and as long as the new boat doesn't exceed a maximum value (what you paid for it or $50,000, whichever is less).

If you sell the boat—or assign or transfer ownership to someone else—coverage will **terminate** at that time, unless prior written consent of the insurer has been obtained.

A Short Leash

Most boatowners policies limit where you can use your vessel. The policy may name a specific lake, or it might describe a bay, **region or boundaries** within which the boat is permitted to operate.

Example: A yacht berthed in San Francisco might be permitted to navigate "the waters of San Francisco Bay and its tributaries, the coastal waters outside San Francisco Bay bounded on the north by Pt. Reyes and on the south by Santa Cruz." If you venture out of this area without contacting your insurance company, you won't be covered.

Why does the insurance company care where you go boating? Insurers base their rates on the risk of loss—and **the farther you travel, the greater the risk**, particularly if you live near treacherous waters. So, the company will charge higher rates for a boat that will navigate the entire globe than for a similar vessel that will navigate only in Chesapeake Bay.

On the other hand, if your boating excursions normally are confined to the San Francisco Bay area, but you want to take your boat on a trip to Mexico, all you have to do is get **permission in advance**—and pay an additional premium to cover the additional exposure.

Where your boat will operate also will have a profound effect on your rates. Because of record-setting damage from hurricanes during the last several years, **boat insurance is tougher to come by** in some parts of the country. However, many insurance companies will sell policies in high-risk areas under certain conditions. You may have to change where the boat is stored during hurricane season (July to November) and agree to navigational limits (e.g., travelling only in inland waters, or no more than 300 miles from land). You may even be asked to come up with a written hurricane emergency plan.

If you're in a high-risk area, you also can expect to pay 25 percent more than you would have before Hurricane Andrew struck in 1992. Boat insurance rates have increased about 15 percent since then. However, as with car insurance, you can opt for a higher deductible to reduce your rates.

What Is and Isn't Covered

Many boatowners policies take an **all risks of direct loss** approach to coverage (though a smaller number are written on a more restrictive, **named-perils basis**). The all-risk policies cover all losses that are not explicitly excluded. This includes coverage for perils of the seas—and for land transportation perils, such as **collision** or **overturn**. (In contrast, watercraft coverage under a homeowners policy, even with endorsements, would not provide such coverage.)

However, as in any insurance policy, there are **exclusions**. Typical property damage exclusions mean the policy will not provide coverage for loss or damage resulting from any of the following:

- **wear and tear**, gradual deterioration, weathering, insects, mold, animal or marine life;

- **marring**, scratching or denting (picture a boat moored at dockside, bumping up against the dock all day long);

- **osmosis**, blistering or electrolysis (these are chemical and electrical actions that take place in fresh or salt water, which gradually affect your boat; only sudden and accidental damage is intended to be covered by the policy);

- manufacturer's defects or **defects in design** (boat policies vary on this point, and some do provide coverage for defects in hull or machinery—as always, ask before you buy); and

- the cost of repairing or replacing any item having a "**latent defect**" however, if such a flaw in material causes other damage—for example, if a defective steering mechanism malfunctions and causes a collision—the policy will cover the resulting damage.

Getting the Coverage You Need

Vital points to address are whether your boat is covered for **actual cash value** (ACV) or **replacement value**, and whether the policy will cover personal possessions on the boat, from fishing equipment to water skis. If you tow your boat to the water, you'll also need sufficient **trailer coverage**.

Some **declared value** policies will pay the **full policy limit** in the event of a total loss, even if the actual value of the craft is less than the declared value. However, most policies that are designed to cover smaller craft include

loss-settlement provisions limiting the insurer's obligation to pay. Usually, the amount the insurer will pay for loss or damage **will not exceed** the lowest of the following:

- the difference between the **pre-loss ACV** and the **post-loss ACV**;

- the **actual repair cost**;

- the **pre-loss ACV**;

- the **actual replacement cost**; or

- the **declared value** of watercraft.

Large watercraft that are damaged or destroyed often have a salvage value, so a boatowners policy also will include a provision concerning salvage charges. Because a salvage company will charge for its services, the insurer agrees to pay those charges. In return, if there is any salvage or recovery after the insurer has paid for a loss, the company has a right to recover what is paid.

Most boatowners policies for **small craft** do not provide coverage for your personal property while it is onboard the vessel or being loaded or unloaded. However, policies for **large craft** often do offer coverage for such things as clothing, personal effects, fishing gear and sports equipment (there is no coverage for money, jewelry, traveler's checks, or valuable papers and documents). They also may include coverage for insured property that has been removed from the craft temporarily for storage on shore. If a policy has this kind of coverage, it won't require that **auxiliary equipment** actually be onboard at the time of loss (which means that coverage is provided for equipment on shore).

The insurance company also will pay the full cost for **necessary and reasonable repairs** to covered property, without deduction for depreciation—with the exception of property described in the "replacement" provision.

For property covered by the replacement provision, the policy provides coverage on an actual cash value basis (the actual repair cost or the replacement cost minus depreciation, whichever is less). This provision only applies to plastic and canvas coverings, all-weather bridge and cockpit enclosures, sails, outboard motors or out-drive units, and components of any of these items.

You also may want to buy commercial **towing and assistance coverage**, which is the boat version of the towing and labor coverage found in a Personal Auto Policy. In an emergency, the policy will reimburse you up to

$300 for the reasonable costs for towing to the nearest place where repairs can be made; for the delivery of gas, oil or parts; or for emergency labor, while you're away from a safe harbor. **No deductible** applies to this coverage.

Liability Concerns

A boat insurance policy includes coverage if you become legally liable to pay because of bodily injury or property damage that arises out of the ownership, maintenance or use of the boat.

> Like an auto policy, a boat policy will have stated limits of liability. The insurance company will pay up to that amount for all damages or losses arising out of any one accident or occurrence, or a series of occurrences arising out of the same event. So, you need to choose your limits carefully.

In the event of a liability claim, a boatowners policy also will pay **defense costs** in addition to the policy limit.

Policies aimed at large craft also may include coverage for liability arising out of:

- Attempted or actual **raising, removal or destruction** of the wreck of your boat;

- **Failure to raise**, remove or destroy the wreck of your boat; and

- Your **liability to paid crew members** under the Jones Act or other Maritime Law.

Naturally, a policy also will include a list of liability **exclusions**. These policies typically do not provide coverage for:

- Liability of **other covered persons** to you, your spouse or other residents of the insured's household;

- Your liability to your spouse or to any other person residing in **your household**;

- Liability assumed by you under **contract or agreement**;

- Fines or other penalties that any **government** requires you to pay; and

- **Punitive damages**.

The first two exclusions are designed to preclude you and your family from seeking damages from one another under the policy, which is supposed

to protect you by covering injuries or damages suffered by other people. So, if another **family member or a friend** is operating your boat with your permission and injures you, you will not be covered if you sue that other person (who would otherwise be a "covered person" under the policy). If you are operating the boat and injure a family member, that injured family member also will not be covered.

Some policies also will include an exclusion for liability that arises while the boat is being **towed**, except when the boat is hauled out or being launched—but most do cover towing as part of the "ownership, maintenance or use" exposure.

Because fines or penalties imposed by governmental agencies—and punitive damages—are a form of punishment for your **intentional actions**, they are not covered.

Finally, you also may want to consider purchasing an **umbrella liability policy** (covered later in this book). Unless boats are specifically excluded from the umbrella policy, it will cover any **liability in excess** of that provided by the homeowners policy or boat policy. However, an underlying boat policy still is required in most cases.

Medical Payments Coverage

A standard boatowners policy will pay necessary **medical, ambulance, hospital, nursing and funeral expenses** resulting from accidental bodily injury. This coverage applies only to persons injured while in, upon, boarding or leaving the insured boat (which is virtually identical to how the coverage applies under a Personal Auto Policy).

Like an auto policy, there is also a time limit on medical payments coverage. The insurance company only will pay costs incurred within one year of the accident date.

This coverage also comes with exclusions. Coverage usually is not provided for:

- injuries to your **employee(s)** while in the course of employment, or while using, maintaining or repairing your boat or its equipment, since this should be covered by workers' compensation insurance;

- any responsibility for **payment assumed under contract** or agreement, since this policy does not cover busines use.

You can select your limit for medical payments coverage. This is the most the insurance company is obligated to pay per person for each accident

or event (which means that if the limit is $5,000 per person and three people are injured in the same accident, the policy could pay up to $15,000).

Uninsured Boater Coverage

Just as uninsured drivers are a problem for car insurance, uninsured boaters are a problem for watercraft insurance—and moreso, because laws requiring watercraft insurance are less rigid. So, the responding coverage is commonly found in most boatowners policies. It is remarkably like the uninsured motorists coverage provided by personal auto policies.

The insurance company agrees to pay damages that you are legally entitled to recover from the **uninsured owner or operator of another boat**, because of bodily injury received aboard your boat. The term "uninsured owner or operator" includes someone who cannot be identified, such as **a hit-and-run boater**.

Policies also include a number of uninsured boater **exclusions**, which are similar to the uninsured motorist exclusions found on a Personal Auto Policy. Uninsured boater coverage does not apply to:

- claims settled without the company's **written consent**;

- any uninsured vessel owned by a **governmental body**;

- any vessel owned by or furnished for the regular use of any insured or family member;

- any insured while using a vessel **without permission**;

- your boat while it is being **chartered**; and

- any loss where **no evidence of physical contact** exists between your watercraft and either an uninsured or a hit-and-run craft.

You also **can't get paid twice** for the same loss under the uninsured boater coverage and the liability coverage of the policy.

Again, you choose your limits for this coverage, and the insurance company will not pay more than that amount for all injuries arising out of any one accident or event, regardless of the number of persons injured, claims made or vessels involved.

Pricing Coverage

The **size, type and value** of your boat—and the waters in which it is used—are factors that help determine how much coverage you need and how much you'll have to pay for it.

One of the primary cost-drivers for boat insurance is whether it is a **motorized craft or a sailboat**. Liability premium charges increase as the horsepower of the engine increases, whereas insurers often don't even charge for liability for sailboats.

An insurer also will look at the **speed at which a boat can travel** and the **skill of the skipper** when setting rates. For instance, according to the Insurance Information Institute (III), the annual cost to insure a 25-foot speed boat worth $20,000 to $25,000 for the physical value of the boat (against theft, fire, wind damage, collision, etc.) and for about $500,000 worth of liability coverage is between $500 and $900. Insuring a sailboat of the same size and value could cost as much as 50 percent less, since it does not go as fast and is assumed to have a more skilled skipper.

In addition to your skill, the insurance company will be concerned about your **boating record**. Because it is difficult to ascertain if you have been involved in a boat accident before, since there is no centralized record-keeping body, most insurance companies will look at **the way you operate a car**. If you have had several speeding violations or a DWI within the last three years, you probably present more of a risk for boat operation than someone who has a clean driving record.

The age of the craft is another factor in setting premium prices. As a general rule, physical damage exposure is greater for an older hull than for a newer one. This is due to the aging process, as well as the nature of the material of which the hull is constructed. Many insurers charge a higher premium for boats with older hulls.

And then there are the miscellaneous credits and surcharges. Insurance companies may give you premium credits for favorable factors—or charge you extra for unfavorable factors. The following chart details typical credits and surcharges.

Miscellaneous Credits and Surcharges

Credits	Surcharges
Sailboat	Older craft
Diesel engine	Wooden hull
Coast Guard/U.S. Power Squadron member	Driving record violations
Only operator is over age 50	
Ship-to-shore radio Coast Guard/U.S. Power Squadron course completed	

Often, you can save 5 percent to 15 percent on boatowners insurance by attending a **recognized safety education course**, such as those offered by the Coast Guard, U.S. Power Squadron and the American Red Cross.

The U.S. Power Squadron also offers **a home video course** for people who live in areas without regularly scheduled courses.

If you have two years of **claim-free experience** and another insurance policy with the same insurance company, you may qualify for additional savings.

Discounts of 5 percent to 10 percent also are available for **diesel-powered craft** that are equipped with safety equipment, such as fire extinguishers and ship-to-shore radios.

In many parts of the country, boats can only be used for part of the year—due to weather conditions, rough seasonal waters, or other factors. If your boat will be out of the water for some time, you can get a premium credit for the time period during which the craft will not be used. However, in exchange for the discount, you give up coverage during the "lay-up period."

Finally, **territorial definitions** or restrictions usually come down to either inland waters/fresh-water or coastal/salt-water boating. **Premium variance** between these two "territories" usually applies just to physical damage coverage for the boat; it does not apply to liability coverage.

Operating Other People's Boats

When you have car insurance, you are covered while driving other people's cars. When you have boatowners insurance, that **isn't always the case**. If you plan to operate other people's boats occasionally—such as when they want to ski on a water-skiing vacation—you need to be sure you get a policy that offers this coverage.

Policies that do offer you coverage while you are operating someone else's boat—assuming you have the owner's permission—include **physical damage coverage** for the boat, but only up to the limit you carry on your own boat. In addition, if there is **any other insurance applicable**—such as that boat's insurance policy—your coverage only will apply as "excess" over the other insurance. In other words, your insurance company will make up the difference if the damage exceeds the coverage on the other owner's policy. (This is nearly identical to the "other insurance" provisions that apply to the use of non-owned autos under a Personal Auto Policy.)

Even if you have coverage while operating other peoples' boats, there are some **exclusions**—primarily designed to keep you from weaseling out of

paying for coverage in the first place. An insurance company will not provide coverage under your boatowners policy for any **other vessel** that is wholly or partially owned by you, rented or chartered by you, is being used for purposes other than private pleasure or is furnished for your regular use.

Yacht Policies

The policies typically purchased by **yacht owners** differ in structure from the boat policies we've discussed so far, but they provide many of the same types of coverage. True yacht policies are structured more like the **traditional ocean marine policies** that are available to cover commercial ships.

Yacht policies also use some different terminology. Here are some of the key coverage concepts and terminology you can expect to find in a yacht policy:

- **Hull coverage.** This is physical damage coverage for the vessel itself, and the equipment and machinery necessary to the operation of the vessel. A few unique coverage clauses (sue and labor, lay-up returns and running down) differentiate this coverage from that found in other boatowners policies.

- **Sue and labor clause.** You must take all reasonable steps to protect damaged property from further damage. Payment will be made for expenses incurred in doing so.

- **Lay-up returns.** As discussed earlier, watercraft policies provide a premium credit for a lay-up period during which the craft is not in use (for example, October 1 to April 30). For very expensive craft, a lay-up of even a few weeks would make you eligible for an appreciable premium credit. This clause provides that if your yacht is laid up and out of commission during an unscheduled period (perhaps it is out of service because of breakdown and repairs) for a certain minimum time period (usually a 15-day minimum), you'll get a premium credit.

- **Running down clause.** This provides property damage liability coverage in the event your vessel strikes another vessel. It covers damage to the other vessel (both hull and cargo), but not bodily injury liability (which is available under protection and indemnity coverage). It is attached to and only written with hull coverage (it is like collision coverage written to protect others).

- **Valued policy**. Coverage for higher-value craft may be written on a valued-policy basis. The hull coverage of most yacht policies is written in this manner, making them more like ocean marine policies than personal watercraft policies, which cover smaller vessels.

- **Protection and indemnity** (P&I). This coverage provides the bulk of the liability coverage for accidents and other events that arise out of the ownership, maintenance or use of the yacht. It includes coverage for:

 a) **Bodily injury to others** (including those on-board your vessel, such as passengers or crew members, and people who are not onboard your boat);

 b) **Damage to the property of others** (this supplements the running down clause, and covers all other types of property damage liability, such as damage to fixed objects and non-collision damage to other vessels); and

 c) Property damage liability arising out of **raising and/or removing** (or failure to do so) the wreck of the yacht.

Yacht policies also include coverage for obligations due to the federal Longshoremens and Harbor Workers Act, which requires compensation benefits for injuries to various maritime workers other than crew members.

These policies also include **medical payments** coverage, like that described for smaller boats.

Insuring Jet Skis

Until now, we've discussed insurance needs for boats. However, Jet Skis and other similar **personal watercraft** require essentially the same type of insurance. You still need **liability** coverage (in case you injure someone or damage someone else's property). And, depending on the money you have invested in your Jet Ski, you may want **comprehensive and collision** coverage. Plus, you may want to add coverage for a trailer to your policy, as well as coverage to pay your medical bills if you're in an accident.

Several companies offer insurance **policies specifically for Jet Skis and related watercraft**. These companies are often easiest to deal with when it comes time to get insurance, simply because they are aware of the kinds of coverage you'll need and the types of craft on the market.

The cost of coverage will depend on the Jet Ski's value and engine size. Costs typically will be higher to insure a personal watercraft with **a motor that is larger than 500cc**. Comprehensive and collision rates also will be higher for newer and more valuable models.

Since personal watercraft can be insured unde a traditional boatowners policy, if you have a boat and several personal watercraft, it probably makes sense to get **one policy** to serve all your needs—and reduce your cost of coverage. In fact, the Independent Insurance Agents of America points out that you may be able to get one recreational vehicle policy for all of your "toys," from boats and Jet Skis to motorhomes and all-terrain vehicles (more on insuring the latter in the next chapter).

Conclusion

Insuring a boat or a personal watercraft is a lot like insuring an automobile. You need liability coverage in case you hurt someone or someone's property. You also may choose to purchase comprehensive coverage in case of fire, theft or vandalism and collision coverage to cover the cost of repairs to your boat. A boatowners policy also will include medical payments coverage.

The type of policy you purchase will depend on your craft. Larger vessels are more appropriately covered by yacht policies, while smaller boats can be quite adequately covered by a personal boat policy. Personal watercraft can be covered by a policy specifically designed for these small, nimble vessels or by traditional boatowners coverage.

The key is to purchase adequate coverage to protect your investment—and to protect your assets, in the event that you are found liable in an accident.

Key Questions

Here's the information to gather before you call an insurance company, agent or salesperson.

1) How long is your boat? _____

2) Is it a sailboat? Yes No

3) For motorboats, does it have an in-board or out-board motor?

4) What is the engine's horsepower rating? _____

5) What make and model is the boat? _____

6) How much is the boat worth? _____

7) How much liability coverage do you want? (You may want to refer to the Personal Assets Inventory in Chapter 3 for help in determining your needs.) _____

8) Do you want comprehensive coverage? Yes No

9) Do you want collision coverage? Yes No

10) Do you want coverage for fuel and other spillage liabilities?

 Yes No

11) Do you need coverage for a trailer? Yes No

12) Do you want medical payments coverage? Yes No

13) Do you want coverage for personal effects? Yes No

14) Do you want coverage for commercial towing and assistance?

 Yes No

15) Do you want uninsured boater coverage? Yes No

16) Do you enter organized racing events? (If so, you may need additional coverage.) Yes No

17) Where will you be using the boat (e.g., ocean, lake, within a few miles of the harbor, along the entire Eastern Seaboard)?

18) Do you want replacement cost coverage? Yes No

19) Do you need coverage for operating another person's boat?

Yes No

20) Is the vessel in question a yacht? Yes No

You may be able to get a discount on boat coverage. Here are key questions to ask.

1) Do you hold a captain's license? (If so, it may qualify you for a premium discount.) Yes No

2) Have you completed a safety course? (It also may qualify you for a premium discount.) Yes No

3) What sort of safety equipment do you have onboard (fire extinguishers, ship-to-shore radio equipment, etc.)?

4) Is your boat in storage when it's not in use? Yes No

5) Do you have a clean driving record? Yes No

6) How old are you? (Discounts are given for boaters over age 50, or over age 45 in some cases.) _____

7) Do you have another insurance policy with this same insurance company, or would you be willing to switch another policy to this company? Yes No

8) Have you filed any boating claims within the last two years?

Yes No

For personal watercraft, the key questions are:

1) What make, model and year Jet Ski do you want to insure?

2) What size is the engine? _____

3) How much liability coverage do you want? (You may want to refer to the Personal Assets Inventory in Chapter 3.)

4) Do you want comprehensive coverage? Yes No

5) Do you want collision coverage? Yes No

6) Do you want medical payments coverage? Yes No

7) Do you want to add coverage for a trailer? Yes No

Chapter 5

Insuring RVs, ATVs and Other Toys

There are all sorts of land-bound motorized vehicles that typically aren't thought of as cars—and that may not be best insured (or even possible to insure) under a personal automobile policy. Insurance companies use the terms specialty vehicles and recreational vehicles to refer to these machines, which include **motorcycles**, mini-bikes, dirt bikes, **mopeds, motorhomes,** camper trailers, three- or four-wheeled **all-terrain vehicles** (ATVs), electric or gas-powered **golf carts, snowmobiles** and **dune buggies**.

For the most part, these vehicles are not covered under a homeowners policy. In fact, a homeowners policy pretty thoroughly excludes liability and medical payments coverage for anything to do with any type of motorized vehicle. It may provide coverage for a boat that is stored on your premises, and it may provide coverage for a golf cart or ATV used to service your property. But if you are going to be using any of these vehicles off-site, you really need to insure them properly.

This can be as simple as adding an **endorsement** to your homeowners policy—or to your automobile policy. But, more likely, you'll want to get special **stand-alone coverage** just for the type of vehicle you need to insure. In this chapter, we'll look at each type of vehicle and the type of coverage offered, along with appropriate coverage issues.

Insuring a Motorhome or RV

You can insure a **motorhome** or **recreational vehicle** (RV) by adding an endorsement to your homeowners or auto insurance policy. However, these policies weren't designed to cover motorhomes; and the endorsements **do not give you the complete coverage** you can get by purchasing an RV policy.

For example, will your automobile or homeowners policy cover appliances, plumbing, outside awnings and other accessories? Will it cover emergency expenses that you may incur while travelling? Probably not.

What's more, in the event of a claim, you may have to pay **expenses out-of-pocket** while your insurance company decides if coverage is or isn't provided under your homeowners or auto policy. If your homeowners and auto policies are with different insurance companies, this can really get ugly.

When it comes to insuring an RV, a Personal **Auto Policy will not cover**:

- **personal belongings** in your RV;

- **liability** when your RV is parked and you're using it as a residence;

- **attached accessories**, including awnings, antennas, rooftop air conditioners and satellite dishes;

- expenses for **lodging or to get you home** if you can't stay in your RV because of a covered loss.

Meanwhile, a homeowners policy usually will allow you to use only 10 percent of your personal belongings insurance limit to cover **off-premises property** (in other words, while it's in your RV). That may not be enough to cover items you bring on a long trip.

In contrast, RV insurance policies were designed specifically for motorhomes, and they probably will better suit your needs.

Typically, an RV insurance policy will offer:

- **liability coverage** in case you injure someone or damage someone else's property (the insurance company also will pay medical bills and wage loss incurred by an injured person, and other damages you are obligated to pay as result of an accident);

- **personal effects coverage** for lost or stolen clothing, cameras, dishes, sporting goods, jewelry, etc.—often available on a replacement-cost basis (rather than a depreciated, actual cash value basis);

- **tow dolly/hitch coverage** (a tow dolly or hitch would be used to haul a car or truck behind the motorhome, so you can run errands once you've parked the big rig);

- **campsite/vacation liability** coverage—for bodily injury or property damage if you are liable for an accident arising out of the ownership, maintenance or use of the RV as a temporary vacation quarters;

- **comprehensive and collision coverage** for damage caused by accidents, fires, smoke, floods, landslides, hail, windstorms, mice or other stray animals, vandalism, low branches or overhangs—this includes coverage for awnings, antennas, satellite dishes, air conditioning units and other roof components;

- **towing** and roadside labor coverage;

- **emergency expense coverage**, which typically will pay up to $750 for reasonable temporary living facilities, transportation and the cost of getting the RV home if it becomes inoperable due to a comprehensive or collision claim more than 50 miles from its usual storage place; and

- **medical expense coverage**, no matter who is at fault.

As you can see from the nature of these coverages, RV insurance is service-oriented. It is designed to offer as much protection as possible, in the event you have mechanical problems on the road. In fact, some policies may offer more of this protection than you actually need—especially if you are a member of AAA or a similar group.

Some companies also offer **replacement cost coverage**. In the event of a total loss, if you purchase this coverage, you will receive a new motorhome of the same model, class, body type, size and equipment as your insured vehicle. Another option is **purchase price coverage**, which will reimburse you for the original purchase price of the vehicle in the event of a total loss.

You can add **uninsured motorist coverage** to most RV policies, as well.

Most insurance companies will place conditions on the coverage of your personal effects. Typically, a company will pay no more than $500 for any single camera or video camera; for travel tickets, passports, manuscripts, stamps and collectibles; for sporting equipment; and for any single article of jewelry, art, antiques or furs.

Certain items are not covered at all under an RV policy, including property pertaining to your **business or occupation**; deeds, **documents**, records,

bills, money, notes, securities, etc.; **animals**; any self-propelled vehicle or **watercraft**; and property otherwise covered by **other insurance**.

To make sure you purchase adequate coverage for your personal property, you'll need to make a complete **list of the items and values** involved—much like the inventory you'd make at home so you could collect under a homeowners or renters policy. (Refer to the Household Assets Inventory in the homeowners section for help in listing all the appropriate items.)

If you live in your RV all the time, companies that specialize in RV insurance can provide what's referred to as **full-timers coverage**. Since you do not have a home, this coverage provides comprehensive **personal liability** protection very similar to that offered in a homeowners package policy. It also covers additional living expenses if your RV becomes unlivable due to a covered loss, and even provides coverage for fire department service charges.

To qualify for full-timers coverage, some insurance companies will require you to have another vehicle in the household to run errands, and they may stipulate that the RV not be used as a commercial or retail work site (e.g., if you travel around the country to swap meets and sell out of your vehicle, it would not qualify for coverage).

Premium rates for motorhome insurance reflect an insurance company's concerns. What are those concerns?

From an operational standpoint, motorhomes have many of the same **driving traits** as one would encounter in driving a truck (size, maneuverability, susceptibility to wind). If you are inexperienced at driving a motorhome, you could have considerable difficulty operating one. Hence, **your experience** is an issue in setting rates.

Another concern, of course, is your **driving record** for passenger cars. If you have a lot of points on your license, the insurance company figures you will be just as likely to commit offenses while driving a motorhome—but with the potential to cause greater amounts of injury and damage.

From a **property insurance** standpoint, a motorhome can have a very high value—which means it presents a significant risk to an insurance company. Because of the high vehicle values involved, many insurers also require **vehicle inspections and photos**—and some insurers charge extra when physical damage coverage is requested for older motorhomes.

Another issue inherent to motorhomes concerns **cooking on-board**. This, of course, increases the chance of fire loss beyond what's present in private passenger cars, so fire extinguishers commonly are required.

What if you loan your motorhome to someone (one of your grown children, for example) or rent it out? Many auto policy endorsements that provide motorhome coverage specifically **restrict liability coverage** in the event you loan or rent the vehicle to someone else—and so do many stand-alone motorhome insurance policies. Why? You can rent out your motorhome to a potentially unlimited range of operators, ranging from good drivers to bad. Since your insurance company only wants good drivers behind the wheel, it may exclude all coverage in rental situations, or it may charge a higher rate for motorhomes that are rented or leased out.

> **Many companies that specialize in RV insurance will offer discounts for mature drivers with good driving records (usually people over 45, but sometimes over 50). You also may be able to get a discount if you belong to an RV association.**

Some companies even offer a program called **disappearing deductibles**, which pertains to comprehensive and collision claims. Typically, if you don't file a claim during the year, your deductible will be reduced by one-fourth for the next year. If you continue to live claim-free, the insurance company will continue to reduce your deductible until it's gone. Needless to say, this is a great way for the insurance company to keep you as a long-term customer.

You also may need special coverage for a **travel trailer or camper** unit. Travel trailers are towed by a car or truck—they do not drive under their own power. So, the **liability** for a travel trailer is covered under the insurance on the tow vehicle. However, **physical damage** protection must be purchased separately based on the value of the trailer.

> **A camper unit can be mounted on the back of a pickup truck if it is specifically constructed for living purposes. It is covered for liability through the insurance on the vehicle to which it is mounted. However, physical damage protection must be purchased separately based on the value of the camper unit.**

Insuring Motorcycles

Coverage for two-wheeled vehicles is a lot like personal automobile insurance. It's just that most insurance companies view **motorcycles** as risky. Quite simply, they'd prefer not to insure them. Fortunately, there are several smaller insurance companies that specialize in motorcycle—and usually dirt bike, moped and ATV—coverage.

When you insure a car, you have the choice of purchasing liability insur-

ance only, and you have the same option when you shop for motorcycle coverage. You also can add the usual options:

- comprehensive coverage;

- collision coverage;

- uninsured/underinsured motorist coverage;

- towing and roadside assistance; and

- medical expense coverage.

Some companies also offer coverage for **custom parts and equipment**—or special policy options for custom or collector bikes.

Liability limits can be relatively low on motorcycle policies, and it is a good idea to refer back to the Assets Inventory in Chapter 3 to determine your liability insurance needs. If a motorcycle policy does not precisely meet them, some companies also will offer motorcycle excess liability coverage of up to $1 million—or you may prefer to purchase a personal liability umbrella policy (see Chapter 10).

If you live in an area in which there are a lot of uninsured drivers, you probably will be interested in purchasing uninsured motorist coverage. Actually, this coverage is even **more important for motorcyclists** than it is for drivers of cars and trucks. Unfortunately, uninsured motorist coverage typically is quite expensive under a motorcycle policy. This is because of the types of accidents to which motorcycles are susceptible.

Often, a motorcyclist can be brushed by a vehicle, while the car's or truck's driver is entirely oblivious. The resulting injury to the motorcycle operator becomes an **uninsured motorist claim** because, more often than not, the driver of the car will never be identified. (Hit-and-run accidents are covered under uninsured motorist coverage, unless your bike is parked at the time. Then your collision coverage would come into play.)

If you ride with a passenger, it is important to make sure the passenger will be covered under your policy. Many insurance companies refer to this as **guest liability**. Some motorcycle policies are more restrictive than others in how they cover guest liability.

Also, be sure to get **year-round coverage** if you may be riding in the winter. **Seasonal coverage** costs less—and it may be all some insurance companies will offer—but if you are riding without coverage on a bright, sunny day in January, you're taking on way too much risk.

Like most insurers of vehicles, motorcycle insurance companies prefer to write policies for mature, experienced drivers with clean records who live far away from city centers and keep their bikes in a garage. They'd also prefer it if you just trailered your bike to shows and never rode it. These preferences are important, only because insurance companies' preferences are reflected in their rates.

Insurance companies also consider the **kind of motorcycle** you are trying to insure when they set rates. When it comes to car insurance, companies typically charge lower rates for safe family sedans than for two-seat sports cars. When it comes to motorcycle insurance, companies are likely to charge more for **modified or customized bikes**, since they can be more expensive to repair in the event of a physical damage claim. Insurance companies also are concerned about the *attitude* of custom bikers. And, finally, insurance companies consider the fact that large highway-oriented machines cost thousands of dollars, and they may be driven on extended cross-country trips.

Insurance companies will reward people who fit their idea of an ideal rider by offering **premium discounts**. For instance, you may qualify for:

- a good rider/driver discount of about 20 percent;

- a motorcycle rider **training course discount**—for instance, for completing a Motorcycle Safety Foundation course—often in the neighborhood of 15 percent;

- a **touring cycle** discount of about 25 percent (since touring cycles are considered less risky than the faster and lighter-weight sport bikes;

- a discount for being a member of the American Motorcyclist Association or the Harley-Davidson Owners Group;

- a **multiple-bike** discount of up to 30 percent; and

- a **claim-free renewal** discount of about 25 percent if you renew with the same company and haven't filed any claims.

Another point worth mentioning: Most insurance companies exclude coverage for any form of racing. If you will be racing your bike, you will need to notify your insurance agent and try to find the appropriate coverage.

Snowmobiles, Dirt Bikes & ATVs

If you purchase **stand-alone coverage** for snowmobiles, dirt bikes, and three- and four-wheeled ATVs, it is much like the motorcycle coverage de-

scribed above. In fact, many of the same insurance companies that offer coverage for street bikes also offer coverage for these **off-road vehicles**. You can find these companies on the Internet, and they also advertise in magazines aimed at riders. (Note that the term *off-road vehicle* is being used to describe vehicles primarily used off of paved roads for recreational purposes—not four-wheel-drive trucks.)

> Coverage issues for snowmobiles, dirt bikes and ATVs are similar to those for motorcycles, but there are a couple of differences. For one thing, to ride a motorcycle on the street, you need to have reached the legal driving age in your state—and you need a motorcycle license. To ride a snowmobile, dirt bike or ATV off-road, you don't need any particular license

First, let's look at the **age** issue. Insurance companies can set rates for individuals who have reached driving age by reviewing their driving records and their **claims histories** on their auto policies. However, for younger operators, your insurance agent may be forced to perform what is known as **loss control**—by interviewing the young operators and advising them of the very real risk of injury to themselves and others arising from careless or reckless operation of the ATV. Otherwise, an insurance company may not be willing to take on the risk of insuring your ATV.

Another issue when it comes to minors riding ATVs is **vicarious parental liability**. Parents can be held liable for the acts of their children, which is an important consideration if those children are going to be riding ATVs, snowmobiles or other motorized vehicles. (It's one thing if your 12-year-old throws snowballs at your neighbor's chicken coop. It's another if he mows down the coop with the family's snowmobile.)

> While virtually all motorcycle riders insure street bikes like cars, many people try to insure dirt bikes, snowmobiles and ATVs under their homeowners insurance policies. And, to some degree, they can do so.

Coverage Under a Homeowners Policy

Homeowners insurance policies obviously are designed to protect your home—not your snowmobile or ATV. Therefore, they have very strict **exclusions** concerning coverage for motorized vehicles.

First, a homeowners policy takes away some coverage for motorized

vehicles. Specifically, it will not cover **bodily injury or property damage** arising out of:

- ownership, maintenance, use, **loading or unloading** of motor vehicles or all other motorized land conveyances, including trailers (whether you own, operate, rent or borrow the vehicle);

- **entrustment** of any such vehicle to any other person (this applies when you lend a vehicle to someone else or let someone else drive); or

- **vicarious parental liability** for the actions of a minor using an excluded vehicle.

However, once they have excluded coverage for the entire universe of motorized vehicles under a homeowners policy, insurance **companies will give back some coverage**—albeit limited coverage.

Liability Coverage Under a Homeowners Policy

To give back some of the liability coverage that has been taken away, a typical homeowners policy will say that the general vehicle **exclusion does not apply to**:

- **trailers** that are not being towed by or carried on a motorized land conveyance. For example, if you have a tow-behind travel trailer simply being stored in your backyard, there would be coverage if a neighbor's child climbed up on it and fell off and was injured. But as soon as you hook it up to your car, even while parked in your driveway, this coverage ceases. (That's a good incentive to unhook your trailer right away.)

- a wide range of **off-road vehicles**, subject to a number of qualifiers. These vehicles must be designed for recreational use off public roads and not be subject to motor vehicle registration.

For instance, a number of three-wheeled and four-wheeled ATVs are specifically **designed for off-road use and are not subject to motor vehicle registration**. Since both conditions are met, homeowners liability coverage may apply to these vehicles.

> However, when it comes to dirt bikes, you have to pay attention to local vehicle registration laws. In some jurisdictions, various classes of dirt bikes (such as dual-sport bikes) are considered motorcycles, and they're subject to motor vehicle registration. So, they would not qualify for coverage, even if they were operated off public roads.

A homeowners policy also has qualifiers based on **ownership**. First, it says that off-road vehicles may be covered if they are "not owned by an insured." So, you may operate a neighbor's ATV almost anywhere and have homeowners **liability coverage** if an accident occurs.

On the other hand, if you own the off-road vehicle in question, the area on which coverage applies is limited to the **insured location**. This means where you live, someplace you are staying temporarily or on a few other types of land owned by or rented to you. It does not include coverage while you are on any other type of public or private land. Thus, there would be no coverage for use of an ATV that you own while you are in a public park, a state forest or even a neighbor's backyard.

For example, if you hop onto the ol' three-wheeler to run down to the convenience store for a gallon of milk, the homeowners liability coverage ends as soon as you cross your own property line.

Another exception to the general exclusion of motor vehicles under a homeowners policy provides liability coverage for motorized **golf carts**—but only while you're using them to play golf on a golf course. In other words, there is no homeowners liability coverage while driving a golf cart to or from a golf course, which is a common practice. Plus, golf carts are commonly used instead of cars in retirement communities, and homeowners liability coverage does not apply to that exposure.

A golf cart does not present the tame, low-risk exposure you might think. Due to their relatively high center of gravity and the nature of their construction, they present a significant hazard of rolling over, especially in hilly areas. Also, there is virtually no protection for the occupants, should a roll-over or other type of accident occur. If you are using a golf cart in lieu of an automobile, an insurance company will consider it a higher risk than one used exclusively to play golf; basically, you'll need an automobile policy to cover a cart used in place of an automobile.

The final exception on a homeowners policy gives you liability coverage for vehicles "not subject to motor vehicle registration" that are used to **service your residence**, are designed to **assist the handicapped** or are **held in dead storage** on the insured location. This provides liability coverage for several types of motorized conveyances, such as a motorized lawn mower or snow remover, or an electric wheelchair. It also opens the door for some off-

premises coverage for ATVs, snowmobiles and dirt bikes that are used to service your residence.

> For example, many homeowners who own significant acreage use ATVs to get around the great distances involved. If you use the ATV to check fences and do routine maintenance on the property, that use constitutes "servicing of the insured residence."

Stretching the Coverage Definitions

There is something of a loophole in many homeowners insurance policies. In these policies, coverage for vehicles used to "service an insured's residence" is **not qualified as to location or current use**. So, if you use your ATV to check fences, liability coverage would continue to apply if you went off the insured location at times to pick up supplies or perform other errands. The same applies to snowmobiles that are used to perform property maintenance tasks during the winter months. If you ventured off your property to gather firewood or to do any other chores related to maintenance of the property, liability coverage would continue to apply.

To stretch things even further, a homeowners policy doesn't say that such servicing vehicles are covered **only** while operated or used in service of the residence. So, if a vehicle is used to service the residence some of the time and is used purely for recreational purposes at other times, it would have **liability coverage all of the time**. In other words, you could take a servicing vehicle into the woods on a camping trip and still be covered by the homeowners policy.

This same opening of coverage also could apply to a **golf cart**. The previous provision of coverage for motorized golf carts said that coverage applies only while used on a golf course to play golf. But if a golf cart were used to service your residence, it would become a servicing vehicle, and once again no limitations as to location or current use would apply.

> A caveat: It's doubtful that insurance companies intend to provide coverage for servicing vehicles at all times and at any location. The fact that policies never used to limit coverage in such cases may have been an oversight, so you should check your policy to see if the insurance company has closed this loophole. If it hasn't, in the event of a coverage dispute over a vehicle used only part of the time to service the residence, a court probably would resolve the issue in your favor due to the absence of limitations in the contract (ambiguities are almost always resolved in the insured's favor).

Still, it's safest to **assume the least** about insurance coverage disputes. If you use an ATV primarily for recreational purposes, don't count on your homeowners insurance policy—loophole or no loophole—to provide adequate coverage.

Property Coverage Under a Homeowners Policy

Homeowners **property damage** coverage for motorized vehicles is more narrowly defined than the liability coverage. Once again, the policy begins with a sweeping exclusion: The list of property not covered includes **motor vehicles or all other motorized land conveyances**, including their equipment and accessories.

And, once again, we find **qualifiers that restore coverage** for some vehicles, but this time coverage is limited to two types of motorized conveyances: those used to service an insured's residence and those designed to assist the handicapped.

This clearly is more restrictive than the liability coverage. There is **no property damage coverage** for any other type of vehicle designed for off-road use, either on or off the insured location. There is no property damage coverage for any golf cart, even when used on a golf course. And there is no property damage coverage for any motorized vehicle in dead storage.

Adding Coverage Via Endorsements

You can expand coverage for snowmobiles, ATVs, dirt bikes and golf carts under a homeowners policy—to a degree—by adding one or more **endorsements**. These are the surest tools for insuring your toys.

For instance, you can use the **Incidental Motorized Land Conveyances Endorsement** to provide off-premises coverage for use of some of the servicing vehicles for which coverage is already given when used on-premises—for an extra charge. However, this endorsement does not provide coverage for motorized bikes, mopeds or golf carts. Also, there is no coverage for any vehicle that can exceed a speed of 15 mph, nor for any vehicle subject to motor vehicle registration, nor for any vehicle while used to carry persons for a fee, while used in business, while rented to others or while being operated in any prearranged race or speed contest.

The **Snowmobile Endorsement** may be used to expand homeowners liability coverage for snowmobiles—again, for an additional premium. An unendorsed homeowners policy provides liability coverage for snowmobiles only when being used "on an insured location." The endorsement adds liability coverage for the ownership, maintenance, use, operation, loading or un-

loading of snowmobiles "off an insured location." Coverage is only provided for **declared snowmobiles** (i.e., the make or model and serial numbers of the snowmobiles you want to insure must be listed by the insurance company on the endorsement).

The Snowmobile Endorsement also expands the definition of "insured" to include **any person or organization** legally responsible for your snowmobile, as long as they are using it with your permission.

> **An example:** The church youth group asks you to bring your snowmobile over to the church for a youth group party. If any member of the group is operating the snowmobile and injures someone, the injured party could sue the church (as the sponsoring organization), the operator (as the driver) and you (as the owner of the snowmobile). Under this endorsement, all would be covered as "insureds" by your homeowners policy.

Some insurance companies also offer endorsements that provide **physical damage coverage** for snowmobiles.

However, in some states, snowmobiles are subject to **motor vehicle registration**. If your snowmobile is subject to registration, it won't be eligible for liability coverage under a homeowners policy for recreational vehicles used on-premises (or any use of a non-owned one).

Coverage Under Your Personal Auto Policy

Generally, personal auto coverage is available for private passenger autos, pickups and vans that have four wheels, that seat up to six people, that are designed for use on public roads and that are subject to motor vehicle registration. In other words, they cover the kinds of cars and small trucks that you sit in traffic with every day.

Coverage for **specialty vehicles** (two-wheeled vehicles, three- and four-wheeled ATVs, golf carts, snowmobiles, etc.) is not intended under a Personal Auto Policy. In fact, liability arising out of ownership, maintenance or use of **any vehicle having fewer than four wheels**—or that is designed mainly for use off public roads—is explicitly excluded. So are medical payments and property damage coverage for these vehicles.

One possible gray area might be pickups or vans that have been modified to include **sleeping or living facilities**. Many people mount camper bodies on the back of a pickup, or modify pickups or vans to have height-extending roofs or width-extending areas (tent-like fold-outs). Since the body of these vehicles qualifies for coverage on your auto policy, the liability exposure is

not really increased (there is no increased capability for off-road use). But the physical damage exposure is increased because of the **additional value** created by these various "add-ons."

Insurance companies handle this situation by adding three exclusions to the physical damage section of an automobile policy. One applies to any owned **camper body or trailer** not shown on the Declarations Page of the insurance policy, which lists what is covered by that policy. (These bodies or trailers may be covered for an additional premium if they are shown in the policy, or acquired during the policy term and coverage is requested within 30 days.) The second exclusion applies to **awnings or cabanas** and equipment designed to create additional living facilities. The third exclusion applies to **custom furnishings or equipment**, such as cooking or sleeping facilities and height-extending roofs.

> While these exclusions limit the coverage under an auto policy, endorsements are available that allow you to buy back much of that missing coverage.

The main endorsement under which an auto policy can be broadened to cover specialty vehicles is the **Miscellaneous Type Vehicle Endorsement**. (However, not all companies that write auto insurance offer this endorsement.) It can be used to extend all Personal Auto Policy coverages to a wider range of vehicles by modifying the definition of *covered auto* to also mean *miscellaneous type vehicle*, a term that may include:

- motorhomes;

- motorcycles and similar vehicles;

- all-terrain vehicles (ATVs);

- dune buggies; and

- golf carts.

Each individual vehicle to which the endorsement applies must be listed on the policy, and you will have to pay extra for each coverage for each vehicle.

This endorsement alters the auto policy in a variety of ways—which makes for some unintended consequences. Under **liability coverage**, it eliminates coverage for **other persons or organizations** for any liability arising out of your operation of any vehicle which is not a covered auto (such as a non-owned ATV). This creates various gray-area issues.

For example, Dale owns a four-wheeled ATV, for which coverage is provided by a Miscellaneous Type Vehicle Endorsement attached to his auto policy. Instead of using his own ATV, he borrows someone else's four-wheeler to take to the church youth group party. If, because of Dale's actions, someone gets hurt and sues the church, the church would not be an "insured" under Dale's policy.

Next, a common endorsment restates the exclusion of **vehicles having fewer than four wheels** to clarify that the exclusion does not apply to any vehicle having fewer than four wheels for which **liability coverage**—and, likewise, **medical payments coverage**—has specifically been purchased under the endorsement.

The final liability coverage revision—and this is a major change—is the addition of a **passenger hazard exclusion**. Normally, under a Personal Auto Policy, you have liability coverage for a passenger in your car who is injured in an accident. Under the passenger hazard exclusion, it is possible to exclude such coverage for anyone "occupying" the described "miscellaneous motor vehicle."

Given the sometimes-more-hazardous nature of operating or riding a motorcycle or ATV, this exclusion can make such a risk more palatable to a cautious insurance company. Asking for the passenger hazard exclusion is also a way to lower your premium, if you need to add the Miscellaneous Type Vehicle Endorsement to your policy. But it adds considerable exposure back onto you shoulders, so avoid this exclusion if you have a choice in the matter.

The final section of the miscellaneous type vehicle endorsement concerns the greatest amount the insurance company could have to pay in the event of a physical damage loss.

While the physical damage coverage is written for a stated amount, the amount shown is not necessarily the amount that will be paid if there is a loss.

Under this coverage, the insurance company will pay the smallest of the following amounts:

- the **amount shown in the schedule** or on the Declarations Page for the vehicle;

- the **actual cash value** of the stolen or damaged property; or

- the amount necessary to **repair or replace** the property with other property of like kind or quality.

An example: You have $10,000 of scheduled physical damage coverage for a current-model ATV, which is stolen. It would take about $14,000 to replace it (since it is still a current-year model), but the actual cash value of the vehicle is about $12,000 (because you've used it). However, because you only purchased $10,000 worth of coverage, the insurance will not pay more than $10,000 for this loss.

Another example: You have $10,000 of scheduled physical damage coverage for an older ATV, which is stolen. The actual cash value of the vehicle is about $8,000 on the current market, but a replacement (same make, model and quality) can be purchased for about $6,500 at an auction. In this case, the insurance company will not pay more than $6,500.

Obviously, the key here is to purchase the right amount of **physical damage coverage** so you don't suffer a loss at settlement time. But there's no point in paying higher premiums for more coverage than your ATV or snowmobile is worth, because it isn't going to get you a **larger settlement**.

Another thing to remember: The **deductible** you have chosen for the automobile part of the policy also applies to the Miscellaneous Type Vehicle Endorsement. So, payment for a loss under this endorsement will be reduced by the amount of the applicable deductible. However, if more than one covered auto is damaged in the same collision (e.g., if you back into your car with your ATV), only one deductible will apply—but it will be the highest applicable deductible.

Covering a Snowmobile on an Auto Policy

You also can add coverage specifically for a **snowmobile** under a Personal Auto Policy. In this case, the Snowmobile Endorsement would be used instead of the Miscellaneous Type Vehicle Endorsement, and it can be used to provide you with most of the **typical auto policy coverages**.

The Snowmobile Endorsement defines snowmobile as **a land motor vehicle**, designed for use off public roads on snow or ice, and propelled only by wheels, crawler treads or belts. Trailers designed to be towed by snowmobiles (but not for transporting them) also are included in this definition.

The definition of "snowmobile" then specifically excludes any vehicle powered by **propellers or fans**. Some very-high-speed hybrid snow/ice vehicles are powered in such a manner, and they cannot be covered by this endorsement.

(You will probably need a **stand-alone snowmobile policy** for higher-performance models; and you may have to purchase separate snowmobile

coverage if you don't have a great driving record. You also may be able to obtain coverage under one of these policies for a snowmobile that you race.)

Any snowmobiles you have must be **specifically listed** on the policy. It also will cover a snowmobile that you buy while the policy is in effect, but only if coverage is requested within 30 days. And it will cover any non-owned snowmobile used as a temporary substitute if your snowmobile is out of service.

Both liability and medical payments coverage are **excluded** if you use the snowmobile for business, if you race it (whether it's in a sanctioned race or not), and if you rent or lease it to anyone. In addition, a **passenger hazard exclusion** may be added. And, if other insurance applies, snowmobile coverage will be treated as excess over any other collectible insurance.

The same restrictions apply under **uninsured motorist** coverage, and under physical damage coverage (except for the business use exclusion). Physical damage coverage again has a **limit of liability provision** that operates in the same manner it does in the Miscellaneous Type Vehicle Endorsement (the insurance company will not pay more than the stated amount, actual cash value or actual cost to repair or replace the property).

When it comes to setting rates, from an insurance company's standpoint, a snowmobile can be an especially high-risk vehicle in the wrong hands. So, the insurance company will check your driving record to see if you are apt to be a safe snowmobile operator. The company also will want to know your level of experience.

Plus, the company will want to know about **your family**. In many states, no licensing requirements exist, so any child in the house can climb aboard and buzz off into the winterscape. Insurers worry about this—and charge accordingly if you have any **children in your household**.

From a property insurance standpoint, the type of snowmobile being considered is important. Is it a **name-brand vehicle**, or did you build your own? The type of drivetrain also must be known, since propeller-driven craft present greater exposures to loss due to their high speed capability—and are excluded by the snowmobile endorsement, as well as by some stand-alone policies.

Insuring Mopeds

What about mopeds? They're often operated on the street, but aren't subject to motor vehicle registration everywhere. Their slow speed can hinder traffic, yet they can be used to weave in and out of traffic. They present a

small profile, which is difficult for other motorists to see. Frequently, they are operated on the streets by children.

If a moped is **not subject to registration**, you would have **liability coverage** on your own premises under a homeowners policy, but no coverage off-premises. If it is subject to registration, homeowners liability coverage is not available at all.

You can obtain **broader liability coverage** under the Miscellaneous Type Vehicle Endorsement to your auto policy—to provide coverage on and off the premises. But many insurance companies will not provide this coverage for mopeds, especially if there are under-age operators.

As a result, you'll probably have to obtain **a stand-alone policy**. These are hard to find, in most circumstances. Motorcycle insurance companies will usually have stand-alone policies...but may not be excited about selling you one, because the premiums are low.

In fact, most people who ride mopeds do not carry specific insurance—and absorb any liabilities they incur.

Conclusion

Specialty vehicles present some unique insurance exposures. If you already have homeowners insurance, you may have limited coverage for some of your toys, but there are sure to be some serious gaps in coverage—for instance, if you ever want to ride your ATV off of your property.

You may be able to add the coverage you need for one or more ATVs, snowmobiles or dirt bikes by purchasing an endorsement to your homeowners policy. Or you may be able to endorse your auto policy to include other motorized types of vehicles.

The other option is purchasing a stand-alone policy for your ATV, snowmobile or dirt bike. A stand-alone policy usually is better tailored to the needs of a specific type of vehicle—but it isn't necessarily cheap. On the other hand, for some specialty vehicles, such as motorcycles and motorhomes, a stand-alone policy is definitely the way to go, since these policies better address your coverage needs.

Whether you go with a stand-alone policy or an endorsement to your homeowners or auto insurance, one way to cut the cost of coverage for liability exposures is to purchase a personal liability umbrella policy.

Key Questions

For motorhome coverage, here are a few key questions.

1) What is the make, model and year of the motorhome to be insured? _____

2) What equipment is on this particular vehicle?

3) How much liability coverage do you need? _____

4) How much personal effects coverage do you need? _____

5) Do you want collision coverage? Yes No

6) Do you want comprehensive coverage? Yes No

7) Do you need tow dolly/hitch coverage? Yes No

8) How much campsite/vacation liability coverage is offered under the policy? _____

9) Does the policy offer 24-hour claim service? Yes No

10) Do you need towing and roadside labor coverage?

 Yes No

11) How much emergency expense coverage does the policy provide? _____

12) Do you want uninsured/underinsured motorist coverage?

 Yes No

13) Do you want medical expense coverage? Yes No

14) Do you want replacement cost coverage? Yes No

15) Do you want uninsured motorist coverage? Yes No

16) Do you qualify for/need full-timers coverage? Yes No

17) How old is the driver? _____

18) How experienced with RVs is this driver? _____

19) Does the driver have a clean driving record? Yes No

20) Does the RV have cooking facilities? Yes No

21) What is the ZIP code where the RV is stored? _____

22) Do you loan or rent out this motorhome? Yes No

23) Do you belong to an RV association? Yes No

24) Does this insurance company offer disappearing deductibles?

 Yes No

For motorcycle coverage, here are a few key questions.

1) What is the make, model and year of the motorcycle to be insured? _____

2) How old is the primary rider? _____

3) Does the rider have a clean driving record? Yes No

4) What is the ZIP code where the bike is stored? _____

5) Is the motorcycle licensed? Yes No

6) What are the liability limits desired? _____

7) Do you want collision coverage? Yes No

8) Do you want comprehensive coverage? Yes No

9) Do you want uninsured/underinsured motorist coverage?

 Yes No

10) Do you want medical expense coverage? Yes No

11) Do you want towing and roadside assistance coverage?

 Yes No

12) Has the rider undergone safety training? Yes No

13) Is the bike garaged? Yes No

For snowmobiles, ATVs, dirt bikes, mopeds, golf carts and other off-road vehicles, here are a few key questions.

1) Will the vehicle be used exclusively on your property?

 Yes No

2) Can you secure adequate coverage by adding an endorsement to your homeowners policy? (You'll have to discuss coverage with your agent.) Yes No

3) Can you secure adequate coverage by adding an endorsement

to your auto policy? Yes No

4) If you are considering stand-alone coverage, how much liability coverage do you need? _____

5) How much is the vehicle in question worth? _____

6) Will minors be riding the vehicle? Yes No

7) Is this a high-performance vehicle? Yes No

8) Will you be insuring multiple vehicles on this policy? (Most companies offer discounts when you insure multiple vehicles.)
 Yes No

9) Are there any discounts available for being claim-free for a period of time? Yes No

10) How can you qualify for discounts?

Chapter 6

The Basics of Homeowners Insurance

Buying a home is the single largest investment most people make...that is an old note, but a true one. The most common way to protect that investment is by purchasing homeowners insurance. Homeowners insurance can be confusing—all the talk about covered perils, uncovered perils, exclusions.

But, when you break the coverage down to its essence, it's pretty easy to see which kind is right for you and your dream house.

For most people, the right kind is one of three basic homeowners policies. These policies are relatively complete packages. They cover you and your home for fire, theft and liability—the residential and personal exposures that most individuals and families encounter.

Basic Types of Homeowners Coverage

Insurance companies generally use standardized forms to describe different types of coverage. If you speak the lingo, it becomes much easier to compare policies. So, here's your first lesson.

Insurance companies use six forms for homeowners insurance, which they call:

HO-1	the basic form	covers your home against fire, lightning and limited forms of internal explosion (a package of optional coverages can be added for an additional premium)
HO-2	the broad form	covers all of the standard and optional perils available on the basic form and expands several of those
HO-3	the special form or the all-risk form	insures against any risks that are not specifically excluded

```
HO-4    condominium
        and coop coverage
HO-6    renter's coverage
HO-8    special coverage
        for older homes
```

Most homeowners will get a policy that uses one of **the first three forms**. These three policies differ in terms of the coverage offered, with HO-1 being the most restrictive and HO-3 being the most generous.

Insurance companies refer to forms HO-1 and HO-2 as **named-perils coverage**, because they list, or name, the perils that are covered. In contrast, form HO-3, the **all-risk form**, lists only the perils that are not covered.

> In addition to providing broader coverage, an all-risk form shifts the burden of proof from you to the insurance company. With named-perils coverage, you have to prove that a covered peril caused the loss. With all-risk coverage, the insurance company has to prove that an exclusion applied in order to deny coverage.

Who Can Buy These Policies?

Homeowners policies are issued to cover a **premises** that is used principally for private residential purposes. Some incidental business "occupancies," such as a studio or office, are permitted. However, if you operate a business from your home, you probably will need **a separate business policy**—or at least an endorsement, which is an add-on that provides expanded coverage to your basic homeowners insurance.

A homeowners policy cannot be issued to cover any property situated on premises used for **farming purposes**.

An insurance company can issue homeowners form HO-1, HO-2 or HO-3 to you if you qualify as any of the following:

- an **owner-occupant** of a dwelling;

- the intended owner-occupant of a dwelling **in the course of construction**;

- one **co-owner of a duplex**, when each distinct portion of a two-family dwelling is occupied by separate co-owners;

- a **purchaser-occupant** when the seller retains title under an installment contract until payments are completed; and

- an occupant of a dwelling under **a life estate arrangement**,

when dwelling coverage is at least 80 percent of the current replacement cost.

If you are a co-owner, a purchaser-occupant or an occupant under a life estate, the **owner or remaining co-owner** also will have what the insurance companies call an insurable interest in the dwelling, other structures, premises liability and medical payments coverage. This interest can be insured by attaching an Additional Insured Endorsement to your policy. However, that co-owner's personal property will have to be insured separately, on another policy.

Mobile homes also qualify for coverage under an HO-2 or HO-3 form, but only when a mobile home endorsement is attached to the policy, which alters certain provisions. To be eligible, a mobile home must be designed for year-round living, and it must be at least 10 feet wide and at least 40 feet long. Mobile homes also may be covered with separate, stand-alone insurance policies.

Typically, homeowners form HO-4 is used to insure a co-op or condominium, and form HO-6 is used for renters. Form HO-8 is a variation on HO-1 that is available in some states. In the rest of this chapter, we will focus on the **typical homeowners policies**: HO-1, HO-2 and HO-3.

What a Homeowners Policy Covers

A homeowners policy includes a number of different coverages, which provide a sort of loose checklist of the kinds of exposures you may face:

- **Coverage A**—Dwelling coverage is the most significant. This coverage applies to **the house itself**, attached structures (such as an attached garage), and materials and supplies on or adjacent to the premises. This includes materials used for repair or construction.

 A homeowners policy will show a **specific amount of insurance** for the dwelling. This will be an amount separate from liability or property coverage.

Dwelling coverage also is sold separately. Because these stand-alone policies don't cover liability or other risks, they are best used in addition to a standard homeowners policy—for second homes, vacation condos, etc. Note: Some state-run home insurance plans are dwelling-only coverage.

- **Coverage B**—Other structures coverage is also included. It applies to buildings on the premises that are separated from

the house by a clear space, or connected only by a fence, utility line or similar connection (such as a detached garage or work shed, or even a guest house). The **standard amount** of insurance for other structures is **10 percent of the amount written for the dwelling coverage**, and it is provided as an additional amount of insurance. (In other words, if you have a $200,000 policy for the dwelling, you automatically get an additional $20,000 of coverage for other structures.)

> **If 10 percent isn't enough, you can buy more other structures coverage.**

- **Coverage C—Personal property coverage** is another key component of a homeowners policy. Personal property means just about any household possession that's financially valuable—from an earring to a refrigerator.

 This coverage applies to personal property **owned or used by you** or anyone else covered under your policy while it is anywhere in the world. It also includes **coverage for theft**. At your request, other people's personal property also may be covered while it is on your premises. This coverage usually is **an additional amount of insurance**—above the policy's face—50 percent of the amount written for the dwelling. If that's not enough, you can increase the limit—and you also can choose to decrease.

> **Personal Property coverage applies in many situations—including when things are stolen from your car while you're travelling. This is the type of protection that people sometimes overlook or forget about. Make sure you don't: Personal property coverage is one of the primary reasons to buy a comprehensive homeowners policy.**

- **Coverage D—Loss of use of living space** coverage will kick in if a covered loss makes your home uninhabitable. Most homeowners policies cover either additional living expenses related to maintaining your normal standard of living or the fair rental value of the part of the residence where you live (it's your choice). If a covered property loss makes the part of your residence that is rented to others uninhabitable, policies also cover the loss of **fair rental value**.

- **Coverage E—Liability coverage** under a homeowners policy is designed to protect your assets if you are sued. It covers injuries or damage caused by you, a member of your family or a pet. It applies to injuries that occur on your property or anywhere in the world. We'll consider this coverage later in this chapter. This coverage has a limit separate from the dwelling limit.

- **Coverage F—Medical payments** coverage also is included in a homeowners policy. It covers necessary medical expenses incurred by others (not members of your household) within three years of an accident that causes bodily injury. (An accident is covered only if it occurs during the policy period.) Medical expenses include reasonable charges for medical, surgical and dental care, X-rays, ambulance service, hospital bills, professional nursing, prosthetic devices and funeral services.

> **This coverage does not apply to medical expenses related to your own injuries—or those of anyone who lives with you, except your employees. This coverage often has a $1,000 limit.**

- The **additional coverages** portion of a standard policy includes coverage for claim expenses, first aid and damage to the property of others.

As the above list implies, if you have a $200,000 homeowners policy, that's not all you'll get if your home is destroyed. The $200,000 limit usually applies only to the cost of replacing the physical structure. Typically, a policy will pay half of the face amount—in this case, up to $100,000—to replace your home's contents, including valuables.

> **A typical policy also will cover legal costs related to a liability lawsuit. In other words, if you have a $200,000 face-value policy, you could get $200,000 to rebuild the house, $100,000 for personal items, $10,000 to re-landscape, $10,000 to rebuild a freestanding garage and $25,000 to cover temporary living expenses. That's a total coverage of nearly $350,000 on a $200,000 face-value policy. And the cost of your defense in a liability lawsuit could add another $50,000 or $100,000.**

A Pretty Complete Package

Homeowners insurance has evolved into a relatively complete package of coverages. However, some perils generally are not covered—or covered

sufficiently—by standard homeowners insurance policies. Chief among these are hurricanes, floods and earthquakes.

> Buying a homeowners package policy usually is a better deal than buying each coverage individually. However, some homeowners prefer to buy just one or two types of insurance—for example, only a dwelling policy.

Purchasing separate coverages becomes a particular concern if your home does not qualify for a homeowners package policy. For more on which types of homes qualify, read on.

Who Is Covered Under the Policy?

It's important to know who will and will not be covered under your policy. The definitions page of a homeowners policy will provide this information. Typically, you—**the named insured**—your spouse and any family members who live with you are covered. Some of the other factors may seem familiar (which is proof you're becoming an insurance expert).

> The **definitions page** may express this in the following way: Insurance on the dwelling and any other structures is provided for the named insured and the insured's spouse, if the spouse lives in the same household.
>
> Personal **property coverage** and personal **liability insurance** are provided for the named insured and all residents of the same household who are relatives of the insured, or who are under age 21 and are in the care of the insured's family.
>
> If the named insured or the spouse dies, coverage continues for **legal representatives**. Until a legal representative is appointed, a temporary custodian of the named insured's property also would be covered. All household members who are insured at the time of the named insured's death will continue to be covered while they live at the residence premises.
>
> Upon the request of the named insured, **the personal property of others** may be covered while on the residence premises, and the personal property of guests or a residence employee may be covered.

A **residence employee** usually means a housekeeper, gardener or any other employee who performs duties related to the maintenance and use of

your residence premises, or who performs household, domestic or similar duties elsewhere that are not connected to a home-based business.

Knowing who is and isn't covered is vital. Not only does it tell you whose personal property is insured, but some coverages apply only if one of the insured parties does not cause the damage.

Real Property, Personal Property and Land

When an insurance company talks about property coverages, it means insurance that is used to cover real property and personal property.

> **Real property includes buildings and structures, but not the land on which they are located. While land usually is part of the purchase price of real property, it is not subject to loss or destruction in the same way buildings are, so it is not covered by insurance in the same way.**

One way to calculate the value of the structures on your property is to use local **tax assessment values**. But the most common way people estimate how much insurance they need is by covering at least the amount of any mortgage or other loans on the property.

> **One caveat here: The amount outstanding on your home loan—or even the original full amount of that loan—may not be enough to rebuild your house if it's destroyed.**

Personal property includes **all forms of property other than real property**. On a homeowners policy, personal property coverage protects household goods, indoor and outdoor furniture, most appliances (but not built-ins), linens, drapes, clothing and other personal belongings, which may range from toys to home computers and small boats.

Which Property and Losses Are Not Covered?

Homeowners insurance covers a lot—but it can't cover everything you own or everything you do. Most homeowners policies list specific property and specific kinds of losses that are not covered. Insurance is designed to cover sudden and accidental losses. Therefore, gradual, preventable or expected losses must be excluded.

The following types of property and losses are **not covered** by any homeowners policy, and they serve as a kind of reverse checklist:

- **land**, including that under an insured residence;

- structures used **solely for business purposes**;

- structures or property (other than a private garage) that are **rented or held for rental** to someone who is not a tenant of the insured dwelling;

- articles that are specifically covered by **other insurance** (since, you can only collect once for a loss);

- **animals** (pets, livestock and any other critters);

- **aircraft** and parts, other than model or hobby aircraft;

- property of roomers, **boarders and other tenants** who are not related to any insured (they'll need to get their own renters insurance);

- accounts, drawings, **paper records**, electronic data processing tapes, wires, records, disks or other **software** media containing business data (blank records or media are covered, and so are music CDs);

- losses caused by perils having **catastrophic potential**—these include flood, hurricane, tornado, nuclear and war risk exclusions;

- losses caused by **off-premises power failure**;

- losses resulting from enforcement of any **building ordinance or law**;

- losses caused by the **neglect of an insured person** to use all reasonable means to save and preserve property (for instance, if you have a hole in your roof and you don't cover it and it rains, the insurance company will not pay for water damage);

- any **intentional loss** arising out of an act committed by or at the direction of an insured (for instance, if you drive through your fence while trying to run down your neighbor's dog, you can't get the insurance company to pay to fix it);

- losses caused by, resulting from, contributed to or aggravated by **earth movement** (earthquake, land shock waves from a volcanic eruption, landslide, mine subsidence, mudflow and earth sinking, rising or sliding); and

- losses to a **motor vehicle** and any electronic apparatus designed to be operated solely by use of the power from the motor ve-

hicle. (However, homeowners policies do cover vehicles that are not subject to motor vehicle registration and are used to service your residence or assist the handicapped.)

If you're hoping to insure any of these items with homeowners coverage, you'll be out of luck. The operating assumption here is that the insurance company will provide coverage against losses that are likely to occur in a person's ordinary experience.

> In many cases, you will be able to use endorsements or riders to adapt standard policies to your specific needs. Endorsements and riders serve as addenda—adding coverage or conditions to standard insurance contracts.

Certain **perils, or risks**, are **excluded** from standard policies because they can be covered better under different insurance (for example, a separate earthquake insurance policy), because they are a natural change that occurs over time or because paying for them might tempt people to commit fraud. Among the exclusions that fall into this category are damage caused by:

- wear and tear;

- deterioration;

- depreciation;

- rust;

- mold and mildew;

- wet or dry rot;

- contamination;

- smog or smoke from industrial or agricultural operations;

- mechanical breakdown;

- settling, cracking, shrinkage, bulging or expansion of pavement, patios, foundations, walls, roof, floors or ceilings; and

- birds, insects (including termites), vermin or domestic animals.

Pay close attention to the **insect and termite exclusion**. It's the reason termite inspections are such a critical part of selling a house...and the reason old houses sometimes need to be fumigated. Also, most policies do not cover any damage from **sewer back-up or seepage** below ground, around windows or through foundations. But this exclusion is one of the most frequesntly litigated parts of homeowners insurance. Policyholders will usually try to prove

water damage resulted from something *other* than sewer back-up. They usually lose their argument.

Perils Covered Under the Basic Form

While every homeowners policy provides liability and property coverage, HO-1 is a very limited policy. That's because this **basic form** only insures the dwelling, other structures and personal property against **direct loss** by specific **named perils**. These perils are:

- fire or lightning;

- wind;

- explosion;

- riot or civil commotion;

- aircraft (e.g., if a plane crash lands on your house);

- vehicles (but not vehicle damage caused by any vehicle owned or operated by any resident of the insured premises);

- smoke damage (from a fire—but not smoke from fireplaces or from agricultural smudging or industrial operations);

- vandalism or malicious mischief (known as VMM), but not if the dwelling has been vacant for 30 consecutive days or more;

- theft (but not theft committed by an insured, theft from a part of a residence rented to someone who is not an insured, or theft in or to a dwelling under construction; and theft coverage for property away from the residence premises is subject to limitations);

- glass breakage; and

- volcanic eruption—excluding losses caused by earthquake, land shock waves or tremors.

Even though HO-1 is the most bare-bones homeowners package policy, it still provides broader coverage than a stripped-down **dwelling policy**. For instance, all of the extended coverage (EC) perils (everything listed above, with the exception of fire coverage) and **vandalism and malicious mischief** perils are automatically included—whereas they are optional on the basic dwelling form.

Wind and hail coverage does not apply to watercraft that are outside, but the policy covers other outdoor property, such as awnings and antennas.

Coverage for **vehicle damage** is also broader—unlike dwelling coverage, a homeowners policy does cover vehicle damage to fences, driveways, walks and outside lawns, shrubs, trees and plants when caused by a non-resident. (All vehicle damage caused by a resident is excluded.)

All homeowners forms include coverage for **theft** of personal property. Dwelling policies don't. This homeowners coverage includes protection for the loss of property away from a residence, but from a known location, when it is likely that the property has been stolen. Property stolen from an **unattended watercraft** or motor vehicle also is covered. However, coverage for theft of property away from the residence premises does not include the loss of trailers, campers, watercraft (including furnishings and equipment) or property at another residence owned, rented to or occupied by an insured person—except while you're residing there.

An insured student is covered while at a residence away from home, but only if he or she has been there at some point during the 45 days immediately before a theft occurs.

> Homeowners forms do not specifically refer to damage caused by burglars, but coverage is automatically provided under the VMM peril.

The basic coverage offered under an HO-1 policy is:

Coverage A	Dwelling	$8,000 minimum
Coverage B	Other structures	10 percent of the amount of Coverage A
Coverage C	Personal property	50 percent of the amount of Coverage A
Coverage D	Loss of use	10 percent of the amount of Coverage A
Coverage E	Personal liability	$100,000 minimum
Coverage F	Medical payments	$1,000 minimum

The problem with an HO-1 policy is that personal property is not covered if it is **damaged indirectly** by an insured peril. So, if a lightning bolt hits your house and shorts out your home theater or brand new iMac, you won't be able to make a claim for that equipment.

Don't think indirect losses are a big problem? According to the Insurance Information Institute (III), lightning strikes more than 30,000 U.S. homes and businesses each year, through direct hits and links to power lines.

Perils Covered by the Broad Form

Form HO-2 offers broader coverage than HO-1. That's why HO-2 is known as the **broad form**.

The broad form insures the dwelling, other structures and personal property against loss by all of the basic form perils. And it adds six additional perils often called broad form perils. (The broad form is still narrower than the all-risk form, because it offers coverage on a named-perils basis.)

The six additional broad form perils are:

- damage caused by **falling objects** (but damage to a building's interior or its contents is covered only if the falling object first damages the roof or an exterior wall);

- damage to a building or its contents caused by **weight of ice**, snow or sleet (however, damage to an awning, fence, patio, pavement, swimming pool, foundation, retaining wall, pier, wharf or dock is not covered.);

- accidental **discharge or overflow of water** or steam from a plumbing, heating or air conditioning system, or an automatic fire protection sprinkler system, or from a household appliance (this does not include loss caused by freezing, or loss to the system or appliance from which water or steam escaped— and coverage is suspended whenever your home has been vacant for more than 30 consecutive days);

- sudden and accidental **tearing apart, cracking, burning or bulging** of a steam or hot water heating system, an air conditioning system, an automatic fire protection sprinkler system or an appliance for heating water;

- **freezing** of a plumbing, heating or air conditioning system, or an automatic fire protection sprinkler system, or of a household appliance (this coverage also is suspended whenever the home is vacant, unoccupied or being constructed, unless reasonable care was taken to maintain heat in the building, or to shut off the water supply and drain systems and appliances); and

- sudden and accidental **damage from artificially generated electrical current** (but not damage to a tube, transistor or similar electrical component).

In addition to adding coverage for these six perils, HO-2 policies expand some of the basic coverages found on HO-1 policies. For instance, **vehicle damage** to a building is covered, even when it is caused by a resident (but vehicle damage to a fence, driveway or walk caused by a resident is still excluded). And, smoke coverage on all forms other than HO-1 includes smoke from fireplaces.

Further, under an HO-2 policy, **loss of use** coverage is doubled, to 20 percent of the amount of dwelling coverage purchased. However, indirect losses—as in the case of lightning shorting out your VCR or computer—still are not covered.

Coverage Under the Special Form

HO-2 offers broader coverage than HO-1, but HO-3 is the broadest of the three. It is known as an **all-risk policy**—or the special form—and it is the most popular and thorough coverage you can get for your home. It typically costs 10 percent to 15 percent more than the HO-1 policy.

Instead of naming the perils that are covered, the HO-3 form names the **perils that aren't covered**. Of course, this is still a long list, because insurance companies like to be very specific about what they will and will not pay for. This protects them in the event you sue for coverage.

While **structures** are insured for all risks under an all-risk policy, **personal property** is insured on a named-perils basis. This policy insures personal property against loss by all of the perils included on the broad form, HO-2—and expands the coverage a bit—you can also endorse it to special form. HO-3 also covers vehicle damage to a fence, driveway or walk—even when it is caused by a resident. And HO-3 also does not suspend coverage for personal property from certain perils, as HO-2 does, whenever your home has been vacant for 30 or more consecutive days—which is important if you travel for extended periods of time. (However, coverage for the dwelling and other structures is still excluded after 30 days of vacancy.)

HO-3 provides the most complete coverage for your home and other structures. In addition to what is covered under an HO-2 policy, an HO-3 policy covers:

- **removal of debris** from covered property if the debris was caused by a covered peril (for instance, if your house burns down and the debris needs to be removed before you can rebuild);

- reasonable repairs to protect your home from **further damage**

(this would include covering a hole in the roof, so rain or snow can't come in and cause further damage);

- **trees, shrubs and other plants** for up to 5 percent of the amount of dwelling coverage—though no more than $500 can be spent on any single tree, shrub or bush;

- up to $500 for any charges the **fire department** bills you for being called to your home;

- damage that occurs while you try to **remove your personal items** when your home has been damaged by an insured peril;

- up to $500 if your **credit card**, fund transfer card, etc., is stolen and used and the card's issuer wants you to pay the outstanding debt;

- up to $1,000 for your share of **loss assessments** charged to you by a homeowners' association or corporation; and

- property lost due to the **collapse** of either all or part of the building, as long as the collapse is caused by perils insured against under HO-2 or due to hidden decay; hidden insect or vermin damage; weight of contents, equipment, animals or people; weight of rain that collects on the roof; or use of defective material or methods in construction, remodeling or renovation (as long as the collapse occurs during the construction, remodeling or renovation).

As comprehensive as it is, HO-3 **does not cover** certain kinds of assetss. These exclusions include:

- property, losses and perils not covered due to limitations of the insuring agreement and the general exclusions;

- loss involving collapse, other than those described above;

- freezing of a plumbing, heating or air conditioning system, or an automatic fire protective sprinkler system, or a household appliance—or discharge, leakage or overflow due to freezing while the dwelling is vacant, unoccupied or being constructed, unless reasonable care was taken to maintain heat in the building, or to shut off the water supply and drain the systems and appliances (such damage by freezing of an occupied premises is covered);

- damage caused by freezing, thawing, pressure or weight of water or ice to a fence, pavement, patio, swimming pool, foundation, retaining wall, bulkhead, pier, wharf or dock;

- theft in or to a dwelling or structure under construction, or theft of any property that is not actually part of a covered building or structure (theft of part of a finished building is covered);

- vandalism and malicious mischief if the home has been vacant for more than 30 consecutive days at the time of loss;

- wear and tear, deterioration, latent defect, rust, mold, wet or dry rot, contamination, smog, smoke from agricultural smudging or industrial operations, birds, vermin, insects, domestic animals or the settling, cracking, shrinking, bulging or expansion of pavements, foundations, walls, floors, roofs or ceilings;

- losses caused by weather conditions to the extent that weather contributes to causes found in the general exclusions (i.e., power failure, flood, etc.);

- losses caused by faulty, inadequate or defective planning, zoning, surveying, siting, design, specifications, workmanship, repair, construction, renovation, remodeling, grading, repair or construction materials, or maintenance; and

- losses caused by acts, decisions or the failure to act or decide by any person, group, organization or government body (for example, if the National Guard comes into your neighborhood after a storm and accidently trashes your garage, you'll have to sue them).

For the home and other structures, if any excluded loss is followed by a loss that is not excluded, the additional loss is covered by HO-3.

Placing a Value on Things

Many insurance policies have a **valuation clause**, which describes how the value of different types of property will be determined in the event of a claim. The valuation clause may use such terms as **actual cash value** and **replacement cost**.

Actual cash value (ACV) is the basis for recovery under many property and liability contracts, regardless of the policy amount. ACV generally means

"the replacement cost of damaged or destroyed property at the time of loss, less depreciation."

For example, if your bedroom set was completely destroyed by a covered peril, the insurance company will look first at the current replacement cost, then account for the length of time you've had it. So, if a new set is $10,000, but the insurance company figures that the one which was destroyed had depreciated 30 percent due to age and use, a policy providing ACV recovery would pay $7,000.

> It is better to purchase a policy that will give you the full replacement cost for your personal property, without deducting for depreciation. This can be done, for an additional premium, by adding an endorsement to guarantee payment of the replacement cost.

If you own an older home, you may not be able to get **guaranteed replacement cost** coverage, because many of the building techniques used in decades past are more expensive than techniques used today. So, you may have to settle for a **modified replacement cost** policy. With this sort of coverage, instead of repairing or replacing plaster walls with similar materials, for instance, the policy would pay for repairs using wallboard. Complete replacement cost coverage may be difficult to obtain if you have extensive ceiling moldings and other fine craftsmanship that would be difficult to replace today.

Homeowners policies also will pay you the full replacement cost for your house and other insured buildings only if you maintain a minimum amount of insurance—usually 80 percent. In other words, if it will cost $200,000 to rebuild your home and you only have $100,000 worth of insurance, no insurance company is going to pay you the full replacement cost.

> For this reason, most insurers require that your insurance be equal to at least 80 percent of the replacement cost at the time of loss.

An important note: Insurance companies don't want to encourage you to file a claim and pocket the money. So, for both building and contents losses, most policies state that full replacement costs will be paid only if the property is actually repaired or replaced. If it is not, claims will be paid on an ACV basis.

Another concept worth noting is the **valued policy**. It provides for payment of the full policy amount in the event of a total loss—without regard to

actual value or depreciation. Valued policies traditionally have been used when it would be difficult or impossible to establish a value after a loss occurs, or when it is desirable to agree on a specific value in advance. For instance, cargo travelling by ship would be insured on a valued policy basis, since it might be difficult to establish cargo values after a ship sinks.

In recent years, some states have passed valued policy statutes that apply to real property, such as homes. If there is a total loss caused by a specific peril, usually fire or windstorm, the statutes call for payment of the full policy amount, regardless of the actual value of the property at the time of loss. This is a way for statutes to **limit the subjective determination** of value.

An important issue in many property insurance policies is the **pair and set clause**. This is written in because a set can be worth more than the sum of its pieces. For instance, an antique pair of candelabras might be worth $1,000. But if one is lost or destroyed, the remaining candelabra might be worth only $200. In this situation, the value of the loss of one part of a pair is not equal to 50 percent of the value of the complete pair.

> For this reason, many property insurance policies give the insurer the option of repairing or replacing any part of a pair or set to restore its value, or of paying the difference between the ACV of the property before and after the loss. In the above example, the insurance company might be able to replace the lost item—or obtain a complete pair of equal value to exchange for the remaining item—at a lesser cost than making a cash settlement. Or the insurer might pay the difference in ACV before and after the loss ($800), if replacement was not possible at a lesser cost.

One last point about the way insurance companies value your property: Say your house is worth $100,000, and you've insured it for that amount. If you have a fire that causes $50,000 worth of damage, the ACV of the building would be reduced to $50,000. If you should have another claim before you repair the damage from the fire (an ambulance responding to the fire and crashes and wipes out the rest of the house), you can file a claim for only the $50,000 ACV.

On the other hand, if you completely repair the fire damage, before the ambulance comes along and wipes you out, your coverage is restored to the full $100,000 (although you'll probably want to move, at that point).

An important part of any policy—and something you should always check—is how **disputes** are handled. If you and the insurance company cannot agree on the value of something—like your house—you may be able to take advantage of an **appraisal condition** in your policy, if you have one. Either you or the insurance company may make a written demand for an ap-

praisal. No matter who makes the request, each side is allowed to bring in an impartial appraiser (at its own expense), and the two appraisers select an umpire. The appraisers separately state the value of the property or amount of loss. If they don't agree, the differences are submitted to the **umpire**. You and your insurer then must abide by the valuation set either by the two appraisers—if they agree—or by the umpire.

The Other Major Component: Liability Coverage

Earlier in this century, government regulations prevented property insurance companies from selling liability insurance. By the same token, liability insurance companies couldn't sell property insurance. So, a homeowner had to purchase two or more policies, from different insurance companies, to obtain total protection.

Starting in the 1940s, these regulations have changed. Now, the Homeowners Policy Program (of which HO-1, HO-2 and HO-3 are a part) provides liability automatically, in addition to property coverage. By combining property and liability coverages, the insurance company is able to reduce processing costs, determine losses more accurately and pass these savings on to you in the form of lower premiums.

The liability portion of the homeowners policy is designed to protect your assets if you are sued by someone who is injured—physically, mentally or otherwise—while on your property.

Most homeowners policies offer you liability protection for bodily injury and property damage. It covers not only the cost of the claim, but also the cost of your defense if you are sued, and a limited amount of coverage for bail bonds and other bonds related to a claim.

> The standard policy's liability protection covers injuries or damage caused by you, a member of your family or a pet. It applies to injuries that occur on your property—or anywhere in the world.

It's important to point out that the liabilities covered by homeowners insurance arise from **civil—not criminal—law**. If you or a family member are indicted in a criminal lawsuit, homeowners insurance won't cover any resulting financial losses.

The Jargon of Liability Issues

Once again, **who** is insured under your homeowners policy becomes an important issue. When the policy says an **insured**, it means the named in-

sured (you), a spouse and any relatives resident in the household, as defined on the definitions page of your policy.

But when it comes to liability, the coverage is broader than for property. In this case, an insured also includes any person or organization legally responsible for animals or watercraft owned by a household member. For example: You board your dog at a kennel while you are away; when one of the employees takes Fido for a walk, he or she is insured if Fido bites another dog.

If you or your spouse dies, all household members who are insured at the time of your death will continue to be covered while they continue to live at your home. But only property coverage continues for **legal representatives**—liability coverage is not extended to lawyers or a temporary custodians.

What is covered is just as important as who is covered. When it comes to liability, **bodily injury** means harm, sickness or disease, and includes the cost of required care, loss of services or death resulting from the injury. This is one of the main kinds of loss that constitutes a civil liability.

Property damage means injury to or destruction of tangible property—and includes loss of use of the property. Loss of use is another of the key kinds of loss that constitutes a civil liability.

Occurrence means an accident, including continuous or repeated exposure to conditions, that results in bodily injury or property damage, neither expected nor intended by an insured person. A situation must be deemed an occurrence before insurance will apply.

Two Important Liability Coverages

There are two kinds of coverage provided under the liability section of a homeowners policy—no matter which policy form you buy.

The first liability coverage is **personal liability**. This pays an injured person—usually a third party—for losses that are due to the negligence of an insured and for which an insured is liable.

> **Example: Mack takes his dog out for a walk without a leash. For no apparent reason, Mack's dog attacks Ethelbert, who is jogging nearby. Ethelbert's injuries cost him $10,000 in lost income during recovery. Mack is personally liable to Ethelbert for this $10,000.**

The second liability coverage is **medical payments** to others. This covers necessary medical expenses incurred within three years of an accident that causes bodily injury. (An accident is covered only if it occurs during the policy period.)

Medical expenses include **reasonable charges** for medical, surgical and dental care, X-rays, ambulance service, hospital bills, professional nursing, prosthetic devices and funeral services.

In the example above, after Mack's dog bites Ethelbert, Mack also will be liable for the stitches, shots and other medical treatment Ethelbert might need.

Medical payments coverage applies only to people who are on the premises with the permission of an insured person. Someone who comes onto your property to rob your house and is attacked by your dog cannot collect damages under your homeowners policy. This coverage does not apply to medical expenses related to your injuries or those of anyone who lives with you, except residence employees.

Away from your home, coverage applies only to people who suffer bodily injury caused by:

- you;

- your animal owned by or an animal in your care (if you happen to be pet-sitting);

- a residence employee in the course of employment by you; or

- a condition in the insured location or the ways immediately adjoining.

In some cases, these costs are simply determined; in other cases, the facts may be unclear—and the insured person may or may not be legally liable. In these cases, the insurance company often will pay medical costs as a **goodwill gesture** to avoid legal action.

For instance, say a visitor to Mack's home **slips and falls** on the front steps. These injuries result in medical expenses to the visitor in the amount of $275. Later, the visitor sues Mack for $10,000, claiming damages for negligence. An insurance company will often pay the $275 quickly, in hopes of preventing the larger lawsuit.

The insurance company has plenty of incentive to avoid lawsuits. Under the standard homeowners policy, it is obligated to provide a legal defense against claims—even if the claims are groundless, false or fraudulent. The company also may make any investigation or settlement deemed appropriate.

All obligations of the insurance company end when it pays damages equal to the **policy limit** for any one occurrence. Both personal liability and

medical payments coverage have limits—medical payments is usually much lower than personal liability. Unless you request something else, you will get the **basic limits** of these coverages, which are the minimum amounts written. But higher limits of liability can usually be purchased for a higher premium.

Personal liability insurance applies separately to each insured person, but total liability coverage resulting from any one occurrence may not exceed the limit stated in the policy. How does this come into play? If Mack and his sister are both walking the dog when it bites Ethelbert, they both might be named in a lawsuit. However, their homeowners insurance will cover them only up to the single limit.

Of course, if Mack was involved in one dog bite incident and his sister was involved in another, the insurance would cover each incident separately up to the limit.

Additional Liability Coverage Issues

Personal liability coverage provides three kinds of insurance, in addition to the **stated limits** of liability:

- claim expenses;

- first aid to others; and

- damage to the property of others.

Claim expense coverage includes the costs of defending a claim, court costs charged against an insured person and premiums on bonds that are required in a lawsuit defended by the insurance company.

> **Expenses incurred by the company—such as investigation fees, attorneys' fees, witness fees and any trial costs assessed against you—also will be covered by the policy.**

If bonds are required in the course of the lawsuit, such as **release of attachment or appeal bonds**, the company will pay the premium—but it is under no obligation to furnish the bonds. That is your responsibility.

Claim expense insurance also covers post-judgment interest: If a court judgment is rendered against you, there usually is a time lapse between the rendering of the judgment and the payment of the damages awarded. The company will pay any interest charges accruing on the damage award during this time period.

Expenses for **first aid to others** are covered when the charges are incurred by you and when the charges result from bodily injury that is covered by the policy. Expenses for first aid to an insured person are not covered.

If damage to the property of others is caused by an insured person, the policy will provide replacement cost coverage on a **per occurrence** limit. This means each liability situation will be treated seperately—and the maximum policy coverage will apply separately each time.

This additional coverage won't pay for:

- damage caused intentionally by an insured person who is at least 13 years of age;

- property owned by you (because this coverage is designed to cover property owned by others); and

- property owned and rented to a tenant or a person who is resident in your household.

So, if you borrow a camera from your neighbor and accidentally drop it in your swimming pool while taking pictures, this coverage will provide up to $500 to replace the camera. But it wouldn't provide coverage if you were to drop your own camera in your pool. (**Personal property** might.)

Miscellaneous Liability Conditions

The liability coverage in a homeowners policy includes a number of other **conditions**, which can limit its applicability. These conditions include the following parameters:

- If you **declare bankruptcy**, this does not relieve the insurance company of its obligations under the policy.

- **Personal liability** coverage will be treated as **excess** over any other valid insurance—unless the other insurance is written specifically to be treated as excess over the personal liability coverage. This means that the other insurance—auto insurance, for example—has to pay out to its limit before the personal liability under the homeowners policy kicks in.

- Your **duties in the event of an occurrence** include providing written notice to the insurance company that identifies the insured person involved, the insurance policy number, the names and addresses of claimants and witnesses, and information about the time, place and circumstances of the occurrence.

- You are required to promptly **forward every notice**, demand or summons related to the claim and, when requested, to assist in the process of collecting evidence, obtaining the attendance of witnesses and reaching settlement.

- You are not covered if you **assume any obligations** or make any payments—other than first aid to others following a bodily injury—except at your own expense.

- Payment of **medical costs** to others is not an admission of liability by you. So, if your auto insurance pays for medical care for someone injured while riding in your car when your son is driving, your homeowners insurance might not pay a liability claim. The injured party may have to submit to a physical examination, if requested by the insurance company, and authorize the company to obtain medical reports and records.

The policy also will pay up to $1,000 for your share of a neighborhood homeowners association or condominium loss assessment made because of bodily injury or property damage suffered by a person on jointly owned property. (Higher limits are available.) However, if a local government makes a charge against your association, your share of the loss is not covered.

Coverage also will apply if you, as a volunteer officer of the association, are sued individually.

When Liability Coverage Does Not Apply

There are three major circumstances under which homeowners liability coverage does not apply. If any of these circumstances applies to you, you'll probably need separate liability or other types of insurance.

The first circumstance is **business activity**. Personal liability coverage is not a business policy—it will only cover personal activities and exposures. The standard policy form itself states:

Any liability arising purely out of the insured's occupation or business and/or the continual or permanent rental of any premises to tenants by the insured is excluded.

The second major circumstance under which liability coverage does not apply is injury to **members of the insured household**. Before this exclusion was added to the standard policy, some courts permitted family members to sue other family members and collect damages. As a result, people would use homeowners liability coverage as a replacement for other kinds of insurance—often instead of health coverage.

The homeowners policy is not meant to be a substitute for accident and health insurance—and this exclusion makes it clear that there is no coverage for an injury suffered by the named insured or other family members who reside in the same household.

The third circumstance under which liability coverage does not apply is the **intentional act** of an insured person, or acts that can be expected to produce bodily injury or property damage. In other words, if you mean to hurt someone, your homeowners insurance won't cover damages.

In addition to these three exclusions, there are a number of other circumstances in which homeowners insurance **does not cover liabilities**. These include the following:

- war or warlike action (most policies have a war risk exclusion—losses due to war are catastrophic and simply too much for insurance companies to protect against);

- rendering or failure to render professional services (again, business activities are not covered);

- transmission of a communicable disease by an insured;

- sexual molestation, corporal punishment or physical abuse;

- the use, sale, manufacture, delivery, transfer or possession of controlled substances (illegal drugs), other than the legitimate use of prescription drugs ordered by a physician;

- entrustment by an insured person of an excluded vehicle, watercraft or aircraft to any person, or vicarious parental liability (whether or not statutorily imposed) for the actions of a minor using any of these items.

Life in a Flood Zone

While your standard homeowners policy will cover water damage caused by heavy rains, most home—and business—owners could not get actual **flood insurance** until 1968, when Congress voted to create the National Flood Insurance Program (NFIP). Prior to that time, the federal government had focused its efforts on flood control techniques, such as building dams, levees and seawalls—and on disaster relief for flood victims.

The National Flood Insurance Act of 1968 took a new tack. It created a federal program to provide flood insurance to communities in flood zones—as long as the communities reduced future flood risks to new construction.

Participation in the program is required on a community basis—rather than an individual basis—because local zoning laws and building codes seriously affect the amount of damage an area will suffer due to flooding. The federal government realized that the whole community would have to get behind efforts to reduce damage—and federal relief costs—in order to make the NFIP work.

To be eligible for flood insurance, a community must require permits for all construction in high-risk areas, and ensure that the materials and techniques used in the new construction will minimize flood damage.

But obtaining flood insurance isn't the only reason communities participate in the NFIP. If an area did not participate and the president were to declare that area a disaster due to flooding, the community would not be eligible to collect federal aid for the repair or reconstruction of insurable buildings in **Special Flood Hazard Areas**. People in those communities still could receive other forms of disaster assistance, such as food and emergency shelter, but they wouldn't get the government's help in rebuilding their homes and businesses.

Needless to say, this is a profound incentive for community participation—and almost all of the communities with serious flood potential have joined the NFIP, which is administered by the Federal Insurance Administration, or FIA, a component of the Federal Emergency Management Agency (FEMA).

If you buy a home in a flood zone, the mortgage lender probably will require that you purchase flood coverage.

What Qualifies for Flood Insurance?

Today, you can insure almost any enclosed building and its contents against flood loss—if your community is participating in the program. If you live in an area that is **prone to flooding**, you probably know that yours is one of the more than 18,000 communities that participate. If you're not sure, you can contact a local insurance agent or broker or your local government.

NFIP insurance can be written on any building that:

- has two or more exterior rigid walls;

- has a roof;

- is fully anchored to prevent flotation, collapse or lateral movement; and

- is principally above ground.

Mobile homes that are anchored to permanent foundations, condos, condominium associations and homes that are under construction also can be covered by the NFIP.

Buildings that are located over water or that are principally below ground cannot be insured under this program—and neither can travel trailers and converted buses or vans.

What a Flood Insurance Policy Doesn't Cover

Many flood insurance policy provisions are similar to those found in a fire insurance policy. Flood policies do not cover:

- accounts, bills, currency, deeds, evidences of debt, money, securities, bullion and manuscripts;

- lawns, trees, shrubs, plants, growing crops, pets and livestock;

- aircraft, self-propelled vehicles and motor vehicles;

- fences, retaining walls, outdoor swimming pools, bulkheads, wharves, piers, bridges, docks, and other open structures on or over water;

- underground structures and equipment, such as wells and septic tanks;

- roads, machinery or equipment in the open;

- newly constructed buildings that are in, on or over water; and

- structures that are primarily containers, such as gas or liquid storage tanks (but silos and grain storage buildings, including contents, may be covered).

What about the elements of your home that are below ground? NFIP coverage includes protection for foundation elements (including posts, pilings, piers or other support systems for elevated buildings), utility connections and mechanical equipment necessary for the habitability of the building (such as furnaces, hot water heaters, clothes washers and dryers, food freezers, air conditioners, heat pumps, electrical junctions and circuit breaker boxes).

How Much Flood Insurance Can You Get?

The amount of flood insurance you can purchase depends on the value of your home. However, the maximum limit for flood insurance is $185,000 for a house, and another $60,000 for its contents. For many people, this may not begin to cover their losses.

If you live in a flood area and have a home that is worth more than these limits, you may want to explore surplus coverage to insure the balance.

The types of items that usually receive limited coverage in a standard homeowners policy (art, jewelry, furs, gold, silver, etc.) receive even less coverage under a flood policy. The maximum coverage for all of these items is just $250. Coverage for business equipment in your home also is limited—

to $2,500. But you can purchase additional insurance to protect all of these things.

BUILDING COVERAGE	Additional Amounts Available	Regular Program	Emergency Program
Single-family dwelling*	$35,000	$150,000	$185,000
Other residential*	$100,000	$150,000	$250,000
Non-residential	$100,000	$100,000	$200,000
Small business	$100,000	$150,000	$250,000
CONTENTS COVERAGE (per unit)			
Residential	$10,000	$50,000	$60,000
Non-residential	$100,000	$100,000	$200,000
Small business	$100,000	$200,000	$300,000

* Higher limits of basic coverage are available under the emergency program in Hawaii, Alaska, the U.S. Virgin Islands and Guam.

In addition to coverage for the house and its contents, the dwelling form of the standard flood insurance policy also includes coverage—up to 10 percent of the policy amount—for **garages and carports**. You also can schedule coverage for up to 10 additional buildings on your property (if you have a workshop or a guest house, for instance).

Buying Flood Insurance

While the NFIP is a federal program, flood insurance is **sold locally**—through insurance companies. More than 200 insurance companies currently sell and service flood insurance under their own names.

However, no matter which company you buy flood coverage from, the rate will be the same, because it is set by the NFIP.

For once, you don't have to worry about the quality of the company that is selling you the insurance policy—because the flood insurance policy is backed by the NFIP. The money for claims comes from the program, too.

However, you do have to have some contact with the insurance company from whom you buy coverage in the event you need to file a claim. The company's adjuster will visit your property and pass along the information gathered to the NFIP.

Your rates will depend on your home's age, where it is located and how it was built. How much your community has done to reduce the risk of flooding also will impact your rates. (This, in turn, may influence the way you vote in local elections.)

If your house is on high ground and was built according to current standards, your rates may be as low as a few hundred dollars a year. On the other hand, if you live in a high-risk area, your premiums could be 10 times that amount or more.

Deductibles for flood insurance typically are quite reasonable (especially when compared with the deductibles for earthquake insurance)—in the $500 to $750 range.

If you are building a home near the water, it should be built on a deep-pile foundation to survive a flood or a major hurricane. Frequently, homes built on slab foundations are destroyed in a disaster, while neighboring homes built on pilings survive. In any case, if the area in which you are considering building has a problem with erosion, you're asking for trouble—whether it's Malibu or Mississippi.

> To determine the relative risk of flooding for a particular site—which obviously profoundly affects your insurance rates—check a Flood Insurance Rate Map (FIRM). Each community's FIRM is issued by FEMA, usually after a Flood Insurance Study has been performed to analyze risk zones and elevations.

Whether your home was built before or after FEMA came in and created the local flood map also impacts your rates. That's because pre-existing structures in flood zones receive subsidized rates—and structures that are shown by a flood map to be outside of serious flood zones benefit from even lower rates. Newer homes outside of serious flood zones get the best rates of all.

Because rates are rigid, the only way you can **save money** on flood insurance is to raise your deductible, rebuild using more flood-resistant materials and techniques, or move to a less flood-prone neighborhood.

But even moving to a less flood-prone area is no guarantee that you'll be safe. Historically, about one-third of all claims paid by the NFIP are for flood damage in areas identified as having only "moderate" or "minimal" risk of flooding. (Flooding in these areas typically is a result of inadequate drainage.) What's more, floods and flash floods occur in all 50 states.

If your community doesn't participate in the NFIP, you may still be able to buy some level of flood coverage. Contact the NFIP for details on your area. You also may be able to have some flood coverage added by endorsement to your homeowners or dwelling policy.

I Feel the Earth Move...

Earthquake insurance is quite different from flood insurance. For one thing, it was—and still is, in some cases—underwritten by insurance compa-

nies, rather than a federal agency. This means the rates and policies differ from company to company.

Since the beginning of 1997, however, Californians also have been able to purchase coverage through a state program, called the California Earthquake Authority (CEA). CEA policies are like flood insurance policies—they are sold by insurance companies, but claims are paid by the CEA.

The CEA was created because of the **1994 Northridge earthquake**, which caused some $12.5 billion in damages—more than the insurance industry expected to pay.

Because California law requires insurance companies to offer earthquake coverage with every homeowners policy, the vast majority of insurance companies either stopped selling new homeowners insurance policies in the Golden State or they scaled back their efforts considerably—restricting new policies to areas unlikely to be affected by an earthquake. One company—20th Century—even made moves toward getting out of the homeowners insurance field in California entirely (though it later decided to continue offering coverage).

Meanwhile, the state legislature was looking for ways to make earthquake coverage accessible and affordable—and to encourage insurance companies to write homeowners insurance in the state. After much debate, in September 1996, an act creating the CEA was signed into law.

The CEA is funded in large part by insurance companies—which must pay to join, if they want to sell CEA policies along with their own homeowners insurance. The rest of the up to $10.5 billion in funding comes from investors and California consumers, via their premium dollars.

CEA policies are **bare-bones**—they're certainly more restrictive than the policies insurance companies had been offering prior to the Northridge quake. And CEA policies aren't cheap, either. This has prompted some consumer groups to fight the CEA—and to decry the plan as "corporate welfare" for large insurance companies. Some scientists and consumers have been fighting the way rates have been set, as well. Meanwhile, homeowners are left trying to decide if the coverage is worth the money.

Unfortunately, CEA policies are quickly becoming the only game in town. While the CEA was being created, the legislature authorized insurance companies to offer more bare-bones coverage to Californians—allowing them to write policies remarkably like the one that is now offered by the CEA. Most insurance companies modified their existing earthquake policies when they came up for renewal—restricting the coverage and raising the deductible. Now that the CEA is in operation, most insurance companies have simply converted their policies to CEA policies on renewal.

The CEA Policy

Earthquake insurance—from the CEA or from a private insurance company—is written in addition to a homeowners or dwelling policy. This is important to note, because the **amount of coverage** that you have on your home under an earthquake policy is limited to the amount of coverage you have on your home under your homeowners or dwelling policy.

The CEA policy also includes a 15 percent deductible. So, if you have a $100,000 homeowners policy, you have to pay to repair the first $15,000 worth of damage to your dwelling and its contents after an earthquake. Then the earthquake coverage kicks in. (Renters only have a $750 deductible on earthquake personal property coverage, since they don't have dwelling insurance. Renters may want an earthquake policy, because their landlord's coverage extends only to the building; it does not protect their belongings.)

However, the CEA earthquake policy does not cover damage to:

- detached garages;

- pools;

- driveways;

- masonry walls or chimneys;

- fences; or

- landscaping.

Condo and co-op owners can only purchase coverage up to a $25,000 limit.

Coverage for your **personal property** also is quite limited, whether you are a homeowner, condo owner or renter. The CEA policy will only pay up to $5,000 for your belongings—and there are restrictions.

The CEA policy also will pay up to $1,500 for living expenses, if your home becomes uninhabitable due to a quake.

If you have substantial damage to your home from an earthquake, including a tremendous new hole in your roof, your insurance company will expect you to seal it off—so rain will not cause more damage. Also, if aftershocks damage the repairs in process, your insurance should pay for these multiple repairs.

Clearly, CEA policies don't offer a lot of coverage. Unless a major earthquake hits, your home probably won't even sustain enough damage to cover your deductible. These are true **catastrophic insurance policies**—designed to cover you only in the event of a catastrophe.

The good news is that the CEA policy does at least offer replacement cost coverage.

If you want more coverage than that offered by the CEA, your choices are limited. You may be able to purchase what the insurance industry calls **wrap-around** coverage. With this sort of coverage, you would buy a CEA policy *and* a wraparound policy—to pay part of the deductible, for example, or to give you more coverage than the maximum limits allowed by the CEA.

However, only one insurance company—USAA—was planning to offer wraparound coverage in the months after the CEA program was put in place. Its wraparound coverage was limited to additional insurance for personal property and living expenses, raising those limits to $25,000 and $5,000 (respectively), or $50,000 and $10,000, or $100,000 and $20,000.

> Most insurance companies that have joined the CEA do not plan to offer wraparound coverage because they're trying to limit their losses from earthquakes—not increase them.

Buying CEA Earthquake Insurance

To purchase a CEA earthquake policy, your best bet is to contact the company who writes your homeowners insurance. If that company is participating in the CEA, it can write the additional coverage for you. If you are new to the market, you will need to find an insurance company that is participating in the CEA.

To qualify for CEA coverage, you must have a house that was built in 1960 or later. Or, if your house was built before 1960, it must be anchored to the foundation, it must have structurally sound weight-bearing walls braced with plywood or its equivalent, and its hot water heater must be secured to the building frame.

If you have been unable to purchase homeowners insurance through an insurance company, you can get homeowners coverage—and earthquake insurance—through California's FAIR Plan. At one point, the FAIR Plan sold its own earthquake policies, but they were converted to CEA policies in March 1997.

How Much Does It Cost?

Rates for coverage depend on where your home is, when it was built and whether it is of frame (wood or stucco-covered wood) or masonry (brick, stone, adobe or concrete block) construction. (Masonry rates are usually significantly higher than frame rates.) Earthquake retrofitting (bringing an older

home up to current building code specifications) also will reduce your rates—and your risk of damage, of course.

> The average CEA rate, statewide, is $3.29 per year for every $1,000 of coverage. However, the range of rates is quite broad—varying as much as 60 percent from one part of the state to another, and even within a given county.

Oddly enough, some areas that traditionally have been considered high-risk zones have lower rates than some areas that traditionally have been considered lower risk. How did this happen? For the most part, the rates were developed by EQE International, a San Francisco firm that specializes in helping companies and homeowners identify and reduce risks that could lead to major damage during a natural disaster, such as an earthquake.

To determine the risks in various areas—and, therefore, the rates that should be charged—EQE looked at every single California earthquake policy in force and ran it through a computer model. The firm considered soil types (which range from bedrock—the safest—to the kind of soft, silty soil you would find at the bottom of a river bed, which is the most prone to damage).

It also looked at the age of the homes in a given area—because earthquake codes have changed over the years, as folks have learned what types of construction do and do not withstand quakes. And, finally, the company looked at the kind of foundation various homes had—and how those homes were attached to the foundation.

EQE then developed rates based on **ZIP codes**—broken down within each ZIP code for different types of construction, age, and kind of dwelling (including houses, apartments, condos and mobile homes). This resulted in 5,000 different rates.

Then, the CEA had an **actuary** work to reduce the total number of rates. Actuaries are the number-crunchers who do a lot of the background work for insurance companies (and other firms). They figure out how much of a risk is posed, how to group risks in a meaningful way, how to add the costs of overhead into the rates and so on.

The rates for these **19 different territories** range from about $1 to $5.25 per $1,000 of insurance per year.

Policyholders also may wind up having to pay more than just their premiums under a CEA policy. If you read the fine print, you'll discover that you may get hit with a **policyholder assessment**, which says that if a major earthquake strikes and the CEA's billions of dollars' worth of resources are wiped out, the agency can bill you again.

But the policyholder assessment cannot exceed 20 percent of your annual earthquake insurance premium.

Warranty Insurance

If you're buying a new home, you also may want to purchase warranty insurance. Why? Most homeowners insurance policies exclude coverage for the cost of defective construction or unforeseen repairs to new homes.

> Insured warranty policies usually cost several hundred dollars. They cover major structural repairs for as many as 10 years—and less severe problems for one or two years. But a series of lawsuits has raised concerns about whether owners of these policies have been getting their money's worth.

With growing frequency, particularly in cases where the home builder has gone out of business, warranties are leading to disputes between the new homeowners and the insurance company over whether the coverage applies under the contract. Usually, such disputes are heard by arbitrators.

One of the problems with buying a new home is that, if the builder goes out of business, it won't be around to make good on defects. Warranty insurance is expensive—on a strictly actuarial basis—because so few people make claims on it. But it makes sense for people who have doubts about the viability of their builder.

Conclusion

It's almost a cliché—though perhaps a true one—to note that many people have most of their financial well-being tied up in their homes. That's why it's so important to have a basic understanding of how homeowners coverage works. While the kinds of coverage offered by homeowners policies are fairly standard, the amounts of coverage may vary.

Traditionally, liability coverage has been one of the distinguishing characteristics of homeowners insurance. It's what separates homeowners coverage from stand-alone dwelling or fire coverage. But liability insurance has become so important that even this distinction is fading. Increasingly, liability coverage is being added to dwelling and fire policies. When liability coverage is not attached to a dwelling policy directly, it sometimes is written as a separate policy.

Liability coverage has two parts: personal liability coverage and medical payments coverage. If damage was caused by you, your spouse, your children or your pets to another person or persons on the premises of your home, you

can be held liable.

Property coverage is the most common coverage people think of when they shop for homeowners insurance. This is insurance for fires and damages that can destroy your house. The amounts of coverage offered by this section of the policy can vary widely on location and insurance company.

It is important to know the different definitions of coverage and how they apply to you legally. It is also important to know when limits of coverage occur in your insurance policy, and when the insurance company stops paying.

Key Questions

This is the information you'll need to decide whether you want to get **homeowners or dwelling coverage**. You'll also need this information before you call an insurance agent or other salesperson to purchase dwelling coverage.

1) Is this coverage for your primary residence? Yes No

 If you answered yes, you'll probably want to purchase homeowners—rather than stand-alone dwelling—insurance. However, answering a few more questions will help you decide.

2) Is your home ineligible for homeowners coverage because of its age, location or value? Yes No

3) Is your home ineligible for homeowners coverage because it is not a single or two-family residential property? Yes No

4) If you answered yes to Question 3, is this home a triplex or a four-family dwelling? Yes No

 If you answered yes to the three questions above, you probably need dwelling insurance, since your home cannot qualify for a homeowners package policy.

5) Is this a rental property? Yes No

 If yes, you may want to purchase dwelling insurance instead of homeowners (e.g., if this is a second home that you rent out most or all of the time). However, rental and other investment properties may be better served by a commercial insurance policy.

6) Is this coverage for a dwelling in the course of construction?

 Yes No

 Again, you may not need all of the coverages available on a homeowners property—if you already have liability coverage on another insurance policy (e.g., for the home you live in while you're building this one, or on your renters insurance policy).

 If you are going to get **dwelling coverage**, here's what you need to know before you call an agent or salesperson:

1) How much dwelling coverage do you need for your house? (Remember not to include the value of the land your home is built on.) _____

2) Do you want to get a basic policy, a broad policy or an all-risk policy? _____

3) How much coverage do you need for other structures (a detached garage, a guest house, a tool shed, a workshop, etc.)?

4) How much coverage do you need for your personal property? (The Household Property Inventory in Chapter 7 will help you calculate this.) _____

5) How much coverage do you need for loss of fair rental value? (If you rent out a portion of the property, how much are you charging?) _____

6) Do you need any of the following endorsements?

 a) Dwellings under construction Yes No

 b) Ordinance or law Yes No

 c) Sinkhole collapse coverage Yes No

 d) Water backup through sewers or drains,
 overflow of sump pump Yes No

 e) Inflation guard Yes No

 f) Broad theft coverage Yes No

 g) Off-premises theft coverage Yes No

 h) Watercraft coverage Yes No

7) Do you want to add personal liability coverage? Yes No

8) How much liability coverage do you need?

9) Do you want to purchase additional medical payments coverage? Yes No

 If yes, how much? _____

Catastrophe insurance questions.

1) Do you live in a flood zone? Yes No

2) Has there ever been a flash flood in your area? Yes No

3) Does your house qualify for flood insurance? Yes No

4) Do you need surplus flood coverage, on top of the $185,000 maximum for your home and $60,000 for its contents? Yes No

5) Do you need additional flood coverage for art, jewlery, furs, silver, etc.? Yes No

6) Do you live in an earthquake-prone area? Yes No

7) If you live in California, can you get coverage underwritten by an insurance company, or are you limited to a CEA policy? (You may have to call a few agents to find out.) Yes No

8) Do you need wraparound coverage to supplement a CEA policy? Yes No

9) Do you need windstorm coverage? Yes No

10) Does your house meet the latest building codes? (This may save you money on your premiums.) Yes No

11) Can you tolerate a higher deductible? (This also should save you money on premiums.) Yes No

12) Can you afford to go without catastrophe coverage? Yes No

Chapter 7

Getting the Homeowners Insurance You Need

Now that you have a basic understanding of how homeowners insurance works, it's time to figure out how much coverage you need.

Your choice of which coverage—and how much coverage—to purchase will be influenced by a number of market factors. Even though insurance is a regulated industry, there can be a lot of difference between two insurance companies—from the way they charge premiums to the way they settle claims.

So, you'll want to compare policies from at least two or three different companies, to be sure you get the best possible coverage—and the best price for the coverage you want. But don't shop price alone. You also will want to compare insurance companies, because you'll want the company to be around—and financially stable—if you ever need to file a claim. And you'll want your rates to remain stable, too.

Start With the Value of Your House

Because insurance companies write coverage based on **the value of your home**, this is the place to start when you are determining your homeowners insurance needs. You also know how much it cost to buy your house—and how much you owe on it. And you probably have a good idea of the **current market value** of your home.

> But remember: The market value of your home includes the value of the land and its location—such things as the quality of local schools and police, the crime level in your area and the quality of life in (or desirability of) the area. These things can't be replaced by insurance—only the value of your home and personal property can. Therefore, the value of these other factors should not be included in the amount of homeowners insurance you purchase.

To decide how much insurance you need to buy, a good place to start is figuring out how much it will cost to rebuild your house. That's the base value that defines the final amount your homeowners insurance will pay for real property damage.

To determine the rebuilding cost, you can ask an insurance company, real estate agent or appraiser to calculate the **current cost of construction** for a house like yours. The appraisal will depend on objective criteria—square footage, number of bedrooms and comparable values in the area. It's an impersonal process, even more so than selling a house.

Being as accurate as possible with this figure is imperative. Why? Because of the **co-insurance penalty** we considered in the previous chapter: If you purchase an amount of insurance that is less than 80 percent of the cost to rebuild, you forfeit the right to collect the full replacement value for your property, even if you only suffer a partial loss.

> **Example:** If the replacement cost of your house is $100,000 and you have a fire in the kitchen that causes $10,000 in damage, you'll collect $10,000—as long as you have at least $80,000 in insurance.
>
> **Another example:** You buy $100,000 of coverage—the estimated replacement cost—on your new home. A few years later, the house burns to the ground. At that time, it's determined that the full replacement cost is $110,000. In order to collect for this loss on a replacement cost basis, you must be carrying at least 80 percent of $110,000, which is $88,000. Since you've got $100,000, you will get full replacement cost.

If building costs had skyrocketed in your area, you may not have enough coverage. Clearly, it is important to keep current with the local costs to rebuild, so you can be sure you have sufficient homeowners insurance.

What If You Have Less than 80 Percent?

If you're insured for less than 80 percent of the cost to rebuild, you have put yourself in a risky situation. This risk is called **implied co-insurance**. Why is this such a big risk? Because the insurance company will not pay off in full—whether your house is completely or only partially destroyed.

Instead, it will make two estimates. The first is the **actual cash value** (ACV) of the part of the house (or other structure) that needs to be rebuilt. The actual cash value is the replacement cost, less depreciation.

> **Example:** If your kitchen cabinets were completely destroyed by a covered peril, the insurance company would look first at the current replacement cost, then account for the length of time you've had those cabinets. So, if new cabinets cost $10,000 and the insurance company figures that yours had depreciated 30 percent due to age and use, a policy providing ACV recovery would pay $7,000.

The second estimate is based on how much insurance you've purchased. If your $100,000 home is insured for $60,000, you have an insurance policy worth only three-fourths of the required 80 percent. If you file that $10,000 claim for your cabinets, the insurance company will pay the larger of two amounts: either three-fourths of the $10,000 repair bill ($7,500, less your deductible) or the actual cash value of the part of the building that was destroyed ($7,000). You will be responsible for the rest of the repair bill.

Strategic Options for Buying Homeowners Insurance

If you are cautious, you may want to purchase a homeowners policy that will pay for 100 percent of the rebuilding costs. Say you have a $100,000 home that suffers $90,000 in damage. With a 100 percent replacement policy, the insurance company will pay $90,000.

If you are willing to take on some risk, buy a policy that pays 80 percent of the rebuilding costs. If your $100,000 home is insured for 80 percent, the maximum value of the policy is $80,000. If you had a partial claim, the insurance company still would pay off in full. But if your home suffered $90,000 in damage, the insurance company would pay only $80,000.

> The surest way to arrange full coverage is to buy a guaranteed replacement cost policy, which will pay up to 50 percent more than the face value of the policy to rebuild your home. (A few companies offer unlimited coverage.)

With a **guaranteed replacement cost** policy, the insurance company automatically adjusts the amount of insurance each year to keep up with rising construction costs in your area. The policy also protects you against the unexpected, such as a sudden increase in construction costs due to a shortage of building supplies (a problem that occurred when Hurricane Andrew ravaged Florida's Atlantic Coast a few years back).

Companies that offer guaranteed coverage usually require that you insure your house for 100 percent of its replacement cost. (Owners of high-risk or older homes may not be eligible for this type of policy.)

If You Have a Mortgage

If you have a mortgage on your house and the face amount of your homeowners coverage is based on your mortgage, make sure it is sufficient to cover the current cost of rebuilding.

Some homeowners get into **automatic insurance packages** that limit the amount of homeowners coverage to the amount they owe on their mort-

gages. If you have this kind of insurance—and especially if you've paid off a good part of your loan—take some time to review its coverage. If your house is destroyed, your mortgage company will be paid off, but you could be left without money to rebuild.

Building a Home?

What if you're in the middle of building or extensively renovating or remodeling your home? Will a homeowners policy cover it? That depends.

Insurance companies are very strict when it comes to structures that are **vacant** (it has neither occupants nor contents), unoccupied (it has contents, but no occupants) or **under construction**. Some property insurance coverages may be suspended automatically when a building is vacant or unoccupied, or when it has been vacant or unoccupied beyond a specified number of days.

However, buildings that are under construction—either when they are first being erected or when they are being remodeled, renovated or repaired extensively—are not considered vacant or unoccupied. So, if you have coverage already, it should not be suspended. Nonetheless, it's always a good idea to discuss the situation with your insurance company or agent. Ask if the policy you're buying has any unusual terms for coverage of buildings that are under construction or being remodelled.

On the other hand, if you are building a new house, you really don't need a complete package of homeowners insurance. It doesn't have any personal property in it yet, and you probably have liability protection under another policy (your existing homeowners or renters insurance). In this case, consider buying only a **cause of construction** (COC) policy, which is sold as a stand-alone policy. (See Chapter 3.)

> Either way, the amount of insurance shown for a dwelling under construction is a provisional amount, usually based on the expected completed value. The amount of coverage actually in effect on any given date is a percentage of the provisional amount, based on how close the dwelilng is to completion.

Other Structures

Once you've figured out how much real property coverage you need for your house, you need to consider the amount of coverage required for any other structures.

Buildings that are not attached to the house (garages, guest houses, tool sheds, etc.) are insured separately, and the standard amount of coverage is a

percentage of the face value of the policy—usually 10 percent—which is provided as an additional amount of insurance. For example, if you have a $100,000 policy for the dwelling, you automatically get an additional $10,000 worth of coverage on top of it for other structures.

This probably is enough if the other structure in question is a work shed or a one-car detached garage. But a guest house or a more extensive project shop may require additional coverage.

This can be purchased for a little more money by requesting either higher limits for **detailed or listed structures** or additional coverage (usually called a rider) for the extra living space.

Pools, hot tubs, gazebos, mechanical waterfalls and other valuable outside items usually are included on the "other structures" limit, as well, and should be considered when you determine your coverage needs.

Keeping Track of Your Personal Property

The next area to consider before you purchase homeowners insurance is the value of your **personal possessions** or property. A standard homeowners policy will provide an additional 50 percent of the face amount of coverage for your personal property. If you have a $100,000 policy, you will get another $50,000 to cover your possessions in the event of a total loss.

Will that be enough?

> **Personal property can be tough to value accurately. One simple way to calculate your insurance needs is to make a list of everything you own that could generally be described as part of your household—including furniture, carpets, drapes, art or other decorations, appliances and clothes. Include the serial number (if applicable) and a brief description of the item. Also list the purchase price, along with the year you bought the item.**

To organize this inventory, it's easiest if you divide the list into relevant rooms in the house. The chart on the following pages should help. It's a good idea to hang onto **receipts or bills** as backup in the event of a claim, especially for expensive items.

It's also a good idea to take **photographs** of all the rooms in your home and keep copies of those photos—along with the receipts and this inventory list—in a safe place, such as a safe deposit box. Some people go as far as photographing each wall of each room with closet or cabinet doors open to back up their written inventory. On the back of each picture, they write the date, the general location and the contents shown. And don't forget to update your inventory regularly.

The **total value** of all of your possessions will give you an idea of how much personal property coverage you need. But it's not the only consideration. There are also exclusions to contend with.

Some Kinds Of Personal Property Are Special

Insurance companies don't consider all types of personal property equal. Some items—particularly those with a high value—will have separate limits under a homeowners policy.

The following is a list of the kinds of items that are treated differently, and their typical limits:

- $3,000 on **computers**;

- $2,500 on **silverware**, silver-plate, goldware, tea sets, gold/silver-plated trophies, etc. (some policies have substantially higher limits);

- $2,500 on **firearms**;

- $2,500 for **business property** kept at home.

- $1,000 to $2,500 on **jewelry**, watches and furs;

- $1,000 or $1,500 on **securities**, deeds, manuscripts, passports, stamps and other valuable papers;

- $1,000 or $1,500 on **watercraft**;

- $500 or $1,000 on **trailers** not used for watercraft; and

- $200 on **coin collections**, gold, silver, medals and currency.

Some policies also place a limit on things like garden tractors, riding lawnmowers, etc.

These limits apply to each category of item, not each item. If you have a substantial amount of jewelry or computer equipment or camera gear—or anything limited under the policies you are considering—you will want to buy additional insurance.

You can raise the limits on any of these categories—or on specific valuables. But you'll have to pay an additional premium, of course.

You can add some items to your policy by **scheduling** them for special coverage. Scheduling is usually the cheapest way to obtain additional coverage—but this option doesn't always cover valuable property sufficiently. Or you can purchase a **floater**, which is separate insurance bonded with a homeowners policy. The cost of floaters is usually minimal and it's certainly

better to secure adequate insurance than to risk leaving family heirlooms, expensive equipment and prized possessions uninsured and unprotected.

Check Out the Coverage Terms Yourself

Different homeowners policies may apply various loss settlement terms to different kinds of property. In other words, even if the policy offers full replacement value for the house, it may offer only actual cash value for specific kinds of property.

Here are a few examples, taken from actual policies:

> **Personal property and structures that are not buildings (e.g., a TV antenna tower) are valued at actual cash value (replacement cost less depreciation) or the necessary cost of repair.**
> **Awnings, carpeting, etc., might be considered as building items, but are to be valued at actual cash value and not replacement cost, which is the usual settlement basis for buildings.**

You need to look for these sorts of shifts when you're buying homeowners insurance that you think covers full replacement value. In fact, you should be careful of promises or assurances that agents give you about policies that cover full replacement value. This term is used freely—but it only applies across the board in relatively few policies.

What About Liability Coverage?

Most people decide how much homeowners insurance they need based on the cost of replacing the house and its contents in case of fire or other disaster. But they often overlook whether the policy provides enough liability coverage. In the last chapter, we considered the reasons that liability coverage is important.

How much liability coverage do you get on your homeowners policy? Most homeowners policies pay **up to $100,000** each time someone makes a legitimate liability claim against you. If the liability claim against you is more than $100,000, you would have to pay the difference.

The liability portion of the policy is designed to protect your assets if you are sued by someone. Anyone can sue you—an angry neighbor, the guy who bought your '69 Plymouth, the parents of a kid on the Little League team you coach. If the person suing you wins a judgment in court, you either have to reach a cash settlement or face the possiblity that the court will place a lien against whatever equity you have in your house.

(please turn to page 165 for the rest of the chapter text)

Household Property Inventory

LIVING ROOM

Article & Description	Serial No./Notes	Purchase Price	Year Purchased
Carpet/rugs	_____	_____	_____
Curtains/drapes	_____	_____	_____
Sofas	_____	_____	_____
Chairs	_____	_____	_____
Coffee tables	_____	_____	_____
End tables	_____	_____	_____
Other tables	_____	_____	_____
Art/room decorations	_____	_____	_____
Clocks	_____	_____	_____
Lamps/fixtures	_____	_____	_____
Television	_____	_____	_____
Radio/stereo	_____	_____	_____
Books/records/CDs	_____	_____	_____
Bookcases	_____	_____	_____
Musical instruments	_____	_____	_____
Plants/planters	_____	_____	_____
Mirrors	_____	_____	_____
Fireplace/tool set	_____	_____	_____
Accessories	_____	_____	_____
Other	_____	_____	_____
Total		_____	

FAMILY ROOM/DEN

Article & Description	Serial No.	Purchase Price	Year Purchased
Television	_____	_____	_____
Books/records/CDs	_____	_____	_____
Bookcases	_____	_____	_____
Desk/desk set	_____	_____	_____
Art/room decorations	_____	_____	_____
Accessories	_____	_____	_____
Clocks	_____	_____	_____
Lamps/fixtures	_____	_____	_____
Musical instruments	_____	_____	_____
Plants/planters	_____	_____	_____
Mirrors	_____	_____	_____
Fireplace/tool set	_____	_____	_____
Other	_____	_____	_____
Total		_____	

BATHROOM (copy and use for each bathroom in the house)

Article & Description	Serial No.	Purchase Price	Year Purchased
Flooring	_____	_____	_____
Curtains	_____	_____	_____
Dressing table	_____	_____	_____
Electrical appliances	_____	_____	_____
Space heater	_____	_____	_____
Scale	_____	_____	_____
Shower curtains	_____	_____	_____
Shower attachments	_____	_____	_____
Bath accessories	_____	_____	_____
Towels	_____	_____	_____
Bath mats/rugs	_____	_____	_____
Clothes hamper	_____	_____	_____
Mirrors	_____	_____	_____
Medicine cabinet & contents	_____	_____	_____
Art/room decorations	_____	_____	_____
Other	_____	_____	_____
Total		_____	
Total (all bathrooms)		_____	

KITCHEN

Article & Description	Serial No.	Purchase Price	Year Purchased
Flooring	_____	_____	_____
Curtains	_____	_____	_____
Tables	_____	_____	_____
Chairs	_____	_____	_____
Cabinets	_____	_____	_____
Lighting fixtures	_____	_____	_____
Bowls	_____	_____	_____
Pots/pans	_____	_____	_____
Utensils	_____	_____	_____
Glassware	_____	_____	_____
Dishes	_____	_____	_____
Refrigerator	_____	_____	_____
Stove	_____	_____	_____
Dishwasher	_____	_____	_____

Article & Description	Serial No.	Purchase Price	Year Purchased
Disposal unit	_____	_____	_____
Microwave	_____	_____	_____
Freezer	_____	_____	_____
Small appliances	_____	_____	_____
Clocks	_____	_____	_____
Radios	_____	_____	_____
Television	_____	_____	_____
Step stool	_____	_____	_____
Food/supplies	_____	_____	_____
Vacuum	_____	_____	_____
Art/decorations	_____	_____	_____
Other	_____	_____	_____
Total		_____	

BEDROOMS (copy and use for each bedroom in the house)

Article & Description	Serial No.	Purchase Price	Year Purchased
Carpet/rugs	_____	_____	_____
Curtains/drapes	_____	_____	_____
Bed frames	_____	_____	_____
Mattresses/box springs	_____	_____	_____
Night tables	_____	_____	_____
Valets	_____	_____	_____
Dressing tables	_____	_____	_____
Dressers	_____	_____	_____
Cedar/other chests	_____	_____	_____
Blankets/bedding	_____	_____	_____
Comforters/bedspreads	_____	_____	_____
Bookcases	_____	_____	_____
Books	_____	_____	_____
Chairs	_____	_____	_____
Desk & contents	_____	_____	_____
Lamps/fixtures	_____	_____	_____
Mirrors	_____	_____	_____
Clocks	_____	_____	_____
Radios	_____	_____	_____
Television	_____	_____	_____

	Purchase Price	Year Purchased	
Sewing machine	_____	_____	_____
Toilet articles	_____	_____	_____
Art/decorations	_____	_____	_____
Clothing	_____	_____	_____
Other	_____	_____	_____
Total		_____	
Total (all bedrooms)		_____	

MEN'S & BOYS' CLOTHING/PERSONAL EFFECTS

Article & Description	Purchase Price	Year Purchased
Coats	_____	_____
Hats/scarves	_____	_____
Suits	_____	_____
Slacks	_____	_____
Sweaters	_____	_____
Jackets	_____	_____
Shirts	_____	_____
Vests	_____	_____
Ties	_____	_____
Underwear	_____	_____
Socks	_____	_____
Belts & wallets	_____	_____
Rainwear/umbrellas	_____	_____
Sport clothes	_____	_____
Shoes	_____	_____
Jewelry/cufflinks/watches	_____	_____
Total	_____	

WOMEN'S & GIRLS' CLOTHING/PERSONAL EFFECTS

Article & Description	Purchase Price	Year Purchased
Coats	_____	_____
Hats/scarves	_____	_____
Suits	_____	_____

Jackets	_____	_____
Sweaters	_____	_____
Skirts	_____	_____
Blouses	_____	_____
Vests	_____	_____
Dresses	_____	_____
Furs	_____	_____
Gloves	_____	_____
Lingerie	_____	_____
Socks/stockings	_____	_____
Belts/wallets/purses	_____	_____
Rainwear/umbrellas	_____	_____
Shorts	_____	_____
Bathing suits	_____	_____
Shoes	_____	_____
Jewelry/watches	_____	_____
Cosmetics/perfume	_____	_____
Total	_____	
Personal effects total	_____	

LAUNDRY ROOM

Article & Description	Serial No.	Purchase Price	Year Purchased
Washer	_____	_____	_____
Dryer	_____	_____	_____
Iron	_____	_____	_____
Small appliances	_____	_____	_____
Cleaning supplies	_____	_____	_____
Other	_____	_____	_____
Total		_____	

GARAGE/BASEMENT/ATTIC

Article & Description	Serial No.	Purchase Price	Year Purchased
Furniture	_____	_____	_____

Luggage/trunks	_____	_____	_____
Sports equipment	_____	_____	_____
Toys	_____	_____	_____
Outdoor games	_____	_____	_____
Lawn furniture	_____	_____	_____
Ornamental lawn items	_____	_____	_____
Lawn mower	_____	_____	_____
Shovels	_____	_____	_____
Spreaders	_____	_____	_____
Sprinklers/hoses	_____	_____	_____
Wheelbarrow	_____	_____	_____
Snow blower	_____	_____	_____
Fuel	_____	_____	_____
Garden tools/supplies	_____	_____	_____
Ladders/step stools	_____	_____	_____
Work bench	_____	_____	_____
Carpentry tools/supplies	_____	_____	_____
Automotive tools/supplies	_____	_____	_____
Spare parts	_____	_____	_____
Canned goods/supplies	_____	_____	_____
Pet supplies	_____	_____	_____
Other	_____	_____	_____
Total		_____	

PORCH/PATIO

Article & Description	Serial No.	Purchase Price	Year Purchased
Chairs	_____	_____	_____
Tables	_____	_____	_____
Umbrella	_____	_____	_____
Floor covering	_____	_____	_____
Lamps	_____	_____	_____
Outdoor cooking equipment	_____	_____	_____
Plants/planters	_____	_____	_____
Other	_____	_____	_____
Total		_____	

HOBBY/SPORTS EQUIPMENT

Article & Description	Serial No.	Purchase Price	Year Purchased
Hobby materials	_____	_____	_____
Sewing machine	_____	_____	_____
Camera/photography equipment	_____	_____	_____
Camping equipment	_____	_____	_____
Fishing equipment	_____	_____	_____
Hunting equipment	_____	_____	_____
Bicycles	_____	_____	_____

HOBBY/SPORTS EQUIPMENT (cont.)

Article & Description	Serial No.	Purchase Price	Year Purchased
Tennis equipment	_____	_____	_____
Golf clubs	_____	_____	_____
Exercise equipment	_____	_____	_____
Other sports equipment	_____	_____	_____
Other	_____	_____	_____
Total		_____	
THE GRAND TOTAL		_____	

> The claims against you don't even have to hold up in court to hurt you financially. The cost of hiring an attorney to defend you in a civil lawsuit can easily reach $10,000. This is another reason liability insurance is valuable—it covers the costs of mounting your legal defense.

The assets you have to protect include more than just the value of your house. They include the value of its contents, as well as the value of **other property** that you own—vacation homes, cars, rental property, investments, collectibles, etc. So, it probably makes sense to buy at least $100,000 of liability insurance.

You can also buy **higher liability coverage limits**—and they are a relatively inexpensive and worthwhile additional insurance.

But how much more should you buy? Some people insure against the non-mortgaged equity they own in a home; others insure against the **total assessed value**. The latter is the safer strategy, and it's usually available.

> If your house is worth several hundred thousand dollars, you have a large enough investment there—and probably elsewhere, too—that it needs as much coverage as you can buy at a reasonable price.

Even if you don't have millions of dollars invested in stocks and bonds, you probably do have some money put away in a retirement fund. Whether this investment is an individual account (such as an IRA or Keogh) or a group account (such as a traditional pension plan, 401[k] or ESOP), it is an asset, and you should protect it.

Pension benefits usually aren't exposed to legal judgments. But they have been called into question, occasionally, when calculating damages levied against someone. For this reason, you probably should include pension benefits when calculating your insurable net worth.

Calculating Your Insurable Net Worth

To decide whether you need high-limit liability insurance, you need to calculate your **insurable net worth**. The easiest way to do this is to add up the equity value you have in your house, any other property you own, major personal possessions (such as jewelry or collectibles), and savings or liquid investments.

The following chart should help you review these assets.

Personal Assets Inventory

For market value, list the most recent comparable value or insured value from other coverages.

Under debts and restrictions, include mortgages, liens and other encumbrances on real property. Also include margin loans on capital investments, and liquidation costs or penalties on accessible pension funds.

Art, jewelry and other collectibles may be covered separately. If so, you may choose to keep them out of this calculation.

		Market Value	Related Debt and Restrictions	Net Value
1)	Home	_____	_____	_____
2)	Other real estate	_____	_____	_____
3)	Capital investments (stocks, bonds, etc.)	_____	_____	_____
4)	Cash savings	_____	_____	_____
5)	Accessible pension accounts	_____	_____	_____
6)	Cars, boats, planes, etc.	_____	_____	_____
7)	Art, other collectibles	_____	_____	_____
8)	Jewelry, furs, etc.	_____	_____	_____
9)	Recreational equipment	_____	_____	_____
10)	Other items	_____	_____	_____
	Total	_____	_____	_____

The **total value** of all these items—even if you couldn't raise it by selling everything tomorrow—is what you need to protect. You'll need to either raise the **limits of liability** coverage on your homeowners policy to this amount or buy **stand-alone liability insurance** separate from your homeowners policy.

Specifically, you may want to buy a **personal umbrella liability** policy. The umbrella policy pays up to a predetermined limit (usually $1 million) for liability claims made against you or a member of your family.

Medical Payments Coverage

A standard homeowners policy will provide a minimum of $1,000 of **medical payments coverage** for visitors on your premises. It covers such medical expenses as reasonable charges for medical care, ambulance service, hospital bills, professional nursing, prosthetic devices and funeral services.

> **A caveat:** This coverage does not apply to medical expenses related to *your* injuries—or those of anyone who lives with you, except your employees. This medical costs coverage is one of the two primary parts of a homeowners policy's liability coverage—with separate limits from the personal liability coverage. And these limits are usually low.

Of course, it's possible to buy **higher limits** for medical costs coverage—but this coverage isn't intended to serve as complete health insurance for someone injured on your property. Plus, if an injury leads to any kind of legal actions, the personal liability coverage comes into play. If you're concerned about having sufficient coverage for people visiting you, you're probably best served by buying higher liability limits.

Medical payments to others pays for necessary medical expenses incurred within three years of an accident that causes **bodily injury**. An accident is covered only if it occurs during the policy period.

At the **insured location**, coverage applies only to people who are there with the permission of an insured.

Away from the insured location, coverage applies only to people who suffer bodily injury caused by an insured, caused by an animal owned by or in the care of an insured, caused by a residence employee in the course of employment by an insured, or because of a condition in the insured location or the ways immediately adjoining.

The policy states that payment of medical payments to others is **not an admission of liability**. When medical payments are made, you are required to provide written proof to support the claim, and to authorize the insurance company to obtain medical reports and records. The injured party must submit to a **physical examination**, if it is requested by the insurance company.

You May Need to Add Endorsements

To get the kind of coverage you want, you may need to add one or more endorsements to a basic policy. Endorsements—like floaters—are additional levels and types of insurance added to a standard policy. Some of the more common endorsements to a homeowners policy include:

- **Guaranteed Replacement—Dwelling.** This is an important

modification to standard coverage. It is supposed to expand coverage to include all costs related to rebuilding your house. Many companies set limits for this coverage, however, paying only up to 120 percent or 150 percent of the policy's face value. A good endorsement will have limits in the 150 percent to 200 percent range. The best endorsement won't include percentage of face value limits.

- **Guaranteed Replacement—Contents**. Let's say that five years after you buy a 32-inch TV and an expensive leather couch, they are stolen from your house. Under a normal policy, the insurance company will deduct five years' worth of depreciation from the replacement cost of the pieces, paying you for their actual cash value. If you want the company to cut you a check for the full replacement cost, instead of deducting for depreciation, you'll need to buy a guaranteed replacement—contents endorsement. This coverage also may be limited, however—typically to 75 percent of the home's replacement cost, as opposed to the standard 50 percent on other policies.

- **Special Computer Coverage**. If the value of your computer hardware and software exceed the stated limit on your policy, you can add the extra coverage you need with this endorsement. It usually will come with a scheduled dollar limit.

- **Scheduled Personal Property**. Where the limits of coverage for specific personal items (jewelry, silverware, etc.) ends, a schedule kicks in. Scheduling personal items provides coverage at their actual appraised value. (You'll have to provide the appraisal, and keep updating it as the items appreciate—or depreciate.) A scheduled item also is protected for things that typically are not covered under a homeowners policy, such as lost or misplaced items and gemstones lost from a piece of jewelry because of a loose or damaged setting. Also, depreciation is not subtracted from a claim if the item is scheduled. The down side of scheduling is that it can be expensive.

- **Personal Property Blanket Endorsements**. A blanket endorsement is much like scheduling, except that it covers several different types of items under a single endorsement—and at a single additional charge. Rather than listing the value and

paying for each item separately, a blanket policy endorsement can cover jewelry, silverware, art, furs, golf equipment, musical instruments, postage stamps, rare and collectible coins, and some other items, depending on what a particular insurance company offers.

- **Ordinance of Law**. Let's say that you own a home that was built in 1910. If it burns down, the town will require you to rebuild it according to the latest building codes—which is usually substantially more expensive. That's where the ordinance of law endorsement comes in. For example, if your policy provides $100,000 of dwelling coverage, but it's going to cost an additional $20,000 to rebuild according to the new building codes, ordinance of law coverage will provide the additional $20,000.

- **In-Home Day Care Coverage**. If you have a day care center in your home, you must carry this additional coverage. A standard policy does not cover in-home day care liability.

- **Inflation Guard**. Inflation protection increases your dwelling coverage automatically each year. The amount of the increase is determined by an industry inflation index.

- **Earthquake**. This endorsement will cover any loss to your home and its contents caused by an earthquake, tremors or aftershocks. Earthquake coverage carries its own deductible. An earthquake endorsement does not cover damages directly or indirectly caused by a flood due to an earthquake.

- **Personal Injury**. This endorsement, when added to a standard homeowners policy, allows the policy to cover personal injury caused by you or someone who lives with you—including libel, slander, invasion of privacy, defamation, and wrongful eviction or entry. However, this endorsement does not cover personal injury arising from contracts, violation of the penal law or business-related activities.

- **Watercraft**. This endorsement provides liability protection for certain types of watercraft.

Ways to Lower Your Premiums

Now that you have a pretty good idea how much coverage you need—

and which endorsements you might like to add—you're ready to go shopping. But before you make those calls to insurance companies or agents, consider a few of the ways you can keep your costs down.

The following are a few of the factors that insurance companies use to adjust their rates:

- **location**;

- **fire-protection class**;

- **type of building**;

- **age of building**;

- **construction costs**; and

- **number of units**.

Residents of areas with traditionally high incidences of **crime, fire or natural disasters** can expect to pay more than residents of low-risk areas. And the rates for wood-frame construction are higher than for stone or brick buildings, since wood is more vulnerable to fire. So, if you haven't purchased a home yet, you may want to consider how a home's location and the type of construction affect the cost of insuring it.

Even if you already own the home you want to insure, there are several ways to help keep costs down. When you talk to an agent or insurance company, ask about the following issues:

- Raising your **deductibles**. The deductible is the amount you pay in the event of a claim, before the insurance company pays a dime. In a standard homeowners policy, deductibles apply only to certain kinds of coverage. Increasing a $250 deductible to $500 can cut your insurance costs by as much as 12 percent.

- Double-checking your **fire-protection class.** The closer you are to a fire station and the better the fire fighters are trained, the lower your premium should be. The Insurance Services Office assigns every neighborhood in the U.S. a fire-protection class, based on the quality of fire protection and the distance of homes from a water source. (Some companies use their own rating systems.) If your assigned class isn't right, you may be paying too much for your insurance.

- Getting **security** conscious. Many insurance companies offer discounts of at least 5 percent if you have a smoke detector,

burglar alarm or even just deadbolt locks on your doors. You may be able to cut your premiums even more—by as much as 20 percent—if you install a sprinkler system and a fire or burglar alarm that rings at the police station or other monitoring facility. (These systems are not cheap, so it's a good idea to make sure the one you're considering qualifies for a discount under your homeowners policy before you install it.)

- Staying with **the same insurance company**. Some companies will reduce their premiums by 5 percent if you stay with them for three to five years—and by 10 percent if you remain a policyholder for six years or more.

- Getting your **homeowners and auto insurance** from the same company. Many insurers offer multi-policy discounts.

- Not making lots of **small claims**. Don't file any claims if you can afford to pay the costs yourself. Many insurance companies offer a discount to people who have not filed a homeowners claim for three years.

- **Not smoking**. Believe it or not, you can save money on your insurance if you don't smoke. That's because smoking is the cause of more than 23,000 residential fires a year.

- Looking into **group coverage**. You may be able to get homeowners insurance through a business association or an alumni association at a reduced rate. (This is the insurance equivalent of buying in bulk.)

- Using **senior discounts**. Insurance companies offer retirees and older homeowners a break of up to 10 percent on their premiums. That's because if they are home, they are more apt to spot a fire, less apt to be robbed and may even spend more time maintaining their homes.

Shop Around

It is important to comparison shop for any major purchase you will make. You probably shopped around extensively before buying your house. Shouldn't you put at least some effort into making sure it is adequately—and affordably—protected?

As you've probably noticed by now, all policies are not created equal. Not only should you compare coverages from different companies before you

buy, but you should also read the policy's exclusions very carefully before you sign on the dotted line. Remember, the agent may have said that it was a particular kind of policy, but it ain't necessarily so.

> Even if you are comparing nearly identical policies, the rates are sure to be different. That's because subjective factors—such as the company's claims-paying procedures and investment income—have begun to play a greater role in premium prices.

These changes also make the financial strength of the insurance company more crucial than ever.

Don't rely on the insurance company—or your agent—to tell you that you still have sufficient coverage under your homeowners policy. Each year, when it's time to **renew**, you'll need to go back and **update your inventory** and photos. The idea is to ensure that your limits are still appropriate. You also may need to add items to your schedules.

If you do any remodeling or renovating, don't wait until the year's up and it's time to renew your policy. Inform your agent as soon as possible. If your renovations are extensive and significantly increase the value of your home, you may exceed the replacement cost threshold of your current homeowners policy, leaving your investment underinsured. In fact, most standard homeowners policies stipulate that coverage will not apply if you fail to notify your insurer of substantial improvements within a specified period of time (usually 30 days) after the work has been completed.

> Whether or not you have made improvements to the property, the cost to rebuild may have increased substantially in your area. Therefore, you may want to hire an outside appraiser to make sure that you still have sufficient coverage when it's time to renew.

Dwelling Coverage

In some cases, your insurance needs may not be as broad as the coverages that the standard homeowners insurance package offers. You may not need liability or personal property insurance—especially if you are insuring **a second home or certain kinds of investment real estate**. In these situations, you may prefer to buy the more limited—and less expensive—dwelling insurance.

You also may need dwelling insurance simply because **you can't get a homeowners policy** for your home. As we have seen before, some dwellings are ineligible for homeowners coverage because of the structure's age, loca-

tion or value, but they may still qualify for dwelling insurance. Also, a homeowners policy may be written only for single- and two-family residential property, while a dwelling form may cover a structure containing up to four living units. (Dwelling policies are issued primarily to cover non-owner-occupied buildings.)

Homeowners coverage is broader than stand-alone dwelling coverage in a number of ways. The most important distinction is that a dwelling policy **does not include liability coverage**.

A dwelling policy also will not cover outdoor property, such as awnings and antennas. And, coverage for vehicle damage to the premises is broader under a homeowners policy. Dwelling insurance does not cover vehicle damage to fences, driveways, walks and outside lawns, shrubs, trees and plants.

> There are many similarities between the two kinds of policies. That's because dwelling insurance is a portion of a standard homeowners policy: the part that covers the dwelling structure and attached structures on your property.

Like homeowners insurance, dwelling insurance comes in **three forms**—basic, named perils (also called broad) and all risk (also called special). Again, all risk is the most generous coverage. It also shifts the burden of proof of the cause of a loss from you to the insurance company.

It's important to point out that, thus far, we have described traditional dwelling insurance. However, with some recent policy revisions, the gap between dwelling and homeowners coverages has begun to close. Personal liability insurance and other coverages that are associated with homeowners policies now have become **options** under dwelling policies—at least in the majority of states.

> A dwelling policy that includes theft and personal liability coverage is very similar to a standard homeowners policy. In fact, many of the coverages and the basic limits of insurance are identical. However, the appeal of the dwelling package is that it provides flexibility: You can include only real property coverage or get the full package or get something in between.

What Kinds of Homes Are Eligible?

To qualify as a dwelling, a building must be a **principally residential structure** that contains no more than four apartments or is occupied by no more than five roomers or boarders. Single-family homes, duplexes and triplexes are eligible for coverage on dwelling forms. Townhouses or row houses also are eligible, if each building does not contain more than four units.

Dwellings in the course of **construction** also are eligible for dwelling coverage. Permanently located **mobile homes** are eligible, but they can only be insured under the basic coverage form. **Farm dwellings** are not eligible. (Coverage for farm houses must be written on separate farm forms.)

Under these policies, dwellings need only be principally residential; eligible dwelling property need not be exclusively residential. Certain **incidental business and professional uses** are allowed. These operations must be conducted by you or a member of your household, they must provide service rather than sales, and they must involve no more than two people working on the premises at any one time. The kinds of home businesses permitted include beauty parlors, photographic studios and professional offices.

Just as in a homeowners policy, an important part of the dwelling policy is distinguishing **who is—and is not—covered** under the policy. Generally, because the dwelling package doesn't include liability insurance, its coverage extends to fewer people.

Insurance on the dwelling and any other structures is provided for the **named insured** (you) and for the named insured's **spouse**, if that spouse is a resident of the same household.

If personal property is insured, the named insured and all members of his or her family residing at the described location are covered for property that they own or use. The personal property of guests and domestic employees may be covered by an endorsement.

If you die, coverage continues for your legal representatives. Until a legal representative is appointed, a temporary custodian of the estate also would be covered.

Three Dwelling Forms

As we've mentioned, three dwelling policy forms are available. Like the different kinds of homeowners insurance, these different forms provide **different degrees of coverage**.

Insurance companies usually require that you purchase minimum amounts of insurance for the broad and special forms. This is because people sometimes choose **very small amounts of coverage** for dwelling insurance. (Since the policies typically only cover the value of buildings—which usually aren't primary residences—minimizing dwelling coverage can make sense.)

The three forms of dwelling insurance are:
- the **basic form**—which insures against fire, lightning, removal and internal explosion (a package of optional coverages-called

extended coverage—can be added for an additional premium, and insurance companies don't require that you purchase a certain minimum amount of coverage);

- the **broad form**—which insures against all of the standard and optional perils available on the basic form and expands several of them (the minimum amount of insurance offered is $12,000 for the dwelling or $4,000 if the policy is written for personal property only); and

- the **special form**—which insures against any risks that are not excluded (minimum insurance is $15,000 for the dwelling).

Many insurance companies offer the same three-level variation in their homeowners policies. The basic form—which may not be the first policy the insurance company offers—usually will cost 20 percent to 30 percent less than the others. The standard deductible on dwelling forms ranges between $250 and $500.

Insuring a Home-Based Business

More than 43 million Americans operate full- or part-time businesses at home—and this number increases each year.

However, a homeowners insurance policy provides very **limited protection for business property**—coverage for such items as computers, fax machines, filing cabinets, tools and inventory usually is limited to $2,500 in your home and $250 away from home. And it provides **no protection for business liability**. So, if you operate a business out of your home, and you don't have a business insurance policy, you may be substantially underinsured.

Another option is to secure additional coverage for a home-based business by adding an **endorsement** to your homeowners policy. The applicable endorsements are:

- **Business Pursuits**. If you do not own the business, but you do conduct some business from home (e.g., if you make sales calls and keep files there), this endorsement provides coverage for the business property and extends liability coverage on a standard homeowners policy.

- **Permitted Incidental Occupancies**. If you own a business and conduct it out of your home, this endorsement (also known as the incidental business endorsement) eliminates the exclusion of business pursuits on the premises and allows liability cover-

age. However, the business has to take up a very small part of your home. For example, this endorsement would cover you if you give piano lessons in your living room. But if you use the second floor for living and the whole downstairs for business, it would be necessary to get a separate business policy.

If your business doesn't qualify for either of these endorsements, you can purchase coverage for your home-based business under a **business owners package policy**, referred to as a *BOP*, which provides property and liability coverage. Some insurance companies even offer a policy that is specifically tailored to meet the needs of an in-home business.

> **These policies provide both business coverage, such as business liability and replacement of lost income, and homeowners coverages, such as fire, theft and personal liability. They are designed to eliminate both gaps and duplications in your coverage—and they are generally quite affordable.**

Conclusion

This chapter has considered some of the critical questions that you will need to ask when you are considering what kind of homeowners insurance you need. By adjusting some of the parameters of your homwoeners insurance, you can increase or decrease the amount you pay for the coverage.

Also, if you have specific needs—and a home-based business is a good example of this—you can buy additional coverages which will expand the insurance protection. Of course, these additions will usually cost some extra money.

You dont need to be an insurance or legal expert to adjust the scope and cost of the insurance you buy. Any reasonable insurance company should be able to modify the policy it is offering you.

Key Questions

This is the information you'll want to gather before you call an insurance agent or other salesperson to discuss homeowners coverage. You will have considered—and put together—this information as you read through this chapter.

1) How much dwelling coverage do you need for your house alone? (Remember not to include the value of the land your home is built on.) _____

2) Do you want guaranteed replacement cost, full replacement or actual cash value coverage? _____

3) How much coverage do you need for other structures (a detached garage, a guest house, a gazebo, etc.)? _____

4) How much coverage do you need for your personal property? (Refer to the Household Property Inventory.) _____

5) How much liability coverage do you need? (Refer to the Personal Assets Inventory.) _____

6) How much medical payments coverage do you need? _____

7) Check the endorsements you'd like:

Guaranteed Replacement—Dwelling	Yes	No
Guaranteed Replacement—Contents	Yes	No
Special Computer Coverage	Yes	No
Scheduled Personal Property	Yes	No
For what? _____		
Personal Property Blanket Endorsement	Yes	No

Ordinance of Law Yes No

In-Home Day Care Coverage Yes No

Inflation Guard Yes No

Earthquake Yes No

Personal Injury Yes No

Watercraft Yes No

8) Do you need to insure a home-based business? Yes No

You'll also want to ask the company or salesperson about the following ways to lower your premiums, where applicable.

1) What happens if I raise my deductible? _____

2) What fire-protection class am I in?_____

 Does this qualify for a discount? Yes No

 If so, how much? _____

3) How much of a discount can I get for:

 a) Smoke detectors? _____

 b) A burglar alarm? _____

 c) An alarm that rings at the police station or a monitoring
 center? _____

 d) Deadbolt locks? _____

 e) A sprinkler system? _____

 f) Any other security discounts?_____

 g) Staying with this insurance company for a few years?

 How long do I need to stay with the company to qualify for a
 discount? _____

h) Not filing a claim for three years? _____

i) Being a nonsmoker? _____

j) Buying homeowners and auto insurance from

the same company? _____

k) Being a senior? _____

Chapter 8

Insurance for Hard-to-Insure Homes

Many homeowners can purchase exactly the coverage they want and need. All they have to do is pick up the phone and call a few agents or insurance salespeople to make sure they get the best policy for their premium dollars.

But for some homeowners, finding insurance is much more of a chore. In fact, insurance companies may not even want to speak to them.

What makes the difference between an insurance search that's a breeze and one that's a bother? Mainly, where your house is located.

If you live in an area that is prone to brush fires, hurricanes, floods or earthquakes, many insurance companies will not want to sell you homeowners insurance. They consider you too risky. Insurance companies also prefer not to write homeowners coverage for **old homes** with low values, and they tend to shy away from inner-city homeowners, too.

Why is finding homeowners coverage in **urban centers** a particular problem? Part of the reason stems from the outbreak of rioting in city centers during the mid- and late 1960s. Until the mid-'60s, riot coverage for homeowners property losses had been widely available as part of standard homeowners insurance packages. That soon changed. Insurance companies began to exclude riot damage from standard policies—and some stopped writing homeowners insurance at all in urban centers.

> In addition to concern about the riot risk, insurance companies were increasingly unwilling to insure property in neighborhoods characterized by congestion and deterioration. Inner-city homeowners and business owners soon found that property coverage was becoming unavailable or unaffordable.

Unfortunately, the absence of insurance usually accelerates the process of **economic decline**. Banks and other lenders require insurance coverage to protect their loans. When insurance is not available, lenders will not make loans for mortgages or new construction. Real estate transactions therefore cease, construction comes to a halt, jobs are lost, and the local economy stagnates or deteriorates.

It didn't take long for Congress to identify this growing urban problem. To remedy the situation, legislators created the Urban Property Protection and Reinsurance Act. It made riot reinsurance available to insurance companies through the **National Insurance Development Fund**, which is operated under the Department of Housing and Urban Development (HUD).

> **Reinsurance is like insurance for an insurance company. You purchase insurance to protect your assets in the event of a claim. An insurance company purchases reinsurance to protect its assets in the event it receives too many claims.**

FAIR Plans

How does making riot reinsurance available to insurance companies help you get homeowners coverage? Well, it's a bit indirect.

By law, any insurance company that wishes to buy riot reinsurance must participate in a HUD-approved FAIR plan. The term FAIR stands for **Fair Access to Insurance Requirements**. Many states created these plans to make essential property insurance available to consumers in areas where coverage had become unavailable—or at least extremely difficult to obtain—due to conditions that are beyond the control of property owners.

> **FAIR plans are state-supervised insurance pools that provide bare-bones homeowners and dwelling insurance in high-risk areas. The plans are in operation in about 30 states.**

In some states, these programs are referred to as the FAIR Plan. In others, they are known as **Joint Underwriting Associations** (JUAs). Some people also call them **assigned risk programs**. Whatever the name, the premise is the same.

Although they are administered by the states, FAIR plans are operated by **participating insurance companies**. Insurers that do business in a state usually have to participate in that state's FAIR plan **in proportion** to the amount of insurance they write in the voluntary market (that is, everything that they are not being forced to write in that state).

> For example, if State Farm writes 10 percent of the standard homeowners insurance in a given state, it will be required to write 10 percent of the high-risk policies in the state's FAIR plan.

Consumers who qualify can buy FAIR plan insurance just as they would buy insurance from a company—directly or through licensed agents representing the participating companies. FAIR plans make coverage available only in **designated areas**, which may include entire cities or counties, or may be defined by ZIP code or other geographical boundaries. In some cases, the designated area includes the entire state.

Because **each state sets up its own FAIR plan** and can regulate the plan as it chooses, there are slight variations in how each plan is run. However, it is possible to provide an overview of how these plans work—and why some of them may cause trouble for homeowners.

Who Qualifies for FAIR Plan Policies?

In most states, you must try to get coverage for your home through insurance companies before you can apply for coverage under a FAIR plan. The assigned risk programs are meant to be the **insurers of last resort**, since the state would prefer not to be in the insurance business—and insurance companies would prefer to choose their own customers, rather than receiving assigned risks.

Rules concerning which homes do and do not qualify for FAIR plan coverage vary somewhat from state to state. For an example of how they are structured, we'll take a look at the Indiana Basic Property Insurance Underwriting Association. It was established in 1968 to make property insurance available to homeowners who were unable to secure coverage through the normal insurance market. Unlike most states' FAIR Plans, the Indiana program allows insurance companies to participate on a voluntary basis, although the state's insurance commissioner strongly encourages companies that write property insurance in the state to participate.

Like all FAIR plans, the Indiana program will not turn down a homeowner because of the house's neighborhood or location, or because of any **environmental hazard** beyond the owner's control. However, in Indiana, the property must be at least 50 percent occupied.

To determine whether a house is insurable under the program, an inspector will consider the home's:

- **physical condition**, including the soundness of the construc-

tion, heating and wiring, evidence of unrepaired prior damage or general deterioration;

- **usage**—that is, whether or not it is vacant, and whether it exhibits substandard housekeeping, overcrowding or storage of rubbish or flammable materials;

- **characteristics of ownership**, meaning any condition, including occupancy or maintenance, that is in violation of law or public policy, or that results in an increased risk of loss.

> These inspections are free in most states, so if an inspector asks for money, call the local FAIR plan office to verify that a payment is required. An inspection is required before a new policy is written, and periodic inspections are required for renewals in Indiana, as well.

The Indiana FAIR Plan will not provide coverage for **mobile homes**, unless the wheels have been removed and the home has been set in a permanent foundation. It also will not write policies for **farm dwellings** with active operations, **vacant or unoccupied homes**, and new homes that are **under construction**. If you are renovating a home, the program will consider the property and determine whether or not the plan will provide coverage.

What Kind of Coverage Do You Get?

In the Indiana plan, the maximum coverage available for a single building (which does not have more than four apartments) is $250,000. This limit is for both the dwelling and personal property combined.

The California FAIR plan offers much higher limits. In the Golden State, the maximum available limit for all coverages—dwelling, other structures, personal property and any endorsements—is $1.5 million per location. These policies are written with a standard deductible of $250 per occurrence. Higher optional deductibles—such as $500, $1,000 or $2,500—are available.

In Indiana, in the event of a loss, the plan will pay you the **actual cash value** (in other words, the depreciated value) of any property that has been damaged or destroyed. You cannot purchase replacement cost coverage.

In California, you can choose from three types of coverage:

- **Actual Cash Value Coverage**. If there is a covered loss to your home, the plan will pay either the depreciated value of the damaged dwelling at the time of loss or the cost of repairing or replacing the property with like construction, but only up to

the policy's limit of liability. If ACV coverage applies, coverage for building code upgrades is not available.

- **Replacement Cost Coverage.** If you choose this option and there is a covered loss to your home, the plan will pay to repair or replace the property with like construction, but only up to the policy's limit of liability. To be eligible for replacement cost coverage, the dwelling must be insured for 100 percent of its replacement cost at the time of loss. Replacement cost coverage does not apply to personal property.

- **Building Code Upgrade Coverage.** This option is available only if the replacement cost coverage option has been selected. Building code upgrade coverage—also known as ordinance or law coverage—provides up to $10,000 of coverage for the additional costs required to bring a damaged dwelling up to current building code requirements. Without this coverage, a policy would pay only the amount needed to repair or replace the damaged dwelling to restore it to the condition it was in prior to the loss, and would not cover any additional costs due to changes required by current building codes.

Under most FAIR plans, the coverage provided is the equivalent of the basic homeowners policy. **You cannot purchase all-risk coverage.** For instance, the risks covered under the Indiana plan are:

- fire;

- lightning;

- internal explosion

- windstorm or hail;

- explosion;

- riot or civil commotion;

- aircraft;

- vehicles;

- smoke;

- volcanic eruption; and

- vandalism or malicious mischief.

> Note that FAIR plans do not provide liability insurance—they only provide bare-bones dwelling and personal property coverage. However, in Indiana, you can apply for personal liability coverage for a home that you occupy, and you also can apply for on-premises theft coverage. Some states are more restrictive in their offerings. However, some insurance companies will offer "wraparound coverage" to go with a FAIR plan policy—personal liability or theft coverage, for example.

FAIR plan policies do not usually provide **flood or earthquake** coverage. You will need to purchase a stand-alone policy to address these exposures if you are in an at-risk area, and you will need to be sure you have adequate hurricane coverage, too. (Indiana is different in this respect, because earthquake coverage can be requested under the FAIR plan.)

Don't Expect the Best Service

FAIR plans are not usually as service-oriented as traditional insurance companies—after all, they aren't trying to keep your business. They also typically have less in the way of resources than a for-profit insurance company.

For both of these reasons, FAIR plans typically will not issue quotes over the phone. In most states, quotes are provided only through the mail after a completed application for coverage has been submitted and reviewed. This is generally acceptable, because people do not comparison shop FAIR plans—people only purchase insurance through them when they can't get it through the lower-priced voluntary market.

> Service does become an issue with FAIR plans when you file a claim—especially if there's been a disaster and thousands of other people are filing claims at the same time.

After Hurricane Fran hit in 1996, many North Carolina residents complained about how slow the North Carolina Joint Underwriting Association (NCJUA) was to respond to their claims. While insurance companies were busy **settling claims** as quickly as possible (and taking advantage of the public relations opportunities their efforts presented), the NCJUA was struggling to find enough adjusters to visit policyholders' homes and evaluate the damage. Three weeks after the hurricane, the NCJUA had paid out just $6,700 in claims—while the agency expected to have $100 million to $200 million in total Hurricane Fran claims.

In contrast, Nationwide Insurance had paid out $74.1 million, or roughly half of the claims it had received. And North Carolina Farm Bureau Mutual Insurance Co., which had received more than 45,000 claims with an esti-

mated value of $125 million to $175 million, had made significant payments on 25 percent of those claims.

Part of the problem with the NCJUA's service was, again, a lack of resources. At the time, the NCJUA had 54 full-time employees. It hired 18 temporary workers to help process claims; but it could not call upon employees in other states to come help out in a crisis, as the national insurance companies do. And it had to rely on independent adjusters to visit its insureds and evaluate the damage done—which left it at the mercy of the marketplace.

As many unhappy FAIR plan customers have noted, when you're stuck in the assigned risk pool, **you pay more and get less**. But at least you get something in the event you need to file a claim—which, of course, is why the programs were created in the first place.

Bloated FAIR Plans

Unfortunately, FAIR plans in some states are virtually overflowing. As huge hurricane and earthquake losses in recent years have forced insurance companies to rethink their underwriting strategies, many homeowners are **no longer able to renew** their existing policies. If they can't find other coverage through normal insurance sources, these people are forced into the FAIR plan— even if they have a very nice, well-built, new home in a good area.

The California FAIR plan is a good example of why some of these programs are filled to the brim. Following the Northridge earthquake in January 1994, insurance companies became reluctant to write dwelling and homeowners coverage in California—due to a state law which required that earthquake coverage be offered in connection with residential property insurance. Coverage rapidly became unavailable for many consumers. So, the insurance department expanded the areas that were eligible to apply to the FAIR plan—making the plan open to homeowners statewide.

As people bought homes for the first time or were not renewed by their existing homeowners insurance companies, the FAIR plan grew. By mid-1996, it was providing about 236,000 people with **$13.5 billion worth of coverage**. However, the plan had collected only about **$40 million in premiums**—and many people worried about its ability to pay claims in the event of a crisis.

The plan was funded by assessments levied on private insurance companies (according to size and the amount of business each did in California) to help pay claims. But Insurance Commissioner Chuck Quackenbush worried that in the event of a major disaster, the state's assessments would force some companies into insolvency.

So, amid great controversy, the commissioner severely restricted the number of new policies that could be written in the state. As of June 1, 1996, the FAIR Plan would only sell policies in designated brush fire areas and in under-served, inner city ZIP codes. (Consumers currently insured through the FAIR Plan can still renew their policies, regardless of their home's location.)

The move sent real estate people and homebuyers into a panic, as they predicted that the market would stagnate and people would be left without any coverage at all. The best advice agents and other professionals were giving at the time was that people should buy stripped-down **fire insurance**, which most could find through some source (if they were in a brush fire area, they still qualified for FAIR plan coverage). For their personal liability needs, many of these people could add a separate personal liability policy—the so-called *wraparound* coverage.

Unfortunately, California is not the only state with a swelling FAIR plan and a frantic public. In August 1997, Florida's Residential Property and Casualty Joint Underwriting Association (JUA) was considering ways to trim the number of agents that could sell its policies. The problem, according to the Department of Insurance, was that many agents **were not trying to secure private insurance** coverage for their clients. They were ignoring state rules and going straight to the JUA.

Meanwhile, Florida Insurance Commissioner Bill Nelson was trying to shrink the JUA and shift more of the homeowners insurance back to the private sector. He had transferred 300,000 policies back to insurance companies earlier in the year, by creating an incentive program and allowing companies to pick and choose the JUA policies that they would take.

To limit access to the Florida JUA, the association's officials recommended restricting the sale of policies in 19 inland counties. Under the proposed plan, the JUA wouldn't renew policies in those counties until homeowners proved that at least two insurance companies had turned them down when they tried to find other coverage. It also would not write new policies in those areas until applicants could prove that they had been turned down twice in the voluntary market.

However, critics pointed out that the insurance companies took the policies that presented the lowest risks, leaving the JUA in worse shape than ever. And the JUA's total number of policies was still at more than 600,000—and climbing—making it the third-largest homeowners insurer in the state.

While some argued that the JUA was still underfunded, it did soon have more than $3 billion available to support its policies. However, the other Florida

state-run insurance pool, the Florida Windstorm Underwriting Association, was growing even more rapidly than the JUA—and seemed poised to be in even worse shape if a major hurricane were to strike.

There was some good news of late for Floridians, however, whose rates had risen by more than 88 percent in the five years since Hurricane Andrew had struck in 1992. Most homeowners insured through the JUA would see a slight decrease in their rates. And more insurance companies were doing business in the state, which would lead to more coverage availability and lower overall rates.

Stay Out or Get Out

Clearly, the goal is to avoid being stuck in a FAIR Plan. If you can find voluntary market coverage for your home, do so. Talk to several insurance companies before you settle for FAIR plan coverage.

> **If you already have homeowners insurance and you're in an area that your company may not find too desirable (within a mile of the beach, for instance, or near an earthquake fault), don't file any unnecessary claims. Instead, raise your deductible and hold onto the policy for as long as you can. Many homeowners have found, after filing two or three small claims, that once an insurance company drops them, they can't find other voluntary market coverage.**

If you are stuck in a FAIR plan, do your best to get out. To find out if anything will make your home more palatable to an insurance company, ask around. Call a couple of insurance agents or call the company directly. Ask if there are any **upgrades or improvements** you can make to your home to make it safer and more insurable in their eyes.

Tips if You Do Have to Apply to a FAIR Plan

As is usually the case, a licensed agent can help you determine the appropriate amounts of insurance and assist you in obtaining supplementary coverages, which may not be available through the FAIR plan, such as theft and liability coverages.

Bear in mind, when applying for FAIR plan coverage, that:

- All information on the application must be **complete and correct**. Incomplete applications will usually be returned unprocessed.

- An application must be **signed by the applicant** or an agent on the applicant's behalf.

- A **deposit is usually not required**, and no premium should be submitted with the application.

- Initial quotations may be **provisional**—that is, the FAIR plan may deny coverage once it inspects the property, or it may charge an additional premium on the basis of an inspection and rating report.

In California, if a residence appears to be acceptable on the basis of the application, a premium quotation will be issued by the FAIR plan. If the premium is not received in the FAIR plan office within 60 days of the date of the quotation, the offer of coverage becomes null and void and a new application must be submitted.

> A commitment to coverage can only be made by the FAIR plan if it finds that your home satisfies its general underwriting requirements.

Occasionally, an agent or broker will claim that he or she can get you FAIR plan coverage **automatically or immediately**. This usually isn't true. While an agent might be able to get insurance with a traditional insurance company that's effective immediately (the technical term for doing this is **binding** coverage), that's not possible with assigned risk insurance.

> An important note: The only payment you have to make to an agent or broker is the standard commission set by the state for FAIR plan business. Agents usually may not charge additional fees for handling FAIR plan coverages. They are not permitted to charge any fees for inspecting property, providing service or assisting in the completion of FAIR plan applications and forms.

Property Inspections

When a properly completed application is received by a FAIR plan, the property becomes eligible for an inspection.

> You have a right to be present during the inspection. You also have a right to request a copy of the inspection report.

An inspection report will note any **hazards or deficiencies** in the property. If repairs are needed and coverage is not in effect, the offer of coverage may be made contingent upon you making the repairs. If coverage is in effect, the FAIR plan may extend coverage for a **specified period of time** in which the necessary repairs must be made or else the coverage will be terminated.

If your property is found to be ineligible for coverage because of severe deficiencies, any coverage in effect will be cancelled and you will be informed of what repairs are necessary or what deficiencies must be corrected in order to make the property insurable.

> **If any insurance is refused or cancelled by the FAIR plan, you may submit a new application for coverage at any time after necessary repairs have been made or deficiencies have been corrected.**

You usually have the right to appeal any act or decision of the FAIR plan which affects you adversely. Appeals of any decision—including rejection of a property for coverage—should be made to the Appeals Board or Governing Committee of the FAIR plan.

Conclusion

Assigned risk insurance is an important tool for many people who live in high-crime or high-risk areas and otherwise could not purchase homeowners insurance. However, FAIR plan coverage usually is more limited than a standard homeowners insurance package—and the level of customer service is often not as high.

When at all possible, you are always better off staying out of your state's FAIR plan—or getting out as soon as you can.

Key Questions

1) Have you been turned down for homeowners insurance by two or more insurance companies? Yes No

2) Does your state have a FAIR plan? Yes No

3) Does your home qualify for coverage under the FAIR plan (based on where you live, etc.)? Yes No

4) Can you get sufficient dwelling and personal property coverage under a FAIR plan policy? Yes No

5) If not, how much additional coverage do you need?

6) Do you also want theft coverage? Yes No

7) Do you also want personal liability coverage? Yes No

8) Will an insurance company sell you a supplemental—or wrap-around—policy to go with the FAIR plan policy? (You may need to call several agents to find this coverage.)

 Yes No

9) What can you do—short of moving your house—to make your home insurable in the voluntary market and get out of the FAIR plan? (You may need to call several agents or insurance companies to find the answer to this question.)

Chapter 9

Coverage for Renters, Condominium Owners & Occasional Landlords

You don't have to own a five-bedroom Georgian in the leafy suburbs or a half-million-dollar condominium in a hip urban enclave to need insurance on the place where you live and the things you own. Even if you're fresh out of school and renting your first apartment, you may have things you need to protect—computers, TVs and VCRs, stereo equipment, sports equipment and so on. These things can be worth thousands—or tens of thousands—of dollars.

So, it's surprising that **fewer than half of all renters** in the United States bother to protect their personal belongings and furnishings with insurance. People under 40 are particularly remiss.

> Tenant advocacy groups and others—such as the Illinois-based Condominium Insurance Specialists of America—estimate that as few as one in four renters in their twenties and thirties buy insurance even though renters insurance is relatively cheap and easy to get.

Renters insurance is a special version of homeowners insurance, written on the HO-4 insurance policy form—also known as, the renters policy. It's available from most property and casualty insurance companies, and the coverage is inexpensive enough to be a worthwhile investment for just about any renter.

The policy **does not provide the complete range** of coverages provided by the other standard homeowners forms. Why? Renters don't usually need to insure the building in which they live. And renters who don't want to pay for liability protection can opt for a policy that covers only personal property.

The Importance of Coverage

Landlords sometimes will require that their tenants carry some form of renters insurance. (This usually applies to luxury apartments and rent-controlled units.) In states with large urban centers, insurance and housing regulators have outlawed these requirements in the name of consumer protection.

Unfortunately, these prohibitions may send the message that renters insurance is a rip-off. That's unfortunate, because it's not so. Renters' policies can be a bargain.

For example, in the mid-1990s, USAA—the Texas-based insurance company that specializes in covering military and former service personnel and their families—offered a tenant protection plan that cost $169 a year in New York City and insured $20,000 worth of belongings, with a $100 deductible. The policy also provided **replacement cost** coverage—and $100,000 of **personal liability** coverage.

Renters insurance can be written on either a comprehensive form for all risks that aren't explicitly excluded or for named perils only. Named-perils coverage generally is about 20 percent less expensive, because the losses it covers are more limited.

Even insurance written on a **named-perils basis** should cover fire, theft or water damage. These are the primary hazards renters face.

Generally, the perils covered on the renters policy are the same as those covered on a condo owners policy:

- fire;

- lightning;

- volcanic eruption;

- windstorm or hail;

- explosion;

- riot or civil commotion;

- aircraft;

- vehicles;

- smoke;

- vandalism;

- theft;

- bursting of a steam or hot water heating system;

- falling objects;

- collapse from weight of ice, snow or sleet;

- freezing pipes;

- damage to appliances by artificially generated electricity; and

- leakage of a plumbing or heating system.

What Kind of Coverage Are We Talking About?

The minimum coverage you can buy on a renters insurance policy usually is $6,000 worth of personal property coverage. A basic renters policy also includes:

- loss of use coverage (in case your residence is rendered uninhabitable), at 20 percent of the amount of personal property coverage;

- personal liability coverage, with a $100,000 minimum; and

- medical payments coverage, with a $1,000 minimum.

As ever, for an extra premium, you can raise these limits as necessary to suit your needs.

> The liability component is important. If you're like many people, you may believe that the landlord is responsible if someone trips in your apartment and is hurt. But the landlord's policy may specifically exclude liability for injury to another person or damage to another person's property if the incident occurred within your apartment. And that means you could be held liable.

Although it doesn't cover the building itself, an HO-4 policy does provide a limited amount of coverage for **building additions and alterations**. This coverage is known as **leasehold improvement insurance**. It means that if you spend money to improve the apartment or house you're renting—and haven't been reimbursed by your landlord—the renters insurance will cover the investments you've made.

How Much Coverage Do You Need?

Whether you're a renter or a condo owner, how much **personal property coverage** you need depends on the value of your belongings. To help you calculate this, you'll want to take inventory of your possessions. (Refer to the Household Property Inventory in the homeowners insurance section to determine the value of your possessions.)

Once you've calculated the value of the things you own, you simply have to ask yourself how much you can stand to lose.

> **If you don't own more than a few hundred dollars' worth of any specific kind of personal property, you probably don't need renters insurance. But if you care enough about a hobby or activity to invest thousands of dollars in related equipment, or if you've invested in collectibles, high-quality furnishings or even designer clothing, you probably do want to insure those things.**

Insuring Against Theft

One reason renters insurance is so attractive is that it covers personal property against **theft**. By comparison, basic dwelling policies do not provide any theft coverage for personal property. A broad theft coverage endorsement has to be added to a dwelling policy—at an additional premium—to provide such coverage.

> **For many insurance companies, the broad theft coverage endorsement to a dwelling policy—sold in a slightly different version as stand-alone insurance—is renters insurance. (For these policies, you would have to add liability coverage separately, if you want it.)**

Theft coverage provides insurance against loss on account of theft or attempted theft, and on account of **vandalism and malicious mischief** as a result of theft or attempted theft. (Vandalism coverage doesn't apply if your home has been vacant for more than 30 consecutive days immediately before the loss.)

Renters insurance (or broad theft policies or endorsements) contains three definitions that affect the coverage:

- **Insured person** means you and residents of your household who are either your relatives or under the age of 21 and in the care of you or one of your relatives.

- **Residence employee** means an employee who performs duties related to the maintenance or use of your home, including household or domestic services, or similar duties elsewhere that are not related to the business of any insured person.

- **Business** means any trade, profession or occupation.

Property used for business purposes isn't considered personal property and, therefore, isn't covered—including your camera gear, if you're a professional photographer.

Only property that belongs to an insured person is covered—so, if the $2,000 leather jacket you're keeping for a friend gets stolen from your trendy downtown loft, you may have some explaining to do. And if your roommates are not listed on your policy, their possessions aren't covered, either. (Many insurance companies recommend that all of the people sharing a residence insure their possessions—either together or on individual policies.)

Finally, **property of residence employees** is covered only if you ask the insurance company to do so. This may raise your premium—though many companies will add the coverage for no additional cost.

The Limits of Renters Coverage

Renters insurance limits coverage either with **one general dollar amount** or a **range of dollar amounts** applicable to different types of personal property. In the first case, a policy would insure all your property—regardless of type—to a limit of $20,000, for example. In the second, a policy would insure computer equipment up to $5,000, stereo equipment up to $2,000, sports equipment up to $1,500, etc.

Even if a particular policy shows one overall limit as the maximum amount of insurance for any one loss, special **sub-limits** usually apply to specific categories of property. Each limit is the most the insurer will pay for a loss for all property in that category.

An example of the special sub-limits of liability might be:

- $200 for money, **bank notes**, bullion, **gold and silver** other than goldware and silverware, platinum and coins;

- $1,000 for **securities**, accounts, deeds, evidences of debt, letters of credit, notes other than bank notes, manuscripts, passports, tickets and stamps;

- $1,000 for **watercraft**, including their trailers, furnishings, equipment and outboard motors;

- $1,000 for **trailers** not used with watercraft;

- $1,000 for **jewelry**, watches, furs, precious and semiprecious stones;

- $2,000 for **firearms**; and

- $2,500 for **silverware**, silverplate, goldware, goldplate and pewterware, including flatware, hollowware, tea sets, trays and trophies.

Limits similar to these are found on homeowners policies. The intent of all of these policies is to provide **basic coverage for special items** of value. Most policies will not allow the full limit of liability to be applied to a specific kind of property. However, some people **collect particular items**, and they may face a greater exposure than what is typically contemplated when setting insurance rates.

On- and Off-Premises Theft Coverage

All renters policies provide coverage for personal property that is at your home. Some policies also provide off-premises coverage.

On-premises coverage applies while your belongings are:

- at the part of the **described location** occupied by an insured person;

- in other parts of the described location **not occupied exclusively** by an insured person, if the property is owned or used by an insured person or covered residence employee (e.g., your clothes while they're in a common laundry room);

- placed for safekeeping **in any bank, trust or safe deposit company**, public warehouse or occupied dwelling not owned, rented to or occupied by an insured person.

If off-premises theft coverage is available, it applies while personal property is away from your home if the property is:

- owned or used by **an insured person**; or

- owned by **a residence employee** while in a dwelling occupied by an insured, or while engaged in the employ of an insured.

Example: If you ride your $2,000 mountain bike from the houseboat you're renting to the mountains north of Seattle—and someone steals it while you're waiting to pay for a cafe latte—the insurance company will get you a new bike.

A number of conditions apply to **off-premises coverage**:

- you can only buy it if you've bought on-premises coverage;

- a separate limit must be shown for off-premises coverage (this limit—usually lower than the on-premises limit—is the most the insurer will pay for any one loss);

- off-premises coverage does not apply to property that you move to a newly acquired principal residence (that is, a new home).

One of the ways in which insurance companies shield themselves from the volatility that sometimes accompanies the renter's lifestyle is by limiting the transferability of a renters policy from one location to another. So, if you move to a new home during the policy term, the limit of liability for on-premises coverage will apply at each residence and in transit between them for a period of 30 days after you begin to move the property. When the move is completed, on-premises coverage applies at your new home only.

Property Not Covered

Renters coverage for theft **does not apply** to certain types of property. As we have seen before, this becomes useful as a negative checklist for coverage:

- **aircraft** and parts, other than model or hobby aircraft;

- **animals**;

- **credit cards** and ATM cards;

- **motor vehicles**—except motorized equipment that is designed to assist the handicapped or is not subject to motor vehicle registration and that is used to service your home (such as a lawn tractor—or even an all-terrain vehicle);

- motor vehicle **equipment and accessories**, and any device for the transmitting, recording, receiving or reproduction of sound or pictures that is operated by power from the electrical system of a motorized vehicle, including tapes, wires, discs or other media for use with such devices, while in or upon the vehicle;

- **business property**;

- property **held as a sample or for sale** or delivery after sale;

- property of **tenants, roomers and boarders** who are not related to you;

- property **separately described** and specifically insured by any other insurance;

- property while at any other location owned, rented to or occupied by **any insured person**, except while an insured person is temporarily residing there;

- property while in the custody of any **laundry, cleaner, tailor**, presser or dyer, except for loss by burglary or robbery;

- property while in the **mail**.

If you've already read the previous chapters, you'll recognize these exclusions from standard homeowners and dwelling policies. A number of these recur throughout **the various forms** of household insurance.

However, it is important to remember that the broad theft form adds **two conditions** that can influence whether or not property (which would otherwise be covered) is covered:

- in addition to standard duties after loss, theft coverage requires that you **notify the police** when a theft loss occurs; and

- the **other insurance** condition that applies to homeowners and dwelling forms is changed slightly: If a theft loss is covered by other insurance, the insurance company is only obligated to pay the proportion of the loss that the limit of liability under the theft endorsement bears to the total amount of insurance covering the loss. So, if you have separate insurance for your baseball card collection and the collection is stolen the renters policy will only pay a pro-rated portion of the loss.

Condominium Coverage

Owning a **condominium or a townhouse** is not the same as renting—and it's certainly different from owning a house. For starters, you don't have to worry about mowing the lawn, mending the roof or fixing a broken gate when you own a condo. Clearly, you have less to maintain.

You also have **less to insure** than someone who owns a house—but more than someone who is only renting. If you own—or are thinking of buying—a condominium, your primary interest should be in insuring yourself and your unit.

> The condominium association should take care of the rest—everything from purchasing insurance for the common areas to fixing a leaky roof. The condo association maintains the facility—including the upkeep of the building (or buildings) and attached grounds.

What Do You Need to Insure?

When it comes to your insurance needs, you have your personal property to consider, as well as liability for anything that happens within your unit. You also may have to insure all of the built-ins within your unit (including fixtures, cabinets and appliances)—or you may only have to insure anything that has been modified (by you or a prior owner) since the condo was first

sold. Your ownership and insurance responsibilities will be defined in the condo association's **Master Deed or Bylaws**.

Because condominium ownership is different than home ownership, you'll need a special sort of insurance policy, known as **homeowners form HO-6**. It covers co-op and condominium owners, and provides coverage for **liability and personal property**.

You don't have to insure the common areas or external walls of the building. Insurance purchased by the co-op or condominium association will cover that—along with whatever else the individual unit owners are not required to insure.

Most **condo associations** carry fire and casualty coverage for their **real property** and **liability** coverage on the common areas of the condominium—as well as for their boards of directors and officers. This **directors and officers (D&O) liability** becomes important if someone—particularly any of the unit owners—sues the association for failing to perform its duties properly.

Condominium owners insurance policies have been designed to work as a layer of **insurance above** what your condo association has. They automatically provide only a few thousand dollars of building coverage. Otherwise, the condo policy is very similar to the renters insurance form.

The condo policy takes into account the facts that:

- condominium owners own only **a portion** of the building in which their units are located;

- as a member of the association, each individual unit owner has **shared ownership** in the building structure; and

- **disputes over shared liability** can result in large legal judgments against individual owners.

Common Walls, Common Problems

Common-interest communities—including condos, townhouses and cluster homes—can pose some unique coverage problems.

For instance, if a fire started by your neighbor damaged your adjoining condo, your neighbor's insurance company might refuse to pay for your damage, claiming that your insurance company should pay.

In most cases, to avoid these problems, condo owners buy insurance to cover the contents of their units, and condominium associations buy coverage on the real property.

Still, problems remain. One common problem is that condominium policies often don't include **broad water damage** coverage—for problems like sewer and drain backup. High-rise buildings also have problems with **wind-driven rain**—though most condo associations aren't covered for this.

> **Example:** You buy a 30th-floor condo—where you plan to live a few months each year—for its magnificent views. You come back to the condo six months later to find your furniture soaked and the walls covered with mildew. A series of storms caused driving rain to seep through the picture windows in upper-level units. Unless your condo association has specific coverage for this rain, you may not be covered.

Claims made by underinsured condo owners are a big issue between condo associations and their insurance companies. If problems occur and the association finds it doesn't have adequate coverage for the damage, unit owners often will sue the board of the association for neglecting its fiduciary duty to protect members.

Some states require that condo associations provide **comprehensive or blanket coverage** against liability and property damage for all members—but many states don't. Condo owners living in buildings that don't have blanket coverage usually have to provide their own coverage.

What's Covered on Your Policy

The condo owners policy, form HO-6, covers many of the same things as a standard homeowners policy—only it offers far **less coverage for the dwelling** itself.

The basic coverage includes:

- Coverage A—**Dwelling**, $1,000 minimum;

- Coverage C—**Personal property**, $10,000 minimum;

- Coverage D—**Loss of use**, 40 percent of Coverage C;

- Coverage E—**Personal liability**, $100,000 minimum; and

- Coverage F—**Medical payments**, $1,000 minimum.

Covered perils include fire, lightning, removal of debris, windstorm, hail, explosion, riot, civil commotion, aircraft, vehicles, smoke, vandalism, glass breakage, theft, bursting of a steam or hot water heating system, falling objects, collapse, weight of ice, snow or sleet, freezing pipes, damage to appliances by artificially generated electricity and leakage of a plumbing or heating system—just like the renters policy.

When You're the Landlord

Renters aren't the only people who need insurance in a rental situation. If you're renting out an apartment, guest house, condo or house that you own, you have significant exposures to financial loss. However, you may find yourself in an awkward place—lost between the limits of a standard homeowners policy and the technical complexity of commercial landlord coverage.

Fortunately, you can protect yourself against some rental losses without getting into commercial coverage. With some modifications, a combination of **dwelling** insurance and **broad theft** coverage should meet your needs.

Protection against tenant theft deserves particular attention—even if you feel that you know the renters well. The chances are good that you won't collect on a basic dwelling policy—which insures the house and contents against theft and damage from fire, wind, smoke, vandalism and other hazards.

If it turns out that your tenants are the thieves, you'll need more coverage than a standard dwelling policy. You'll need the same theft coverage that the renters themselves should be buying.

There also can be problems if a renter forgets to double-latch the door or secure a window—making it easy for a burglar. If your insurance company finds out, it could resist paying for some stolen items—on the grounds that the low premium rates for its standard coverage were based on the assumption that you will be around to help **keep the home and contents safe**. At best, the company might pay for such things as a stolen television set and furniture—but not for missing jewelry, furs, silver, coins and watches.

So, review your homeowners or dwelling policy before you accept a renter's deposit check. In particular, you need to look in the exclusions or conditions section for a clause that reads something like:

> peril of theft does not include any part of loss when the property is rented by the insured to another party.

If your policy has language like this, you may want to convert to an **all-risk homeowners** policy (form HO-3)—or buy an endorsement that broadens your theft coverage.

As we've noted before, you can expect to pay as much as 20 percent more than the cost of a basic policy for all-risk coverage. The endorsement to add broad theft coverage usually will cost less than this—but still 10 percent to 20 percent more than a standard theft package.

> If you rent your home frequently (or permanently), you may need an even costlier special multi-peril policy. This kind of insurance—which is actually a commercial policy—is designed for professional landlords. It covers just about every exposure a landlord faces, and can be modified to insure against various particular risks. But if you're just renting out one house or apartment, you'll probably do best to use endorsements to expand the coverage of a standard homeowners or dwelling policy.

Some part-time landlords may be tempted to avoid the extra insurance and, if there's an insurable loss, simply fail to mention to the insurance company that the incident occurred **while the property was rented**. This may work, but this kind of claim can progress quickly from white lie to outright **fraud**. For most people who have assets to insure, it's better to tell the whole truth and pay a slightly higher premium.

Exchanging Homes

The practice of exchanging homes—where you stay in another family's home while they stay in yours during vacations—can present several different kinds of problems.

For instance, does the exchange include use of **the family car**? What if someone using your home has an accident with your vehicle, or you have a collision as you drive an unfamiliar car in a foreign country?

> In the United States and Canada, your car insurance—collision and liability—automatically remains in effect as long as the driver has your permission to get behind the wheel. This is not the case everywhere in the world.

You also may want to consider increasing your personal liability insurance to safeguard your assets—just in case, for example, someone who's unfamiliar with that low cellar doorway suffers a concussion and decides to sue.

If you're thinking about turning your house over to guests of any sort for more than a few days, you probably want to **expand your homeowners or dwelling policy**.

Typically, an all-risk homeowners policy provides up to $2 million worth of liability insurance—you may need this if your house has a swimming pool, sauna or other potentially dangerous amenity.

Damage caused by renters or people who use your house in an exchange usually will be considered normal wear and tear, and will not be covered by a basic policy. In these cases, an all-risk or special form policy may be worth the extra premium cost.

Conclusion

Overlooking insurance can be a big mistake. Even if you are not a homeowner, you probably have belongings of value. Fortunately, there are policies available for renters to insure protection in the case of theft or other loss.

And there are policies designed with condominium, townhouse and co-op owners in mind, too.

Unfortunately, there is no policy designed just for people who rent out a home or trade homes occasionally. You will have to be a bit more creative—adding to your homeowners, dwelling or theft coverage policy to be sure you don't wind up underinsured.

Key Questions

For renters.

1) Do you have at least $6,000 worth of personal property?

 Yes No

2) How much personal property coverage do you need? (Refer to the Household Property Inventory in the homeowners insurance section.) _____

3) Do you want named perils or all risk coverage?

4) How large of a deductible can you tolerate? (The more risk you assume—and the more cost you absorb in the event of a loss—the lower your premiums will be. Renters deductibles typically are less than $500.) _____

5) Do you have any property that needs to be covered under a floater, a schedule or an endorsement (e.g., camera gear, computer equipment, collectibles, etc.)? _____

6) Do you want off-premises theft coverage? Yes No

7) How much liability coverage do you need? Do you need any? (Refer to the Personal Assets Inventory in the homeowners section to help determine this amount.) _____

For Condominium Owners

1) Does your condo association provide blanket liability and property damage coverage for unit owners? Yes No

2) Do your condo association's bylaws require you to insure built-ins, such as appliances and cabinets? Yes No

3) Do your condo association's bylaws require you to insure any upgrades made (by you or a prior owner) since the unit was first sold? Yes No

4) Does your condo association provide coverage for sewer backup or wind-driven rain? Yes No

 If no, can you add this coverage to your own policy by endorsement? Yes No

5) How much dwelling coverage do you need? (Questions 1, 2 and 3 will help you answer this.) _____

6) How personal property coverage do you need? (Refer to the Household Property Inventory.) _____

7) How much liability coverage do you need? (Refer to the Personal Assets Inventory.) _____

For Occasional Landlords

1) Describe the property that is being rented (e.g., guest house, mother-in-law's apartment, second home, etc.).

2) Do you ever occupy the property personally? When?

3) How much coverage do you need for the dwelling?

4) How much personal property coverage do you need (for your own property that is on-site, including furniture, carpet and drapes, dishes, etc.)? (Refer to the Household Property Inventory.) _____

5) Do you need broad theft coverage? Yes No

6) Will the policy in question cover theft if the property is rented out? Yes No

7) Do you need liability coverage for this property? Yes No

8) If you exchange homes, will this policy provide sufficient coverage? Yes No

Chapter 10

Personal Liability Policies

Having friends over for a few beers seems harmless enough—unless one of them drives off and gets into a serious accident. Then you may wind up in court. These days, you can be held liable for the damages your guests cause after you "allow them" to consume alcohol at your home and then "allow them" to drive. Some states have laws that mandate a **host's liability**, much like a saloon keeper's or a **bartender's liability**.

> **You could be responsible for the payment of medical bills, vehicle repair costs, lost time from work—and, in the worst case, claims for wrongful death that may result in huge monetary settlements.**

Do you have coverage for such a situation? Certainly not under your Personal Auto Policy, even though the claim might be auto-related. You may have coverage under your homeowners policy. But this coverage will be limited.

In most cases, you would need a **personal umbrella liability** policy to cover this sort of problem. (Of course, you also shouldn't let your friends drink and drive, but that's another story.)

When else would you need a personal umbrella policy? If you're being sued for libel or slander in a non-business situation, if your dog bites another person or animal, or if someone gets injured at your home and sues you for medical bills and pain and suffering.

While common personal liability policies (such as a homeowners or Personal Auto Policy) do provide coverage for their respective liability situations, often the limits aren't high enough to pay all the damages that could be awarded in even a moderately severe case. What if you have a $250,000 limit

for automobile bodily injury and a court enters a judgment of $500,000 against you?

> If a court hands down a liability judgment that exhausts the limits of your homeowners or car insurance policy, you are responsible for the balance. Perhaps your house will have to be sold, your IRAs will need to be cashed out, or other assets will have to be liquidated in order to make payment on the judgment. If your assets are exhausted and a judgment is not fully satisfied, future earnings may be attached in further settlement of the outstanding judgment. A major liability loss can wipe out assets that took a lifetime to accumulate.

Is anyone exempt from **personal liability** exposures? Except for minors, the legally incompetent and the indigent (who have no assets at risk), most of us have exposures. How can anyone who drives an automobile be absolutely positive he or she will never be involved in an at-fault accident? How can any homeowner—or renter—be certain that no visitor will ever be injured on the premises? How can anyone be sure that a personal liability claim will never arise out of something they say or something they do?

The simple answer is: **You can't.**

Another reason to consider this coverage: Obtaining an umbrella policy is a good way to lower your home or car or boat insurance costs, since getting an umbrella policy typically is less expensive than getting additional liability coverage on a homeowners, boatowners or auto policy. And an umbrella policy provides coverage for all three areas, plus things those **underlying policies** will not cover.

Umbrella Liability Policies

Umbrella liability policies, which were first written in this country in the 1940s, serve two major functions: They provide **high limits** of coverage to protect against catastrophic losses, and they usually provide **broader** coverage than underlying policies.

Umbrellas are written to provide insurance on an **excess** basis, above underlying insurance or a **self-insured retention** (the equivalent of a large deductible).

Most of the various personal umbrella policies on the market can be organized into two categories:

- **Following Form Excess Policies**. These provide high limits over the exact same perils, coverages and exclusions found in all of the underlying policies over which coverage is being provided (e.g., your homeowners and auto policies).

- **True Umbrella Policies**. In addition to high limits of liability coverage, these provide broader coverage than is provided by the underlying coverages.

True umbrella coverage will protect your present and future income streams most effectively. It provides three essential things:

- **excess limits** over underlying policies;

- **broader coverage** than the underlying policies; and

- **defense costs** in addition to the limit of insurance.

> **An umbrella policy will usually defend a claim even if it is groundless.**

For losses that are covered by your primary insurance, the umbrella coverage begins to apply only after the primary coverage has reached its **limit**. For losses that are covered by the umbrella and not by your primary policies, the umbrella coverage begins to apply after a loss exceeds your **deductible**.

> **There are no standard umbrella policies, so it isn't easy to generalize about them. Early umbrella policies were extremely broad and contained few exclusions. However, carriers soon learned that they would need to narrow the coverage by creating more specific insuring agreements and exclusions.**

The intent is to provide **affordable and comprehensive coverage** for catastrophic losses, incidental exposures and modest insurance gaps, but not to provide blanket all-risk coverage in multiple areas where there is no primary insurance. For this reason, insurance companies usually will require you to maintain an **adequate range of underlying coverages** before they will sell you umbrella liability coverage.

The exclusions and limitations of an umbrella often are much like those found in the underlying policies. However, the umbrella usually will have **fewer exclusions** than primary coverage and a broader insuring agreement.

The Legal Theory Behind Liability Issues

When you violate society's law, you have committed a crime. When you violate the rights of another person, you have committed a tort. The person committing a tort is known as the tortfeasor.

It is important to note that liability insurance applies only to the financial consequences of torts. You cannot buy liability insurance to protect against the consequences of crimes.

> If you are angry at your neighbor and intentionally burn down his house, you have committed the crime of arson—and liability insurance will not cover the damages. However, if you are having a backyard barbecue and accidentally start a fire that burns down your neighbor's house, liability insurance may cover the damages.

The majority of personal liability cases involve **unintentional torts**. The basis for unintentional torts is usually negligence, so we had better have a working definition of **negligence**. In order for negligence to exist, four elements must be present:

- **Duty to act**. The duty to act in a reasonably prudent manner toward another (such as driving your car safely down the street in a manner that avoids hitting other cars or pedestrians).

- **Breach of the duty to act**. The tortfeasor does not act in the prudent manner described above.

- **Occurrence of injury or damage**. Another party actually must suffer an injury or damage.

- **Negligence is the proximate cause of the injury or damage**. The tortfeasor's breach of duty is actually what caused the injury or damage.

If any of these elements is absent from an event, negligence does not exist and you will not be held liable due to negligence. But when the required elements are present, the injured party usually has a valid claim for damages based on negligence.

Damages is an important term to understand in any discussion of liability. When someone is held liable for injury or property damage to another, that person can be required to pay compensation to the injured parties. For these types of claims, we need to be concerned with two broad types of damages:

- **Compensatory damages**—which simply means compensation for the loss incurred. These may include specific damages (the documentable, actual expenses incurred by the injured party, such as medical bills, wages lost and property replacement costs) and general damages (monetary awards for more subjective, less quantifiable aspects of the loss, such as pain and suffering, or loss of consortium).

- **Punitive damages**—these are damages that the court can compel the tortfeasor to pay in addition to the compensatory

damages awarded. Punitive damages represent a fine, or punishment, for outrageous, severe or intentional conduct.

Common Kinds of Liability

Vehicle-related liability is the greatest single source of personal liability. Your use of a vehicle generally causes you to be in the proximity of many other people and vehicle operators, while operating a several thousand pound machine moving in and around other such machine operators. All in all, it's a wonder there aren't more accidents.

Vehicle liability can arise from property damage to other people's cars, injury to people occupying other cars, injury to pedestrians and damage to property other than cars (such as a neighbor's brand-new fence).

Injuries and damages related to vehicle use also may be caused or aggravated by many factors, such as excessive speed, driver inexperience, disobedience of traffic laws (such as running a stop sign), use of intoxicants (drugs or alcohol) or simple carelessness brought on by inattention (such as watching the scenery instead of the road).

Residence-related liability is the next big source of personal liability. Whether you own or rent your home, you may be personally liable for injury or damage to others. Such situations could include:

- trip and fall incidents due to ice and snow, debris, etc.;

- accidents related to swimming pools or other attractive nuisances, such as jungle gyms and trampolines;

- property damage scenarios (for example, a renter causing damage to the premises by careless smoking);

- injuries sustained by, or injuries to others caused by, domestic workers, such as maids, gardeners, etc.;

- injury caused by an overly protective dog (if Fido bites your neighbor's little Fifi, you could wind up paying the vet's bills—and a lawyer's—and watch out if Fido bites your neighbor's child, no matter how much Junior was teasing).

Generally, a personal umbrella policy will not cover business liability. However, some business exposures may be covered by personal liability policies. For example, an umbrella policy may cover certain home office exposures.

So far, we've discussed unintentional torts. **Intentional torts** can involve **infringement of property and privacy rights** (for example, trespassing). Property rights also can be violated by nuisance-type activities that interrupt a property owner's ability to use the property (for example, when you test the volume limit on your new 2500-watt CD player while your neighbor is trying to relax on a Sunday afternoon). Other intentional torts involve **personal injury**, which includes bodily injury and damage to reputation through untrue statements, libel (in print) or slander (spoken).

These are by no means the only examples of personal liability exposures. Your children, your pets, your premises, your hobbies, your car and many of your daily activities create exposure to personal liability.

Personal Umbrellas

A personal umbrella policy (as opposed to a business umbrella policy) offers coverage above and beyond the liability coverage you have on your homeowners or car insurance policy. And some personal umbrella policies also offer coverage for boats and Jet Skis—either with or without an underlying boat or specialty vehicle policy.

> For many people, a personal umbrella policy is well worth the extra $200 or $300 a year—especially if you can save that much on your homeowners and automobile policies by reducing your liability limits.

However, bear in mind that you still will have to have at least the minimum liability limits on your auto policy that are required by law in your state. And most personal umbrella policies also require that you have a minimum amount of **underlying insurance** in place. For instance, Nationwide auto policyholders need to carry at least $300,000 of coverage per person and per accident in bodily injury liability. Homeowners need to carry at least $300,000 in comprehensive personal liability coverage.

Since the **minimum liability coverage** available under a personal umbrella typically is $1 million, this means you'd have $1.3 million worth of auto liability coverage—and $1.3 million worth of comprehensive personal liability coverage. (In effect, the liability limits on your auto and homeowners insurance policies serve as a deductible on the umbrella policy.)

Many liability coverages are written as a **combined single limit**, or CSL. This means that the single dollar limit is made available for both bodily injury and property damage (or any other type of injury or damage covered by the policy) for which you are found liable as the result of a covered acci-

dent, occurrence or event. A good personal umbrella policy provides coverage in this manner.

Another variation is known as **split limits of coverage**. Automobile policies commonly provide split limits, under which separate limits are stated for bodily injury coverage per person, the maximum amount of bodily injury coverage per accident and property damage coverage per accident. When an umbrella provides coverage above split limits, it will begin to provide excess coverage above each of the stated underlying sublimits.

A variation provided by some insurers is an umbrella with what is called a **smoothed limit**. Under this approach, the umbrella limit is the total amount of coverage that will be provided. Instead of providing coverage in addition to that provided by an underlying policy, the smoothed limit policy only provides total coverage up to its limit.

> **Example:** Oliver has a $1 million umbrella policy written with a smoothed limit and $200,000 of underlying homeowners liability. The umbrella insurance company will only provide $800,000 of excess coverage for losses covered by these policies.

Broader Scope of Coverage

One of the most important functions of a true umbrella is that it provides broader coverage than the underlying policies. The term **drop-down coverages** is often used to name the coverages provided by the personal umbrella that are not provided by the underlying liability policies.

Some of these include:

- **Personal injury coverage**. The typical underlying homeowners policy provides liability coverage for accidental bodily injury (meaning physical injury or death), but not for events involving libel, slander, false arrest and the like. The personal umbrella does cover you for liability arising out of these events.

- **Regularly furnished autos**. The standard Personal Auto Policy contains language that precludes liability coverage for the use of vehicles that you do not own but that are made available for your regular use (such as a company car). The personal umbrella does not exclude such coverage.

- **Contractual liability**. The standard homeowners policy severely limits coverage for liability assumed by contract. So, if you sign an easement agreement to build a shared access road

with your neighbor—and he sues you because the road is never completed—the umbrella will cover you.

- **Damage to property of others**. The standard homeowners policy excludes coverage for damage to property of others left in your care, custody or control. The personal umbrella does not exclude coverage for damage to such property.

An important concept that comes into play when a personal umbrella covers a loss that is not covered by an underlying policy is termed a **self-insured retention** or SIR. (It's called a **retained limit** in some policies.) When the umbrella alone provides coverage for a loss, you pay what amounts to a deductible by "retaining" the first small portion of the loss (typically $250).

> Loss payment is administered somewhat differently than with traditional deductibles. In this case, you write a check to your insurance company for the amount of the SIR, and it pays the injured party the entire amount for which it is liable.

Defense Costs Provided: Duty to Defend

Another major benefit of personal umbrella coverage—which we have discussed before, but not in detail—is that the policy provides for **payment of defense costs**. When you are accused of being liable for damages to someone else and are taken to court over it, legal costs will be incurred, even if the suit is totally groundless and ends in your favor.

Fortunately, most underlying liability policies also provide coverage for defense costs, whether or not the suit is groundless. Also, these costs are paid in addition to the available limits of liability (in other words, the entire liability policy limits are available to pay damages).

Actually, the insurance company does much more than simply pay defense costs when a suit is brought against you.

> In other words, the insurance company steps in and provides the defense and does so at its own expense. However, the insurance company's duty to defend ends when it has paid or offered to pay its maximum limit of liability.

For example, you have a homeowners policy providing $100,000 of personal liability coverage, and you also have $1 million of personal umbrella coverage. One day your pit bull bites and severely injures a visiting child, and the child's parents sue for $500,000.

If the **underlying insurer** believes a defense may be successful, it may defend the claim to conclusion, regardless of the outcome. (There may be no liability, the liability awarded may be less than the homeowners policy limit, or the award may exceed that limit.) The **umbrella insurer** observes but does not participate in the defense. It will, however, pay its share of any award in excess of the $100,000 homeowners limit.

However, the underlying insurer might not have to provide a defense. If it believes a successful defense is doubtful and that any settlement is going to exceed its policy limit, it might immediately **offer to pay** its $100,000 limit and **avoid defense costs** (its obligation ends when it exhausts its limit). In this case, you no longer have the underlying insurer defending its claim.

> The personal umbrella becomes very valuable at this point for two reasons: First, the umbrella company will step in and defend the remainder of the claim; second, the umbrella's liability limit can make up the remaining $400,000 if the child's parents win their entire demand.

An umbrella policy's **duty to defend clause** is also very important when there is no underlying coverage for a particular suit. For example: Lily has a homeowners policy, but she does not have an endorsement to provide personal injury coverage. Lily is sued by someone for slander. There is no coverage for the claim under Lily's homeowners policy—the insurance company is not obligated to provide a defense or pay defense costs. In this case, the personal umbrella company will step in and provide a defense, pay the defense costs and provide **drop-down personal injury coverage** for damages that may be awarded in addition to the defense costs.

Even if you have umbrella coverage, you need to be careful about defense costs. Many policies do cover defense costs in addition to the limit of liability. But be aware that under the terms of some personal umbrellas, defense costs are included in the policy limit and are **not additional coverage**.

Buying Coverage

Typically, personal umbrella liability coverage comes in **increments of $1 million**, starting at $1 million and going up to $5 million—for a premium of $200 to $600 annually. (It is possible to get even higher limits. There are companies writing $10 million policies.)

Your **premium** will depend on the limits you select; the number of cars, homes, boats, etc., that you own; and the area in which you live.

To figure out how much umbrella liability insurance you need, you will

need to determine your **current net worth** (assets minus liabilities). Do you expect this amount to increase in the near future? Because of the relatively low cost of this type of insurance, you might consider buying enough coverage to protect your net worth for several years.

If you are thinking about buying a personal umbrella liability policy, it's best to place it with **the same insurance company** that writes your homeowners and auto coverage. Not only are you likely to get a **discount** for having multiple policies with the same company, but you are more likely to **avoid gaps in coverage** if one company is handling all your overlapping insurance needs. Besides, most companies tailor their excess liability coverage provisions around their auto and homeowners policies.

Personal umbrella liability policies vary from company to company. To help you compare different policies and to optimize the coverage that you receive, we've developed a chart that appears at the end of the chapter.

Comprehensive Personal Liability Policies

Unlike personal umbrella liability policies—which are secondary, or excess, coverage—a **comprehensive personal liability** (CPL) policy is a form of primary coverage.

It used to be that personal liability exposures arising out of your home and the activities of you and your family members were covered exclusively under a comprehensive personal liability policy. However, as homeowners policies have evolved into more complete packages of coverage, they have come to include CPL coverage.

Stand-alone CPL coverage is virtually identical to the liability coverage provided by a homeowners policy—and to the coverage provided by a liability supplement attached to a dwelling policy (in fact, that supplement was intended specifically to replace CPL insurance forms). In short, CPL coverage could be considered homeowners coverage without the property insurance.

Generally, the difference between the liability insurance provided under a **homeowners policy** or a **supplement to a dwelling policy** and the liability insurance provided under a CPL policy concerns the **minimum limits** available. Comprehensive personal liability policies continue to carry the basic limits homeowners policies used to have. The minimum limits written are:

- **personal liability**—$25,000 per occurrence (this has been raised to $100,000 on homeowners policies and the dwelling liability supplement);

- **medical payments**—$500 per person (this has been raised to $1,000 on homeowners policies and the dwelling liability supplement); and

- **damage to the property of others**—$250 per occurrence (this has been raised to $500 on homeowners forms and the dwelling liability supplement).

So, one benefit of a stand-alone policy is the chance to purchase **lower limits**, if you have very little in the way of assets to protect. On the other hand, a separate CPL policy also can be written with much higher limits, for those who have significant assets to protect.

So, if this coverage is redundant to what you can get with a homeowners policy or a dwelling liability endorsement, why are separate CPL policies still available?

The most common use for CPL policies is as a supplement to a FAIR plan homeowners policy. FAIR plan policies typically are written for substandard risks—homes with a very low value, homes in neighborhoods that insurance companies tend to shy away from, etc. These FAIR plan policies typically offer very limited property coverage—and they do not offer liability coverage. And that's where the CPL comes in.

Because CPL policies provide homeowners-style liability coverage, insurance companies sometimes do set some **restrictions in terms** of your residence—though many offer coverage to almost all conceivable dwellings. Anyone who lives in an apartment, a dwelling having no more than four family units, a condominium or a mobile home usually is eligible for a CPL policy.

Car and Motorcycle Excess Liability Coverage

Another option, if you are looking for more liability coverage, is an Automobile Excess Liability or Motorcycle Excess Liability policy. These work much like a personal umbrella liability policy, only they are tailored to take over exclusively where an auto or motorcycle policy leaves off—and, of course, they only cover liability related to your car or bike.

These policies typically are written with a $1 million limit. And some of them also allow you to use your car or bike for business—as well as personal—purposes.

Although these policies are usually inexpensive, for the money, it is hard to beat a personal umbrella liability policy. The breadth of coverage offered is worth what may be only a $100 a year in additional premiums, compared with one of these narrower excess liability coverages.

Conclusion

In this litigious era, it sometimes seems that no one wants to take responsibility for their actions. If someone falls and injures himself, he can't just say, "Aren't I clumsy? Can you please call an ambulance for me?" He calls his lawyer, too.

Therefore, most people probably don't have enough personal liability insurance to cover this and other kinds of claims. Fortunately, there are coverages out there, and they're reasonably inexpensive (especially when compared with losing your house and all your other assets).

You can raise the liability limits on your homeowners policy to address slip-and-fall and other exposures. You also can raise the liability limits on your auto or motorcycle insurance policy—or even purchase an excess liability policy specifically to address these liabilities.

But the broadest possible liability coverage is offered by a personal liability umbrella policy. It will provide excess liability coverage on top of your homeowners and auto policies. It will provide coverages that they exclude. And it will provide other coverages completely apart from homeowners and auto liabilities, including some boatowner liabilities.

A personal umbrella policy is also quite affordable for the amount of coverage offered, so it makes sense for many people with assets to protect.

Key Questions

The following questions should help you establish some parameters for buying umbrella insurance.

1) Are you a FAIR plan participant in search of liability coverage? Yes No

2) If you are in a FAIR plan, you may be able to buy a wrap-around liability policy designed especially for people in your situation. Are these available in your area? Who sells them?

3) What is the liability limit on your homeowners policy? Does it include any relevant exclusions or exceptions?

3) What are the liability limits on your auto policy? Does it include any relevant exclusions or exceptions?

4) What is your total net worth, which is the amount of wealth you will need to protect?

Home equity	_____
Other real estate	_____
Stock/bond portfolio	_____
Annuities/trust funds	_____
Deferred income/ pension funds	_____
Jewelry/precious metals	_____
Royalties/patents/ intellectual property	_____
Collectibles	_____
Cash	_____
TOTAL	_____

The following section will help you compare personal liability policies among companies.

Comparing Personal Umbrella Liability Policies

Coverage Offered	Company A	Company B	Company C
Libel and slander	Yes No	Yes No	Yes No
Auto bodily injury liability	Yes No	Yes No	Yes No
Comprehensive personal liability	Yes No	Yes No	Yes No
Boat liability	Yes No	Yes No	Yes No
Jet Ski liability	Yes No	Yes No	Yes No
Protective dog liability	Yes No	Yes No	Yes No
Coverage applies worldwide	Yes No	Yes No	Yes No
Boat rental coverage	Yes No	Yes No	Yes No
Defense costs paid on top of limit purchased	Yes No	Yes No	Yes No
Any limits set on defense costs	Yes No	Yes No	Yes No
Coverage for rental property*	Yes No	Yes No	Yes No

Limits Desired
Cost for $1 million in coverage _____

Cost for $2 million in coverage _____

Cost for other limit desired ($_____) _____

Underlying Coverages Required
Auto policy bodily injury _____

Homeowners personal liability _____

* Note any restrictions: _____

Chapter 11

Health Insurance

Going without health insurance is risky. What if you get injured and require surgery? The cost of a hospital stay can be as much as $400 a day. Or what if you or your significant other becomes pregnant? Even through a clinic, the price of prenatal care and delivery can exceed $5,000 today.

Insurance is designed to help you in these situations—to assume the risk of paying your medical bills—for a fee, of course.

If you have to pay for your own health insurance, you know it isn't cheap. But one major medical expense can make one or two or even 10 years' worth of premiums pay for themselves.

Many people get their health insurance from their job. Health insurance first became an **employee benefit** in the United States during World War II. "Many companies found that offering health care coverage was an effective way to attract scarce workers without violating the wartime freeze on salaries," said Kathleen Sebelius, insurance commissioner for the state of Kansas. "After the war, full health care coverage soon became an expected benefit of big-business jobs."

Today, **full health care coverage**, for the most part, remains the domain of large businesses, with an estimated 41 million Americans still going without. According to the Washington Insurance Council, data from a 1991 survey of 3,322 firms show that only 40 percent of employers offer health coverage—although their employees account for 77 percent of the work force in this country.

Many small employers cannot afford to offer health insurance to their workers. And plenty of mid-size and even large firms can do so only if the employees pay part of the cost.

Still, if you already have at least some health coverage through your employer, you're in pretty good shape—even if you have to pay part of the price. You also may have the option of paying those costs with pre-tax dol-

lars, which reduces your taxable income for the year and shrinks the bite Uncle Sam takes out of your paycheck. Sometimes, the tax benefits wind up making your health insurance virtually free—for you, anyway.

Remember When?

Once upon a time, people could go to any doctor they wanted. If their general practitioner decided they needed to see a specialist, they could see any specialist they pleased. If they needed medicine, they could go to any pharmacy and get exactly what the doctor prescribed.

For the vast majority of Americans, things have changed. Today, we have **HMOs**, **PPOs**, **generic drugs**, lists of doctors insurance companies say we can and can't see, treatments we are allowed—but only after two or three doctors agree they're necessary.

Health care—and health insurance—have been changed radically during the last couple of decades.

It all started with **skyrocketing medical costs**. According to the Washington Insurance Council, in 1969, per capita expenditures for health care were $268 per year in this country. By 1990, the figure had increased to $2,567. During the same 20-year period, health expenditures grew from 5.3 percent of the gross national product (GNP) to 12.2 percent.

By the year 2000, the Health Care Financing Administration projects the annual per capita expense will be $5,712—and the national health expenditure will be $1,616 trillion a year, or approximately 16.4 percent of the GNP.

Health insurers have had to pay for much of these costs—and they've had to contend with ever-increasing fees for doctors, lab tests, prescription drugs and hospitals. These growing costs meant insurers either needed to keep increasing their premiums, or they needed to find another way. To some degree, they did both.

They certainly have passed along increasing costs to their customers for years. But there comes a time in every business's life when it realizes it can't just pass along its costs any longer. It has to do something else to remain competitive. It has to cut the costs themselves.

What have insurance companies done to cut costs? They've set up agreements with doctors or health provider organizations that enabled them to standardize fees for various services. They've limited your choices to generic drugs, if they're available. And, they've limited you to a select group of doctors in your area, or only to one primary care physician. Want to see somebody else? You'll need permission—or you'll have to pay the bills yourself.

But you do still have choices when it comes to health insurance, whether you are buying your own or getting it through your employer. And that's what this chapter is about.

Pick Your Plan

When it comes to health insurance these days, you have a choice: Do you want to join a **health maintenance organization (HMO), a preferred provider organization (PPO)**? Or do you want to pay more and get a **reimbursement-style policy (Medical Expense plan)** so that the insurance pays you back for a percentage of your costs, after you meet the deductible?

An HMO is a form of managed care and consists of a network of doctors and hospitals that provide comprehensive health care services to their members for a fixed periodic payment, usually monthly. As a result, the HMO is both the insurance company and the health care provider. Because price is an important factor, about one in three Americans are enrolled in an HMO today, with 15 million enrollees in California alone.

The other Americans are covered by a more traditional **reimbursement plan**, **Medicare**, or they have **no health insurance** at all.

If you're searching for your own coverage, there is a tremendous variety of policies available in today's health insurance market. Some contain a single coverage (for example, hospitalization coverage only) or a combination of the major types of health insurance. Even if you're just choosing among the two or three plans offered by your insurance company or your employer, this chapter will cover what you need to know to choose the plan that's right for you—and your family.

Medical Insurance

The most common form of health insurance is **Medical Expense** insurance, designed to insure you against sickness and accidental bodily injury. Medical Expense policies are of two types: **Basic Medical Expense** and **Major Medical Expense**.

Basic Medical Expense policies cover one of three expenses and include: hospital, physician and surgical expenses. You can purchase only one, or a combination of expense coverages. The **hospital expense** coverage includes room and board, including intensive care, operating room fees, lab fees and other necessary services and supplies. Rooms are limited to semi-private and, telephone and television charges are not covered.

Surgical expense coverage includes any doctor's fees related to surgery and coverage for various types of procedures based on the company's surgical

schedule (the maximum amount payable for particular operations). While **physicians expense** is for any treatment by a physician not related to surgery.

Basic Medical Expense policies are usually written with deductibles ranging from $100 to $500 per calendar year. Once the deductible is met, the insurer pays the remaining costs in full, up to the policy limits. In contrast, **Major Medical Expense** insurance is aimed at catastrophic medical expenses.

Introduced nationally in 1951 by insurance companies, today virtually every health insurance company offers this policy. It's intended to cover serious illnesses and accidents that end up costing you thousands and thousands of dollars. As a result, they come with very high deductibles but also, very high limits. Sometimes up to $1million, which can mean a lot if you need a bone marrow transplant or cancer treatments over an extended period of time. They generally also have a co-insurance clause, meaning you must pay a portion of the covered expenses, usually 20 percent and then the insurance company pays the remaining 80.

Be sure to look for any limitations, however, since most medical expense policies limit the amount they will pay for such things as mental illness and drug or alcohol dependency.

> There are two types of Medical Expense plans (Basic and Major Medical) and two types of Major Medical Expense plans (comprehensive and excess). The Basic Medical Expense policy offers primary protection for sickness and accidental injury while Major Medical Expense offers catastrophic coverage. Of the Major Medical Expense policies, one offers comprehensive protection so that basic coverage and extended health care benefits are integrated. The other is a supplement and provides excess coverage over the basic hospital/physician/surgical expenses. It basically "wraps-around" the primary policy and provides additional expenses.

All medical expense policies are almost always subject to either a **deductible** or a **co-insurance payment**. Generally, you have to pay a certain small amount (the co-payment) each time you see a doctor or have a prescription filled, and the insurer pays the rest of the money directly to the provider—if you have **assigned the benefits** to the provider. If you haven't "assigned" the benefits, you will have to pay the provider directly and the insurance company will reimburse you later.

> If you choose a reimbursement insurance plan, you will have to pay for any medical services up front, then fill out a claim form and send it to the insurance company. The company will reimburse you for a percentage of your expenses (often 80 percent)—but only after you have satisfied the deductible.

Preferred Provider Organizations

The Medical Expense plan can give you complete freedom of choice when it comes to doctors, pharmacies and hospitals. Or it can attempt to limit you to a **preferred provider organization (PPO)**. In this case, it would provide a list of "preferred" doctors and hospitals. If you go to a doctor or hospital that is not on the list, the insurance company will penalize you by reimbursing a smaller percentage of your medical expenses. If you see a preferred provider, you will get the full reimbursement percentage.

If your regular doctor and your neighborhood hospital are on a list of preferred providers, it often is beneficial to go with a PPO program—instead of a full freedom of choice plan—because you'd be paying less to go where you planned to go already.

The Other Choice: An HMO

Nearly 38 million members enrolled in a total of 550 HMOs in 1991—up from 6 million in 1976, according to the Group Health Association of America. Why would so many people join? To save money on their premiums.

HMOs were formed to control skyrocketing medical costs and provide preventative health care *before* members got sick. (It's a lot less expensive to pay for hypertension medication than a heart transplant, after all.)

They keep their costs down by getting hospitals, doctors and other medical personnel to join the HMO. These **providers** offer health care to the HMO's members in return for a pre-paid monthly charge. So, you can go to the provider as often as you need to for the same monthly premium—plus an additional small fee (or **co-payment**) per office visit or per prescription. Most other medical services are fully covered by an HMO, such as hospital stays.

However, in exchange for lower premiums, you give up your freedom of choice (unless of course, your doctor is part of the HMO and listed as your primary physician). Rather than being penalized by getting less of a reimbursement, as in a PPO plan, with an HMO you'd have to pay the whole bill yourself. (Clearly, this is a strong incentive to see only providers within the HMO.) Today, many HMOs have added options to their plans which allow you to see a doctor of your choice who is **out of network**—of course, this, too, will cost considerably more than a co-payment.

HMOs usually sell their plans to businesses, which offer them to employees. But these days, with the increase in the number of independent contractors, it is becoming easier to join an HMO on your own.

Choosing the Right Plan

What kind of plan is right for you or your family? Only you know for sure. You will need to choose which style plan to purchase. And, if you opt for a Medical Expense plan, you'll also have to choose a **deductible**. As with other types of insurance, the higher your deductible, the lower your premium.

For most people, a deductible in the $100 to $250 range is the most manageable. But compare other deductibles, too. If your family has been healthy for a number of years, you may want to switch to a deductible of $500 or $1,000. You'll notice a sizable **reduction in premiums**. (Just remember that you'll have to pay the bills out-of-pocket until you satisfy the deductible.)

Some people even choose a deductible in the thousands of dollars—making theirs, in essence, a catastrophic insurance policy. In this case, you'd absorb all the everyday costs of medical care, from doctors visits to prescriptions. But if you got seriously ill, you'd be covered after you satisfied the deductible. (**Medical Savings Accounts** or MSA's, are designed for this very reason and discussed later in the chapter.) If you are healthy, this could wind up saving you money.

> When comparing coverage, it is vital to look into a plan's limitations and exclusions to determine which expenses are not covered and which are restricted. For instance, many policies will pay only for treatment that is deemed "medically necessary" to restore you to good health. These policies often will not cover routine physical examinations or cosmetic procedures.

You'll also want to investigate what the insurance company considers usual, **reasonable and customary charges**, if at all possible. That's because the charges a company considers normal for a particular medical procedure in a specific geographic area are the maximum it will pay. If the charges are higher (and they often are), you'll be stuck paying the difference.

Also, find out if the plans you are looking into exclude coverage for **pre-existing conditions** (more on them in a moment). Unless you want to pay for your own medical expenses, it's best to avoid these policies if you can. If not, try to find one that excludes coverage for a limited period of time only.

> Another way you can save money on your premiums, if you can afford to do it, is by paying them annually. It's worth looking into how much the service fee is for monthly payments—and inquiring about a discount for prepayment.

Even if you already have health insurance, you'll want to review your policy once a year to be sure it still matches your needs. As the health care

system continues to change, your health insurance should change with it.

Buying Your Own Coverage

If your employer does not provide healthcare insurance—or if you're self-employed—you can purchase insurance on your own. Unfortunately, you'll wind up paying more for your own insurance than an employer or other group would—since insurance, like most other things, is cheaper by the dozen.

Another option is to obtain health insurance through a **group**. By becoming a member of a trade association, labor union, college alumni association, church group, or other similar entity, you'll be eligible for any member benefits provided that often include health insurance at reduced costs.

If you do have to seek coverage on your own, you'll want to shop around for the best coverage at the best price. You can contact an insurance company **directly**, or you can go through an agent. This will help you find the best overall deal. You also will want to check with your state insurance department to see if there have been a lot of complaints about the insurance companies you're considering.

You can even check out the insurance companies' financial stability ratings. A.M. Best Co. rates each company on a letter scale from A to F, in order to provide an overall indication of the company's ability to meet its policyholder obligations. Their ratings are based on financial strength, the company's market profile and operating performance. For instance, A++ and A+ indicate Superior while F indicates the company is in liquidation. These ratings can be found at your local library or on-line.

These days, you should be offered a choice of the various medical plans we've discussed. These are, in order of decreasing cost:

- a **Medical Expense** plan (full freedom of choice plan);

- a **Preferred Provider Organization** (PPO); or

- a **Health Maintenance Organization** (HMO).

If your doctor is already a contracting provider with a PPO or HMO, you may be able to save a good bit of money by going with one of the more restrictive plans—and you'd still get to see the doctor of your choice. In other words, read the preferred provider list, or the HMO's provider list, before you decide.

Applying for Insurance

To get an accurate quote for health insurance, you will have to fill out an application. It's very important that you do this **completely and correctly**. If you lie on the application, the company can not only deny you coverage for a

problem down the road, it can rescind the policy entirely. And, most companies can get your medical information anyway through a non-profit association called the **Medical Information Bureau** (MIB).

The MIB was formed in 1902 by a group doctors who were also medical directors at several, large insurance companies. Because their companies had lost significant dollars to dishonest applicants, they sought a means to centralize health related information on individual applicants and reduce the potential for fraud, hence the birth of the MIB.

Today, the MIB maintains medical information only on approximately **two out of every 10 applicants** for health, life or disability insurance. That's because only those applicants with significant medical or longevity conditions are required to be reported to them by the 750 or so member companies. And, medical conditions are reported by the use of a series of codes—a total of about 210—which means there is a good chance for errors.

> Before you apply for insurance, it might be a good idea to check if there's a report on file for you, it's at no charge. And, if there is one and it's wrong, you can correct it. Just telephone them at (617) 426-3660 and ask for your free report.

The application for health insurance also will ask for your **age and health history**. Most insurance companies will ask your doctor for your medical records, and they may require you to undergo a physical with one of their doctors or even get additional blood tests. (However, they cannot conduct an HIV test, except if you are also applying for life or disability income insurance—and then it has to be with informed consent.)

Completing the application, you will have to let the insurance company know about **pre-existing conditions**. The company will want to know what illnesses and health problems you have had during the last couple of years (possibly longer). Most insurance companies would prefer not to pay you for treatment for a pre-existing condition, such as an ulcer or a gallstone. However, they are usually required by law, to cover pre-existing conditions eventually—usually after **six months to a year**.

> An insurance company also may restrict certain benefits for a set period of time. For instance, it may not cover expenses related to a pregnancy until the coverage has been in effect for one year. If you're already pregnant, this would be treated as a pre-existing condition. So, if you're planning on becoming pregnant, you'll want to get your health coverage sorted out as far in advance as possible.

If you've had a serious pre-existing condition, such as cancer or a heart attack, an insurance company may not want to issue you coverage at all. Or it

may require you to sign a waiver. This is a rider or amendment to a policy that restricts benefits by excluding certain medical conditions from coverage. (However, some states have begun to prohibit this practice.)

Your age also is an important factor in pricing and obtaining insurance. Many insurance companies have age "bands," when it comes to costs for coverage. For instance, everyone age 21 to 25 may fall into one price range, and everyone 26 to 30 would cost a bit more to insure each month.

Insurance companies prefer to write policies for young, healthy people—and they prefer to stay away from older, less healthy people. So, it pays to pick a good plan when you're relatively young and stay with it, if you can.

Some companies allow you to change your mind and get your money back after you purchase health insurance—but only if the policy has a "free look" or review period, which typically ranges from 10 to 30 days. So, you'll want to read your policy as soon as you get it.

You may even want to ask your pharmacist and your doctor how different plans are handled before you sign up. They should be more than happy to tell you which companies and which plans are easy to work with, and which ones make life difficult for them and for their patients.

There Are Other Options

If insurance companies consider you **uninsurable**—because of your age or a pre-existing condition—you probably are qualified for a state-sponsored health insurance program.

These programs should be used as a last resort, because they typically offer only limited benefits, are expensive and usually include a waiting period before the benefits kick in and you are covered. But at least they're there, if you need them. You can find out about these plans by calling your state insurance department.

If price is the problem when it comes to securing insurance, you may qualify for **Medicaid**. It provides medical assistance to low-income families and individuals of all ages. (Your county's Social Services Department can fill you in on the eligibility requirements.)

If you are an employer who can't afford to offer your workers coverage through normal channels, you also may be able to get help from your state.

For instance, in California, companies with three to 50 full-time employees are eligible for the Health Insurance Plan of California (HIPC), a state-sponsored pool. It guarantees coverage to your workers in any one of 20 different health plans offered through insurance companies or HMOs at more favorable rates.

Most small employers also cannot be refused coverage because of the medical history of one or more of their employees. This is known as a **guaranteed issue**. (Some individual plans also are available on a guaranteed-issue basis, although they will have higher premiums.)

Criticisms of HMOs

HMOs can be quite restrictive, and many people don't learn the details of their plans until they have a medical problem.

Many critics question whether managed care has been stretching its method of *cost curbing* too far. Among other things, managed care is criticized for depleting funds for scientists and medical schools, proposing "gag" rules to restrict treatment discussions between doctors and patients, and offering financial incentives to its staff for curtailing medical costs.

In the mid-1990s, the American Medical Association called on all managed care plans to cancel "gag" clauses in their contracts or policies with physicians. A few months later, the American Association of Health Plans (AAHP), a national trade group based in Washington, D.C., that represents roughly 1,000 managed care plans, announced its adoption of a similar program to urge the strengthening of the patient-physician relationship.

> The so-called "gag" rules, outlined in a physician's contract, are a way for managed care organizations to discourage discussion between physicians and patients regarding treatment options that managed care organizations do not want to cover (usually more expensive and non-traditional methods of treatment). The rules initially were intended to prevent the physician from criticizing the managed care organization.

But gag orders didn't stop the criticism, especially from outside sources, like consumer advocacy groups. In some cases, managed care organizations have been criticized for offering incentives such as bonuses, to physicians to curtail medical costs. These financial incentives were used to determine the type of treatment or tests the doctors either recommended or avoided. In other cases, managed care organizations required a second opinion from another physician before they would dole out the money for coverage.

According to Timothy B. McCall, M.D., "[Under] managed care, doctors' incomes are often directly proportionate to how little they do. Bonus plans reward doctors who order fewer expensive services." The result, McCall said, is "doctors in managed care may be more likely to advise against costly interventions that might benefit [the patient]."

To help protect you, the patient, lawmakers in a number of states have

unveiled provisions to guarantee broad protections for managed care enrollees. Under the bipartisan legislation, managed care plans would be required to provide safeguards to enrollees by addressing such issues as clinical decision making, access to personnel and facilities, choice of provider, grievance procedures and quality of care based on clinical outcomes.

And, public sentiment has put pressure on HMOs to change some of their policies. For example, many HMOs have changed their policies regarding mastectomies. Believe it or not, a few managed-care providers actually had decided that a mastectomy should be treated on **an outpatient basis** only.

In response to tremendous criticism, the AAHP's board of directors issued a statement saying, "The decision about whether outpatient or inpatient care best meets the needs of a woman undergoing removal of a breast should be made by the woman's physician after consultation with the patient."

The group also stated that health plans do not and should not require outpatient care for a mastectomy, and that physicians should make medical decisions based on the "best available scientific information" and the individual needs of each patient.

An FHP International Corp. spokesman compared the so-called "drive-through mastectomy" to the **"drive-through delivery"** issue dealt with in 1995. Some HMOs had placed **strict limitations** on the amount of time a mother could stay in the hospital after giving birth. The drive-through delivery debate resulted in a federal law mandating that new mothers have the option to stay in the hospital for 48 hours after delivery.

Most plans now cover at least one night's hospital stay for patients undergoing mastectomies.

Before You Join an HMO

You are going to want to ask a few questions before you join an HMO. Here's a list of the most important questions to ask to get you started. Most of these questions also apply to a traditional health plan.

- What exactly does the plan cover? Some services, such as **mental health treatment**, **drug rehabilitation** or **dental care**, may not be included at all. While you can't possibly predict all of your health care needs, find out if the treatments you think you'll need are covered. Also, find out if treatments that are considered **experimental** or non-traditional, are permissible under your plan and, if you're interested, if alternative or holistic treatments are covered.

- What will it really cost? Don't just look at the monthly premiums. Consider the **overall costs**, including co-payments and deductibles. Some plans offer a reasonable limit on the total you will pay each year. Others place a lifetime limit on what the company will pay, which you can reach if you have one major health problem.

- Do you have a **choice of doctors**? Be sure you have some flexibility. Also be sure at least a few local hospitals and pharmacies are covered under the plan.

- Is there a **utilization review**? In some plans, you cannot switch doctors or see a specialist without authorization. What happens if you don't like the doctor you choose? This can delay—or deny—care.

- Who decides what is considered "**medically necessary**"? Is it the insurance company or the doctor who decides?

- What about **pre-existing conditions**? If you have a pre-existing condition, such as high blood pressure, you may be liable for all costs relating to the illness. Know when and if your insurance pays for illnesses you may have.

- What is the relationship between your doctor and the healthcare company? If your doctor receives a set fee per patient (**capitation**) or receives a **bonus for minimizing costs** (incentives), your healthcare could get shortchanged. The physician may be reluctant to order tests or referrals under these situations. **Gag clauses** can prevent doctors from revealing their compensation or discussing treatment options not covered by the plan.

- Does the plan you're considering have a **grievance procedure**? What if something goes wrong? Can you appeal? Be sure to talk with someone who is authorized to answer your questions, like the plan administrator—and keep good records. Who regulates HMOs in your state and what's the procedure to lodge a complaint if you think you're being treated unfairly?

The Choices If You're a Senior

If you're one of 38 million Americans over 65 or permanently disabled you qualify for **Medicare** insurance. Medicare is a federally funded, national

health insurance program run by the Health Care Financing Administration (HCFA) and administered by the Social Security Administration (SSA) that covers hospital and medical expenses. Anyone 65 years of age or older, disabled or with permanent kidney failure qualifies to have many of their medical bills paid by the government. There are two parts to Medicare: **Part A is Hospital Expense** and **Part B is Medical Expense**. Enrollment is either automatic or you must apply.

You are **automatically enrolled** if you're receiving benefits before you reach 65 from either the Railroad Retirement Board or Social Security Administration. Your Medicare card will be mailed to you approximately three months before your reach your 65th birthday. If you're disabled and receiving benefits from either organization for 24 months, your card will be automatically mailed as well.

> However, if you're not receiving retirement benefits, you must apply directly to either the Social Security Administration or Railroad Retirement Board. Be sure to do it at least three months before you reach 65, to avoid any delays in coverage. You only have seven months to enroll, beginning three months prior to your 65th birthday, otherwise you'll have to wait until January 1 though March 31 just to enroll. Then your benefits don't kick in until July 1. So be sure you know your dates.

How much does it cost? Since Medicare is financed in part by payroll deductions paid by employers and their workers, the Social Security Administration funds a portion. The other comes from the Self-Employment Tax paid by self employed persons. If you or your spouse worked for at least 10 years in a Medicare covered job (meaning you were having deductions withheld from your paycheck for payroll withholding tax) and you are a citizen or permanent resident of the United States, eligible for Medicare, there is *no charge* for **Part A (Hospital Insurance)**. Disabled individuals, kidney dialysis and certain transplant patients are not charged either.

If none of these fit your particular circumstances, you may purchase Medicare Part A if you are at least 65 years of age and meet other restrictions. The per-month cost in 1997 (based on 30 to 40 quarters of Medicare-qualifying employment) was $187. If you worked fewer than 30 quarters during your adult life, the monthly cost was $311.

There is, however, a fee for **Medicare Part B (Medical Expenses)** for all enrollees. In 1997 the monthly premium was $43.80 and automatically deducted from Social Security payments. Enrollment is automatic, unless you state you don't want it, when you are eligible for premium-free Part A. If you don't qualify for premium-free Part A and are 65 or older, generally you can purchase it.

> Medicare is made up of two parts: Part A is Hospital Insurance and Part B, Medical Expense insurance. Medicare Part A covers costs associated with inpatient care in a hospital and skilled nursing facility care after a hospital stay. It also covers home health care and hospice care. It pays for the cost of whole blood or units of packed cells, after the first three pints during a covered stay in a hospital or skilled nursing facility as well. In addition, it pays 80 percent of durable medical equipment when approved, such as wheelchairs and walkers.

For this part of Medicare coverage, you will have to pay a **deductible** of $760 for each benefit period, beginning with the first day of admission to a hospital or skilled nursing facility and continuing for 60 days. If you are released or hospitalized for more than 60 days, a **new benefit period** begins and a new deductible applies. The good news is, there is no limit on the number of benefit periods you can have. The following chart illustrates what Medicare Part A covers, pays and what your portion is.

MEDICARE PART A (HOSPITAL EXPENSE)

YOUR COST	MEDICARE'S COST	TIME PERIOD	BENEFIT
$760	Everything after $760	Day 1 - 60	Hospitalization, including room and board (semi-private); in-patient psychiatric care (if recieved in a Medicare participating psychiatric hospital, up to 190 days per lifetime only); emergency care; general hospital and nursing supplies and services
$190 day	Everything after $190 a day	Day 61 - 90	
$380 a day	Everything after $380 a day	Day 91 - 150	
All costs	Nothing	Over 150 days	
Nothing	100% of approved	Day 1 - 20	Skilled Nursing Care, including room and board (semi-private); rehabilitative and skilled nursing services; other services and supplies approved
Up to $95 a day	All but $95 a day	Day 21 - 100	
All costs	Nothing	Over 100 days	
20% of approved amount for durable medical goods and no cost for all other approved services	80% of durable medical goods and 100% for all other approved services	No limit, as long as you're eligible for services	Home Healthcare, for medically necessary home health visits approved agency such as physical therapy and speech therapy, on intermittant or part-time basis; durable medical equipment; home health aides

YOUR COST	MEDICARE'S COST	TIME PERIOD	BENEFIT
Co-payment for 5% for for pain management drugs, but no more than $5; if Respite care is needed, $5 per day to provide time off for caregiver	All costs except co-insurance for pain management drugs and in-patient respite care	No limit if doctor certifies need	Hospice Care, for terminally ill beneficiaries in home by Medicare approved hospice. Physician and nursing services; durable med. goods; Drugs for the management of pain; social services; physical, occupational and speech therapy
For the first three pints	All but the first three in a calendar year	Unlimited if med. necessary during benefit period	Blood, when furnished by a skilled nursing facility or hospital during a covered stay

Medicare Part B is Medical Expense insurance covering costs associated with doctors' services, outpatient care, laboratory tests, x-rays, mammograms and pap smears, and medical supplies. You'll have to pay the first $100, which is the **annual deductible**, then Medicare will pay 80 percent of all approved charges for any eligible medical expense. The approved charge may or may not be close to the actual fee charged by your provider, and you are responsible for the difference, as well as the additional 20 percent of the approved charge. (Fortunately, when doctors accept a **Medicare assignment**, they agree to charge the patient no more than Medicare's approved charge.) Here's what Part B covers:

MEDICARE PART B (MEDICAL EXPENSE)

YOUR COST	MEDICARE'S COST	TIME PERIOD	BENEFIT
$100 deductible, then 20% of approved cost; 50% for outpatient mental health and 20% of the first $900 for each physical and all charges thereafter each year	80% of approved charges after $100 deductible is met; 50% for outpatient mental health and $720 a year for each independent occupational and physical therapy	Unlimited if medically necessary except for independent occupational and physical therapy	Medical expenses such as doctor's fees; in-patient/out-patient medical services as well as surgical services laboratory tests; physical/occupational and speech therapy; durable medical supplies
Nothing	100% of approved charges	Unlimited if medically necessary	Laboratory tests including blood and urine
After your $100, 20% of hospital charges	Approved charges for hospital costs	Unlimited if medcially necesary	Outpatient services for diagnosis and treatment of illness or injury

MEDICARE PART B (MEDICAL EXPENSE)

YOUR COST	MEDICARE'S COST	TIME PERIOD	BENEFIT
Same as Medicare Part A, only if you do not carry Part A	Same as Part A, only if you do not carry Part A	Same as Part A, only if you do not carry Part A	**Home Healthcare:** same as Medicare if you do not carry Part A and paid only if you *do* carry Part A
After $100 deductible, first three pints plus 20% for additional pints	80% of approved amount beginning with fourth pint	Unlimited if medically necessary	**Blood**

The government estimates that Medicare really only pays about half of the costs needed to cover the elderly and there are large gaps in coverage. For instance, Medicare doesn't cover the cost of hearing aids or eye glasses, items virtually essential to seniors today, not to mention prescription drugs. As a consequence, approximately 89 percent of all Medicare recipients supplement their health care through what is commonly referred to as a **Medicare Supplement**.

> Clearly, Medicare is not going to pick up the tab for all of your healthcare needs. Gaps in coverage and restrictions abound within this system. So, insurance companies stepped in to fill those gaps in coverage with what are called Medicare Supplement policies or "Medigap" insurance.

To clarify benefits and standardize the types of policies offered, Congress passed a law effective August 1, 1992, directing all insurance companies to standardize the policies they offer as Medicare Supplements. As a result, 10 standard plans were developed by the National Association of Insurance Commissioners (NAIC) and are the *only* plans that may be sold as Medicare Supplement policies.

And the best part is, no one can be turned down, for any reason, as long as you're 65 and apply within six months after you first enroll in Medicare Part B. The policies are **guaranteed renewable**, meaning you have the right to renew the policy with no change in terms, as long as you pay the premium. The only catch is the insurance company can and often does, increase the premium when claims costs exceed premium revenue.

Medicare Supplement policies have letter designations, corresponding to the level of benefits provided, beginning with the **basic plan labeled "A"** and progressively increasing in benefits to the most **comprehensive plan labeled "J."** All states must allow insurers to sell Plan A and all Medigap insurers must make Plan A available if they are to sell the more extensive and expensive plans. However, all insurers are not required to make all 10 plans available, they may only sell a few if they chose to, as long as Plan A is one of them.

The policies are designed specifically to work with Medicare, to provide

supplemental accident and sickness insurance for hospital, medical or surgical expenses. Most, if not all, pick up Medicare's co-insurance charge to you—and may even pay your deductible. Many charges not covered by Medicare are included in some of the plans, such as **prescription drugs** for out-patients. The more comprehensive plans also cover the co-payment required for **hospital and skilled nursing facility** stays. They also cover the 20 percent of approved charges you would ordinarily pay under Part B of Medicare. However, coverage for prescription drug costs may be subject to an **annual limit**. The following chart illustrates what each plan covers. It's a good idea to review it in conjunction with the Medicare charts previously outlined.

MEDICARE SUPPLEMENTS (MEDIGAP)

Plan	A	B	C	D	E	F	G	H	I	J
Basic Benefits	Yes	Yes	Yes	Yes	Yes	Yes	Yes	Yes	Yes	Yes
Medicare Part A Deductible		Yes	Yes	Yes	Yes	Yes	Yes	Yes	Yes	Yes
Medicare Part B			Yes	No	No	Yes	No	No	No	Yes
Skilled Nursing Care			Yes	No	No	Yes	No	No	No	Yes
Foreign Travel Emergency			Yes	Yes	Yes	Yes	Yes	Yes	Yes	Yes
At-Home Recovery				Yes	No	No	Yes	No	Yes	Yes
Preventive Care					Yes	No	No	No	No	Yes
Excess Charges, Medicare Part B						Yes at 100%	Yes at 80%	No	Yes at 100%	Yes at 100%
Prescription								Yes	Yes	Yes

What's Included?

Basic Benefits (Plan A) supplement Medicare benefits by providing coverage for your hospitalization co-insurance payment from day 61-90 and 91-150. This means that the $190 and $380 per day you would be required to pay under Medicare, will be

paid for by the supplement. If your benefits end during a period of hospitalization, the supplement pays for an additional 365 days at 100 percent. In addition, the 20 and 50 percent co-insurance payment under Medicare Part B is covered after you pay the required $100 deductible. The first three pints of blood or packed red blood cells are covered as well under both Part A and B.

Plan B includes the Basic Benefits and adds on coverage for the Medicare Part A deductible of $760 per benefit period. Therefore, if you had Plan B, you would have your deductible met and all co-insurance payments.

Plan C includes everything in Plan A and B and adds the co-insurance amount of $95 a day for skilled nursing care you would be required to pay under Medicare Part A for days 21-100. It pays the $100 deductible under Medicare Part B and 80 percent of emergency care while in a foreign country after a $250 deductible. If you travel out of the country, you may want to consider this!

Plan D includes everything preceding it except the Medicare Part B deductible and adds on coverage for custodial care (dressing, laundry, shopping, etc.). Medicare Part A Home Health Care coverage does not pay for custodial care and many seniors need assistance with daily life functions, especially after recovering from a serious illness or injury. This pays up to $1600 a year for short-term assistance.

Plan E does not cover the Medicare Part B deductible or At-Home Recovery services but does include Preventive Care. The benefit amount is $120 per year for routine physical exams, screening procedures such as blood pressure and cholesterol as well as patient education.

Plan F does not included Preventive Care or At-Home recovery but does add on Excess Charges for Medicare Part B expenses. What this means is if you go to a doctor that does not accept Medicare assignments (meaning they will not honor the Medicare approved charges), you would be obligated to pay the entire bill. This benefit pays the amount you'll be billed for at either 100 percent of 80 percent. If 80 percent, you would be obligated to pay the remaining 20 percent.

Plan G excludes the Medicare Part B deductible and Preventive Care and pays the Excess Charges at a level of 80 percent, rather than 100 percent as in Plan F.

Plan H includes coverage for prescription medications at 50 percent with an annual limit of $1250 per year, after a $250 deductible is met. This is called the Basic Benefit. An Extended Benefit is available only in Plan J that increases the annual amount to $3000.

Plan I excludes Medicare Part B deductible and Preventive Care but includes Prescription Drugs at the basic level of $1250 annually.

Plan J is the most comprehensive and includes coverage for all benefits previously listed at the maximum levels. It is also the most costly, however.

The key is to shop carefully if you're in the market for Medigap coverage. While the benefits will be the same, no matter what company you purchase your policy through, the prices will vary from state to state and company to company. That's because not all states have the same medical costs and, insurance companies have different claims experience. And, prices are increasing, which has forced many people and companies alike, to opt for a managed care approach to covering seniors' health care issues.

> Since Plan C is Plan C, no matter which company is offering it, when you shop around for coverage, you'll be looking at price, service and reliability. It's also vital to find an insurance company you feel comfortable with—and one that is reputable and in good shape financially. Your state insurance department can alert you to any problem companies.

Medicare HMOs

Due to the increasing costs of Medicare Supplement policies, more and more seniors are switching to managed care. The federal government estimates approximately 70,000 Medicare recipients a month are switching to some form of managed care. Currently, of the 38 million seniors and disabled eligible for Medicare, almost 6 million are enrolled in a Medicare HMO.

Medicare HMOs basically combine the benefits of Medicare and Medigap policies all in one. **What makes them so attractive?**

The federal government funds most of the revenue for each participating HMO, which makes the cost to you only the premium you would normally pay for Medicare Part B ($43.80/month for 1997), depending on the HMO. (However, that may be changing soon, with rising costs and increased claims, companies are beginning to charge premiums in addition to the government's funding.) And, items such as eyeglasses and prescription drugs are covered under most HMOs. As long as you have Medicare Part B, continue to make the payments and live in a service plan's area, you are eligible for enrollment without health screening.

You can find the names of HMO plans in your area by calling your state's insurance office. Remember, however, the same criticisms previously discussed in terms of HMOs still apply.

Please note: Once you enroll in a Medicare HMO you can switch back

to Medicare anytime. However, you may not switch back to a Medicare Supplement policy you previously had without the company's permission. And, you can be sure they will review your health record if you do and possibly turn you down. That's why some seniors hang on to their Medicare Supplement policy while enrolled in an HMO, just to make sure they are happy with it. This guarantees continuous coverage under the supplement if they change their mind and go back to traditional Medicare service.

The other managed care option you have is through a program called **Medicare Select.** Basically, this is another form of medicare supplement insurance sponsored by the federal government, that may or may not be continued. In 1998, Medicare Select came up for review and, by the end of 1998, the Medicare system still was having trouble replacing it as a Medicare option.

Congress proposed Medicare Select in 1990 as a pilot program for those seniors who wanted some level of choice in where and with whom they could secure health services. Service delivery is in the form of a **Preferred Provider Organization (PPO)** and provides standard Medicare supplement benefits, depending on which policy you buy.

If you buy a Medicare Select policy, you are buying one of the standard Medicare Supplement policies. You can purchase a policy through an insurance company or HMO, but be sure to inquire which policy you are buying and if it meets your needs. When you enroll in a Medicare Select policy (should such policies continue to be available), you choose a physician or medical provider from a list provided by the insurance company of "preferred providers." To receive full benefits you must go to the doctor or medical provider selected.

If you choose to go elsewhere, Medicare Select policies are not required to pay any benefits for non-emergency services. So it pays to go to your doctor of choice. And, if you decide you don't like the policy, you can always return to an individual Medicare policy. You will, however, have to reapply for a Medicare Supplement, just as with HMOs.

In short, there is a plan to meet your needs as you move through your "golden years." Remember to review the cost, check the benefits and the service issues that are important to you, *before* you make a choice. And, don't be afraid to ask questions. It's your health, you deserve the best!

Other Common Forms of Health Insurance

In addition to medical and hospitalization coverage, some people opt to purchase dental coverage, vision coverage and a separate prescription plan.

You can obtain **dental insurance** through an insurance company's individual or group plan (a group plan might be offered by your employer or by an association to which you belong), or through a prepayment plan or a dental service corporation. All of these plans will reimburse you for at least part of the money you spend on dental service and supplies.

This sort of coverage usually includes payment for preventive care, such as regular checkups, X-rays and cleanings. It also pays for the things we all hate: fillings, tooth extractions, inlays, bridgework, oral surgery and root canals. This insurance also will help you out with expenses for dentures and orthodonture. You'll have to shell out a pretty hefty co-payment, although that co-payment may be smaller for preventive services. (Typically, insurance will not help pay for cosmetic work on your teeth.)

Vision plans typically are **discount services**. For a small fee—about $15 to $20 a year—you get a membership card that entitles you to discounts on eye exams, glasses and contacts. These discounts (usually in the 50 percent range for eyewear) often are good at a wide variety of stores, including most of the major chains. Some of the plans also offer contact lenses at a discount by mail. Some even provide a discount on non-prescription sunglasses.

> If you purchase glasses or contact lenses on a regular basis (for example, if you wear disposable lenses), these plans can be quite cost-effective.

Prescription plans are much like vision plans. They also get you a discount on prescriptions if you visit a participating pharmacy. Again, they typically include most major chains. Discounts range from 5 percent to 50 percent on most drugs. Discounts may be higher if you purchase your prescription drugs through a **mail-order program**.

> Most people who have health insurance do not need a prescription plan—unless they have an extremely high deductible on a major medical plan and purchase prescription drugs on a regular basis.

In addition to all the types of coverage discussed so far, some insurance agents or insurance companies may try to sell you **supplemental insurance** policies. These are designed to pay in addition to your regular medical coverage.

They pay limited benefits, such as a daily dollar amount if you are hospitalized (these are known as **hospital income policies**) or expenses incurred to treat a specified "dread disease," such as **cancer** or a stroke.

Cafeteria Plans

Congress first authorized cafeteria plans in 1978, as part of the Internal Revenue Code (Section 125). (Cafeteria plans are also known as "flexible-spending accounts" and "Section 125 plans.") A company can set up a cafeteria plan for its employees. This allows the employees to pay for a full menu of medically oriented expenses with **pre-tax dollars**. This not only reduces taxable income for employees, which can make the benefits virtually free—it also reduces taxable payroll for the employer.

You can use the money from a cafeteria plan to pay for any number of deductible medical items. This can include **health insurance premiums**, **unreimbursed medical expenses** (including co-payments for doctor visits or prescription drugs), dependent care expenses, **alternative medical treatments** (including acupuncture and chiropractic), **treatment of alcoholism**, programs to lose weight or quit smoking, vision care (eye doctor visits, glasses, contacts, etc.), birth control pills (which some health plans do not ordinarily cover), sterilization, special schooling and care for people with disabilities (from wheelchairs and crutches to artificial limbs and Braille books), **dental fees** and dentures, orthodontia, psychiatric care, electrolysis and hearing aids.

If your employer offers a cafeteria plan, **you choose the amount** you would like to have withheld from each paycheck. If you typically spend $200 a month on child care and another $50 on prescription co-payments, for example, you might elect to have $250 a month withheld from your paycheck. If you also have annual expenses for glasses, co-payments for checkups, dental visits and so on, you can have an additional amount deducted each month to cover these costs, as well.

This money is placed into an **escrow account**. Whenever you have a medical cost that is not covered by your insurance, you submit a claim to the company that manages your employer's cafeteria plan, and that firm debits your account and sends you a check.

A cafeteria plan can be a very good way to save money on health care costs. However, the key is to **avoid having too much money deducted** from your paychecks. Whatever money you put into a cafeteria plan each year must be used for health care costs. If there is money left over, it **cannot** be rolled over into the account for the following year or returned to you. As far as you're concerned, it's gone forever.

The chart below illustrates why you might want to pay for medical expenses you already have with pre-tax dollars.

The Benefits of Using a Cafeteria Plan

Without a Cafeteria Plan
Gross Salary	$1,600.00
Federal & State Taxes	$221.82
Social Security (FICA)	$122.40
Less Medical Premium	$110.60
Less Medical Expenses	$60.00
Less Dependent Care	$200.00
Spendable Income	$885.18

With a Cafeteria Plan
Gross Salary	$1,600.00
Federal & State Taxes	$135.43
Social Security (FICA)	$94.05
Less Medical Premium	$110.60
Less Medical Expenses	$60.00
Less Dependent Care	$200.00
Spendable Income	$999.92

Source: Cynthia Pogue Baker, CPA

If You Leave Your Job

If you have health insurance through your employer and you leave the job, odds are you can keep this coverage for a time. Under the Consolidated Omnibus Budget Reconciliation Act, or **COBRA**, which is part of a federal law enacted in 1986, you have the right to **keep your coverage at group rates** if you lose your group health insurance because of a reduction in your hours of employment or because you leave or lose your job—unless you are fired for gross misconduct. You also have the right to continue coverage for your spouse and any dependents.

COBRA only applies, however, to employers with 20 or more employees, 50 percent of the time during the preceding period.

How long you can keep this coverage depends on your particular "qualifying event"—that is, dying, being fired, quitting. If you were fired (for anything other than gross misconduct, in which case, you don't qualify at all),

you, your spouse and dependent children are entitled to 18 months of continuous coverage. Any other qualifying event entitles you to up to 36 months of coverage, if you decide to pay for it.

When your COBRA coverage is going to run out (assuming you haven't taken another job in the interim that provides group health insurance), you can apply to the insurance company for **conversion from COBRA** to an individual policy—but you must do so within 31 days of termination of COBRA. The company is not obligated to provide you with an individual policy, however, if they only sell group insurance.

Your former employer will not keep paying for your health insurance. You'll have to start picking up the tab. The company can charge you 102 percent of what the coverage under the group plan actually costs (the extra 2 percent is to cover administrative costs). But rest assured that this amount is almost always less than what you would pay if you purchased your own individual coverage—and it is often substantially less.

> By law, your employer is required to let you know about COBRA and what steps you must take to retain your health insurance coverage. Your employer also will break down the costs for various coverages you may have, so you can choose to continue all or only some of them—for instance, you may decide to keep your HMO coverage but give up your vision and dental plan.

The Health Insurance Portability and Accountability Act of 1996 also made a few changes to the provisions of COBRA, which became effective January 1, 1997. Now, newborn and newly adopted **children** of people who have COBRA coverage automatically qualify for the coverage, as long as you enroll them within 30 days of the adoption or birth. In addition, **a disabled COBRA beneficiary** is eligible for 11 additional months of coverage if he or she was determined to have been disabled under Social Security at the time of the qualifying event or at any time during the first 60 days of continuation. This is true, as long as the disabled individual notifies the plan administrator of his or her disability status within 60 days of the determination and within the first 18 months of continuation.

If your COBRA coverage is about to expire and you anticipate getting another job that provides health insurance soon, you may want to consider a **temporary insurance policy**. This sort of coverage is fairly limited, but it will protect you from any catastrophic medical expenses. It usually will have a deductible, then will reimburse you for a percentage of your costs. Some plans will **reimburse you on a percentage basis** up to a set amount (sometimes $5,000), then pay 100 percent of your costs above that threshold.

A temporary medical policy will pay typical **hospitalization costs**—but only for procedures that are medically necessary, at rates that are usual and customary—as well as **recovery costs**, including time in a nursing home or in-home visits from a registered nurse. It often will not pay for any condition you had during the **24 months prior** to the start date of the policy, or for any **self-inflicted injuries** or anything that might be covered by workers' compensation insurance (that is, job-related injuries or illnesses).

Also excluded are coverage for injuries incurred in a war (you should be covered by the military, if you're serving or by the Veterans Administration), **dental treatment**, routine physicals and immunizations, routine pediatric care of a newborn child, **normal pregnancy** or childbirth, sterilization (or the reversal of sterilization), mental illness, alcoholism or drug abuse, prescription drugs and medications that you get when you are not confined to a hospital, treatment outside the United States—and the list goes on.

> In addition, if you purchase 120 days' worth of temporary medical coverage and get a job in 30 days, the temporary insurance cannot be cancelled. (Ordinarily, if you had some other sort of medical insurance, you could get a refund—less administrative expenses—for the unused portion.

However, bear in mind that there is probably a **probation period** with your new employer, during which you are not eligible for the company's medical plan. So, a temporary policy to protect you in case of a medical catastrophe during that period may be worth the money.

Medical Savings Accounts

A new option, when it comes to health insurance, is the tax-free **medical savings account** (MSA). It combines a long-term savings account and a high-deductible health insurance policy.

As of January 1, 1997, these accounts could be offered to a limited number of individuals that are **self-employed** or **employed at firms with 50 or fewer employees**. The accounts are part of a pilot program that was put in motion by the Kennedy-Kassebaum bill, passed in August 1996. The pilot program allows no more than 750,000 policies to be distributed—and is designed to offer consumers more choices in the health insurance market. Policies are being sold on a first-come, first-serve basis to those who qualify.

How do MSAs work? They're like a combination of a **cafeteria contribution plan** and an **individual retirement account** (IRA). As in a cafeteria plan, you contribute pre-tax dollars to the account. That money can be used to pay a variety of medical expenses. This is the premium for the MSA.

When you start an MSA, you also switch to a **high-deductible health insurance policy**. (Both are usually offered in tandem by the same insurance company.) The annual deductible for a single person must be between $1,500 and $2,250; for families, it must be between $3,000 and $4,500.

> **Individuals then can contribute up to 65 percent of the deductible into the MSA each year, and families can contribute up to 75 percent. The contributions are not subject to federal income taxes and are used to meet the deductible, until the insurance coverage begins to kick in, of course.**

MSAs also allow you to use that money for a broader range of services than are covered by most health plans. The funds in an MSA can cover small, everyday expenses, as well as dental care, eyeglasses, psychotherapy and home health care. MSAs also can be used toward payment of premiums for long-term care insurance or COBRA coverage upon leaving a job.

Premiums for MSAs will differ, depending on such factors as your age, the type of plan and your place of residence.

Money that you put into an MSA grows tax-free, like an IRA or a 401(k) retirement plan. And unlike a cafeteria plan, MSA funds can accumulate over time. If the annual premium is not exhausted at the end of the year, this amount will roll over into the next year. When you turn 59½, the money in the account becomes your property and is **no longer restricted** to use for healthcare. Prior to that time, the money can be withdrawn for non-health-related expenses, but you will have to pay ordinary income tax on whatever money you withdraw, plus a 10 percent to 15 percent penalty.

This is why MSA policies are being marketed as investment tools—since the leftover money can be rolled over year after year and collect interest.

Conclusion

According to the Census Bureau, the number of people without health insurance in the United States increased from 33.4 million in 1989 to 34.7 million in 1990. The current figure according to the White House, is in the neighborhood of 41.5 million people.

Many of these people work full-time, but are not offered benefits by their employers and cannot afford the high cost of health insurance on their own.

The explanations of coverage offered in this chapter should help keep you out of this ever-growing group of uninsured Americans—and help you get the best coverage to suit your needs.

1) Does your employer offer you health insurance? Yes No

2) Do you have a choice between an HMO and a reimbursement-style policy? Yes No

3) Is your regular physician a provider for the HMO you're considering? Yes No

4) If you choose a medical expense policy, how much of a deductible are you considering? (It's worthwhile to compare premiums for a policy with several different deductibles.)

5) Would you consider purchasing catastrophic coverage by increasing your deductible substantially? Yes No

6) Do you belong to a group that offers discounts on health insurance (e.g., a trade association, an alumni association, a church)? Yes No

7) Have you asked your doctor or pharmacist to recommend a health insurance plan? Yes No

 What did he or she recommend? _____

8) If you have been unable to obtain insurance on your own, do you qualify for a state-sponsored health insurance pool?

 Yes No

9) Do you qualify for Medicaid? Yes No

10) Do you qualify for Medicare? Yes No

11) Have you considered a Medigap policy? Yes No

12) Do you need dental insurance? Yes No

13) Do you need a vision plan? Yes No

14) Do you need a prescription plan? Yes No

15) Does your employer offer a cafeteria plan? Yes No

16) How much money would you want to have withheld from your paycheck for a cafeteria plan? (Add up your regular monthly medical-related expenses, and also include an allotment for annual costs, such as co-payments for doctors' visits and glasses.)

Health insurance premiums _____

Average monthly co-payments _____

Dental premiums/fees _____

Alternate therapies, etc. _____

Psychological counseling, etc. _____

Child- and elder-care expenses _____

Vision care expenses _____

Medical equipment _____

Other health-related expenses _____

Monthly total _____

17) If you're about to leave your job, have you investigated COBRA coverage? Yes No

18) If you do not have group health insurance through your job, have you considered a medical savings account? Yes No

Chapter 12

Long-Term Care Insurance

Long-term care insurance will pay your expenses if you need to enter a nursing home. It also provides coverage if you need someone to come to your home and help you with the tasks of everyday living, such as bathing, dressing and eating.

Long-term care (LTC) insurance is a relatively new idea. In 1980, only about a dozen insurance companies offered this kind of coverage. But LTC insurance is gaining in popularity, and fast. Today, hundreds of insurance companies offer this coverage, and millions of Americans have purchased policies. Why is the market growing so quickly? There are a number of reasons, including:

- the aging of our population;

- longer life expectancy;

- increasing health care costs; and

- the fact that government programs often do not provide the kind of coverage needed—or desired.

You can get LTC coverage on an individual policy or through an employer-sponsored group program. Or you can add an LTC rider to your life insurance policy.

Losing Your Independence

By the year 2000, there will be more than 35 million people in the United States who are over age 65. And that figure is expected to nearly double by the year 2030. In addition, by the year 2000, life expectancy for both males and

females is expected to exceed 80 years of age—by 2030, it most likely will approach 90 years of age. And, by the year 2025, the number of people over age 80 is expected to double, while the age group over 90 is expected to more than triple.

As people live longer, they are exposed to health-related risks for longer periods of time. They also are more likely to require help with the **activities of daily living** (ADLs).

Examples of ADLs include:

- walking;
- moving into and out of a bed, chair or wheelchair;
- dressing;
- going to the bathroom;
- bathing; and
- feeding.

If you are no longer able to perform some or all of these activities of daily living, you'll need what is known as **custodial care**. You also can get this sort of care at home, if someone comes in to help you. You can move in with friends or family to get this sort of care. Or you can move into a nursing home. Today, about 80 percent of routine senior care is provided by friends and relatives. But what if you live in a community of other seniors? Due to their own physical problems, friends and neighbors may be unable to assist with custodial care.

Depending on relatives for custodial care may not be practical, either. Today's family tends to be dispersed and very mobile. Many times, parents live in the Sun Belt and their children are scattered around the country or even the world. Thus, when you need assistance with bathing, eating, transportation, medical treatment and taking medication, your family members may not be close enough to lend a hand.

Even if they are local, your children may not have the financial resources to assist you when you get on in age. They may have to work full-time to make ends meet. Staying home to take care of a parent simply may not be a financial option.

Or perhaps you're very independent and you don't want to rely on help from friends and family. Perhaps you'd rather take care of yourself—even if that means paying someone to come to your home and feed and dress you.

> If you have to enter a nursing home to get the custodial care you need, money will be a big concern. Nursing home care can cost from $35,000 to $65,000 a year—and prices continue to increase.

Unfortunately, if you are now 65, your risk of having to spend at least some time in a **nursing home** is between 35 percent and 49 percent. While most nursing home stays average 90 days or less, at age 65, your risk of spending more than a year in a nursing home is about 22 percent.

(Long-term care is not just a problem of the elderly, either. While the odds that you will need long-term care at a younger age are slim, a chronic illness or severe accident can result in catastrophic expenses for care.)

How will you pay for a long-term stay in a nursing home—or for someone to come to your home and help you with the activities of daily living? There aren't a whole lot of choices. You can:

* use personal assets to pay for assistance;

* depend on relatives and friends for help and support;

* depend on government programs; or

* purchase LTC insurance to kick in when you need it.

Using Personal Assets

Most people who have been independent all their lives would prefer to remain independent later in life, too. They'd rather pay their own way when the time comes to get custodial care.

Unfortunately, most retirees do not have large amounts of savings, cash or other assets. Approximately one in six retired people lives at or below the poverty level in the United States.

Unless you are quite wealthy, it won't take long to run through a lifetime of assets if you must move into a nursing home. You'll soon spend your nest egg and your children's inheritance. You may have to sell your home, your car and any investments you had hoped to pass along to your heirs.

After you've run through most of your assets, you will qualify for assistance through **Medicaid**, a state-funded and -operated program that receives some federal subsidies and provides health insurance for the financially needy. The Health Care Finance Administration reports that about half of all Medicaid spending goes to people who had financial resources when they entered a nursing home, but reached the poverty level while they were there.

Using up a lifetime of accumulated assets is a frightening scenario for a

single senior citizen. But what if your spouse is still living at home and you must move into a nursing home? Will you have to sell the house to cover your nursing home costs? Where will your spouse live?

At one time, Medicaid rules did require you to liquidate virtually all of your assets—including cash, investments (such as stocks and bonds), bank accounts, real estate and even some forms of cash-value life insurance—to qualify for coverage. Fortunately, the federal government modified the requirements in 1993 to allow surviving spouses and disabled children to retain more of the family's assets.

Now, if you are married and you enter a nursing home while your spouse remains in your house, the **at-home spouse** is permitted to keep:

- one home;

- one car;

- the greater of one-half of the couple's assets or $75,740; and

- up to $1,919 in monthly income.

These amounts are indexed annually for inflation and are significantly lower for unmarried seniors. However, once neither spouse is living in or likely to return to the home and the house is sold, Medicaid may demand **reimbursement** for expenses associated with prior nursing home services.

An entire "Medicaid planning" specialty has emerged in the estate planning field to help people avoid running through their life savings before qualifying for Medicaid. Some people are even tempted to give away assets so that they can qualify for Medicaid and still pass something along to their heirs. However, the government frowns on this: Federal provisions enacted in 1996 set criminal penalties for transferring assets for the sole purpose of qualifying for Medicaid—penalties that include fines of up to $25,000 and imprisonment for up to five years.

What About Medicare?

As we mentioned in the previous chapter, Medicare also may pay for some nursing home costs. However, custodial care is not a **covered expense** in accordance with Medicare provisions. Medicare will pay only for skilled nursing care—and then only if you are an inpatient in a Medicare-certified skilled nursing facility. Many nursing homes are not certified by Medicare, because they provide more custodial care than skilled care.

Since Medicare will pay only for rehabilitative services, it also requires prior hospitalization before admission to the skilled nursing facility. For example, say you're hospitalized for major surgery. Following the hospital stay, the doctor orders you to a skilled nursing facility for necessary physical or

rehabilitative therapy. Medicare would normally provide some benefits for this situation.

> **However, if a doctor suggested that a senior citizen be placed in a nursing home for routine custodial care, Medicare would not provide benefits.**

When Medicare does pay, it fully covers the first 20 days of confinement in a skilled nursing facility—if you are receiving skilled nursing care.

After the first 20 days, you will be required to make co-payments for skilled care. The amount of these co-payments changes each year and is applicable to the next 80 days of confinement. Typically, this co-payment feature will result in a Medicare payment of approximately 10 percent of the expense—provided the care is skilled care.

After 100 days of confinement, Medicare pays nothing.

> **Nationwide, Medicare pays for less than 3 percent of total nursing home expenses each year.**

It is also important to note that **Medicare supplemental insurance** policies do not provide coverage for custodial care. Both Medicare and Medicare supplement insurance are designed to cover only acute medical care.

Are There Other Options?

What if you are not wealthy, you don't want to depend on friends or family to take care of you, and you don't want to spend down your assets so Medicaid will cover the costs of a nursing home? There is another option: purchasing long-term care insurance.

In a sense, owning LTC insurance enables you to maintain your independence, even when you need help with the activities of daily living. Long-term care insurance will pay you a benefit to cover the costs of a nursing home or the costs of in-home care. LTC insurance also enables you to select a nursing home that suits your needs and desires—rather than just your budget.

Of course, the government has no intention (and does not have the resources) to pay for the long-term care of people who can afford it themselves.

Who Should Buy LTC Insurance?

For many people, purchasing LTC insurance is more appealing than the alternatives. But not everyone who is approaching retirement age is a candidate for LTC insurance. Probably the most important reason for purchasing

LTC insurance is **protection of assets**—so you don't have to liquidate everything you have to qualify for Medicaid. However, a person without substantial assets may not be a candidate for LTC insurance.

For example, let's say Joe and Irene Brown are both 67 years old. Their only source of income is Social Security and a small pension ($200 monthly). They rent an apartment in a senior citizen complex, have a very small amount of life insurance (enough for burial) and usually maintain a savings account balance of no more than $1,000. They have no other assets, other than personal possessions and an automobile.

> **Are Mr. and Mrs. Brown prospects for LTC insurance? Probably not. First of all, it's doubtful that they could afford the premiums, based on their relatively small retirement income. Secondly, they have no assets of any consequence to protect. They do not own a home, have a large savings account or have other investments. However, they probably are eligible for Medicaid benefits, should they be forced into a nursing home.**

Let's consider another example: Jim, age 64, will retire in a year. When he does, he and his wife will have a monthly income of $3,000 from Social Security and Jim's pension, as well as his wife's pension. They plan on selling their home and buying another home in Florida. In addition to their Florida home, Jim and his wife have a $5,000 savings account, Certificates of Deposit valued at $30,000 and some stock investments with a current market value of $50,000.

Jim and his wife certainly have assets to safeguard from the impact of nursing home expenses. If there is a real possibility that their assets would be exhausted or reduced to an unacceptable level, then the purchase of LTC insurance may be a viable alternative.

> **When it comes to the decision to purchase LTC insurance, the actual probability of confinement in a nursing home doesn't have to be high, but the potential loss of being uninsured must be severe—i.e., the loss of personal assets.**

How severe a particular loss will seem is a relative thing. For instance, a wealthy individual may not view the loss of $50,000 to $100,000 as severe.

Example: Ralph will be retiring soon and permanently relocating to Hawaii with his wife, Lenore. His total retirement income will be $10,000 per month. He is selling his business and a summer home. His total assets, including stock holdings, will total nearly $3 million.

Would Ralph be seriously affected by a loss of $100,000 due to expenses incurred as the result of nursing home confinement? Probably not.

In this case, Ralph doesn't really need LTC insurance. He is, in essence, **self-insured**.

> The question "who should purchase LTC insurance?" can be answered rather simply: Anyone who stands to lose an unacceptable amount of personal assets due to a confinement in a nursing home.

How much does long-term care actually cost? LTC expenses can be defined as the excess daily cost of long-term care over the average daily cost of non-long-term care.

Example: George, age 74, and his family are considering the possibility of admitting him to a nursing home. It is estimated that his food and rent expenses currently average $50 a day. A nursing home charges $70 per day for room and board. So, the actual LTC expense is $20 per day. Accordingly, George's personal assets would be depleted at the rate of $20 per day.

How long will George be willing to reduce his personal assets to meet the costs of the nursing home? Of course, the answer will depend on the value of these assets. If George has hundreds of thousands of dollars, then a depletion of $20 per day may be inconsequential. On the other hand, if George only has hundreds of dollars, a $20-per-day reduction in assets is significant.

The smaller the amount of personal assets at risk, the less likely you will need (or be able to afford) LTC insurance.

As a rule of thumb, if you have personal assets of **$25,000 or less**, you probably are not a prospect for LTC insurance. You may already be at the asset level required for Medicaid payments.

> If you have personal assets ranging from about $25,000 to $150,000, you are the most likely candidate for LTC insurance.

If you have assets **in excess of $150,000**, you probably can cover the costs of a nursing home on your own.

The critical question is not, "Can I afford to buy LTC insurance?" It's "Can I afford *not* to purchase LTC insurance?"

What Does LTC Insurance Cover?

Long-term care insurance provides four principal types of benefits:

- skilled nursing care;

- intermediate care;

- custodial care; and

- home health care.

Skilled nursing care is care provided under the direct supervision of a licensed physician. The care is provided on a 24-hour basis and is administered by registered nurses and/or physicians.

For example, Sarah, age 77, has had serious surgery. Sarah is well enough to be discharged from the hospital, but she needs skilled nursing care for a period of time due to the surgery. She is admitted to a nursing home.

Intermediate care is nursing care for individuals who do not require the degree of care that a hospital or skilled nursing facility provides, but do require some medical care under the direction of medical personnel. Intermediate care is administered under the supervision of a registered nurse, but also may be administered by a licensed practical nurse or physical therapist.

Example: Sarah slowly recovers from the effects of her surgery and is now able to take care of herself to a small degree. However, she is still in need of frequent medical care. Sarah's care may be downgraded to intermediate care.

Custodial care is primarily for the purpose of meeting essential daily living requirements. This type of care may be administered by volunteer workers, licensed practical nurses and therapists.

Example: Due to the seriousness of Sarah's surgery and her age, she is never able to fully recover and needs daily help with such things as walking, bathing, dressing and feeding herself. Although recovered from her surgery, she may be in need of continued custodial care.

Generally, LTC policies provide benefits for each of these levels of care. The policy may require that the care be provided by a state- or Medicare-approved nursing facility.

Home health care is intermediate and/or custodial care provided in a home setting. The home health care benefit provided by LTC policies is usually 50 percent to 85 percent of the regular skilled nursing care benefit. Some policies now allow you to select whether to receive institutional or home care. To qualify for home health care benefits, you usually need to be certified by a physician as unable to perform two or more of the activities of daily living.

Home health care benefits include visits to the patient's home by a registered nurse, the services of practical nurses, physical therapists, etc. More liberal LTC insurance policies may even pay for home care provided by family members. However, this is specifically excluded from coverage on other policies.

In recent years, there has been a shift in LTC insurance claims. More and more, LTC insurance policyholders are filing for home health care and adult day care benefits—rather than skilled nursing benefits.

Basic LTC Benefits

Level of Care	Type of Care	Administered By
Skilled	Administration of medication, changing surgical dressings, therapy, general rehabilitative and custodial care	Doctors, RNs, practical nurses and therapists
Intermediate	Therapy, general rehabilitative and custodial care	RNs, practical nurses and therapists
Custodial	Assistance in walking, bathing, dressing, eating and general daily living requirements	RNs, practical nurses and therapists
Home	Intermediate and/or some custodial care workers and therapists	RNs, practical nurses, social

Adult day care almost always is provided as an optional benefit on an LTC policy. An adult day care facility provides a structured environment, where the adult receives medical care and participates in a variety of health, social and related support activities for a few hours each day. Such care includes transportation to and from the facility, as well as meals.

Hospice care may be a standard or optional benefit. A hospice is an organization whose primary purpose is to provide comfort and an acceptable environment for the terminally ill. Coverage for hospice care will include home visits by social workers, as well as registered nurses. It also includes in-patient services in a hospice. Typically, a hospice will keep a terminally ill patient comfortable in his or her last days, but it does not provide life-saving or life-prolonging treatment.

Often, as part of the hospice benefit, **respite care** may be provided for family members who are responsible for the care of the terminally ill patient. Respite care provides a break in the day-to-day routine and care of the terminally ill. For instance, a patient may be admitted to the hospice to give the family "a temporary rest" for a short period of time. Following the respite, the patient returns to the home and the care of the family.

Qualifying for Benefits

Early LTC policies normally required a period of prior hospitalization before you would be eligible for benefits. This prior-hospitalization requirement also is referred to as a **gatekeeper mechanism**.

Many of these policies required at least a three-day stay in a hospital due to sickness or an accident before you would be eligible for LTC benefits. In addition, admission to the long-term care facility had to occur within a specified period of time following discharge from the hospital (for example, within 30 days). So, if you were hospitalized as a result of sickness or an accident for at least three days and were admitted to a nursing home within 30 days of discharge, you were eligible for LTC benefits.

Newer LTC policies no longer require prior hospitalization as a condition for receipt of benefits. In fact, many states have passed laws that prohibit LTC policies from having this type of gatekeeper mechanism.

Some of the newer LTC policies base eligibility for admission to a nursing home on the inability to perform some of the activities of daily living. These contracts do not require prior hospitalization, nor do they require that you be admitted to a nursing facility as a result of sickness or injury. For example, if you are unable to take care of your personal hygiene or unable to walk or "get around," you would be eligible for admission to a nursing home and payment of policy benefits.

Federal legislation enacted in 1996—the Kennedy-Kassebaum Act—which expands the tax advantages for purchasers of LTC insurance, also raises the thresholds for disability (for example, by eliminating "walking" from the list of qualifying ADLs). Laws in your state may supersede this legislation, however. An insurance agent or salesperson will be able to explain what will or will not trigger benefits under a particular policy—and your state insurance department can let you know if your state requires insurance companies to provide coverage if you become unable to walk.

How an LTC Policy Pays

The majority of LTC policies are **indemnity contracts**. This means that a daily benefit, such as $100 per day, would be paid for each day of care.

However, some LTC policies are based on a **reimbursement** (or expense-incurred) format. As with many health insurance plans, the insurance company will reimburse you for a percentage—such as 80 percent—of actual expenses incurred due to a stay in a nursing home.

Some policies offer a daily benefit for nursing home coverage, but a

reimbursement benefit for home health coverage. Still others offer a maximum lifetime benefit amount, from which incurred expenses are deducted.

> You'll need to determine how a particular policy will pay when you are comparison shopping. You also may want to look into how much nursing home care will cost in your area, so you can make a wise choice between an indemnity or a reimbursement-style policy.

When a Policy Pays

LTC policies do not have a monetary deductible, like the one you would find on an auto or homeowners policy. Instead, they have an **elimination period** (EP), which is, essentially, a time deductible. Once an event occurs that would trigger benefits, you will have to wait a certain length of time—the elimination period—before you actually start receiving those benefits.

> Most insurance companies will offer EPs of 15, 30, 60 or 90 days. Some may offer policies with waiting periods of less than 15 days or longer than 90 days. And some even offer EPs that apply only once per lifetime.

When shopping for LTC insurance, you will need to determine how long you can wait before you begin to receive benefits. Not surprisingly, the longer you have to wait, the smaller the premium you will have to pay.

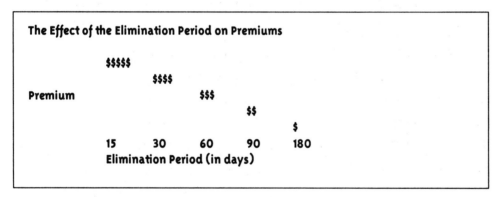

The Effect of the Elimination Period on Premiums

It is also important to note that all long-term care policies will contain some exclusions and/or limitations. These typically describe the kinds of claims for which the insurance company will not pay. **Common exclusions** include:

- losses due to war and act of war;

- losses due to intentionally self-inflicted injuries;

- care for stays in government facilities, such as a veteran's hospital;

- losses that are covered by workers' compensation or similar statutory benefits; and

- losses due to mental, psychoneurotic or personality disorders, when there is no physical or organic disease involved.

Mental or personality disorders resulting from an accident, Alzheimer's disease or other organic diseases are covered.

How Long Will the Policy Pay?

Another key consideration when shopping for LTC insurance is how long the policy will continue to pay you benefits. This is the **benefit period** (BP). An LTC policy will not simply pay you benefits for life. You have to choose the length of the benefit period—and pay premiums accordingly.

> Most insurance companies will offer benefit periods of one to five years, and some offer lifetime benefits—but these are expensive policies.

Some policies may contain both a BP per stay and a lifetime maximum benefit period. For instance, a policy may offer a three-year benefit period per nursing home stay, but a maximum lifetime benefit period of five years. So, if Sam were confined to a nursing home on three different occasions for periods of six months, one year and two years, he would receive the benefits he was entitled to for each stay, since each of these stays was no longer than three years. In addition, he would have used up three-and-one-half years of his five-year maximum lifetime benefit, leaving him with one-and-a-half years of additional coverage.

As you might expect, the longer you will receive benefits, the higher the premium.

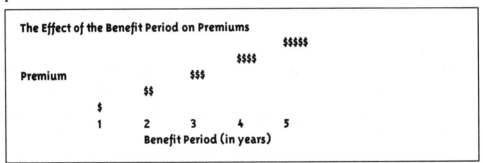

The Effect of the Benefit Period on Premiums

Common Policy Provisions

Different insurance companies use different forms for their long-term care policies—unlike homeowners insurance, which is written on standard

forms. So, long-term care policies differ from company to company. However, there are a few common policy provisions.

For example, most individual long-term care policies are **guaranteed renewable**. This means the insurance company guarantees to renew the policy at the end of its term—but it does not guarantee at which premium the policy will be renewed. The insurance company cannot cancel the policy, but it does reserve the right to increase premiums in accordance with the policy provisions.

If the premiums are to be increased, they will be changed on the policy anniversary, and the increased premium will be for an entire class of insureds, not just a single individual. For example, all policyholders in a given state will have their premiums increased on their respective policy anniversaries.

A small number of individual LTC policies are **optionally renewable**. The insurance company has the option to renew, cancel or increase the premiums by class. Most companies market guaranteed-renewable contracts and refrain from issuing optionally renewable ones. Eventually, there also may be non-cancellable LTC contracts issued—meaning both renewability and the premium are guaranteed for the life of the policy.

LTC policies also provide for a **30-day free look**. If you are not satisfied with your policy when it arrives, you have 30 days during which you can return it to the insurance company for a full refund of any premium paid.

Some LTC policies also provide a **guaranteed-purchase option**, which allows you to buy higher amounts of coverage at specific intervals. For instance, the provision may read: The policyholder may increase coverage by 25 percent of the underwritten amount every two years until protection is doubled.

Newer policies offer prescription drug benefits, nursing home bed reservations, an accidental death benefit, benefits for durable medical equipment and benefits for home modification. Others are offering managed care-type benefits, where care is provided through a preferred provider network.

Because they are so new, long-term care policies are still evolving. They are being revised and refined to better reflect people's LTC needs.

Care Coordination Benefits

Some LTC policies include **care coordination benefits** (CCB), which provide payments for the services of a professional care coordinator. The care

coordinator assesses your condition and the support available from family members, formulates a **plan of care** and then assists in the implementation of that plan. This is a valuable benefit, as it relieves you and your family members from having to coordinate and monitor the care you're receiving, which is sometimes the most difficult and time-consuming part of long-term care.

> The care coordinator could recommend a plan under which the individual is confined to a nursing home indefinitely. Conversely, the coordinator could recommend a plan that combines home health care, family care and some skilled care, depending on your needs.

The purpose is to better utilize the services and benefits provided by the various types of **covered facilities**—in an effort to be of better service to the patient and, at the same time, conserve expenses.

Most LTC plans that offer this benefit typically will pay the fee of the care coordinator in full or provide a benefit equal to some factor of the daily nursing home benefit, such as 10 times or 20 times the daily benefit.

Inflation Protection

Adequate levels of coverage purchased today may **gradually erode** over time due to **inflation**. The insurance industry has been exploring this issue as it relates to policy benefits, as well as premiums.

Typically, inflation protection appears in an LTC policy in one of two ways: as built-in inflation protection or as inflation protection by option.

> Although inflation protection usually is offered as an optional benefit—and adds substantially to the cost of the LTC policy—it is a worthwhile expense. The cost of care is only going to increase in future years. Protection against inflation is an important consideration for the senior citizen. In addition, many states now have laws that require inflation protection as a standard provision in LTC policies.

Built-in inflation protection provides benefit increases for both the daily benefit and the lifetime maximum benefit. Inflation increases are guaranteed and occur automatically, without option and without regard to actual increases in the cost of living. Typically, the benefit increase equals a stated annual percentage. This percentage is either based on a simple interest rate or a compounded rate.

For instance, inflation protection often will provide an increase of 5 percent of the amount of the daily benefit each year. Thus, if you purchased a policy with a $100 daily benefit five years ago, you would realize a benefit 25

percent greater today. Following are examples of the simple interest rate and compounded rate concepts.

5 Percent Simple

The annual benefit increase is 5 percent of the *original benefit amount* for the first 10 policy years. The ultimate benefit then becomes 150 percent of the original benefit. If the inflationary period is 20 years, then the ultimate benefit becomes 200 percent of the initial policy benefit. Thus, an initial $50 daily benefit will become a $75 daily benefit after 10 years, and a $100 benefit after 20 years.

$50 x 5% = $2.50 $2.50 x 10 years = an additional $25
$50 x 5% = $2.50 $2.50 x 20 years = an additional $50

5 Percent Compounded

The annual benefit increase is 5 percent of the *previous year's benefit*. The ultimate benefit becomes 163 percent of the initial benefit after 10 years and 265 percent after 20 years. Thus, an initial $50 daily benefit will become $81.50 after 10 years, and $132.50 after 20 years.

$50 x 163% = $81.50
$50 x 265% = $132.50

Inflation options are another way to protect the purchasing power of the LTC dollar. With this approach, you are contractually guaranteed the right to purchase additional benefit amounts in order to keep pace with inflation.

For instance, say you are 65 and your policy has an initial $80 daily benefit. You are given the right to buy an **additional annual benefit** equal to 5 percent (simple or compounded) of the initial benefit amount. The option dates are every three years from the age of 68 to 80. The option amount is equal to 5 percent for each of the three-year intervals (or 15 percent). The following chart illustrates the effect this would have on your benefit.

Initial Daily Benefit: $80

Age	5% Simple Option Amount	Total Benefit	5% Compounded Option Amount	Total Benefit
68	$12	$92	$13	$93
71	$12	$104	$14	$107
74	$12	$116	$17	$124
77	$12	$128	$20	$144
80	$12	$140	$22	$166

This option approach could be expensive—both for you and for the insurance company. Because the option method guarantees you the right to purchase additional amounts of insurance **regardless of your health**, from the

perspective of the insurance company, the "expense" becomes a matter of **substandard risks** purchasing insurance benefits at standard rates. This means, the older you are, the more likely you are to have medical problems, which affect your insurability. If you become **less insurable** but are guaranteed more insurance, the insurance company faces greater odds of paying you more money. (Insurance companies call this **adverse selection** against the insurer.)

From the consumer's perspective, policies that provide inflation protection will result in **increased premiums**. If you're retired and living on a fixed income, you'll be faced with increasing costs, since LTC policies do not guarantee the premium. This fact—coupled with potential additional costs for the inflation protection—may only add to your burden.

The Impact of Inflation Protection

This chart illustrates the difference in premiums that can be expected for an LTC policy with a $100-per-day nursing home benefit, a 90-day elimination period and a four-year benefit period.
Column A shows premiums for no inflation protection, and Column B shows premiums for a policy with 5 percent compound-for-life inflation protection.

	Column A	Column B
Age 60	$325	$700
Age 70	$950	$1,750
Age 75	$1,550	$2,400

What we may see in the future are LTC policies that pay **reasonable and customary** LTC expenses, similar to the way many hospitalization policies calculate benefits.

Such an insurance product would automatically keep pace with inflation, but it also probably would need to have a higher initial premium than most current LTC policies.

Nonforfeiture Provisions

Early LTC policies made no provision for **nonforfeiture.**

In other words, if you stopped paying premiums and allowed the policy to lapse (or died without ever having used the LTC benefit), you or your heirs received nothing in return for all those months or years during which you paid premiums.

Consumer advocates and state insurance departments took action, and now nonforfeiture provisions are offered as part of most individual long-term care policies and group policies (where the employee is paying the premium).

> The purpose of nonforfeiture provisions is to provide you with a mechanism whereby all policy values or benefits won't be forfeited, should you elect to stop paying premiums on the LTC policy.

Most commonly, when a policy lapses, you are offered either a **return of premiums paid** or a **shortened benefit period**. If you choose the latter, the benefit period will be adjusted so that it is equal to the type of policy you would have purchased, based on the total premiums already paid. In other words, if you were paying for a policy with a five-year benefit period but stopped paying premiums after several years, the insurance company might adjust the policy to provide a three-year benefit period. In addition, many policies provide that upon the death of the policyholder, there is a **return of premiums** paid, less any claims that have been paid out.

Insurance companies offer several different standard nonforfeiture options. It's wise to know which are relevant for the policy you're considering, in case you are unable to continue paying premiums at some point. The nonforfeiture options that would apply to LTC insurance include:

- **Cash Surrender Value**. This is a guaranteed sum paid to you upon surrender or lapse of the policy. This sum generally is equal to some portion or percentage of the insurance company's policy reserve at the time premium payments cease.

- **Reduced Paid Up**. This is a lesser or reduced amount of daily benefit payable for the maximum length of the policy's benefit period with no further premium payments required.

- **Extended Term**. This provides an extension of insurance coverage for the full amount of the policy benefits without any further premium payments, for a limited period of time only.

- **Return of Premium**. This provides a lump-sum cash payment equal to some percentage (60 percent, 80 percent, etc.) of the total premiums paid, paid to you when you surrender the policy or it lapses. Normally, any claims previously paid to you would be deducted from the amount returned.

The reduced **paid up and extended term options** are paid from the policy's cash value. These are fairly standard and are very similar to the nonforfeiture options found in permanent life insurance policies.

For example, Larry has paid $15,000 in premiums for his LTC policy and has had one claim totaling $5,000. The policy contains a 70 percent return

of premium nonforfeiture provision. If Larry were to terminate his policy, he would be entitled to 70 percent of the premium paid (70% x $15,000 = $10,500), less the claim ($10,500 less $5,000 = $5,500).

A variation on this option is a return of premium in the form of **banked LTC claims**. Instead of the return of premium being paid in a lump sum, the value would be banked and paid out as future LTC claims until the banked amount was exhausted.

> **Without nonforfeiture provisions, if your policy lapses or you surrender it, you get nothing. All value and all premiums paid are lost. This is a major disadvantage if you never have a claim and terminate the policy. Contracts with nonforfeiture provisions provide that all is not lost—an important point to consider when shopping for a policy.**

Typically, you can **reinstate** a health insurance policy within a short time if it has lapsed for non-payment of premium. The length of time that you have to reinstate a policy often is expanded and enhanced with LTC policies.

> **Some insurers specify that you can reinstate an LTC policy up to six months, nine months or even 12 months after it has lapsed—if the reason for the lapse was a cognitive impairment. Often, a senior citizen simply forgets to pay the premium, thinks it has already been paid or doesn't understand the purpose of the premium notice.**

To qualify for reinstatement after the standard reinstatement period, you (or your representative) would have to submit a physician's report to the insurance company as proof of a cognitive impairment. **Cognitive impairment** means a deficiency in the ability to think, perceive, reason or remember, which results in the inability of individuals to take care of themselves without the assistance or supervision of another person.

Pre-Existing Conditions

Most policies also will contain a six-month **pre-existing condition provision**, which means the policy will not pay any benefits for a pre-existing condition during the first six months that the policy is in force. (State laws usually prevent insurance companies from having a pre-existing condition limitation that is greater than six months.) More liberal policies may state that all pre-existing conditions are covered as of the effective date of the policy, if the condition is stated on the application.

> **A pre-existing condition usually is defined as any injury or illness for which medical treatment or advice was received or recommended within a certain period of time prior to the effective date of coverage.**

Chapter 12: Long-Term Care Insurance

For example, Mike saw his doctor June 1 for a back problem. On September 1, he applies for LTC coverage. Mike must answer *yes* to any question on the application regarding pre-existing conditions. If Mike's policy contains a six-month pre-existing condition provision, any nursing home stay due to his bad back will not be covered for the first six months of the policy.

What if Mike doesn't see his doctor about his bad back, but he does call him and the doctor prescribes some medication over the phone? Does Mike have a pre-existing condition? Yes, because he has **received advice** (and medication) from the doctor regarding the condition.

Other Provisions to Consider

The **waiver of premium provision** is fairly standard. Most LTC policies provide that after you are confined to a nursing home and receiving benefits for at least 90 consecutive days, the policy premium will be waived for the duration of the confinement, as long as benefits continue to be paid.

The **recurring provision** found in LTC policies is similar to **relapse insurance**. Under this provision, if you are released from a nursing home and are readmitted within 180 days due to the same or a related condition, the second admission (the relapse) will be considered a continuation of the previous nursing home stay. However, if more than 180 days has elapsed since you were released from the facility, you'll have to wait out a new elimination period (EP)—but, on the positive side, you also start a new benefit period.

For example, Mary Beth, age 72, has an LTC policy with a 30-day EP and a three-year benefit period. Her daily benefit is $100. Mary Beth is admitted to a nursing home to recuperate from hip surgery. She is in the facility for a total of four months, at which point she is released. However, three months later, she undergoes surgery again on the same hip and returns to the nursing home to recuperate.

Mary Beth's second admission is within 180 days of her discharge from the first stay, and it is for the same condition: hip surgery. Under the recurring provision, the second admission is nothing more than a **continuation** of her first claim. During her first stay, she satisfied the 30-day EP and received daily benefits. Therefore, no new EP is required, and she will continue to receive $100 per day for the balance of the benefit period, if necessary.

How Much Insurance Do I Want?

You'll need to consider the amount of personal assets you have to determine if you need LTC insurance—and, if so, how much you need.

If you have a very limited amount of assets, you probably are already at the Medicaid level and may not need LTC insurance.

If you're very wealthy, you probably don't need LTC insurance, either, because you can afford to pay your own way—or, essentially, self-insure.

If you're somewhere between these two extremes—with personal assets ranging from about $25,000 to $250,000—you are the most likely candidate for long-term care insurance. Consumer advocates suggest that you should not spend more than **five to 10 percent of your income** on such coverage.

Generally, the amount of assets you have also will determine the type of coverage you choose. As a general rule, the most comprehensive policy will be selected by people who have assets of $100,000 to $150,000 or more.

> **A more comprehensive policy is characterized by higher daily benefits ($100 to $200 per day), relatively short elimination periods, plus one or more optional benefits. All of these benefits will result in a higher premium.**

If you have substantial assets, you certainly can afford to pay a higher premium. But you also may choose to **self-insure**—or purchase a **limited-benefit policy**. If you purchase a limited-benefit policy, you pay less for premiums, and you have coverage only when you really need it—which would be the equivalent of purchasing a **high-deductible, catastrophic health insurance** policy. This may be a wise choice if you have enough liquid assets to cover the cost of a six-month nursing home stay, for example, but prefer not to have to sell your home if you need to be confined to a nursing home for a longer time period.

If funds are tight, you have other options. For example, Margaret, age 66, has limited assets and a small retirement income. She would like to purchase an LTC policy with a $100-per-day benefit, a 10-day elimination period and a five-year benefit period. However, she cannot afford the premium. What can she do to reduce her premium costs?

1) She can **reduce the daily benefit** to a lesser amount—for example, $50.

2) She can **increase the elimination period** to 60 days, 90 days or longer.

3) She can **reduce the benefit period** to two or three years.

These are the primary factors that you can control, when it comes to the price of LTC insurance.

The other primary factor—which you cannot control—is your **age**. While you are most likely to need long-term care in later years, it is in your best interest to consider purchasing LTC insurance when you are 50 to 60. This is because you are more easily insurable at this age—and your premiums will be much lower.

Most insurance companies offer policies beginning at age 50, though a few offer them to people as young as age 40. As loss experience and underwriting data are accumulated, this minimum age may be reduced to a much lower entry level and, consequently, lower premiums.

However, to date, no insurance company offers a **non-cancellable contract**—meaning one in which both renewability and the premium are guaranteed. Many policies are guaranteed renewable, but the premium is not guaranteed. So, even if Margaret had purchased an LTC policy at a much younger age, she still might find it hard to pay the premium when she reached age 66.

Comparison Shopping

For many older citizens in need of LTC insurance, how comprehensive or how costly a policy is may not be as important as which benefits and provisions are contained in the contract.

> When purchasing LTC insurance, it's vital to pay close attention to the type of policy benefits provided, the amount of coverage available for each level of care, the basic policy provisions, and the policy exclusions and limitations.

The four basic types of benefits provided by individual policies include skilled nursing care, intermediate care, custodial care and home health care. Home health care may appear as an optional policy benefit. All benefits are provided after you have satisfied the policy's elimination period. After the EP is satisfied, benefits will be paid for the maximum benefit period or until you have received the maximum lifetime benefit of the policy.

Two common forms of optional policy benefits include **inflation protection** and **adult day care**. As we mentioned earlier, inflation protection typically adds 5 percent each year to the amount of the daily benefit. Adult day care is designed to provide needed custodial and social activities for functionally impaired adults away from their home environment.

Payment Options

The usual method of paying for LTC insurance is a **lifetime, annual** or **monthly premium**. But some insurers offer a 10-year or 20-year paid-up op-

tion. There are also **single-pay policies** available to retirees who want to roll over a lump-sum retirement amount into an LTC insurance policy.

Tax Considerations

The federal Health Insurance Portability & Accountability Act of 1996 established that the premiums paid for individual LTC insurance are **tax deductible** as a medical expense—to the extent that your total unreimbursed medical expenses exceed 7.5 percent of your adjusted gross income.

This "advantage" sounds better than it really is. Many purchasers of LTC insurance are age 65 or older. Since only about half of the individuals over age 65 pay income tax and even fewer itemize their deductions, the tax benefit is of limited application. For a person who has a substantial income, the 7.5 percent figure can render this deductibility meaningless. Also, the tax deduction is subject to age-related limits, ranging from $200 per year for taxpayers under age 40 up to $2,500 per year for taxpayers age 71 and older (these limits are subject to annual indexing).

> **LTC benefits are considered reimbursements for medical expenses already incurred, and are therefore received tax-free up to a per-day maximum of $175 per day (to be adjusted for inflation after 1997).**

When group long-term care insurance premiums are paid by the employer, the premiums are tax-deductible for the employer and benefits are received tax-free up to specified limits.

Consumer Protections

Partially because of the vulnerability of the senior market and partially because of the complexity of the long-term care insurance product, LTC is among the most heavily regulated areas of the insurance industry.

Serious problems arising out of the first long-term care insurance policies invited regulatory scrutiny and resulted in a flurry of state laws and regulations. Consumer advocacy groups lobbied for tighter and tighter controls on company underwriting practices, policy provisions and agent activities.

Most states have passed laws that prohibit certain practices with regard to LTC insurance. Here is a summary of common consumer protections:

• **Applications**. Applications for LTC insurance (except guaranteed issue) must contain clear, simple questions designed to ascertain the applicant's health. Each question must contain only one inquiry, and it must require only a *yes* or *no* answer (except for names of physicians and prescribed medica-

tions). Many times, states require the application to include the **warning**: "Caution: If your answers on this application are misstated or untrue, the insurer may have the right to deny benefits or rescind your coverage."

If the insurance company does not complete **medical underwriting** and resolve all reasonable questions on the application before issuing the policy, the company may only **rescind** the policy or deny a claim on clear evidence of **fraud or material misrepresentation**. What's more, the fraud must pertain to the condition for which benefits are sought, involve a **chronic condition** or involve dates of treatment before the date of application, and it must be material to the acceptance for coverage.

• The policy also will have a **contestability period**—usually two years. During this time, the insurance company has the right to rescind the policy for material misrepresentations on the application. After that time, even if the insurance company finds out that you lied on the application, it cannot rescind the policy.

• **Cancellation**. LTC policies may not be cancelled, nonrenewed or otherwise terminated on grounds of age or deterioration of mental or physical health.

• **Benefits**. Most states have passed legislation establishing standard definitions for LTC terminology and setting minimum benefit standards for eligibility, levels of care and policy provisions. In most cases, policies may not provide coverage for skilled nursing care only, or provide more coverage for skilled care in a facility than for lower levels of care. Plus, no LTC insurance benefits may be reduced because of out-of-pocket expenditures made by you or made on your behalf.

• **Exclusions**. LTC policies may only exclude coverage for the following:

1) pre-existing conditions (and only for six months);

2) mental or nervous disorders (but not Alzheimer's or senile dementia);

3) alcoholism or drug addiction;

4) war or act of war;

5) participation in a felony, riot or insurrection;

6) service in the armed forces;

7) suicide, attempted suicide or self-inflicted injury;

8) treatment in a government facility provided at no charge to the insured; and

9) territorial limitations.

- **Termination of benefits**. If the insurance company terminates your LTC insurance policy, it must continue paying any benefits that were underway at the time the coverage was terminated—without interruption. However, the extension of benefits may be limited to the duration of the benefit period, if any, or to payment of a maximum benefit, and it may be subject to any policy waiting periods and all other policy provisions.

- **Disclosure**. Limitations on pre-existing conditions must be set forth in a separate paragraph on the first page of the policy and clearly labeled. Any limitations or conditions for eligibility also must be set forth as a separate paragraph and labeled "Limitations or Conditions on Eligibility for Benefits."

Individual LTC policies must contain a renewability provision on the first page of the policy, which states the terms of renewability: duration of the term of coverage and duration of the term for which it may be renewed.

- **Outline of Coverage.** One must be delivered at the time of LTC policy application. The outline must include a description of the principal benefits and coverage provided by the policy; a statement of the principal exclusions, reductions and limitations of the policy; its renewal provisions, including any reservation of a right to change premiums; and a description of the policyholder's continuation, conversion and replacement rights. If benefits are paid under a "usual and customary" or "reasonable and customary" basis, those terms must be defined and explained in the outline.

- **Certificates**. A certificate issued under a group long-term care policy must include a description of the principal benefits and coverage provided, a statement of the exclusions, reductions and limitations, and a statement that the group master policy determines governing contractual provisions.

- **LTC and life insurance**. When an individual life insurance policy provides LTC benefits, it must be accompanied by a policy summary that includes an explanation of how the LTC benefits interact with other components of the policy; an explanation of the amount of benefits available, the length of time benefits will be paid and the guaranteed lifetime benefits (if any) for each covered person; any exclusions, reductions or limitations on LTC coverage, if applicable; disclosure of the effects of exercising other rights under the policy, of guarantees related to LTC costs, and current and projected lifetime benefits.

Other Consumer Protections

Riders or endorsements that reduce or eliminate benefits usually require the signed acceptance of the policyholder (unless otherwise requested by the policyholder). You also must agree in writing to riders or endorsements that increase benefits and increase the premium, unless the change is required by law.

Many states provide protection against **unintentional lapse** of LTC insurance, due to a covered cognitive impairment. Applicants usually are asked to designate an additional person who will receive notice of any impending lapse or termination of coverage due to nonpayment of premium. Also, the policies must include a provision allowing such person to reinstate terminated coverage within five months, as long as the person submits proof of cognitive impairment and pays past-due premiums.

Insurance companies also must make "every reasonable effort" to discover whether you already have accident and sickness or LTC insurance, and the types and amounts of such insurance.

In recommending the **purchase or replacement** of an LTC policy, an agent must make reasonable efforts to determine the appropriateness of the recommended purchase or replacement. Many states have incorporated language to this effect into their insurance laws.

Laws prohibit insurance companies, brokers and agents from persuading anyone to replace an LTC insurance policy unnecessarily, especially when the replacement causes a decrease in benefits and an increase in premiums. To this end, LTC insurance application forms must include a question about whether the proposed insurance is intended to replace any other LTC insurance presently in force. Upon determining that a sale will involve replacement, the insurance company is required to furnish the applicant with a Notice Regarding Replacement.

If a group LTC policy is **replaced** by another group LTC policy, the replacing insurance company must:

- provide benefits **identical or substantially equivalent** to the terminating coverage;

- **calculate premiums** based on the policyholder's age at the time of issue of the original coverage (however, if the replacement coverage offers new or increased benefits, the premium for those benefits may be calculated based on the policyholder's age at the time of replacement);

- offer **coverage to all persons** covered under the replaced policy;

- not exclude coverage for **pre-existing conditions** that would have been covered under the terminating coverage;

- not require **new waiting periods**, elimination periods, probationary periods or similar preconditions;

- not vary the **benefits or premiums** based on the policyholder's health, disability status, claims experience or use of LTC services.

If existing coverage is converted to or replaced by a new form of LTC insurance with the same company, the insurance company may not establish any new waiting periods—except for an increase in benefits voluntarily selected by the policyholder.

Applying for LTC Insurance

When an insurance company is considering your application for long-term care insurance, it will look at many of the same factors it considers when reviewing a health insurance application. The process of considering these factors is referred to as **underwriting**. Generally, **health insurance underwriting** is concerned with the following:

- the probability of a sickness;

- high-risk avocations or occupations;

- health history and current physical condition; and

- certain moral or ethical considerations.

LTC underwriting is concerned with the same factors, but the emphasis may be different. For example, if you apply for major medical insurance and indicate a mild heart condition, the underwriter has to be concerned about the possibility of having to pay for open-heart surgery.

If you are applying for LTC insurance, this heart condition takes on a different significance. Since the policy will not pay for surgery or hospital stays, the underwriter now must view the potential heart problem in terms of how likely it is to result in a prolonged confinement in a nursing home. Accordingly, the heart condition could cause the underwriter to decline the individual for a major medical policy, but the underwriter might accept the same person for LTC insurance.

The underwriter must follow the underwriting guidelines established by the insurance company. For example, some companies have established minimum and maximum issue ages for long-term care insurance. And some com-

panies do not issue LTC policies to substandard risks.

Probably the most important cog in the underwriting machinery is the agent. The agent is normally the only person who ever sees you personally. The agent is responsible for completing the application for insurance as accurately and thoroughly as possible. This may include asking more detailed questions than the ones on the application.

An insurance company also may use an **inspection report** to determine whether or not to issue you a policy. The purpose of such a report is generally to verify information contained on the application or to obtain additional information about a specific condition or possible problem that may have surfaced on the application. In accordance with the Fair Credit Reporting Act, if an investigative report is to be completed as part of the underwriting process, you must be notified.

Medical information is extremely important to the underwriter, too. Much of this information will be found on the application. Additional medical information may be obtained directly from your doctor, through the use of an Attending Physician's Statement and request for medical records. Occasionally, applicants for LTC insurance are required to take a paramedical exam. This is usually required for applicants age 80 and over.

Finally, a face-to-face interview may be conducted to establish cognitive abilities. It is increasingly common for insurance companies to ask applicants for LTC insurance to submit to an evaluation of cognitive reasoning abilities, since these problems usually do not show up in routine medical history files. Sometimes, a cognitive assessment is required only for applicants above age 75 or 80.

Classifying You as a Risk

Once all of the underwriting information is gathered, the underwriter will classify you as a preferred, standard or substandard risk. If you are a standard risk, you will pay the standard rate—or premium—for the policy. Preferred risks are entitled to premium discounts, while substandard risks may be declined, or they may have to pay an extra premium for the policy or have a policy issued with a rider omitting some element of the coverage.

To determine the risk classification, the underwriter is concerned with the following factors:

- past medical history and current physical condition;

- age and sex of the applicant;

- occupation (if still working) and avocations;

- morals; and

- pre-existing conditions.

What If You're a Substandard Risk?

If you are considered a substandard risk, the insurance company may charge you an additional premium to cover the additional risk. Or the company could add exclusion riders, reduce the benefit amount, increase the elimination period or reduce the benefit period.

> **Adding riders that exclude a particular condition from coverage is not a common technique for LTC policies—reducing the benefit amounts is.**

For example, Marie applies for an LTC policy with a daily benefit amount of $150, following a 30-day elimination period. Benefits are payable for up to five years. Marie indicates on the application that she has several medical problems—high blood pressure, arthritis, borderline diabetes and hardening of the arteries.

Marie's medical history presents underwriting problems. Therefore, the insurance company may choose to limit the daily benefit for this impaired risk. For example, the underwriter may approve the policy issue, but only for $50 per day in benefits. In essence, the policy is reduced from a total benefit of $273,750 (five years x $150 per day) to $91,250 (five years x $50 per day).

Or the insurance company may choose to increase the elimination period from 30 days to 90 or 100 days. Increasing the EP will have the effect of eliminating some of the smaller claims.

Or the underwriter could approve the policy with a shorter benefit period to reduce the dollar amount of the potential loss to the insurance company. Reducing the benefit period from five years to one year would result in Marie receiving a maximum benefit of $150 x 365 days, or $54,750.

Or the underwriter could employ all of these devices. For example, the insurance company could issue a policy with a reduced benefit amount (for example, $50 per day), plus a reduced benefit period of three years and an increased elimination period of 90 days. If this were done, Marie would be issued a policy with a potential maximum benefit of $54,750, payable after a 90-day EP.

Another tool insurance companies use to reduce claims paid is the so-called **gatekeeper mechanism**. One such device is a policy provision which stipulates that any confinement to a nursing home must be preceded by a hospital stay—typically, at least a three-day prior hospitalization due to acci-

dent or sickness. Further, the provision will state that admission to a nursing home must occur within 30 days of discharge from the hospital. This provision should reduce the number of potential claims, plus admission to a nursing home for purely custodial care normally would not be covered.

Another policy provision that may serve to reduce potential claims is the use of a **probationary period**. A probationary period is a waiting period for sickness benefits. The policy may state that no benefits will be paid until the policy has been in force for three months, six months, etc.

LTC Attached to Life Insurance

In recent years, some insurance companies have begun to offer long-term care coverage in the form of a rider attached to a new issue of life insurance or possibly some other policy form, such as a disability income policy. With this marketing approach, there are two sales—the life sale and the LTC sale—which should be beneficial to the insurance company, the insured and the agent.

LTC rider benefits are very similar to those found in an LTC policy. The benefit structure includes the following:

- elimination periods in the range of 10 to 100 days;

- benefit periods of three to five years or longer;

- benefits may be triggered by impaired activities of daily living; and

- levels of care include skilled, intermediate, custodial and home health care.

In addition, certain optional benefits may be provided, such as adult day care, cost of living protection, hospice care, etc.

> One difference with this "LTC package" is the method of determining LTC benefits. The benefits may be expressed as a specific daily amount—$50, $100 or $150 per day, for example. They also may be expressed as a factor of the face amount of the life insurance policy. For instance, 2 percent of the face amount of the policy may be paid monthly as an LTC benefit, up to a specified maximum.

For example, John has a $100,000 universal life policy with an LTC rider that provides a monthly LTC benefit of 2 percent of the face amount, up to a maximum of $50,000. If John were admitted to an LTC facility, his benefit would be 2% x $100,000 = $2,000 per month. John would be limited to a

25-month benefit period, since within 25 months, the maximum LTC benefit of $50,000 would be exhausted.

There are basically two approaches to the LTC rider concept. The first of these may be referred to as a **generalized or independent approach**. Under this approach, the LTC rider is independent from the life policy, in that LTC benefits paid to the insured will not affect the life policy's face amount or cash value.

For example, Sam has a $100,000 life policy with an independent LTC rider and collects $20,000 in LTC benefits. The $100,000 face amount, as well as the policy's cash value, will not be reduced by the amount of the LTC benefits paid.

The **integrated approach** links the LTC benefits paid to the life policy's face amount and/or cash value. The result is a reduction in these values.

Example: Sam has the $100,000 life policy with an integrated LTC rider and collects $20,000 in LTC benefits. The face amount of Sam's life policy is reduced by the benefits paid, resulting in a reduced death benefit of $80,000.

Critics of this approach argue that the reduction in the policy's death benefit is a disadvantage to the insured. Valuable life insurance benefits are being lost or reduced at a time when they may be needed most. In addition, even if you wanted to purchase additional life insurance to offset this reduction, there's a very good chance that you will be uninsurable, having spent some time in a nursing home.

> This combination of life insurance and LTC benefits is marketed as a Living Benefit or Living Needs rider. This approach draws on the life insurance benefits to generate LTC benefits. Thus, the LTC rider is attached to the life policy "at no charge." It's like borrowing from the life insurance to pay LTC benefits.

Generally, the **Living Needs Rider** provides funds for LTC expenses or for expenses incurred with a terminal illness. Under this rider, you may be advanced life insurance dollars to cover these expenses. There are usually two options associated with this rider.

The first is the **LTC Option**, which typically provides up to 70 percent to 80 percent of the policy's death benefit to offset nursing home expenses. The second is the **Terminal Illness Option**, which can provide 90 percent to 95 percent of the death benefit as a pre-death benefit to be used to offset medical expenses.

The conditions under which these benefits are paid are determined by the policy and the insurance company. The rider may link benefits to activi-

ties of daily living, or it may require a minimum prior hospitalization due to an accident or sickness.

Typically, the rider also will contain an elimination period. The benefit period is linked to the dollar amount, as opposed to a time element. Benefits will cease when you have used up all of the money available (the percentage of the policy's face amount). In most other respects, the Living Needs Rider functions in much the same way as a basic LTC policy.

LTC and Annuities

LTC coverage is not only being combined with life insurance policies, it is being combined with annuities and disability income insurance.

An **annuity**, which is designed to be a retirement vehicle, may be issued with an LTC rider in much the same way that the LTC rider may be attached to a life insurance policy. With this arrangement, the annuity provides necessary funds to help with LTC expenses. It might be said that the annuity and the LTC policy are cousins, in that annuities provide retirement income and LTC needs normally occur after retirement.

When and if needed, annuity funds will be paid to cover LTC expenses. This, of course, will have the effect of reducing the amount of money in the annuity and, consequently, the monthly retirement income may be reduced, as well.

LTC and Disability Income Insurance

Another progressive use of an LTC rider is in combination with a disability income policy. Disability income insurance is designed to protect a person's most important asset—the ability to earn an income. However, your disability income needs normally end at age 65 or at retirement, since you no longer have earned income.

How does this combination work? Here's an example: Jack, age 45, purchases a disability income policy to protect his ability to earn an income. He adds a **Guaranteed Insurability Option** (GIO), whereby he will be eligible to purchase units of LTC coverage ($10 to $50) at certain option dates from age 55 to 70, without the need to prove insurability. At age 65, Jack retires and "surrenders" his disability income policy for an LTC contract.

This appears to be an ideal mix of products, as the disability income insurance need terminates at retirement and, generally, the need for long-term care coverage begins.

In the years and decades to come, it would appear that the types of LTC policies offered will only be limited by the imagination of those responsible

for product design to meet the LTC needs of the senior citizen.

Conclusion

The chance of an expensive stay in a nursing home is a very real risk for the senior citizen. Due to increasing life expectancy, the average length of a nursing home stay will gradually increase, as will the average expense.

The basic problem is how to pay for nursing home care. Medicare actually offers very few benefits for care in a nursing facility, especially for custodial care. Medicaid will cover nursing home expenses only for the financially needy.

Another alternative is to rely on friends and relatives for necessary care. Or you can pay for nursing home costs from present financial assets. Depending on the length and cost of such a stay, the bill could be considerable and you may exhaust available financial resources. While this would make you eligible for Medicaid, it's cold comfort for people who had planned to leave something to their heirs.

The natural solution to the problem is LTC insurance. This type of policy can protect your assets. It also gives you flexibility and freedom of choice in the selection of a nursing home. And it allows you to maintain a degree of independence.

Key Questions

The following is a checklist of LTC policy features that you should consider. You'll want to make copies of this checklist and fill in the appropriate answers when you compare policies from different insurance companies.

TYPE OF POLICY BENEFITS

Does the policy provide benefits for the following, and how long will benefits be provided?

Skilled nursing care	Yes	No	Length: _____
Intermediate care	Yes	No	Length: _____
Custodial care	Yes	No	Length: _____
Home health care	Yes	No	Length: _____

Does the policy have a maximum benefit amount expressed in dollars or time?

Yes No

If so, what is the maximum benefit? _____

Does the policy contain nonforfeiture provisions? Yes No

Does the policy contain any of the following optional policy benefits?

Adult day care	Yes	No
Hospice care	Yes	No
Inflation protection	Yes	No
Home health care	Yes	No

AMOUNT OF BENEFITS

Are policy benefits paid on a reimbursement basis? Yes No

 If so, what is the percentage? _____%

 How long will benefits be provided? _____

Are policy benefits paid on an indemnity basis? Yes No

 If so, what is the daily benefit for each level of care?

How long will benefits be provided? _____

Does the policy have a maximum lifetime benefit? Yes No

If so, how much is it? _____

POLICY PROVISIONS

How long is the elimination period? _____

How long is the benefit period for each level of care?

Does the policy require prior hospitalization? Yes No

 If so, for how long? _____

Does the policy base benefits on the ability to perform the activities of daily living? Yes No

If so, how many activities must you be unable to perform to trigger coverage?

Is the ability to walk one of the activities that triggers coverage?

 Yes No

Does the policy provide purely custodial care? Yes No

Is there a waiver of premium provision? Yes No

POLICY EXCLUSIONS OR LIMITATIONS

Does the policy cover Alzheimer's disease? Yes No

Does the policy cover pre-existing conditions? Yes No

If so, after how long? _____

What are the policy's other exclusions?

	Yes	No
Mental or nervous disorders	Yes	No
Alcoholism or drug addiction	Yes	No
War or act of war	Yes	No
Participation in a felony, riot or insurrection	Yes	No
Service in the armed forces	Yes	No
Suicide, attempted suicide or self-inflicted injury	Yes	No
Treatment in a government facility provided at no charge to you	Yes	No
Territorial limitations	Yes	No

Chapter 13

Disability Income Insurance

People will insure their home, their cars, their things, but they'll often forget to insure the asset that pays for all of these—their ability to earn money.

If you have a family, you probably have life insurance to protect them in case you die. But what if you don't die? What if you suffer a stroke tomorrow and can no longer work? What if you are diagnosed with a debilitating illness?

If you died, your life insurance would pay off. Your family also would get Social Security survivor's benefits, and they might be able to sell any assets you have.

But if you live and you can no longer earn a living, what will happen? Will you be able to pay your bills? Will your family suffer? You may live for many years totally disabled—and, therefore, unable to generate an income to pay for the higher medical and living expenses caused by the disability.

Did you know that, in the United States, the most common cause of mortgage foreclosures is the disability of the borrower?

The Odds of Becoming Disabled

If you're like most people, you think it won't happen to you. But it could. In fact, a person is more likely to become disabled than to die at almost any age.

The chart on the following page, shows that the risk of becoming disabled during peak earning years is substantial—especially for people age 50 and younger. And as you get older, the duration of the average disability increases—as do the chances that you will never totally recover.

By the time you're 50, if you've got a disability that has lasted more than 90 days, odds are it will take you more than six years to recover. For most people, who work for a living, this kind of downtime is catastrophic.

The Probability of Disability
Compared to Death at Specific Ages

Age	Number per 1,000 Disabled	Number per 1,000 Dying	Probability of Disability Compared to Death
32	6.87	1.74	4 to 1
37	7.75	2.27	3.5 to 1
42	9.46	3.39	2.8 to 1
47	12.00	5.00	2.4 to 1
52	15.78	7.36	2 to 1

Source: Commissioner's Individual Disability Table and Commissioner's Standard Ordinary Mortality Table

How Much Can I Really Earn?

Do you really need to worry about protecting your income? Consider how much you could earn between now and age 65, if you are the age listed in the left most column below:

Potential Earnings to Age 65

	Monthly Income			
Age	$2,000	$4,000	$6,000	$8,000
25	$960,000	$1,920,000	$2,880,000	$3,840,000
30	840,000	1,680,000	2,520,000	3,360,000
35	720,000	1,440,000	2,160,000	2,880,000
40	600,000	1,200,000	1,800,000	2,400,000
45	480,000	960,000	1,440,000	1,920,000
50	360,000	720,000	1,080,000	1,440,000

Your ability to earn an income could generate **more than $1 million in an average lifetime**. And the chart above doesn't include things like pay raises or cost of living increases.

What Happens If You Become Disabled?

Disability income insurance is a form of health insurance that provides a weekly or monthly income benefit to replace a portion of the salary or wages lost when you're unable to work because of an injury or illness.

If you don't have disability income insurance, you have to rely on **other resources** to help offset the effects of a disability. What sorts of other resources?

- Cash Savings

- Investments

- Business Assets

- Government Programs

- Borrowing

How long will your savings last? And how liquid are your investments or business assets? If you have an art collection or a car collection, it might take months or years to find the right buyer at the right price—and the same goes for a business. What are you going to live on in the meantime?

And who is going to loan you enough money to cover your costs during an extended disability? Certainly not a bank, since you have no way of repaying the loan if you aren't earning a living. (On the other hand, if you can rely on a rich relative who loves you dearly, you may not need disability income insurance.)

What about programs through work? If you're an employee, there may be some work-related benefits available from a group disability plan, a salary continuation plan, employee stock plan, workers' compensation, etc.

But **group disability benefits** are of short duration—a year or less—and cover only a percentage of lost income. These fixed and capped benefit plans also tend to discriminate against higher-paid employees.

For example, a group plan might provide benefits equal to 60 percent of your pay, up to a maximum benefit of $2,000 per month ($24,000 annually). This may prove to be an adequate benefit if you earn $40,000 or less per year. But for people earning more, the disability benefit is still limited to $24,000 per year. If you earn $60,000 annually, then your disability benefit would cover only 40 percent of your ordinary pay.

> An important point about group benefits or work-related plans is that you merely "rent" this coverage. Benefits are available on the condition that you continue to be an employee. If you terminate employment, your disability benefits also are terminated. If a disability strikes between jobs, no work-related benefits are provided.

Workers' Comp and Social Security

Workers' compensation provides another source of disability income benefits—but only if your accident or sickness is **job-related**. Falling out of bed

in the morning and breaking your arm does not constitute a workers' comp claim. Slipping on a wet floor at the job site and breaking your arm also is a workers' comp claim.

The intent of the workers' comp system is to make the employer liable for **occupational disabilities** without you having to prove that the company was at fault. Your employer either will cover such claims out of company funds or elect (as almost all do) to cover this risk by means of workers' comp insurance.

The laws—and the benefits provided—vary somewhat from state to state. But benefits are usually low—about $300 a week at most.

You also might think you can count on Social Security disability income benefits. But it's not easy to get Social Security benefits—and they're pretty puny when they do come. To be eligible for disability benefits under Social Security, you have to be both "fully insured" and "disability insured." **Fully insured** status means that you have paid Social Security taxes for 40 calendar quarters (10 years). **Disability insured** means that you have paid Social Security taxes in at least 20 out of 40 calendar quarters (5 out of 10 years) prior to filing a disability claim.

In addition, you must be under age 65, the disability must be expected to last for at least 12 months or end in death, and the disability must satisfy the definition of total disability in accordance with the Social Security law.

Total disability is defined as the inability to engage in any substantial gainful activity by reason of a medically determined physical or mental disability relative to a person's education and prior work experience.

This means that you must be unable to perform your previous job—or any other substantial work that exists in the national economy relative to your age, education and prior work experience.

In addition, there is a five-month waiting period before any benefits can be paid. In reality, due to the waiting period and the time it takes to process an initial claim, you probably won't receive your first Social Security claim check until about a year after the onset of the disability—if you're one of the very few who qualifies to collect benefits in the first place.

What About Other Coverage?

If you weren't injured on the job, some states (including California, Hawaii, New Jersey, New York and Rhode Island) provide **state benefits for**

non-occupational disabilities. The amount of the benefits will vary. Generally, the state plan will provide 50 percent to 60 percent of your wages for a limited period of time—such as six to 12 months.

Yet another form of coverage that could kick in is **Accidental Death and Dismemberment** (AD&D) coverage, which frequently is provided as part of an individual or group life insurance contract. AD&D coverage pays a "principal sum" (basically, the policy's face amount) for accidental death in accordance with the policy's provisions and definition of accidental death. This same amount is paid if you lose use of both arms or both legs, or if you lose vision in two eyes due to an accident. This amount usually is identified as the **capital sum** if the policy is paying an accidental dismemberment benefit.

What if your back gives out? Then what?

You could qualify for coverage under your **long-term care** (LTC) insurance—if you have it. It will pay for the care of persons with chronic diseases or disabilities, and may include a wide range of health and social services provided under the supervision of medical professionals.

You also might have another insurance policy that would help out in the event of a disability. For instance, **accident only insurance** provides coverage for injury from an accident—but it excludes coverage for sickness. Benefits may be paid for all or any of the following: death, disability, dismemberment, or hospital and medical expenses. This is not a kind of insurance that most people need. But some, who travel often, will either buy it themselves or get it as a work-related benefit.

What about **life insurance**? Unfortunately, it isn't much help in the event of a disability. The life insurance benefits (other than a typically small policy cash value) aren't available. Pension benefits usually aren't available either.

What about **credit insurance**? This policy is issued only if you are in debt to a creditor. The coverage is limited to the total amount of your indebtedness—but some insurance companies even balk at paying that. If you're given the choice of purchasing credit insurance, for the most part, you're better off spending the premium money on disability income insurance.

Disability Income Insurance Is the Solution

It is clear that most people cannot rely on any of the other kinds of insurance that they may have—or their savings or collections—to help them through a prolonged disability. Fortunately, there is a form of insurance designed to do just that. It's aptly called **disability income insurance**.

Disability income insurance (also referred to as **loss-of-time insurance**) pays you a weekly or monthly benefit for disabilities due to an accident or

sickness. The primary purpose of this coverage is to replace the loss of personal income due to a disability.

Disability income policies are issued on an individual basis—or on a group basis, through an employer-sponsored plan, labor union or association. Benefits paid are in accordance with the policy's provisions and, to a degree, your loss of income.

Figuring Out How Much You Need

Disability income insurance can enable you to pay a mortgage and other necessary expenses when a total disability due to an accident or sickness cuts off your income. But exactly how much of this insurance do you need?

To figure this out, you will need to gather some information. This includes: **what you make** and **what you have to protect**.

Usually, it's best to use a worksheet when conducting a needs analysis. (See page 292 for a worksheet.) This helps you consider problems, needs, and objectives consistently. It also helps you avoid the main problem that plagues needs analysis: overlooking something.

What you make is fairly simple to calculate. It's the amount of **earned income** you expect to have during a specific period of time. In most cases, insurance companies calculate this number by asking what you make in salary and other earned income. A good insurance company will ask for some kind of proof of income—like an IRS W-2 form or other tax document.

Don't attempt to fudge these numbers. If you do, the insurance company will not have to pay you *anything* in the event of a claim. You'd be amazed how many people blatantly lie on their applications, and then haul their insurance companies into court when they won't pay. Just in case this doesn't sound so bad, it's worth noting that the insurance company wins when you lie. And you wind up with lawyers' bills on top of everything else.

To determine your disability income insurance needs, you also need to calculate how much you need to protect. Among the most common of these issues are educational objectives for dependent children, other family needs, business objectives and retirement goals.

In greater detail, these are the factors that will impact your disability needs most directly:

- **Fixed Obligations**. Such expenses as mortgage or rent, car payments, utilities, food, installment purchases, insurance premiums, etc., must be itemized.

- **Variable Expenses**. These are the unexpected, non-fixed ex-

penses that occur from month-to-month, such as car repairs, medical expenses, prescriptions, home repairs, etc. Try to estimate these unexpected monthly expenses to the best of your ability.

- **Added Expenses**. In addition, there are added expenses due to a person's disability—additional medication, doctors' bills, prosthetic appliances (such as braces), the rental of a hospital bed or a wheelchair, hospital bills that are not fully covered by hospitalization insurance, etc.

Your Resources

Once you know how much you make and how much you need to protect, the next question is: Where is the money going to come from to pay these various obligations?

It's time to examine your other sources of money. This may include:

- **Personal Assets**. Start with the most liquid asset, your personal savings. Do you have any savings? If so, how much and how adequate is it for purposes of paying expenses? Furthermore, will you be willing to use personal savings to pay expenses associated with a disability?

- **Work-Related Benefits**. What type of disability benefits do you have from your employer? Is there a formal sick pay or salary continuation plan? Do you have any accumulated sick days?

- **Government Benefits**. Are you eligible for disability benefits from Social Security? (Because so many claimants are denied, don't expect to receive any Social Security disability benefits. Besides, even if you do qualify, it takes nearly a year to receive the first check.) What about state disability benefits?

- **Non-Earned Income**. If you own an apartment building, the rents will keep coming in, even if you're disabled (although you might have increased expenses, if you have to hire someone to take care of things you ordinarily do yourself). Other forms of non-earned income include interest income, dividends, other rental income, deferred compensation and residual commissions, royalties or other miscellaneous income, and group disability income insurance.

Charting Your Needs

Most insurance companies use fairly **standard worksheets** to determine a monthly expense estimate that relates to disability coverage needs.

The worksheet below will help you add up your expenses, such as mortgage or rent, utilities, food, auto or transportation expenses, tuition or education expenses, clothing, outstanding consumer loans or installment purchases, insurance premiums, medical or dental care costs, taxes and miscellaneous expenses.

Then it will help you look at your other sources of funds in the event of a disability, and consider your potential needs, should you become disabled. If the final income figure is negative, check your numbers—with an eye toward making sure that your expenses are all covered and that the non-earned income is absolutely reliable. If your final number is still negative, you don't need to worry about disability insurance—you should be thinking about retiring.

For most people, the final income figure will be positive—and probably disturbingly large. And remember, this is only a monthly number.

Disability Income Needs Assessment Worksheet

PART 1

Enter your monthly expenses related to each of these items and add them for Subtotal 1. If possible, average what you spent during each of the last sixth months.

Mortgage or rent	_____
Utilities	_____
Phone	_____
Food	_____
Auto expenses/transportation	_____
Tuition/education expenses	_____
Clothing	_____
Loans and installment purchases	_____
Insurance premiums (car, home, etc.)	_____
Medical/dental care costs	_____
Miscellaneous expenses	_____
Taxes	
Subtotal 1	_____

PART 2

Enter your monthly income provided by each of the following sources of "non-earned income." For the insurance items, check each policy's maximum benefit. For the other items, average your costs over the last six months, if you can. Add them to come up with Subtotal 2.

Group disability insurance benefits	_____
Other insurance benefits	_____
Interest income	_____
Dividends	_____
Rental income	_____
Deferred compensation, residuals, royalties, etc.	_____
Subtotal 2	_____
PART 3	
Subtract Subtotal 2 from Subtotal 1. This will provide you with the monthly income figure that you need to insure against disability.	
Subtotal 1	_____
minus	
Subtotal 2	_____
equals	
Total monthly income to be insured	_____

In order to estimate the likely total loss from a disability, refer to the disability duration chart below.

The Average Duration of a Disability **that Lasts for More Than 90 Days**	
Age at Onset	**Duration**
30	4.7 years
35	5.1 years
40	5.5 years
45	5.8 years
50	6.2 years
55	6.6 years
Source: Journal of the American Society of Certified Life Underwriters	

Then multiply the total monthly income you need to insure by the average duration of a disability that lasts at least 90 days.

Total monthly income to be insured	_____
multiplied by	
Average duration of a disability that lasts at least 90 days equals	_____
Average long-term disability loss	_____

The key to staying in good financial shape, even while you are disabled, is covering that monthly figure. Now you know the three numbers you need to tell your insurance company or agent when you're shopping for disability coverage: the **total monthly income** to be insured, your current **monthly earned income** and the average **long-term disability loss**. These numbers provide a range within which your income coverage (whether it's disability insurance, Social Security or simple cash savings) should fall.

Analyzing Coverage

Once your needs analysis is completed, you're ready to start comparing disability income policies. Once again, this process usually works better if you use a formal method of review. Let's start by explaining the variables, that affect disability income insurance. The following are the items you can change to raise or lower your premium—and to suit your needs.

- The length of the **elimination period** (EP). This is the waiting period between when you make an income insurance claim and when the coverage begins. EPs work much like deductibles in auto or homeowners insurance—the larger they are, the cheaper the coverage. If you have a substantial amount of savings that you are willing to spend to support yourself and your family in the event of a disability—or if you have a short-term disability plan through work—you can afford to select a longer elimination period.

- The length of the **benefit period** (BP). This is the amount of time that the income insurance will pay benefits. It may pay for a year, two years, five years or even for the rest of your life. The longer the benefit period, the bigger the risk the insurance company takes—so the higher your premium will be.

- The amount of the **monthly benefit**. This may be the most important factor of all. The bigger the benefit, the more costly the policy.

- The inclusion of **optional benefits**. These usually are based on your individual needs and financial goals—the subjective factors that are difficult to quantify.

Finally, there is one other consideration that profoundly affects your rates and the amount of coverage an insurance company will provide: your **occupational classification**. We'll cover this in more detail later in this chapter.

Choosing an Elimination Period

Most of these variables can be adjusted to provide for an increase or decrease in the premium, and should be considered if the price of the policy is a critical factor. For instance, the elimination period is similar to a deductible—but it's a **time deductible**, instead of a dollar deductible. The longer the EP, the smaller the premium. The shorter the EP, the higher the premium. Thus, a plan with a 30-day EP will have a considerably higher premium than a plan with a 90- or 180-day EP.

An illustration of this trade-off can be seen in the following chart:

The Premium and the Elimination Period	
Male, Age 45, $1,000 Monthly Benefit Payable to Age 65	
Elimination Period	**Annual Premium**
30 Days	$690
60 Days	$550
90 Days	$495

Usually, a plan with a 60-day EP will cost approximately 20 percent less than a plan with a 30-day EP. Most insurance companies will offer elimination periods ranging from 30 days to as long as two years. Even though a savings in premium can be realized with the longer EP, it may not be in your best interest.

For example, if you choose a 90-day elimination period, you will not begin to accrue a benefit until the 91st day of a disability. However, the insurance company won't issue a claim check until the end of the month. Therefore, you'll wait roughly 120 days—four months—from the onset of the disability until you receive any benefit.

When determining which elimination period to elect, you must answer the question, "How long can I go without any income from my disability income plan?" The answer to this question will depend on the size of your monthly income insurance need and the amount of cash savings or the size of the liquid assets you have in reserve.

> Every situation is different, but you probably will end up choosing among 30-, 60- or 90-day elimination periods. A policy with no EP is usually very expensive. A policy with more than a 90-day EP usually doesn't begin paying benefits soon enough.

It's usually a mistake to assume someone who has a higher income can live with a longer EP. If you make more money, you often have bigger ex-

penses—which puts you roughly in the same place as someone making less money. A corporate executive earning $250,000 may not have any more liquidity than a worker earning $25,000 per year.

The best way to be sure you can live with a longer EP is to make sure you have short-term disability insurance to cover you during the wait. This short-term coverage is what's provided by most work-related plans.

Selecting a Benefit Period

Once you've figured out what kind of elimination period you can tolerate, you need to choose the length of time that benefits will be paid. The most common **benefit periods** are one, two, or five years and *to age 65*. In some cases, a lifetime accident and/or sickness option may be included in the policy, which extends the benefit period for your lifetime.

Like the elimination period, the benefit period is a reflection of the premium you pay. The longer the benefit period, the higher the cost of the policy. Short benefit periods result in lower premiums, especially when they are coupled with long elimination periods.

The following chart illustrates this concept.

The Premium and the Benefit Period	
Male, Age 45, $1,000 Monthly Benefit Payable to Age 65	
Benefit Period	Annual Premium
1 Year	$255
2 Years	$330
5 Years	$510
To Age 65	$690
Lifetime	$830

If you determine that a 30-day elimination period is adequate, then it would be reasonable to consider a two- or five-year benefit period. On the other hand, when evaluating the risk of a **permanent disability** the potential loss of income during a to-age-65 benefit period is controlling.

Although insurance experts normally discuss disability income benefits in terms of monthly amounts, they look at the bigger picture when determining the benefit period. The **potential loss of income** due to a permanent and total disability can literally be in the millions of dollars.

For example, a 40-year-old earning $50,000 per year who becomes totally disabled stands to lose more than $1.2 million before age 65 if the disability becomes permanent.

And, as we've seen, the older you are at the onset of a disability, the more likely it is that you will **not recover fully**. This possibility suggests that you should get the longest benefit period possible. However, a longer benefit period leads to a larger premium.

Following an analysis of all of the facts and your needs, the deciding factor may well be the cost of the policy. In this case, ask yourself: Should you use your resources to pay for a shorter elimination period or use the premiums to cover a longer benefit period?

Selecting the Benefit Amount

The next factor to consider is the **amount of the monthly benefit**. While it would be nice to make more money if you were disabled than if you were working, this is not an option. The insurance company does not want to encourage you to stay home.

The insurance company uses what are known as issue and participation limits to determine the maximum amount of monthly benefits that may be issued. (Any state laws on the subject also would come into play.) Typically, this limit will be a predetermined percentage—such as 70 percent or 75 percent of your earned income (before taxes).

Another factor that determines the amount of the benefit is the existence of any **other disability income coverage** in force. On the application for insurance, you must indicate the name of the insurance company and particulars regarding the additional coverage. Any other coverage will cause the amount requested to be limited.

For example, assume that Company A will issue disability coverage up to 70 percent of a person's gross earned income. In addition, it will participate with other insurance companies' coverage up to this 70 percent maximum.

Diane, a pharmacist, earns $3,000 per month. She may purchase disability income up to 70 percent of her earned income—or $2,100 per month. However, she indicates on her application that she has other coverage with Company X in the amount of $1,000 per month. The maximum coverage that Company A will issue is an additional $1,100 per month. Company A is participating with Company X, and total benefits are limited to Company A's issue and participation limits of 70 percent of earned income.

A third factor that can limit a policy's benefit amount is your **non-earned income**. Typically, if a person has non-earned income amounting to $15,000 or more each year, the insurer will want to reduce the benefit amount.

A **high net worth** also can reduce your need for disability insurance—

and the insurance company's desire to provide it for you. If you're a multi-millionaire, you're basically self-insured and probably don't need disability income insurance. Your personal and/or business assets should provide plenty of protection. The insurance company is aware of this: It may decline coverage for a person with a high net worth—or offer some small token benefit.

In short, when an insurance company's issue and participation limits are **70 percent of gross earned income**, this amount probably will be very close to your net income—or take-home pay after taxes. In this way, the loss is made relatively whole again. If you were to get more than the equivalent of your take-home pay, the insurance offers you a disincentive to return to work and encourages you to commit fraud.

Optional Policy Benefits

When you're considering an income insurance package, the final ingredient is the inclusion of any **optional policy benefits**. And disability income policies provide a smorgasbord of options.

The ones that appeal to most people include:

- **Future Increase Option**. This is important if you're under 40 years of age. It protects future insurability by providing the guaranteed right to purchase additional amounts of disability income insurance in future years. (The assumption is that you will get raises over time.) Normally, the rider is not available past age 40, although some insurers may offer it up to age 50.

- **Cost of Living Rider**. To protect the purchasing power of disability income benefits, many applicants add the Cost of Living Rider to their base policy. This simply states that, as a predetermined cost of living standard increases, the benefits provided by the policy will increase by a corresponding amount.

- **Lifetime Benefits Option**. Although it is a relatively expensive option, Lifetime Accident and Sickness has particular appeal to a person who is likely to experience dramatic increases in earnings over the years.

> **Example:** A young physician in the first year or two of practice may not be earning a substantial amount of income, but most certainly will over his or her professional career. A career ending in disability would have a drastic effect on such a person by substantially reducing potential lifetime earnings. Extending the benefit period for life will help reduce the effect of such a loss.

These and other optional benefits are described in more detail below.

> The additional premium charged for most of the optional benefits described here is relatively low. Depending on the option, the additional cost would range from $30 to $100 annually.

Future Increase Option

This option also may be referred to as the **Guaranteed Insurability Option** or **Guaranteed Purchase Option**, since it enables you to purchase additional disability income protection—regardless of your insurability—at specified future dates.

This benefit comes with several limitations:

- The premium charged for the **future coverage** will be based on your age at the time of purchase—not your age when the policy was originally issued.

- You will be able to purchase only a specified, predetermined amount of **additional disability coverage** at each option date (many insurance companies limit the amount of additional coverage available to half the original amount.)

- Your **earned income** must warrant additional coverage.

There are a **specific number of option dates** on which you may purchase additional coverage. Usually, these option dates will be every two or three years from ages 25 to 40—or, sometimes, to age 50. These dates may be arbitrarily selected by your insurance company, or they may coincide with your birthday, marriage or births of children.

For example, George, age 24, earns $3,000 per month and currently has a disability income policy that provides a monthly benefit of $2,000. His company's issue and participation limits are 70 percent of monthly earnings. His policy contains a future increase option, which allows George to purchase an additional benefit of $300 per month on his 25th, 28th, 31st, 34th, 37th and 40th birthdays—plus upon marriage and the birth of children.

George doesn't see any increase in his salary by the time he turns 25, so he's unable to exercise the $300 option amount ($2,300 in benefits would exceed 70 percent of his monthly salary).

However, when he turns 28, George is making $3,500 a month. He can exercise the $300 increase ($2,300 is less than 70 percent of his monthly salary). A year later, George gets another raise and gets married. With his

salary at $4,000 a month, he can exercise his option again—and increase the monthly benefit to $2,600.

Cost of Living Benefit

The purchasing power of fixed disability benefits may be eroded due to inflation and increases in the cost of living. To protect against these trends, most insurance companies will offer an optional **cost of living benefit**.

Under this option, your monthly disability benefit automatically will be increased as needed, once you are on claim. Typically, this increase will occur after you are on claim for 12 months—and each 12-month period thereafter—as long as you remain on claim.

> **Once you're off claim, the total disability benefit reverts back to the original amount.**

Many insurance companies will permit a person to **buy back** the additional monthly benefit when coming off claim. This means your available disability benefit will be increased to include the cost of living adjustments—and the premium charged will be increased to reflect the bigger benefit.

For example, Lucy has a disability income policy with a $1,000 monthly benefit and a cost of living benefit. She's totally disabled for five years and gets a 5 percent cost of living increase each year. During her time on claim, she gets a $200 per month increase in her disability benefit. Eventually, she recovers from her disability and can return to work. When she does, she can pay a slightly higher disability premium and keep the extra $200 a month in force.

If you buy back a cost of living increase, the additional premium will be based on your age at the time of the buy back.

Lifetime Benefits Option

This option extends your benefit period from age 65 to your lifetime. This extension may apply to **accident only benefits** or to **accident and sickness benefits**.

Normally, it means that if the total disability is due to an accident and it occurs prior to age 65, benefits will be paid for the rest of your life, provided you remain totally disabled.

Most companies will place some time limitations for the lifetime sickness benefit. That is, the disabling sickness must begin prior to a specified age, such as 50 or 55. A policy providing lifetime sickness benefits might state, if total disability, due to sickness, begins at age 55 or earlier, total dis-

ability benefits will be paid for the lifetime of the insured. If total disability begins at age:

- 56—total benefits are paid to age 65, then 90 percent of the benefit will be paid for the lifetime of the insured;

- 57—total benefits are paid to age 65; then 80 percent of the benefit for the lifetime of the insured;

- 58—total benefits are paid to age 65; then 70 percent of the benefit for the lifetime of the insured; and so on.

The **progression of benefits** would continue in this manner until age 65. If the total disability began at age 65 (typically, the policy is not renewed past age 65), then the payment of total disability benefits would be limited to one or two years.

Rehabilitation Benefits

Rehabilitation benefits is an optional coverage that can be purchased with a disability income policy and an optional benefit that can be claimed under most workers' comp systems. As a result of a disability, you may not be able to return to the work you were doing before, but you may be able to work another job. However, moving to a new job or career may necessitate some vocational training.

> **If you elect to participate in vocational rehabilitation, total disability benefits will continue as long as you are actively participating in the training program and remain totally disabled.**

Some insurers may provide a **lump sum payment** for vocational training. Whether a lump sum or a monthly payment, this benefit enables you to take positive steps toward returning to work. Thus, this option benefits both you and the insurance company.

Social Security Riders

The Social Security Administration defines **total disability** as the inability to perform any substantial gainful work. In addition, the disability must be expected to last at least 12 months or end in death. Clearly, this is a very conservative definition of *total disability*.

As a result, the Social Security Administration denies about two-thirds of the disability claims filed each year. For that reason, many people buy special disability coverage that will take effect whenever Social Security won't.

This coverage may be called a **Social Security Rider** or simply an **Additional Monthly Benefit (AMB) Rider**. Regardless of the name, the purpose is the same—to provide additional disability income benefits during the first year of a claim, while you are waiting for Social Security to begin.

> These riders also are used to complement other disability income sources, such as short-term group disability benefits provided through an employer.

There are two different methods by which a rider may provide benefits:

- **All or Nothing Rider**. Under this concept, you will be paid a benefit if Social Security pays nothing. Conversely, if Social Security provides any benefit, then the rider pays nothing.

- **Offset Rider**. The benefit provided by the rider will be reduced, or offset, by the amount of any benefit provided by Social Security.

The Additional Monthly Benefit rider also can be used to complement group disability coverage. For example, Jack has a short-term group disability benefit through work. This provides him with a benefit of $1,000 per month for a period of one year, after which no benefit is provided.

Jack needs and can qualify for a disability income benefit of $1,500 per month, payable to age 65. To coordinate his individual plan with the group plan, Jack should purchase a $1,500 total disability benefit payable to age 65 with a one-year EP. This will take over when his group coverage stops. He also should buy a $500 Additional Monthly Benefit Rider with a 30-day EP and a benefit period of one year. This will supplement his group policy.

Hospital Confinement Rider

Ordinarily, you have to wait until the elimination period has been satisfied to begin collecting any disability benefits. However, the **hospital confinement rider** will begin paying the regular total disability benefit *during* the elimination period, if you are hospitalized. However, the benefits will be paid only as long as you are in the hospital.

Example: Sean has a disability income policy with a 30-day elimination period and a $1,000 monthly benefit for total disability, payable to age 65. He also has the hospital confinement option. He is hospitalized for minor surgery for a period of two days. Following the hospitalization, he returns to work within three days. Sean can claim total disability benefits for the period of two days. The amount paid will be 2/30 of $1,000—or $67.

Non-Disabling Injury Rider

This option does not pay a disability benefit. Rather, it provides for the payment of **medical expenses** incurred due to an injury that does not result in total disability. In short, it's a form of health insurance.

Example: Arthur has a disability income policy that includes the non-disabling injury benefit. He's injured in a recreational baseball game at a picnic. He is taken to the hospital for X-rays and treatment for a badly sprained ankle. He incurs medical expenses totaling $550, but returns to work the next day. He doesn't receive any disability income benefits, but he would be reimbursed $550 for his non-disabling injury.

> This is a kind of coverage that makes most sense for people who have trouble qualifying for traditional health insurance. It is a kind of loophole for insuring medical costs.

Waiver of Premium

This rider specifies that, in the event of a disability, premiums will be waived retroactively to the date of the disability. The waiver usually requires **permanent and total** disability, though some policies allow broader claims.

> A caveat: Many people assume that all forms of insurance include this kind of waiver. Unless they include it specifically, almost none do.

Accidental Death and Dismemberment

Like stand-alone accidental death and dismemberment insurance, **AD&D riders** include a death benefit, which is payable in the event of death resulting from accidental bodily injury. A companion coverage is provided for loss of limbs or sight, often called **dismemberment coverage**.

When you buy this additional coverage, your insurance company will attach a **schedule** that lists various dismemberments and losses of sight for which specified sums will be paid. The sums payable usually are expressed as percentages of the death benefit limit, or sometimes as percentages of a limit in the policy known as the **principal or capital sum**.

> The intent of the dismemberment feature is to provide you with a lump sum that will help you through any period of rehabilitation or pay for training for work other than what you used to do.

In some cases, however, you might be disabled for a while and—during the disability—suffer one of the losses listed in the schedule. In this situation,

you would be paid disability income up to the time of the loss of limb or sight only, then you would receive the lump sum.

Most company policies provide that, even if you are not disabled after an accident, if a loss of limb or sight occurs within 90 days of the date of the accident, the sums in the schedule will be paid.

Accidental death and dismemberment coverage provides both a life insurance and a health insurance benefit. However, the life insurance benefit applies only to accidental death and is not paid for death by natural causes.

Presumptive Disability

This benefit usually is considered optional and provides for **total disability benefits** to be paid if an injury or sickness causes you the total and irrecoverable loss of:

- speech;

- hearing in both ears;

- sight in both eyes; or

- use of bodily limbs (hands, legs, etc.).

So, if you have a stroke and—as a result—lose the ability to speak, you have suffered a presumptive disability and would be entitled to total disability benefits for the duration of the benefit period.

Usually, the requirement that you be under the care of a physician is waived due to the nature of presumptive disabilities.

The claims process typically is simplified with presumptive disabilities. Normally, when you have a disability claim, you and an attending physician must complete a claims form periodically—every month or once a quarter—for the duration of the claim.

For a presumptive disability claim, there is a single claims form to be completed at the onset of the claim. Due to the severity of the disability, no further claims forms usually are needed.

How Insurance Companies Price Disability Coverage

In order to make good decisions as a consumer of disability income insurance, you should have some understanding of how insurance companies price the coverages they sell. We'll take a brief look at this pricing process—and give you some tools for asking the right questions if an insurance com-

pany quotes you a premium that seems too expensive.

The insurance company's sources of information include:

- the agent, also known as a **field underwriter**;

- the application—including the agent's statement;

- **inspection reports**;

- **medical information** and attending physician's reports; and

- other information, such as occupational or avocational questionnaires.

The field underwriter is usually the only person who actually sees you. So, it's his or her job to deal with subjective or personal issues—and to provide the insurance company with clear and accurate information about you.

In this process, one of the underwriter's most important responsibilities is the completion of the insurance application. It contains such information as:

- your age and sex;

- your occupational history;

- information about any unusual hobbies or avocations you may have;

- your past medical history, your family's medical history and current physical condition;

- your moral habits;

- information regarding other insurance that you own; and

- your net worth.

Age and Sex

From the perspective of the insurance company, your age and sex are important. This is especially true regarding gender.

A fact that most people find surprising is women become disabled **more frequently** than men do. Therefore, women present a higher disability risk. This is opposite to most trends in the life insurance market—where women are usually a lower risk.

Insurance experts have various theories about why women make disability claims more often than men do. The most common: Women pay more attention to their health than men do—and, therefore, use disability insurance

more frequently. This contributes to their longer life expectancy and lower life insurance rates. They also get **pregnant** occasionally.

> **Whatever the reason, the underwriting impact remains clear: Because women pose a bigger disability risk, the disability income premiums for women are usually higher than for men.**

Age is also a factor in pricing coverage, because the duration of a disability generally increases as you get older. Your body does not respond to trauma as it did when you were younger. For example, small children can experience major accidents or sicknesses and "bounce back" much more quickly than older people.

Another factor that might increase the duration of disabilities among older people is motivation. Insurance companies that do a lot of business in disability coverage claim that older people sometimes subconsciously decide to ease their way into retirement as a result of a disability. According to this scenario, a 55- or 60-year-old simply may not be as motivated to return to work following a serious disability.

Occupational Classification

The **kind of work** you do is a very important factor that affects the cost and structure of disability income insurance. Most insurance companies group jobs according to the risk of injury they pose. These groups typically are identified as Classes 1, 2, 3 and 4 or A, B, C and D. Class 1 (or A) occupations are the least hazardous and Class 4 (or D) occupations are the most hazardous.

The following chart illustrates a typical occupational classification table.

Occupational Classifications

Class 1 (or A) Physicians, dentists, lawyers, accountants, school teachers, actuaries, insurance sales representatives, corporate officers, most engineers, architects, corporate executives.

Class 2 (or B) General clerical employees, bank tellers, inside salespersons, outside salespersons with limited travel, most building contractors (office duties only), barbers, electricians (no high voltage work), chemists, registered nurses, practical nurses.

Class 3 (or C) Bartenders, waiters and waitresses, cooks, gas station attendants, salespersons with extensive travel, high-voltage electricians, plumbers, mechanics, most factory workers.

Class 4 (or D)	Bridge workers, construction workers, truck drivers, sanitation workers, fire fighters, police personnel, mine workers, tree trimmers, window washers.

If you work in a Class 3 or 4 occupation, an insurance company will multiply the base rate for coverage by a factor of anything from 1.1 to 3.0 to determine the premium you have to pay. These multiples usually will be determined, at least in part, by a company's claims history for particular occupations.

> Pricing models for disability income insurance are not standard. Different insurance companies will sometimes classify the same job differently. And the multiples that one insurance company applies to job classifications may be different than those used by another company. So it pays to shop around.

Another occupational pricing factor: An accident or sickness that would be considered minor for someone in most occupations could be totally disabling in other jobs. For example, a beautician with an infected finger due to a torn cuticle might be unable to perform the duties of her occupation and be disabled. A bank president with an infected finger is not likely to be totally disabled. Therefore, in this context, a beautician would present a higher **occupational risk** than a bank president.

The **benefit amount** also may be restricted by occupation. For example, a doctor may be able to purchase up to $15,000 a month of disability income protection, but a plumber who may have the same earned income as the doctor is limited to a maximum benefit of $5,000 per month—due to the higher occupational risk to which the doctor is subject.

Still other restrictions or limitations may apply due to a person's **occupation**. For example, a fire fighter may have a restricted maximum benefit amount—and only may be able to purchase a disability income policy with a maximum benefit period of two years and nothing shorter than a 90-day EP, due to the occupational risks involved.

Sometimes, there is a range of risks within a given occupation. For instance, a salesperson working in a clothing store does not present any unusual degree of risk—but a travelling salesperson who drives 60,000 to 80,000 miles per year is exposed to a much higher level of risk.

Hobbies

Even if your occupation is relatively risk-free, what about your hobbies? Such hobbies as skin diving, scuba diving, sky diving and auto racing are

certainly more hazardous than golf or tennis. For this reason, the insurance company will ask if you have any high-risk hobbies when it's considering your application for disability income. If you answer yes, you'll have to fill out an **avocation questionnaire**, providing more specific information about your hobby.

Example: Gail worked her way through school as a scuba diving instructor. Now, as a marketing executive for a computer software company, she still dives occasionally—on weekends, vacations and whenever else time allows. After she submits an application for disability insurance, the company writes back to her and asks her to fill out a questionnaire about her hobby. It includes questions about the location of these dives, frequency, depths, etc.

The insurance company may determine that Gail dives occasionally enough that the hobby doesn't pose much of an additional risk. More likely, though, it will determine that her diving does make her more likely to suffer a disabling injury.

The company may sell Gail the policy. But it probably will add a surcharge to her premiums to reflect the added risk that scuba diving presents.

Medical Profile

Naturally, the insurance company will be interested in your medical history and your current condition. If you have chronic back problems, you obviously are more likely to become disabled than if you are completely healthy.

Most disability insurance companies ask you about your medical history—and your family's—on a policy application. They also may ask you to take a physical exam (usually at the company's expense).

If you have to have a physical examination performed by a doctor in lieu of simply answering medical questions, your application normally is referred to as a **medical application**. If the company obtains medical information simply by reviewing answers to questions on the application, it is referred to as a **non-medical application**. Depending on the medical problem, your personal physician may be asked to complete an **Attending Physician's Statement**. The purpose of this report is to provide more detailed information about your medical history or current physical condition.

Past medical history refers to what *was*; **current physical condition** refers to what *is*. These two factors, plus hereditary traits—such as heart disease or diabetes—would indicate what will be (or a prognosis for the future).

Example: Ralph has just been given a clean bill of health following a

physical exam. A week later, he has a severe heart attack and becomes totally disabled.

How can this happen? The family physician normally is looking at the patient today—at a specific moment in time. It is entirely possible that at that precise moment, Ralph appeared to be in excellent condition.

He came from a family with a history of heart problems, though. And for many years he had been overweight, with a high cholesterol diet and a sedentary lifestyle. Even though he had trimmed down a bit before his physical, he was a candidate for heart problems.

> Due to the evasive nature of disability, an insurance company will look at your medical history and your family's medical history, as well as your current condition, in its attempt to determine whether there is any unusual physical or medical risk involved.

Moral Hazards and Morale Hazards

An insurance company will also try to determine whether or not you present a moral hazard or a morale hazard—that is, whether you behave in a way or have chosen a lifestyle that suggests you might have claims problems or that invites disability risks.

A person who presents a **moral hazard** might be the type who would file a fraudulent disability claim in times of financial distress. The old insurance industry saying "pain doesn't show up on an X-ray" gets to the issue of moral hazard. A disability policyholder could claim a whiplash neck injury as the result of a relatively minor auto accident—when, in fact, he is not disabled. Any tendency to use the disability income policy wrongfully is an example of a moral hazard.

In determining whether you pose a moral hazard, the insurance company will look to see if you've had your driver's license suspended or revoked, or if you have a history of substance abuse or a record of criminal activities.

In addition to moral hazards, a disability insurance company also will try to avoid insuring any **morale hazards**. A morale hazard is an indifferent attitude displayed by a person that increases the risk of loss. From an insurance company's point of view, a person who regularly receives speeding tickets might be demonstrating an indifferent attitude toward the risk of injury due to high speeds.

Again, the policy application is the main mechanism by which a company evaluates moral or morale hazards. If the company does conclude that you pose either of these additional risks, it will add a surcharge to the disability premium or—more likely—decline the application.

Other Insurance

Another factor that impacts how much a disability insurance company will charge for coverage is how much—and what kind—of **other insurance** a person carries.

Once it has obtained accurate information regarding the amount, elimination period and benefit period of other coverage you carry, the company will price its policy accordingly.

The company's goal in this process is to **prevent overinsurance**. The company also wants to make sure that it generates enough premium income from the policy to cover—on average—a maximum benefit claim.

Net Worth

Your total **net worth** also may affect the amount and price of disability income coverage a company will sell you. A person with $1 million in the bank probably doesn't need disability income insurance.

The amount of total net worth and the liquidity of such assets will determine whether a **reduced amount of disability coverage** will be issued—or no coverage at all. If your assets are easily marketable or if you have a large amount of unearned income, then the underwriter may decide that you are not eligible for any coverage.

For example, Joe is an orthopedic surgeon who earns $120,000 a year. His insurance company's issue and participation limit is 60 percent of earned income. It characterizes him as a Class 1 occupational risk. So, at this stage, Joe would be insurable for $6,000 a month of disability income coverage.

But Joe also has about $60,000 a year of unearned income from rental properties, interest and dividends. This complicates things.

The combination of $6,000 of monthly disability coverage plus $60,000 annually of unearned income may remove Joe's incentive to return to work. Joe's insurance company therefore may reduce the amount of disability income protection it will sell him to reflect the impact of his unearned income. It could decide to issue Joe only $3,000 per month of disability income coverage.

A Personal Interview

After you've submitted a disability insurance application, a personal interview usually is performed by a **trained interviewer**. The interview normally is completed over the telephone.

Generally, the purpose of the interview is to verify application information. Specifically, data regarding medical history, hobbies and occupational duties may have to be explained or additional information may need to be

gathered through this report. (You will be notified of this interview in advance. Typically, this is done in writing.)

Standard and Substandard Risks

Once all the information has been reviewed, an insurance company makes a decision about the acceptance of the risk.

Most applicants are classified as **standard risks**, which basically means that they fit the profile of an average policyholder. In these cases, a policy will be issued as applied for by the applicant. The rate or premium charged will be the standard premium relative to the person's age, sex and occupation—as well as the benefit amount, elimination period and benefit period selected.

Occasionally, an applicant for disability income will be classified as a **substandard risk**. This usually results from a problem with one or more of the factors we have considered—such as a past or current medical problem or evidence of a moral hazard.

One point mentioned before bears repeating: The **factors that impact disability insurance** coverage are different than the factors that might influence life insurance or other coverages. If you have a history of back problems, you might have no trouble getting life insurance—but a lot of trouble getting disability insurance. You won't usually die due to a backache, but you certainly could become disabled because of one.

If you are classified as a substandard disability risk, an insurance company has several alternatives available for issuing a special policy:

- an **extra premium** may be charged whereby the coverage is issued as applied for and the higher premium is used to compensate for the higher risk involved;

- a **rider** may be attached to the policy, modifying the coverage (a full exclusion rider is used when the nature of the condition is likely to result in recurrent disabilities—for example, a full back exclusion rider may be used for people with chronic back disorders);

- a **qualified condition exclusion** rider may be used to exclude coverage for a specified medical problem for a specified period of time;

- the company may **change the elimination or benefit period** for disabilities related to a particular medical condition, (example, Larry has a disability income policy with a 30-day elimi-

nation period—and a rider that calls for a 90-day elimination period for any disability due to a gall bladder disorder. The insurance company will cover a disability due to gall stones, but no benefits would be paid until after 90 days);

- the insurance company may increase the elimination period or shorten the benefit period for the **whole policy** to compensate for the medical disorder (example: Ellen has a problem with ulcers and applies for disability income protection with a 30-day elimination period and a to-age-65 benefit period; due to the nature of the disorder, her insurance company decides to issue Ellen a policy with a 180-day elimination period and a five-year benefit period).

Of course, a final alternative available to the insurance company is simply to deny coverage.

Group Coverage

Many people have at least a small amount of disability income insurance through benefits offered by their employers. These **group disability income policies** (like group life policies) are underwritten on very liberal terms.

Policies usually are provided without any reference to an individual's medical information. Most insurance companies, however, will require that a certain number of employees participate in a group plan (such as 10, 25, etc.) for that plan to be issued without evidence of insurability.

Generally, you're required to provide information regarding your address, social security number and certain work-related information.

The insurance company will concentrate on such group factors as occupational duties, industry type and the amounts of disability income being offered. Due to the nature or risk of an occupation, the insurance company may limit or refuse to write group disability income coverage for certain groups—such as for the mining industry, the lumber industry, the entertainment industry, etc.

> Group disability coverage usually will be limited to not more than 70 percent of your earned income and subject to a low maximum benefit—such as $1,000 or $2,000 per month for a year.

Because there is no medical underwriting involved with group cases, the underwriter's primary job is to protect against overinsurance or large amounts

of coverage and adverse selection against the insurance company. **Adverse selection** occurs when an insurance policy encourages people with the highest risk profiles to use the coverage—and encourages those with lower risk profiles to find more cost-effective insurance.

To avoid adverse selection, the insurance company may limit the amount of coverage offered, decline to write the group policy at all or offer the coverage on a non-occupational basis. **Non-occupational coverage** will not offer benefits for work-related disabilities.

Although not group insurance, strictly speaking, **association coverage**— offered to members of a trade association or other group—has some of the same underwriting characteristics as group coverage. Association coverage might be described as individual policies administered as group insurance.

Most association plans require some medical underwriting or what is sometimes referred to as **simplified or progressive underwriting**. Association underwriting may take the form of three or four medical questions asked of the individual. Due to the size of the association membership, relatively minor medical problems may be overlooked and policies issued.

Nevertheless, even with simplified underwriting, it is possible for a member to be declined for the insurance—unless the association offers a guaranteed-issue plan.

In addition, the underwriting procedure is simplified by the fact that there are limits as to the amount of coverage that may be issued, as well as the length of the elimination and benefit periods. There is also no need to occupationally classify association members, since they all have essentially the same occupation, which is normally low risk.

Premiums for association coverage normally are banded by age and amount. For example, everyone between the ages of 25 and 30 pays the same premium for a 30-day EP and a $1,000 monthly benefit payable to age 65. From age 31 to 35, a new band of premiums would be used, and so on.

Another underwriting consideration with regard to association coverages pertains to **the place** where the association member conducts his or her business. Normally, individuals who work out of their homes cannot qualify for disability income coverage because it is difficult to determine if, in fact, they do become disabled. Their workplace is also their recovery place—and, thus, a conflict arises.

Often, the underwriter simply may decline to offer this type of association any coverage at all.

Conclusion

A disability income insurance policy is priced according to your age, sex, occupation and health—factors you can't typically change.

But as with other types of insurances there are other factors that you can change that will affect the policy's premium—and help you customize the benefits to suit your needs. These factors are the length of the elimination period, the length of the benefit period and the benefit amount.

The following chart illustrates these points.

<div style="border:1px solid">

Premium Considerations

Objective	Actions
Lower the premium	Reduce the benefit period
	Increase the elimination period
	Reduce the benefit amount
	Eliminate optional benefits
Raise the premium	Increase the benefit period
	Decrease the elimination period
	Increase the benefit amount
	Add optional benefits

</div>

Other factors that will affect the price of your policy include any optional coverages you may buy. The purpose of these **optional benefits** is to enhance overall protection and to help meet your specific needs. The more common optional benefits include the Future Increase Options, Cost of Living Rider, Social Security Rider and the Additional Monthly Income Rider.

Key Questions

1) What is your current monthly earned income? (Refer to the Disability Needs Assessment Worksheet.) _____

2) What is your current monthly non-earned income? (Again, refer to the Disability Needs Assessment Worksheet.)

3) How much total monthly income do you need to insure? (This figure is the bottom line on the Disability Needs Assessment Worksheet, and it would be equal to your monthly benefit.)

4) Would you like a 30-day, 60-day, 90-day or longer elimination period? (A longer elimination period means a lower premium.) _____

5) Would you like a one-year, two-year, three-year, five-year or to-age-65 benefit period? (A longer benefit period means a higher premium.) _____

6) Would you like the Future Increase Option, also known as the Guaranteed Insurability or Guaranteed Purchase Option?

Yes No

7) Would you like the cost of living benefit? Yes No

8) Would you like the lifetime benefits option? Yes No

9) Would you like rehabilitation benefits? Yes No

10) Would you like a Social Security Rider? Yes No

11) Would you like an Additional Monthly Benefit Rider?

 Yes No

12) Would you like a hospital confinement rider? Yes No

13) Would you like a non-disabling injury rider? Yes No

14) Would you like the waiver of premium option? Yes No

15) Would you like the accidental death or dismemberment rider?

 Yes No

16) Would you like the presumptive disability option?

 Yes No

17) Do you have any risky hobbies? Yes No

 If yes, what are they? _____

18) Do you have any medical problems that might make you a
 substandard risk? Yes No

 If yes, what are they? _____

19) What other disability insurance do you have (e.g., a group
 policy through work)? _____

Chapter 14

The Different Kinds of Life Insurance

Life insurance has been bought and sold in the United States since the mid-1700s, but it wasn't until the 1840s that the industry made a significant impact on the American business scene. Since that time, **individual life insurance** has grown steadily.

Life insurance plays an important role in the financial planning of many families. More than 80 percent of American households have purchased individual life insurance policies.

In the purest sense, life insurance is something that pays a **death benefit** to someone when you die. Its primary purpose is to protect against the risk of you dying too soon. Your premature death would expose your family or business to certain financial risks, such as burial expenses, paying off debts, loss of family income and loss of business profits.

You also may want your life insurance policy to pay estate taxes or to set up a college fund for your children.

> **If you don't have dependents, you probably don't need life insurance. But if you have a spouse, children or elderly parents who rely on your income, you need to consider buying life insurance to pay expenses for them. You also may want to consider insuring the life of a spouse who is not earning money—particularly if that spouse is caring for your children. (Not only would you have funeral expenses, but you'd have to start paying for child care.)**

Life insurance is the only financial services product that guarantees a specific sum of money will be available at exactly the time it is needed. Savings accounts, mutual funds, stocks, bonds and other investments do not make such a guarantee—and, in fact, they can be tied up in probate at the time of your death. Life insurance will be available immediately—and it creates, in essence, an estate that did not previously exist.

Over the years, life insurance policies have evolved from fairly straightforward contracts that provided a simple death benefit into complex contracts that often include numerous types of benefits and features. Life insurance companies have been particularly creative in the last couple of decades, introducing new combination products at a remarkable rate. Many of these are designed to serve a particular type of client—or in response to changing economic conditions and consumer preferences, and that trend is expected to continue, making it even more difficult to choose the right policy.

The Basics

With life insurance, you get what you pay for. What you pay for is the policy's **face amount**—the amount the life insurance company will pay when you die.

Since the face amount of the policy is payable upon the death of the insured person, the element of risk to the insurance company is much different than it is for an automobile policy. When an insurance company issues an auto policy, it hopes you will be a safe driver and will never have an accident—so you'll never file a claim. When an insurance company issues a life policy, it knows it will be called upon to pay a claim someday, because every human being dies. For the insurance company, the only unknown is whether the claim will be made in one year or in 50.

Not surprisingly, life insurance costs vary based on your age, health and the amount of insurance you buy.

The term **ordinary insurance** is sometimes used to describe individual life insurance. There are three broad types of individual or ordinary life insurance—**whole life, term life and endowment policies**.

A caveat: There are no standard policies in life insurance, as there are for homeowners or automobile insurance. This makes it tougher to comparison shop among companies.

Death benefits are the one thing that all types of life insurance have in common. If it doesn't pay a death benefit, it isn't life insurance. The death benefit *is* the pure life insurance protection.

You could argue that anyone who knew for certain he or she would live to an old age would be foolish to spend money on life insurance. The premiums could be put to better use over the course of a long life—and it would only be necessary to set aside a small sum for the eventual funeral.

But none of us can be certain that we will live for a long time—even if

our ancestors are long-lived. There is always the possibility that a disease or accident will result in a premature death. Anyone can become a victim of a natural disaster or an act of violence.

More Than Just Death Benefits

The need to cover expenses and replace lost family income if a person dies young is the main reason people purchase life insurance—but it is not the only reason. Today, many forms of life insurance include other types of benefits, in addition to a death benefit, and people also buy life insurance to protect against the risk of *not* dying prematurely—to protect against the risk of living for a long time.

Certainly death benefits continue to play a major role in life insurance sales presentations and purchase decisions, but the many uses of life insurance today extend far beyond the original concept of a death benefit.

Many transactions that may add to your family's finances and security can be backed up by life insurance. For example, when you go to borrow money for a real estate purchase, an investment opportunity or starting a small business, the funds may not be available unless you purchase insurance on your life—to protect the interests of the lender, in case you die before you pay off the loan. In this way, life insurance can be used to help you build personal assets and family security.

In addition to death benefits and investment opportunities, many life insurance contracts include other types of insurance benefits. These **non-life insurance benefits** may be included in a policy, or they may be attached as optional riders.

One of the most common is known as a **waiver of premium**. This is actually a disability insurance benefit, which pays the life insurance premiums while you are disabled. You also can attach a **disability income benefit** to life insurance policies, which will pay a monthly income if you become totally disabled.

Dismemberment benefits may be attached to a life insurance policy, too, most frequently in the form of **accidental death and dismemberment** benefits. This pays an additional death benefit if you die because of an accident. (When twice the face amount of the policy is paid upon death occurring accidentally, such coverage popularly is known as **double indemnity**. However, as anyone who's ever read a detective novel can attest, an accidental death is sometimes hard to determine.)

The dismemberment part of the benefit pays a specified sum if you lose one or more limbs, or sight in one or both eyes and, in some cases, hearing as

the result of an accidental injury. Since you are still alive and this is not a death benefit, it is not—technically—a form of life insurance.

> In recent years, the concepts of *living or accelerated benefits* and *long-term care coverage* have been showing up increasingly as benefits attached to life insurance contracts. In the case of living benefits, a portion of the proceeds that would otherwise be payable as a death benefit is advanced if you have a terminal disease and a need for special medical care. It is widely acknowledged that this is a humane application of life insurance proceeds, because the funds often are used to ease pain, suffering and discomfort during the final period of life. These benefits usually are provided without charge, because the payment of a death claim is imminent.

Long-term care benefits pay for nursing care, home health care or custodial care (assistance with the tasks of daily living, such as eating, bathing, dressing, etc.), which may be needed following a period of hospitalization. This is actually a health insurance benefit; however, it is often available as a rider to a life insurance policy.

When sold as a separate benefit, an additional premium is charged and the benefit will not affect the policy's face value or cash value. When sold as part of an integrated plan, an additional premium is not charged for long-term care benefits, since they are simply borrowed from the life insurance benefits—and accordingly reduce the remaining **face value** and **cash value**.

Term Life

The two most common forms of life insurance policies are term life and whole life. The names are remarkably apt. A **term life** policy lasts for a set period, say 10 years. If you die during that 10-year term, the policy will pay. If you don't, it expires and that's that.

A **whole life** policy lasts for your whole life. You absolutely will die during the policy period for a whole life insurance policy (although most will pay you the benefit before you die, if you live to be 100).

Typically, **term life** insurance provides protection for a period of from one to 20 years. The best way to think of term life is as temporary insurance. A whole life policy is permanent insurance.

Term products usually are used when you have a temporary need, such as a mortgage, business obligations or a particular need for income when your children are young.

Whole life products are effective when you have a permanent need, such as to supplement your surviving spouse's income, cover funeral costs, pay capital gains taxes, to make charitable donations and even pass a family business from one generation to the next.

A term policy does not build any cash, loan or surrender values. It essentially provides a death benefit only.

For this reason, it is usually the least expensive form of life insurance—and the one most likely to be used by cash-strapped young families. Its low cost allows you to buy higher levels of coverage at a younger age, when your need for protection is often greatest.

Of course, it would be simply if there were only one kind of term life to consider. Instead, there are three. **Level term** provides a consistent amount of insurance throughout the policy period. **Decreasing term**, which is a good type of insurance to use to cover a shrinking debt obligation (such as a mortgage), starts with a specified face amount, which decreases annually until it reaches zero when the policy expires. **Increasing term** provides a growing amount of insurance, but the need for this type of protection is rare.

Some term policies are **renewable**. The benefit here is that you don't need to prove to the insurance company that you are still "insurable" (you wouldn't have to mention your new heart condition, for instance) to renew the policy. But, each time you renew, the premiums will be higher because you are older and, therefore, more likely to die during the policy's term.

Many term policies are also **convertible**, which means they may be exchanged for another type of life insurance. Choosing a **convertible term life policy** is one way to make sure you will be able to get permanent coverage at a later time, without having to prove that you are still insurable.

You won't want to stick with term life insurance for your entire life (assuming that you live a long time). By the time you reach 70 or 80 years of age, the **premiums** for a term policy usually approach the face amount of the insurance, because the insurance company figures you're going to die soon.

Whole Life Insurance

Whole life insurance, sometimes called **straight life** or **permanent life**, is protection that can be kept as long as you live. This is what is typically thought of as traditional life insurance. It enables you to pay the same premium over the years—averaging the cost of the policy over your lifetime.

Whole life insurance builds a **cash value**—a sum that grows over the years, tax-deferred. If you cancel the policy, you receive a lump sum equal to this amount (and you pay taxes on it only if the cash value plus any dividends exceeds the sum of the premiums you paid). If you need to stop paying premiums due to a temporary financial crisis, you can use the cash value in the policy to pay those premiums for a period of time. You also can withdraw

part of the cash value in the form of a **policy loan**. (If you die before repaying it, the loan and any interest due is repaid from the death benefit amount.)

The **face amount** in a whole life policy is **constant**, and this amount is paid if you die at any time while the policy is in effect. The policy is designed to mature when you reach 100 years of age. If you do live to be 100, you won't have to pay any more premiums, and the policy's cash value will be equal to the face amount. So, the insurance company usually will pay you the face amount—even though you're still alive.

Although whole life policies are among the most common forms of insurance sold, most individuals do not plan on paying premiums until age 100. More commonly, whole life insurance is used as a form of **level protection** during the income-producing years. At retirement, many people then begin to use the accumulated cash value to supplement their retirement income.

> **Whole life insurance plays an important role in financial planning for many families. In addition to the death benefit or eventual return of cash value, a whole life policy has some other significant features.**

For instance, it may pay dividends. Whether or not is does is the primary difference between a **participating (par) policy**, issued by a mutual life insurance company, and a **nonparticipating (non-par) policy**, issued by a stock life insurance company. A participating policy is one in which the policyholders receive dividends (if a dividend is declared).

Many people use these dividends to buy additional amounts of insurance, instead of taking the cash. This is really no different than taking a few extra dollars out of your pocket and making a separate purchase. Still, dividends are often a successful sales tool, because some people like the idea of getting something extra back—even though they've paid more initially.

One of the benefits of a whole life policy is that it *guarantees* the level of premiums you pay, the death benefit and the growing cash values within the policy. It also **guarantees the interest rate** on any loans you take out against the cash value of the policy. (While you also can get a bank loan using the cash value of the policy as collateral, the guaranteed interest rate in the policy may be much lower than that available from a bank.) The only feature that is not guaranteed is a dividend in a participating policy.

Universal Life Insurance

Another common form of life insurance is universal life. With this kind of policy, you may pay premiums at any time, of virtually any amount, sub-

ject to minimums. The amount of cash value the policy builds is based both on the **premiums paid** and on the **interest earned**. The insurance company subtracts money from the fund each month to cover the cost of the insurance and expenses.

> While universal life policies build cash value, they seek to compete in the term insurance marketplace. They offer standard rates that can be substantially cheaper—as much as 30 percent or more—than standard rates charged by insurance companies for comparable term coverage.

Some universal life policies feature **progressive underwriting** (which means it's easier to get coverage, even if you don't look insurable on paper). These policies usually are structured so that if you pay the level minimum annual premiums, coverage won't lapse for 15 or 20 years.

Another form of this insurance is **variable universal life**. It provides death benefits and cash values that vary according to the investment returns of stock and bond funds managed by the life insurance company. These policies also allow you significant discretion regarding the premiums paid each year.

For many people, variable universal life is as much an **investment tool** as a true insurance tool.

Target premiums are fixed in the first year—but policyholders, because of the flexible nature of the products, are not contractually entitled to those amounts in subsequent years. In fact, target premiums for variable universal life insurance are among the highest in the industry. This is why marketers sell variable universal so aggressively—because their commissions are often based on target premiums, so they can make more selling this than any other kind of life insurance.

In some cases, the **cost basis** of variable universal life becomes too uncertain for most people because of the open-ended method of premium payment. There's trouble if the insurance company can't project costs.

Choosing the Right Kind

Determining what type and amount of life insurance is right for you requires some careful thought—and, it sometimes seems, a secret decoder ring.

In addition to term life, whole life and universal life policies, these days, there are a number of **derivative insurance products**, many of which are marketed by aggressive salespeople. These products usually are based on the three major kinds of insurance, but they're complex. They usually have been

designed to fit extremely specialized situations—and often don't make sense for most consumers.

To help you make an informed decision, we'll consider when you would want to purchase a term life or a whole life policy. Then we'll take a look at some of the hybrids on the market.

The debate over whether term life or whole life is the **better deal** likely will go on as long as there is insurance. People who believe in (and often sell) term swear whole life is a rip-off. People who believe in (and often sell) whole life swear that term is the rip-off.

Like the Lilliputians in *Gulliver's Travels* who went to war over which end they cracked first when eating an egg, both sides may seem obsessed with trivia. But there are some important differences between the two kinds of policies.

An old insurance industry rule of thumb holds that people who rent their houses tend to buy term insurance, and people who own their houses tend to purchase whole life. There's some logic behind this. The factors that influence someone to rent are typically that he or she is:

- short on cash;

- in transition—not settled in job, family or place;

- facing financial uncertainty;

- not in a position to make long-term commitments;

- interested in investing money in other ways.

These are the same reasons people give to explain why they purchased term insurance instead of whole life insurance.

Other factors influence people to buy a home. These—which are some of the same reasons people for buying whole life—typically include:

- belief in owning and building equity;

- focus on long-term thoughts and plans;

- sufficient stability to make commitments;

- a desire to accumulate wealth and build savings;

- a need for tax benefits;

- a desire to accomplish financial goals during working years;

- a desire to pass wealth and assets on to children.

The following questionnaire will help you decide which category of insurance would be best for you.

Are You a Term or a Whole Life Buyer?

AVAILABLE CASH

Does your current cash flow allow you to save money? Yes No

If your answer to this question is "no," then term insurance is your only option.

AVAILABLE SAVINGS

Are you consistently saving every month? Yes No

Are you saving as much as you think you could if you
had a systematic plan? Yes No

If you answered "no" to these questions, then the systematic savings feature of cash-value (or whole life) insurance may be of interest.

SPECIFIC SAVINGS GOALS

Do you need to start or increase your
retirement savings plan? Yes No
Not Applicable
Do you need to start or increase your
college savings plan for the children? Yes No
Not Applicable

If you answered "yes," then the tax-free accumulation inside a whole life policy may be interesting to you.

RETIREMENT AND TAX-FREE INCENTIVES

Are you in a high tax bracket? Yes No

Do you plan to work 10 or more years before retiring? Yes No

If you answered "yes," then whole life probably makes the most sense for you.

Whole life and other cash-value life insurance makes the most sense for people in **higher tax brackets** and for people who are planning to **keep the coverage for more than 10 years**.

In contrast, even the most structured kind of term policy will offer you a steady price for a few years—but the insurance company can raise the premium (sometimes 900 percent...or more) if you don't pass a medical exam at the end of the term.

Troubles With Term

The most important right you have in a life insurance policy is the right to **keep the policy in force** without restrictions or dramatic premium increases. Some term policies are guaranteed renewable and some are not. Some require a physical at the end of the term and some don't.

> If the company requires you to pass a medical examination to avoid a premium increase in the future, you have assumed a big risk. You get a discount for taking the risk, but is it worth it?

Some critics of term insurance argue that term insurance companies reduce the premium for a few years so that they can coerce you into a medical examination in the future. This view may be extreme, but there is an element of truth to it. Many consumers are seduced by the low premiums on policies that require medical requalification to maintain a reasonable premium.

To avoid this kind of problem, ask the following questions about any term policy you're considering:

- If I don't pass the medical requalification, what will the premiums be?

- Are they written in the contract? Are they guaranteed?

- If you're required to take and pass a medical exam in order to avoid dramatic increases, how extensive is the exam?

- What standards of underwriting will be applied at that time?

- Will the underwriting standards be the same for requalification as for new applicants?

- Will there only be a "pass" or "no-pass" standard, or will there be a range of ratings?

If the answers to these questions aren't in writing in the policy, get another policy.

More Help Deciding

You don't have to have an in-depth understanding of life insurance to **eliminate some options**. Here are a few scenarios that may help you to decide which kind of coverage is right for you.

- If you're young and have a family and you're broke, a term policy is where you start.

- If you're a young family trying to save money but having a tough time at it, a mix of term and cash value insurance might be ideal.

- If you're divorced and need to (or are required to) maintain life insurance until your children are grown, a level term policy for the number of years necessary will best fulfill this need.

- If you need life insurance for fewer than 10 years, term insurance is a better choice. If you clearly need it for more than 15 years, whole life or cash value wins the race. If you need it for only 10 to 15 years, it's a toss-up.

- For people over 60, term is rarely useful, because premiums quickly become unaffordable.

- The higher your tax bracket, the more valuable whole life or other cash-accumulating insurance will be—if you properly understand it.

- If you've decided to start a college savings plan for your children or grandchildren, a rapidly accumulating cash-value policy might be best.

- If you're in your forties and realize that you need to increase your retirement savings, several types of cash-accumulating policies will make sense.

- If you're over 60 and need life insurance to pay estate taxes, you'll almost certainly need a cash-accumulating plan.

- If you're an active investor under 50 and want to accumulate cash for retirement, a variable universal life plan may be of interest, because you get to control the investment.

- If you are an equity investor, you can use cash-value life insurance as the liquid part of your total portfolio.

Whatever you do, don't buy a policy that you are afraid you can't continue. Cash-value insurance only makes sense if maintained for more than 10 years.

Why is cash-value insurance a poor short-term investment? The costs of operations, commissions, marketing, etc., are loaded into the first few years of the policy. Therefore, the **cash accumulates slowly at first**.

Why is cash-value insurance a good long-term investment? The cash accumulates **tax-free**. Therefore, for people in higher tax brackets who need the insurance for more than 15 years, cash-accumulating policies are the most cost-effective.

You have to decide for yourself on which side of this issue your circumstances place you. It's usually fairly clear whether you need term or cash-value life insurance.

The following chart will help you compare costs for three kinds of policies—term, whole life and a blend of term/whole life.

Term vs. Whole Life

Financial Comparison for 30 Years
Insurance Alternatives for a 40-Year-Old Male
Insurance Benefit: $100,000

Annual Outlay	Term (Plan A)	Blended Term/Whole Life (Plan B)	Whole Life (Plan C)
Year 1	$159	$1,287	$1,884
Year 10	194	1,287	1,884
Year 11	249	1,287	0
Year 20	525	1,287	0
Total Outlay (Age 40-76)	$16,111	$46,314	$18,840
Ongoing Insurance	$0	$238,713	$160,303
Cash Value	$0	$174,257	$110,038
Annual Lifetime Income	$0	$17,406	$11,038

Plan A: Premium increases annually. Insurance ends at age 70.
Plan B: Level premium payments.
Plan C: Level premium payments for only 10 years.

These figures are for illustration purposes only.

A Few of the Hybrids

If the decision to buy term or whole life seems complicated, then you're not going to like what comes next. Not only are there combinations of the two, there are also a plethora of derivative or hybrid policies on the market now, since insurance companies have been scrambling to create products that will meet **particular needs** or **market niches**.

> Some of these policies offer additional benefits. Some offer additional non-insurance benefits. Some will be appropriate for first-time insurance buyers—but most will not.

We couldn't possibly discuss all the different kinds of life insurance products here. (It sometimes seems as if every life insurance company has at least one unique policy.) But we will consider some of the most common combination and derivative products.

Family Income Policy

One of the most popular, and perhaps most useful, of the combination life insurance contracts is the family income policy. This policy combines whole life insurance with **decreasing term coverage**. The term portion of the coverage provides monthly income benefits for the family, and the whole life part of the policy provides a lump sum payment.

Some family income policies split the lump sum into **two parts**. In this case, one-half the policy's face amount would be paid upon your death, to assist in paying for the funeral expenses and the costs of the last illness. This would then be followed by income payments to your designated beneficiary (or beneficiaries) for a period of years—assuming the term part of the coverage had not expired. At the end of the payment period, there would be another lump sum payment equal to one-half the face amount of the policy.

So, a family income policy has two **time elements**. The family income portion of the policy corresponds to the decreasing term time period. The base, or lump sum, part of the policy is usually whole life—thus, some degree of protection is provided for your whole life.

> The family income policy fulfills the need for higher amounts of coverage during the initial child-rearing years. When your children become self-supporting, the need for protection and coverage usually is reduced (unless you begin caring for elderly parents at that point).

Joint Life Policies

Joint life policies are whole life contracts written with **two or more persons as named insureds**. For instance, you and your spouse might decide to purchase a joint life policy.

Most commonly, the policy is issued in this way—with the insured amount payable on the death of the first insured only.

However, some policies pay on both deaths. Some even pay on the first death and then increase the amount of coverage on the remaining insured or insureds, so that the total coverage remains the same (usually for business insurance purposes).

> Typically, a joint life policy will provide a conversion or exchange privilege for the surviving insured, so that person can continue the coverage on his or her life following the death of the other insured.

A variation on the joint life policy is the **last survivor policy**. It pays the insured amount not to the beneficiaries of the first insured to die, but to those of the last.

Modified Life

Modified life is typically a whole life product that is purchased at a very low premium for a short period of time (three to five years)—followed by a higher premium for the life of the policy. The policy may be a combination—

with term for the modified period, converting to a whole life premium. In this way, premiums are lower than average during the modified period—and slightly higher than average (to make up for the early deficit) thereafter.

> **Generally, this type of policy is sold to people who want whole life but, for the next few years, will be unable to pay the typical premium.**

Graded premium whole life is similar to modified whole life in that, initially, the premium is very low. Unlike modified life—which increases to a higher—level premium for the life of the contract, graded premium policies provide for an increase in premium each year for the first five to 10 years of the policy. After this **step rated** premium period, the premium remains level.

Graded premium and modified life policies do build cash value—but the amount of cash value is usually less than for a straight whole life policy, because of the smaller outlay of premium up front. Typically, a graded premium policy will have very little, if any, cash value during the graded premium period.

Deposit Term Insurance

In contrast, deposit term insurance is a level term insurance policy that has a much higher premium for the first year than for subsequent years. The initial premium is significantly higher than the average premium needed to cover the **cost of mortality** during the term period.

The excess front end premium—the deposit—is then set aside to earn interest, and these dollars (the deposit plus interest) will be applied to reduce the premium payments required in the following years. The premium levels are set so that the entire deposit will be exhausted when the final annual premium is paid. In effect, this arrangement provides a method of paying a portion of the premium in advance.

> **Example: The annual premium for a 10-year level term policy may be $500 (a total outlay of $5,000). The same type of policy may be purchased as a deposit term contract for an initial premium of $2,500, followed by annual premiums of $200 (a total outlay of $4,300). The initial deposit and interest are used to make up the difference in premium. Mathematically, the insurance company actually receives an equal amount of premium for these two policies, when the time factor and interest earnings are taken into account, but you get a discount of $700.**

Split-Life Policy

The split-life policy is a combination of a whole life or a term life insurance contract and an annuity contract, which provides a savings feature. (We

go into annuities in more detail in Chapter 16.) This savings feature is a retirement annuity to age 65, and the life insurance feature is usually yearly renewable term insurance.

> **The sale of the split-life policy has not been approved in all states, because it seems to discriminate in favor of those individuals who purchase annuities. Those who do not purchase an annuity along with their life insurance do not receive the same low cost benefits as those who do.**

The insurance contract may be **renewed** as long as the annuity premium continues to be paid. The most common amount of coverage found is up to $10,000 of term insurance for each $10 of annuity premium paid.

Adjustable Life Insurance

An adjustable life policy offers you the option of adjusting the policy's face amount, premium and length of protection—without having to complete a new application or have another policy issued. This kind of insurance introduces the flexibility to convert to any form of insurance (such as from term to whole life) without adding, dropping or exchanging policies.

Adjustable life is based on a **money purchase** concept. The question, then, is not so much which type of policy you buy, but rather how much money you will spend.

Example: If Betty, who is 25, says she can afford to pay a $500 annual premium, an adjustable policy may be mostly term for the first few years, then a blend of term and whole, then finally a whole policy several years later. By the time Betty is 50 and planning for retirement, the same $500 premium would be used for some form of permanent insurance protection with guaranteed cash values.

> **This type of policy is flexible, but if you make an adjustment that results in a higher death benefit, proof of insurability (that is, a relatively clean bill of health, as determined by a physical) may be required for the additional coverage.**

Industrial Life Policy

The industrial policy is written for a small face amount, usually $1,000 or less, and the premiums are payable as frequently as weekly. This coverage derives its name from the fact that it was originally sold in England to the industrial class of factory workers.

If you bought an industrial policy, you would determine how much you could pay each week, and this would determine the face amount of coverage.

Traditionally, a company representative would call on the policy owner each week, usually at home, to collect the premium. The policy benefit usually was used to pay for **final illness and burial expenses**. Grim stuff.

Selling policies this way is very expensive for two reasons. First, the mortality rates are high for industrial policyholders; these people tend to have higher-than-average health risks and poorer-than-average living standards. Second, having an agent collect the premium each week boosts overhead costs.

The market for industrial life has decreased considerably over the last several decades. Today, industrial life represents about 1 percent of all life insurance in force.

However, a variation on the industrial life concept, known as **home service life insurance**, has emerged recently. Policies are usually modest in size, ranging from $10,000 to $15,000 in face value, and they often are sold as a monthly debit plan (the premiums are paid via automatic withdrawal from your bank account). In general, these policies are more expensive per dollar of coverage than standard term life policies.

Credit Life Insurance

If you're paying off a loan (or two...or six) or have some credit card debt to contend with, your unexpected death could create serious financial problems for your family. Credit life insurance provides that, in the event of your death, the **outstanding balances** will be paid off in full.

Credit life insurance can be written on a group basis or in individual credit life policies. It usually is written as a **decreasing term** type of coverage, so the amount of insurance shrinks as the amount of the debt shrinks. Level term insurance also may be written, which would remain level for the term of the policy (appropriate, for example, if you typically live with a certain amount of credit card debt).

With this sort of insurance, you pay the premium. If you die, the benefits are paid to your creditor—to reduce or extinguish your debt. It is not usually the most cost-effective form of insurance.

And it's not meant to be. These policies are often added to the finance contract for a major purchase—so that, in effect, the insurance premium is being financed along with the item being purchased.

Riders and Other Modifications

One mechanism that smart consumers use to tailor insurance policies to their needs is the use of riders and other modifications. This way, you can buy

a more basic policy and customize it yourself, rather than having to take some benefits you want along with some you'd rather not pay for.

> **Riders can be used to enhance or add benefits to the policy, or they can be used to take away benefits from the policy.**

Riders usually require the payment of a relatively small additional premium for the benefits provided. Among the most common kinds of riders:

- **Accidental Death** (Double Indemnity). This provides an additional death benefit and a dismemberment benefit for loss of certain body parts, if the death or the loss is due to an accident. The accidental death benefit, usually referred to as the **principal sum** (the rider's face amount), pays an additional death benefit if the cause of death is due to an accident as defined by the policy. Usually, death must occur within 90 days of the accident for the benefit to be paid.

 The insurance company may elect to have a very liberal definition of **accidental death** or a very strict, limited definition. Regardless, if a death claim is submitted, it must comply with the policy's definition if the additional accidental death benefit is to be paid.

> **Example: John has a $10,000 whole life policy that contains the accidental death rider (double indemnity), which also has a $10,000 value. If he is killed accidentally as defined by the policy, the total death benefit will be $20,000.**

- **Waiver of Premium**. This provides that, in the event of total disability as defined by the policy, premiums for the policy will be waived for the duration of the disability. The rider is temporary, in that it usually expires at age 65.

> **There is usually a six-month waiting period before the rider's benefits are payable. This means that you must be totally disabled for six months (a few insurance companies require only three months), and then future premiums will be waived for the duration of the total disability.**

- A variation on this rider is **Waiver of Premium with Disability Income**. The same concept applies, but this rider also will pay a weekly or monthly disability income benefit.

- **Guaranteed Insurability**. This guarantees that at specified dates in the future (or at specified ages or upon the event of specified occurrences, such as marriage or the birth of a child), you may purchase additional insurance without evidence of insurability. The rate for any additional coverage purchased will be based on your attained age, not the age at which the policy was issued.

 The **amount of insurance** on the option dates usually is limited to the amount and type of the base policy. For example, if you had a $10,000 whole life policy with the guaranteed insurability rider, you could purchase up to an additional $10,000 of whole life coverage on the option dates.

The biggest advantage offered by this rider is the opportunity to buy additional amounts of insurance as your responsibilities and needs change, without proof of insurability.

 The option dates are usually the policy anniversary nearest your birthday at ages 25, 28, 31, 34, 37 and 40. In addition, marriage and the birth of children (when you are between the ages of 25 and 40) also trigger additional options.

- **Return of Premium**. This rider was developed primarily as a sales tool to enable the salesperson to say, "In addition to the face amount payable at your death, we will return all premiums paid if you die within the first 20 years." The rider is simply an increasing amount of term insurance that always equals the total of premiums paid at any point during the effective years. Technically, the rider does not return premiums, but pays an additional amount equal to premiums paid to date of death. The policy owner who purchases the rider is simply buying additional term insurance.

- **Return of Cash Value**. This seldom-used rider was designed to offset the common—though invalid—complaint, "When I die, the company confiscates the cash value." This complaint is based on lack of understanding of the mathematics involved in a level face value life insurance policy. However, if the salesperson can say, "We can attach a rider returning the cash value in addition to the face amount," the objection is more easily

answered than if it is necessary to explain the mathematics involved.

The **return of cash** value rider is similar to the return of premium, in that it is merely an additional amount of term insurance that is equal to the cash value at any point while effective. If you buy it, you are simply getting additional term insurance.

- **Cost of Living Adjustment**. This rider is important to people who are in a position to be impacted strongly by inflation. Because of the high-inflation years of the 1970s, many policy owners were concerned that the face amounts of policies purchased would not be adequate to cover expenses by the time the death benefit was paid. The cost of living rider changes the face amount of the policy each year by a **stated percentage**, such as 5 percent. This amount is compounded annually.

 This rider can be used to both **increase and decrease the face amount** of the policy, depending on that year's cost of living. There are limits on how much the face amount can be decreased, however.

- **Additional Insureds**. These riders are commonly attached to life insurance policies to provide coverage on the lives of one or more additional people. Usually, these are term insurance riders covering a spouse, one or more children, or all family members in addition to the named insured. Many companies will issue additional insured riders on request. Some companies actively market combination coverage policies for family members as a **family protection policy**.

- **Living Need**. This rider is a recent development in life insurance. It allows a terminally ill individual to obtain part of the insurance proceeds prior to death. To be eligible for this benefit, you must present medical proof of a terminal illness. Most companies offering this benefit will limit the amount of the insurance proceeds that may be paid in this manner. Companies usually do not charge an additional premium for this rider, because it is an advance against the death proceeds for which you are already paying premiums.

A caveat: Sometimes companies offer a wide variety of riders and options as sales tools—to allow a salesperson to focus on the riders and distract your attention from the poor quality of the company and the basic product. Beware of agents pushing the unique benefits and riders as compelling reasons to buy a life insurance policy.

Exclusions and Limitations

Life insurance policies may contain certain exclusions or restrictions. The main exclusions are:

- **Suicide**. Initially, life insurance contracts excluded the risk of suicide entirely. This exclusion left dependents without protection, which defeated the purpose of purchasing insurance. Also, it was incorrect to exclude suicide completely, because death by suicide is included in the mortality tables upon which premiums are based. So, the majority of life insurance policies issued today contain a **time provision** that restricts liability in the event of suicide. Usually, the time limit on the restriction is **two years**, although, occasionally, it is only one year or less. A typical provision is that in the event of suicide within this period, the liability of the company shall be restricted to an amount equal to the total of premiums paid, without interest, less any indebtedness.

- **Aviation**. In the past, aviation exclusions were very common. Today, this type of exclusion is rarely found in life insurance policies. Among the types of aviation restrictions still found are:

1) Exclusion of all aviation-caused or -related deaths, except those of fare-paying passengers on regularly scheduled airlines. Some policies do not include the phrase, *regularly scheduled airlines*, thus covering nonscheduled flights also—but only for a fare-paying passenger.

2) Exclusion of deaths in military aircraft only or death while on military maneuvers.

3) Exclusion of pilots, crew members, student pilots and (sometimes) anyone with duties in flight or while descending from an aircraft (for example, parachuting).

Companies using any or all of these restrictions will afford coverage of civil aviation deaths for an extra premium. The

exclusions or restrictions apply only to those unwilling to pay the extra premium required—and to military duties.

- **War and Military Service.** In wartime, it has been common for companies to include restrictions that limit the death benefit paid to a refund of premium, plus interest usually—or possibly an amount equal to the policy's cash value. Also, in the past, the policy's benefits often were suspended during a war or an act of war. (The term **act of war** has been used to describe the Korean and Vietnam conflicts.)

 Traditionally, there are two types of restrictions or clauses that may be used. The **status clause** excludes the payment of the death benefit while the insured is serving in the military. The **results clause** excludes the payment of the death benefit if the insured is killed as a result of war. Today, most insurers will provide some form of life insurance coverage for those on military duty.

- **Hazardous Occupations and Avocations.** By today's underwriting standards, few applicants are declined life insurance because of their occupations. For example, fire fighters and police personnel can purchase life insurance at standard rates. Even commercial airline pilots usually can purchase life insurance (although possibly at higher-than-standard rates).

> Much of the underwriting attention is focused on avocations, or hobbies. If you participate in a hazardous hobby—such as auto racing, sky diving, scuba diving, etc.—then the amount of insurance that can be purchased may be limited, or an extra premium may be charged due to the additional risk. Depending on the hobby, the death benefit also may be excluded if death is a result of the hazardous avocation.

Provisions Not Permitted

Most states' insurance departments have made certain provisions illegal in life insurance policies. In most states, life insurance policies are not permitted to contain the following provisions:

- A provision that **limits the time for bringing a lawsuit** against the insurance company to less than one year after the reason for the lawsuit occurs.

- A provision that allows a **settlement at maturity of less than the face amount**, plus any dividend additions, less any in-

debtedness to the company and any premium deductible under the policy.

- A provision that allows **forfeiture of the policy** because of the failure to repay any policy loan or interest on the loan if the total owed is less than the loan value of the policy.

- A provision making the soliciting agent the **agent of the person insured** under the policy, or making the acts or representations of the agent binding on the insured. (The agent must only be an agent of the insurance company.)

Further, the law of the state in which the policy is sold governs the contract. The policy may not contain a provision by which the laws of the home state of the insurance company govern the policy provisions.

Conclusion

In spite of all the choices, the basics of life insurance are pretty simple. Its primary purpose is to pay a death benefit, and a death benefit is the one feature that all forms of life insurance have in common. Death benefits usually are purchased and used to cover final expenses, pay outstanding debts, and provide income and security for survivors. They also can be used to pay estate taxes and set up an education fund for your children.

Life insurance products have evolved in response to changing economic conditions and consumer preferences. All life insurance policies include some form of true life insurance protection. Many policies also include other types of insurance benefits and non-insurance elements.

If you don't have any dependents and you don't own a business, you probably don't need life insurance. And even if you do have people who are counting on you for financial support, it is important to insure only what you need to insure.

For example, a disability waiver on a small life insurance premium is expensive for what you can expect to get. If you're confident that you'll be able to pay the small life insurance premium, even if you become totally disabled (for instance, if you have a short-term disability income plan through work or have purchased disability income insurance), then you can skip the waiver and save your money.

> Another key point about life insurance is that your beneficiary will not have to pay taxes on the death benefit. This is one way life insurance enables you to provide an estate without the burden of estate taxes.

Key Questions

1) Do you have any dependents? Yes No

2) Do you own a business? Yes No

If you answered *no* to both of these questions, you probably don't need life insurance. If you answered *yes* to one or both, read on.

3) Do you want to purchase a term or whole life policy, or a combination policy?

 Term Whole Combo

4) Do you want to purchase a family income policy?

 Yes No

5) Do you want to purchase a joint life policy? Yes No

6) Do you need a policy that allows you to pay less money now and more in the future, such as a modified life policy?

 Yes No

7) Would you prefer to pay more money now and less in the future, such as for a deposit term insurance policy? Yes No

8) Are you interested in a policy that combines life insurance and an annuity? Yes No

9) Would you like any of the following riders:

Accidental death?	Yes	No
Waiver of premium?	Yes	No
Guaranteed insurability?	Yes	No
Return of premium?	Yes	No
Return of cash value?	Yes	No
Cost of living adjustment?	Yes	No
Additional insureds?	Yes	No
Living need?	Yes	No

Chapter 15

Dealing with Life Insurance Sales Tactics

So, now you know how much insurance you want (at least roughly). You know who your beneficiaries are. And you know how to compare insurance companies.

You're ready to start shopping. Unfortunately, this usually means dealing with insurance marketers, agents and salespeople.

In an increasingly competitive insurance market, some companies—and their agents or salespeople—will press the limits of legal and ethical sales practices. It's up to you to proceed carefully.

The Presentation

Agents and salespeople are subject to a number of laws and regulations that should shape their behavior during sales presentations. And some agents are quite professional and ethical. Unfortunately, the basic sales presentations that insurance salespeople and agents sometimes use—called sales **illustrations**—can be very misleading.

Problems crop up especially because some companies:

- make overly aggressive return **projections**;

- arbitrarily assume future **mortality improvements** (they fudge the death projections, so people will live longer and they will have to pay fewer claims);

- compound mortality improvements into the future (they carry their fudging to the *nth* degree);

- assume **future lapses** to dramatically improve projections;

- fabricate **future earnings** that have no historical basis; and

- **mistreat existing policyholders** to improve future projections for new policyholders.

Insurance Buying Guide 341

Financial **assumptions** are the magic of actuaries and life insurance companies. By changing small assumptions, actuaries can make a mouse look like an elephant down the road.

Example: A dollar invested at 5 percent every year for 40 years grows to $126. The same dollar invested at 10 percent every year becomes $486 in 40 years. That's a difference of nearly four-fold caused by only a 5 percent change in a performance assumption.

> **The important thing to remember is that insurance companies are not required to meet the projections included in sales illustrations. In the end, you simply cannot rely on illustrations for comparison.**

It's far better to rely on the company's actual **historical performance** than a particular policy or illustration. Actual histories are available. If a company cannot or will not provide its investment performance and financial history for comparison, look for a company that will. If your agent cannot provide this information, find someone who can.

In many jurisdictions, agents also must provide you with a policy summary and a buyers guide when you apply for coverage.

A **policy summary** is a document that summarizes the coverages, benefits, limitations, exclusions and terms of the policy for sale.

A **buyers guide** is a consumer publication that describes the type of coverage being offered, and provides general information to help you compare different policies and reach a decision about whether the proposed coverage is appropriate for you.

> **Even if these support documents aren't required where you live, you can always ask an agent or salesperson to send them along with the application. Strong companies, which don't mind useful comparisons, won't mind giving you background information. If the agent hesitates, be concerned.**

The Four Key Deceptions

Salespeople tend to use the same sorts of tricks over and over. Here are the four key ones to watch out for.

One: Premium Deception. The **lowest premium** may be the lowest premium only because the company made unrealistically aggressive assumptions. Suppose you are a 45-year-old male, and have told the agent that you want $500,000 of coverage and want to pay a premium for only 10 years—at

which time the premium will vanish (that is, the policy will become self-financing and you won't have to pay any more premiums). The agent shows you two different companies:

| Company A | $4,772 | 10-year vanish |
| Company B | $7,285 | 10-year vanish |

This appears to be an easy decision, right? Same amount of insurance, same payment period, but dramatically different premiums.

Actually, Company B may be a better choice (but you will need more information to know whether it is).

What happens when a company arbitrarily decides to assume policyholders will live longer? Premiums drop dramatically. Let's look at the effect on premium for a 45-year-old male, based on **improved mortality**.

Male, Age 45

500,000 Face Amount

10 Payments, 6.25% Interest Rate

Life Expectancy	Age	Required Premium
35 years	80	$7,295
39 years	84	$6,082
43 years	88	$4,772

As insurance companies try to out-illustrate each other in their **sales presentations**, some have begun fabricating new mortality tables that have no basis in reality.

How can insurance companies do this? Imagine that an insurance company can show a 1 percent mortality decrease in the past year. It can assume a 1 percent decrease compounded for 80 years and say the new mortality is supportable—based on a **historical trend**.

However, you should expect some volatility from a projection based on a one-year historical trend.

Two: Cash Value Deception. The highest cash value projected for five, 10 or 40 years in the future may be the result of manipulating mortality, lapse ratios, interest assumptions, expense projections, persistency bonuses, etc.

Say you are looking at two illustrations. The premium is the same for both. The face insurance amount is the same for both. After 20 years, the cash values are:

Company A	Company B
$69,300	$92,298

You might assume that Company B is a better value. But there's very little reason to make that assumption. A fast-growing *projected* cash value doesn't mean that the policy will actually build that cash value. It may simply mean **aggressive assumptions** on the insurance company's part.

Whole life premiums typically assume that the life insurance company will be able to earn a 4 percent interest rate on its premium income. It may perform substantially better, but the premium is calculated on a worst-case scenario of 4 percent. This is why **whole life premiums** are higher than universal life. They're also guaranteed at this rate, so they are safe assumptions.

Universal life premiums typically assume a non-guaranteed **current rate** of interest. Obviously, if an insurance company assumes that it will earn a 6 percent or 8 percent interest rate on its investment, it can figure that it will use that money to cover some of its operating costs—and calculate a lower premium than a guaranteed 4 percent rate. But if current interest rates fall, the premium for the current rate universal life policy may increase in the future.

> This kind of interest rate assumption has been a big problem—and a big surprise to people who bought universal life insurance in the late 1980s. At that time, interest rates were much higher, so premiums were low. When rates fell, policies collapsed.

Three: Vanishing Premium Illustration Deception. Many smart consumers look for **vanishing premiums**. These usually are associated with whole life or related policies that build enough cash value in 10 or 15 years that their dividends and interest income pay the premiums.

Buying vanishing premiums is expensive in the short run, but can make a lot of sense in the long run.

> A caveat: The lowest premium or shortest number of years to vanish in a sales illustration may be the result of aggressive—and baseless—assumptions, like the ones we've already seen.

Four: Highest Retirement Income Deception. A salesperson can falsely illustrate significant retirement income improvements in a cash value policy by only running the illustration to ages 85, 90 or 95—rather than the usual 100. The insurance industry has been soundly criticized for making projections look—and sound—like reality. On the bottom of every sales illustration, the law requires a paragraph of **disclaimers** that say, effectively:

> Everything you see is a projection, not a promise. These are
> not estimates or guarantees of future results. Actual results may
> be better or worse in the future.

Assume they'll be worse.

Economic Pressures Are Intense

A last caveat: As actual interest rates fell below projections during the late 1980s and early 1990s, consumers became wary of interest-sensitive policies, like universal life. And as aggressive assumptions were proved wrong, consumers found their vanishing premiums didn't vanish and their level premium policies required more money.

Some insurance companies concluded that they had to carry out the illustration war in the arcane invisible world of **undisclosed assumptions**. They began to manipulate mortality assumptions and lapse ratios. These changes can have a big impact on pricing and projected cash values—yet are virtually impossible to debunk because they're undisclosed in compliance documents.

A small reduction in mortality can lower a premium significantly. Suddenly, companies that have no history of extraordinary performance are able to out-illustrate everyone else. Other companies then jump in with even more aggressive assumptions.

One trick some insurance companies use to appear more competitive than they are is called **segmentation**. The companies classify their policies by age and change their portfolio management to credit newer policies with higher dividends, lower expenses and lower mortality assumptions.

This punishes existing policy owners in order to seduce new ones. Eventually—three or four years later—the new policy owners will become subject to the same treatment that "old" customers received.

Some larger companies have acknowledged that they use segmentation. And the justification other companies offer for withholding actual historical performance—which would reveal segmentation—is that the old policies don't reflect the current plans offered.

Purchasing Strategies

As with many other products, you have a wide range of options when considering which life insurance policy to buy. To make cost-effective selections, there are two basic methods you can follow: the traditional net cost method, and the interest-adjusted cost method. There are advantages and disadvantages to both.

The traditional **net cost method** adds the premiums you expect to pay over 10 years (or the maximum number, if the term is less than 10 years), then subtracts the cash value expected to be accumulated and dividends to be paid by the end of the 10-year period. This number is averaged (divided by 10, in this case), for a final number that is referred to as the **average annual surrendered net cost**.

To do this calculation, you should get premium, dividend and cash value numbers from each of the insurance companies you're considering. Calculations should be compared on a **per $1,000 of insurance** basis.

By making this calculation with several policies, you can determine the policy with the lowest number and, theoretically, the lowest cost.

However, there are three main problems with this calculation. One, it assumes that you will have the policy for exactly 10 years. The averages would be different for a 20-year period. (You can compare figures for other time periods, if you so choose.) Two, dividends are only assumptions. If dividends are higher or lower than predicted, cost averages are affected. Three, this comparison does not take into account when premiums and benefits are paid—the time value of money.

The **interest-adjusted cost method** is similar to the traditional net cost method, with the exception that it accounts for an interest rate. After the selection of a time period for analysis (such as 10 years) and the selection of an interest rate (such as 5 percent), the calculation proceeds as follows:

- add the annual dividends at interest to the cash value at the end of the period;

- divide this amount by an interest factor, which converts it to a level annual amount;

- subtract this result from the annual premium.

> Even with this method, comparison of policy costs is still inexact. Coverages provided may differ in policies, and dividend amounts are assumptions only. No policy is cost-effective for its owner if it does not meet that person's (or institution's) needs.

Payment Schedules

In addition to choosing a life insurance company and a life insurance policy, you'll get to choose how often you want to pay your premiums. Most life insurance companies base their **premium payment schedule** on a yearly cycle. But you can pay on a semi-annual, quarterly or monthly basis.

However, if you opt to pay more than once a year, you may get hit with

an increased service charge—to offset the added expense of processing additional payments and the fact that the company has to wait to get your money.

Usually, you will let the insurance company know how are you going to pay when you apply for the policy. Most companies also will allow you to change **the frequency of your payments** at your discretion.

Direct withdrawal of funds from your checking account to pay premiums has become a standard feature within the life insurance industry. Don't be surprised if your company has this requirement tied to its monthly premium arrangement. This assures the insurance company that your payment will be received on time, and it cuts down on additional paperwork costs.

Time to Apply

And now, the moment you've been waiting for: It's time to **apply for coverage** from a company. Because the application process for life insurance may involve **a physical and a blood test**, you probably are not going to want to apply to more than one—or maybe two companies. In other words, you'll definitely have to do your homework before you start filling out applications.

Nonetheless, an application is not a binding contract. Even though you sign it, you are not committing to buy insurance. You are requesting that the insurance company review your information and offer you coverage. This is when you find out what the price will be.

> Some hard-sell agents or companies may try to tell you that you have to accept the coverage offered. This is never true. Insurance is not in force until premiums are paid—and even after you have paid, you usually have the right to cancel the policy within as many as 10 days and get a full refund.

It is very important to read the policy as soon as you receive it—paying particular attention to any exclusions—so you can be sure this is indeed the coverage you want to buy.

The Application

The form of the application may differ from one company to another. However, most applications ask for the same basic information.

Part 1 of the application asks for some **general information** about you, including your full name, address, phone number, date of birth, business address and occupation, marital status, social security number, billing address and other insurance owned.

Part 2 of the application is designed to extract information regarding

your **medical history**, current physical condition and personal morals. It will ask about current medical treatment for any sickness or condition, as well as the types of medication taken.

Usually, Part 2 will include questions regarding alcohol and drug use, as well as avocations and high-risk hobbies. (Hint: Scuba diving, hang gliding, flying small aircraft and bungee jumping are considered high-risk.)

If you're applying for a relatively **large amount of insurance**, you also may have to undergo a medical examination (paid for by the insurance company)—in which case Part 2 of the application would be completed.

> Increasingly, underwriters are relying on paramedical exams and blood tests for information in order to accurately evaluate a health risk. Blood testing is almost universally used to determine cholesterol levels, elevated liver enzymes and the presence of the AIDS virus.

After a review of the medical information contained on the application or provided by the medical exam, the underwriter may request an **Attending Physician's Statement** (APS) from your doctor. Usually, the APS is designed to obtain more specific information about a particular or potential medical problem.

Some simplified forms of life insurance require **no medical exam** and ask only very basic health-related questions on the application. Usually, this type of insurance is available only in low face amounts.

> The application also will ask you to select the mode of premium (monthly, annually, etc.), the use of dividends (will you use them to buy more coverage or will you collect them?) and the designation of a beneficiary.

To supplement the information on the application, the underwriter also may order an **inspection report** from an independent investigating firm or credit agency, which covers financial and moral information. This information is used to determine your insurability. If the amount of insurance applied for is average, the inspector will write a general report concerning your finances, health, character, work, hobbies and other habits. When larger amounts of insurance are requested, the inspector will make a more detailed report.

At the time you complete the application, you sign and date it to confirm that all the information you have given is true to the best of your knowledge. Most companies have a clause regarding **misstated information**. This gives the company the right to review its decision if you have provided false information or omitted information.

The **contestability period**—which usually lasts for two years—is the time within which an insurance company may deny a claim based on information you have stated in the application. After this period, the policy becomes **incontestable** and the company may not deny a claim, even if fraudulent or concealed information is discovered. The only way the insurance company can deny a claim after the contestability period is on the ground that an insurable interest was not present between the insured and the policy's owner at the time of application.

Gender and AIDS

In recent years, there have been various state and federal court decisions holding that sex cannot be used as a factor to determine a life insurance or annuity policy premium. As a response to discrimination, various laws were passed during the late 1970s, prohibiting the use of gender as a rating factor in financial matters.

> **Using gender as a factor in determining rates had generally resulted in women paying lower life insurance premiums than men.**

AIDS is beginning to have a large impact on the insurance industry, too. The costs associated with AIDS are those of premature death and medical costs, including long hospital stays and very expensive drug treatments. These costs affect medical, disability and life insurance coverages.

(Ironically, as sophisticated drug therapies have begun to lengthen life expectancy for people with AIDS, some have been caught in a difficult place. They've exhausted health and life insurance benefits—the latter by using "living need" benefits, which pay the face amount of the insurance policy before your death—but still have years to live.)

AIDS testing prior to policy issuance has become a common underwriting requirement. Typically, this takes the form of a blood test. In many jurisdictions, HIV testing requires informed consent of the applicant, confidentiality of results and proper notification procedures.

An AIDS test is particularly likely to be required if you are applying for a large amount of insurance. Different companies will set different ages and amounts as thresholds at which blood tests for the AIDS virus are required.

Policy Receipts

Once the underwriting process is complete and you have been approved, the life insurance policy will be issued by the insurance company. The coverage is not effective until the policy is delivered and the initial premium has

been paid. Smart consumers proceed carefully through this stage of the application process.

> Often, you will pay the initial premium with the application. When this occurs, the agent will provide you with a receipt for the initial premium, and the effective date of coverage will depend on the type of receipt issued.

A few companies use an unconditional or **binding receipt** that makes the company liable for the risk from the date of application. This coverage usually lasts for 30 to 60 days—or until the insurance company either issues a policy or declines the application, whichever is earlier.

With a binding receipt, regardless of your insurability, you are covered for a **specific period of time** following completion of the application and payment of the initial premium. Not surprisingly, use of this receipt is rare.

A **temporary insurance agreement** is another type of receipt that provides you with immediate life insurance coverage while the underwriting process is taking place—whether or not you are insurable. If you should die during this period, the coverage is in force, regardless of your insurability or risk classification as a result of the underwriting process.

Once you receive your policy, it's time to start looking it over carefully. Remember, even if you've paid the first premium, you can refuse to accept a policy for 10 days after receiving it and still get a full refund.

What should you look for? Make sure you review the type of plan, the named insured(s), beneficiary, premium, face amount and schedule of future premiums thoroughly—before accepting a policy. Be sure you understand the exclusions, the length of time the policy will be in force and any optional values. If you use an agent, he or she usually will provide a summary page that minimizes any confusion.

Also be sure you understand what rights the company has to make changes and what assumptions were used.

> If you receive a rated (or classified) policy (which means you're being charged more than the standard rate) and you didn't expect one, you may want to apply for coverage with another company. Underwriting standards vary from company to company.

Changes You Can Make

At any point during the life of a life insurance policy, you have the right to change certain provisions. These include:

- changing to a **lower face amount**;

- changing the primary **beneficiary** or contingent beneficiary;

- changing the **type of plan**, in some cases;

- changing the **payer**;

- changing the **owner** (by sale or gift, or by transferring or assigning the policy); and

- changing the **billing cycle**.

Changing from One Kind of Insurance to Another

During the 1980s, there was a term **price war** and every year companies offered lower-priced products. Agents would sell Company A's policy one year; the next year they'd come back to the same client offering Company B's policy at better rates.

> Agents encouraged this *churning* because they received a new first-year commission every time they sold a new policy. Since these first-year commissions were higher than *renewal servicing commissions*, many agents simply replaced their own policies every two or three years.

As price competition increased, consumers quickly realized that by replacing the old policy with a cheaper new one every two or three years, they could get a free medical examination and save money on their policy.

However, some consumers ended up trading larger benefits for smaller ones or—even worse—paid-up cash-value policies for term policies.

In the wake of all the problems with agents churning and customers jumping ship, insurance companies needed to do several things:

- keep the policyholder paying premiums for a **longer period** (five to 10 years);

- keep the agents from **replacing the policies** every two years with cheaper products; and

- offer low **attractive prices**.

Clever actuaries found a solution in the arcane laws governing the amount of money insurance companies have to reserve per $1,000 of insurance. The solution was to offer level term insurance for five, 10, 15 or 20 years. At the end of the level period, the premium would increase like traditional **annual renewable term**.

This solved all of the problems:

- The customer was provided the incentive to **keep the policy** for the full level period;

- The agent couldn't easily persuade the customer to change policies; and

- The insurance company found a way to **lock in the consumer** for a five-, 10- or 15-year period.

Still, replacing an existing policy can be a perilous process for everyone involved.

The Replacement Game

Because of the cash value that can build up in a policy, and the favorable loan interest rates in older policies, **replacement can be bad** for consumers. The reasons for this are many. For example:

- the new insurance may require you to prove **insurability**;

- the **premiums may be higher** for a new policy;

- the new policy provisions will have to be complied with, such as a new **incontestability period**;

- the existing **policy's provisions** may be more liberal than a new policy's provisions; and

- a new policy usually will not have any **current cash value**.

Because of the problems that have been experienced with replacing policies (including scandals at several life insurance companies concerning **churning**), if replacement is involved in any insurance sale or transaction, the agent or broker is required to:

- list all existing life insurance policies to be replaced;

- give the applicant a completed **Comparison Statement**, signed by the agent or broker, and a **Notice to Applicants Regarding Replacement of Life Insurance** (a copy of the forms should be left with the applicant); and

- give the insurance company a copy of any proposals made, and a copy of the Comparison Statement with the name of the insurance company that is to be replaced.

The duties of the replacing insurance company include:

- making sure that all replacement actions are in **compliance with state regulations**;

- **notifying each company** whose insurance is being replaced and, upon request, furnishing a copy of any proposal and Comparison Statement; and

- **maintaining copies of proposals**, receipts and Comparison Statements.

Each state has its own rules and regulations regarding the replacement of life insurance products, and these rules are designed to protect the interests of the public.

Things to Look Out for in a Trade

Employer-sponsored group insurance or association group insurance usually can be cancelled at the company's discretion, but this usually isn't so for individual policies. Therefore, you'll want to be careful about trading an individual policy that can't be unilaterally cancelled for a group policy that can.

> **There are numerous policies in which benefits are only available for a 10-year period, a 20-year period or to age 70. Make sure you're not trading a long-term policy for one that has more time restrictions.**

Low premiums may mean hidden restrictions. Many companies offer 10- or 20-year term policies with limited **conversion rights**.

Guaranteed renewability is another standard term you will see often. It means that the policy is guaranteed to give the option of continuing insurance at some point in the future. It may be renewable for 10 years, to age 70, to age 100 or for life. The renewing of the policy assures you that the policy cannot be cancelled by the company until that future date arrives.

Some unwary people will trade a policy with guaranteed renewability for one without. Avoid this at all costs—especially if you're over 40.

Reinstating Lapsed Policies

If you had a life insurance policy and let it lapse, there are many benefits to reinstating that policy and paying back premiums, instead of applying for a new one.

- The lapsed policy, written at an earlier date, may have **more liberal contract provisions** than a current policy.

- The interest rates on the **policy loans** may have been lower.

- A policy issued at a **younger age** most likely has a lower premium schedule than one written at your current age.

- If the policy date is more than two years old, **suicide and incontestability clauses** may no longer apply.

If You're Uninsurable

If your life insurance application is rejected because of information in an investigative report, you must be notified and given the name and address of the reporting company.

> If your health problems are so severe that you are classified as uninsurable—or even if a new life insurance policy is just too expensive for you—it's good to know that some companies offer *guaranteed-issue* life insurance. This insurance is available in smaller face amounts, like $10,000.

The full face amount is payable in the event of accidental death, but for death from natural causes, the benefit is limited to the total of premiums, plus interest, at least for the first few years of the policy. After that, the benefit equals the face amount.

Guaranteed-issue life insurance is a good solution for covering expenses, such as funeral costs, for otherwise uninsurable people.

If you are rated a **substandard risk**, there are a number of things you can do to get at least some life insurance coverage. While uncommon, an insurance company may issue a **waiver** with the policy, stating that death by a particular event will not be covered. This might be done if you have a particularly hazardous occupation or hobby. More commonly, an insurance company might issue a more limited policy—or offer a lower face amount than that applied for.

Saving Money

What do insurance companies look for in an applicant? Immortality would be nice. But they'll settle for someone who seems likely to live as long as possible. That way, they can collect all the premiums and earn interest on them for years to come.

Among the things insurance companies look for in a preferred risk:

- Someone who has no personal history of heart disease, stroke, diabetes, cancer, alcoholism or drug addiction.

- Someone who has no family history of heart disease prior to age 60.

- Someone who is not a private pilot or student pilot—and who has not participated in aviation during the two years prior to applying.

- Someone whose blood pressure does not exceed 150/90—and who has no history of hypertension treatment. Some companies will allow treatment if your blood pressure has been under control for two years, as long as it doesn't exceed 140/90.

- Someone whose cholesterol level doesn't exceed 260.

- Someone whose weight fits within the preferred limits for his or her height (though slightly higher weights may be allowed if you don't have a problem in any of the other areas).

A sample weight table—for men—follows, for illustration.

Height	Preferred Weight Limits	Standard Weight Limits
5'3"	175	204
5'4"	180	209
5'5"	185	215
5'7"	195	225
5'8"	200	230
5'9"	205	235
5'10"	210	242
5'11"	216	251
6'0"	222	256
6'1"	229	263
6'2"	236	271
6'3"	243	279
6'4"	250	286
6'5"	257	293
6'6"	264	300
6'7"	272	307
6'8"	280	316
6'9"	288	325
6'10"	296	333
6'11"	305	341

We all know that losing weight, reducing our cholesterol levels and our blood pressure, quitting smoking and getting off alcohol and drugs can add

years to our lives. Not surprisingly, these same moves can cut your life insurance costs. If you can show consistent improvement in one or more of these areas for a year or two, most insurance companies will consider that evidence of **permanent improvement** and will consider you for preferred status.

Quitting smoking is a particularly good way to lower your life insurance rates. Believe it or not, smokers are twice as likely to die while they are insured as non-smokers. So, if you quit, you can save 20 percent to 30 percent on your premiums.

Timing is everything, so they say. And they do have a point when it comes to life insurance. Just before your birthday and six months after your birthday are really good times to shop for insurance. That's because your rates are raised to the next age in the rating tables either at your birthday or at your half-birthday. If you buy right beforehand, **you'll be considered a year younger**—and pay less.

If it's right after your birthday, ask about **backdating to save age**. Many companies will allow you to "backdate" a policy up to six months to give you a better rate. However, the company will expect you to pay "back" premiums for this period. If the amount of back premiums exceeds the savings for a younger age rating, you obviously won't want to do this.

Sometimes, you can buy a little more coverage without spending significantly more. That's because companies typically **discount rates** at $100,000, $250,000, $500,000 and $1 million of coverage. You don't want to buy a policy with a face value just below one of these points.

In addition, you also may be able to save money by **consolidating** several smaller life insurance policies into one larger policy that offers the same coverage. However, before you get rid of an older policy, compare the rates and benefits carefully—and watch out for penalties.

Conclusion

The way life insurance is sold is changing. It's becoming a price-driven, commodity market. Long-time professionals in the industry aren't sure where the business ultimately will land. A lot of agents are getting out of insurance; a lot of those who are staying are, frankly, scared. More than ever, buyers have to beware.

It's increasingly likely that you'll buy your next life insurance policy over the phone, via computer or through the mail. You'll likely be dealing directly with the insurance company (and even if you use an agent or broker, that person is increasingly likely to be working for a single company). You'll need all the critical tools you can find to determine the best deal for you.

1) If you're considering a particular policy, what is the life insurance company's historical investment performance and financial history? _____

2) Did the agent, salesperson or company give you a policy summary?

Yes No

3) Did the agent, salesperson or company give you a buyers guide?

Yes No

4) If the agent or salesperons is pitching a policy with vanishing premiums, have you ascertained how the company computes them—and are you convinced that the interest rates they project are attainable? Yes No

5) Have you computed the interest-adjusted cost when comparing two or more policies? Yes No

6) Will you be paying monthly, quarterly, semi-annually or annually? _____

7) Does the insurance company require that the premiums be withdrawn automatically from your bank account? Yes No

8) Are you healthy and happy to prove it? Yes No

If so, you may want to be sure the insurance company gives you a physical exam.

9) Do you participate in any high-risk hobbies? Yes No

 What are they? _____

10) Are you replacing an existing policy? Yes No

 If so, you'll need to compare closely, to be sure you aren't giving up a more favorable interest rate or sacrificing cash value for term insurance.

11) Is the policy you're considering guaranteed renewable? (This is an important consideration if you are replacing a policy, as well.) Yes No

Life Insurance, Annuities and Retirement Planning

Life insurance and related annuity products frequently are used to provide the funding for retirement plans and other types of plans, due to the tax advantage they can offer. Some of these plans also may be funded with other products, such as mutual funds, certificates of deposit, stocks and bonds, cash held in bank accounts, etc.

For example, a **retirement income insurance policy** accumulates a sum of money for retirement while providing a death benefit. When you retire, the policy will pay you an income, such as $10 per $1,000 of life insurance for your lifetime—or for a specified period. Once the **cash value** in the policy becomes greater than the **face amount**, that cash amount becomes the death benefit.

However, these policies are expensive, and cash-value accumulation is high to pay for the monthly income.

Retirement plans that include insurance and other corporate and individual plans may be described as **qualified or non-qualified**. All plans must be in writing and be communicated to the participants—beyond these similarities, there are many differences between the qualified and non-qualified retirement plans.

Qualified plans:

* must be filed and approved by the IRS;

* usually are established by an employer for the benefit of employees (there are a few exceptions);

* cannot discriminate as to participation (all eligible employees must be included);

* will provide a tax deduction for the employer for plan contributions;

- generally exclude employer contributions on behalf of the employee from the employee's gross income—no tax is due until benefits actually are distributed to the employee; and

- defer taxes on investment income realized by the plan until it is received by plan participants.

Non-qualified plans:

- are not filed with the IRS;

- may discriminate as to participation—they may be selective as to who is covered; and

- do not provide a tax deduction for the employer for any contributions made.

> The fact that a non-qualified plan is not approved by the IRS does not imply that it is illegal or unethical. A non-qualified plan is a legal method of accumulating money for retirement funds and other purposes. It just doesn't provide tax benefits the way a qualified plan does.

For example, a person buys an individual annuity for the purpose of accumulating his or her own retirement benefits. When this person pays the annuity premium or payment, there is no tax deduction for the payment of the premium (as there would be for a qualified plan, such as an IRA or 401[k]).

Pension plans and other qualified plans may include life insurance benefits, but these must be incidental to the purpose of the plan. The primary purpose of the plan must be to provide retirement benefits.

Generally, the cost for insurance protection under a pension or profit sharing plan is taxable as income to an employee to the extent that any death benefit is payable to the employee's beneficiary or estate. The cost for any protection for which the proceeds are payable to and may be retained by the plan, trustee or employer is not taxable as income to the employee.

Example: An executive insured under a **key person life policy** does not have to pay tax on the cost of that coverage.

Retirement Options With Cash Value

When you retire, you can use a cash-value life insurance policy in several ways. You can **borrow cash values** or **annuitize payment plans**. Both methods will allow you to use your money for retirement, but each has distinct pros and cons.

If you have accumulated cash value in a life insurance policy when you

retire, you can begin withdrawing the money on a tax-free basis. On the other hand, money that you withdraw from qualified retirement plans, such as Keoghs or IRAs, will be taxed as income.

Borrowing allows you to avoid income taxes. This is the good news. However, if you borrow all of your cash value and the policy terminates, you will be hit with capital gains tax on any amount in excess of the premiums you paid—for money you spent years ago. That's the bad news. This kind of capital gains tax can be a nasty surprise at age 80 or 85, when most people are busy worrying about health coverage or estate taxes.

> Depending on the individual policy characteristics (the crediting rate, the dividend, etc.) and the actual amount you decide to withdraw, you may be able to avoid paying back a policy loan. If you are careful to keep enough cash in the policy to keep it in force, upon your death, the life insurance proceeds will pay off the loan.

A caveat: Be very careful about the **rate of return** you assume when figuring out how much money you can take out. Overzealous agents sometimes will show illustrations that lead to a big retirement benefit. You have to remember that illustrations are based on the assumption that the company will continue to credit the cash value of the policy at a certain rate. However, many people lost a lot of money on these investments in the 1980s, when interest rates fell and policies weren't performing the way consumers expected.

Annuities

Annuities are not—strictly speaking—life insurance, but they often are sold by life insurance companies and agents, so a basic understanding of how they work may be useful.

Life insurance is designed to protect against the risk of premature death. Annuities are designed to protect against the **risk of living too long**. Annuities are sometimes called **upside-down life insurance**. From the insurance company's standpoint, an annuity presents the opposite mortality risk from life insurance: Life insurance pays a benefit when you die; an annuity only pays a benefit if you and/or your beneficiary are living.

> The basic function of an annuity policy is to liquidate a sum of money systematically over a period of time.

Annuity contracts offer you a tremendous range of options. You can buy an annuity with a **single payment** or a series of **periodic payments**. You can schedule benefits to begin immediately or be deferred until a specific future

date. You can choose an annuity that pays benefits for a specific period of time—or for the lifetime of one or two individuals. It can begin paying those benefits on a specific date (such as when you reach a stated age) or a contingent date (such as when your spouse dies).

Usually, but not always, an annuity guarantees a lifetime income for the recipient.

> An annuity that pays you benefits immediately typically will provide you with a steady stream of retirement income in return for your purchase. An annuity that pays you benefits at a later date (a deferred annuity) typically will help you accumulate money.

The **annuitant** is the insured, the person on whose life the annuity policy has been issued. As is the case with life insurance, the owner of the contract may or may not be the annuitant. Unlike insurance, though, the annuitant, in most cases, is also the intended recipient of the annuity payments.

Depending on the type of annuity and the method of benefit payment selected, a beneficiary also may be named in an annuity contract. In these cases, annuity payments may continue after the death of the annuitant, for the lifetime of the beneficiary or for a specified number of years.

Fixed vs. Variable Annuities

There are two principal types of annuities: fixed and variable.

A **fixed annuity** is a fully guaranteed investment contract. Principal, interest and the amount of the benefit payments are guaranteed. In other words, the money in a fixed-income annuity is legally protected, should the insurance company become insolvent.

> By guaranteeing both the principal and the interest, a fixed annuity is not unlike a certificate of deposit (CD) purchased from a bank. However, a CD is backed by the Federal Deposit Insurance Corp. (FDIC). A fixed annuity is not—its security is directly related to the financial health of the company selling it.

There are two levels of guaranteed interest for a fixed annuity: current and minimum. The **current guarantee** reflects current interest rates and is guaranteed at the beginning of each calendar year. The policy also will have a **minimum guaranteed** interest rate—such as 3 percent or 4 percent—which will be paid even if the current rate falls below the policy's guaranteed rate. The minimum guarantee is simply a predetermined lowest rate.

A **variable annuity**—like variable universal life insurance—is designed to provide a hedge against inflation through investments in a separate ac-

count of the insurance company, consisting primarily of common stock. If the portfolio of securities performs well, then the **separate account** performs well, so the variable annuity—backed by the separate account—also will do well. If the company's investments don't do well, neither does your annuity. In other words, there is **investment risk** involved; there is no guarantee of principal, interest or investment income associated with the separate account.

An insurance company or salesperson will provide a **prospectus** when you are considering a variable annuity.

Different annuities will offer you different investments, which offer different degrees of risk and reward. The investment options include stocks, bonds, combinations of both or accounts that provide for guarantees of interest and principal. By choosing among the available fund options, you can create an annuity that meets your objectives—and your tolerance for risk.

If the funding options you choose for your annuity perform well, they may exceed the rate of inflation—or the rate for fixed annuities. If they don't, you may lose not only prior earnings, but even some of your principal. However, some policies will guarantee that the value cannot fall below a minimum level. A **fixed account option** will guarantee both principal and interest, much like a fixed annuity. This way, you have the option of dividing your money between the low-risk fixed option and higher-risk funding options, such as stocks, all in one annuity.

With either type of annuity, **expenses are deducted from earnings**. Either a fixed or a variable annuity can guarantee expenses, which means any expense deductions made to annuity benefits are guaranteed not to exceed a specific amount or a percentage of the payments made. As long as they're reasonable, these expenses can be worth absorbing.

Mortality also can be guaranteed, which provides for the payment of annuity benefits for life.

Occasionally, you may decide that it is in your best interest to purchase an annuity that offers some guarantees, but also offers protection against inflation. This type of annuity usually is identified as a **combination or balanced annuity**.

Both sorts of annuities may be purchased with a single payment, or you may make periodic payments. A **single-premium** or **single-payment annuity** usually is purchased by making one **lump-sum payment**. Example: You cash in a 20-year-old cash-value life insurance policy soon after you retire. This generates a sizable lump sum of cash—say, a little over $100,000. You can use the cash to buy a single-premium annuity that creates income for

you—and for your spouse, if you should die first.

Variable annuities also may be purchased with a variable-premium feature, known as a **flexible-premium deferred annuity (FPDA)** contract. Like variable universal life insurance, this type of annuity allows you to pay as much or as little as you like during each premium period—although there usually is a minimum payment required.

When an Annuity Pays

If you pay for an annuity in a single payment, the benefits may begin immediately (typically, within a month) or they may be deferred. If you buy an annuity with a series of periodic payments, then the benefits will be deferred until all payments have been made. (This second kind of annuity is commonly called a **periodic-payment deferred annuity**.)

There are two periods of time associated with an annuity: the accumulation period and the annuity or benefit period.

The **accumulation period** is the time during which you are making contributions or payments to the annuity. The interest paid on money contributed during this time is tax-deferred. That interest will be taxed eventually—but not until you begin to receive the benefits.

The **annuity period** is the period following the accumulation of your payments (principal and interest), during which annuity benefits are received. You can choose to receive income payments monthly, quarterly, semi-annually or annually.

A variable annuity poses several other unique issues:

- As evidence of your participation in the separate account, **units of the trust** are issued. This is very similar to shares of a mutual fund, which are issued to mutual fund investors. During the accumulation period, these units are identified as **accumulation units**. Both the number of units and the value of these units will vary in accordance with the amount of premium payments made and the subsequent performance of the separate account.

> **Example:** Jack invests $100 per month in his variable annuity. On the day the insurance company receives his $100 payment, the value of an accumulation unit is $10. Thus, Jack is credited with 10 additional accumulation units.

- When you reach the annuity period, these accumulation units are converted to **annuity units**, and the number of annuity

units remains constant, since no further money is being contributed to the annuity.

While the number of annuity units remains constant, their **value will vary** in accordance with the daily performance of the separate account. Accordingly, during the annuity period, the size of the monthly benefit check will vary depending on the value of the annuity units at the time the check is issued.

Annuity settlement options decide when and how the annuity will pay—and to whom. Generally, when you decide to take money from the annuity, an annuity option will be selected as a method of disposing of the annuity's proceeds. Even if an annuity option is elected at the time of purchase, it may (and probably will) be changed at the annuity period to reflect your changing needs. (These changes usually have something to do with retirement or the death of a spouse.) Both variable and fixed annuities offer the same options for settlement of the contract.

> The amount of money available during the annuity period is determined by the annuity option selected, the amount of money you've accumulated and your life expectancy.

A **life-only** or **straight-life option** provides for the payment of annuity benefits for your lifetime—with no further payment following your death. There is a risk involved—in that you must live long enough once the annuity period begins to collect the full value. If you die shortly after benefits begin, the insurance company keeps the balance of the unpaid benefits. This option will pay the highest amount of monthly income, because it is based only on life expectancy, with no further payments after your death.

A **refund option** will pay you for life, too—but, if you die shortly after the annuity period begins, there may be a refund of any undistributed principal or the cost of the annuity. The refund may take the form of continued monthly installments (in the case of an **installment refund annuity**) or it may be in one lump sum (a **cash refund annuity**), whichever you have selected. This option assures you that the full purchase price of the annuity will be paid out to someone other than the company issuing the annuity. If you live well beyond the average life expectancy, then all of your investment in the annuity probably will have been paid and there will be no refund.

Life with period certain is basically a straight-life annuity with an extra guarantee for a certain period of time. This option provides for the payment of annuity benefits for your lifetime but, if you die within the predetermined

period of time, annuity payments will be continued to a survivor for the balance of that period.

The **period certain** can be just about any length of time—five, 10, 15 or 20 years. Most often, the period selected is 10 years, because 10 years is approximately the average life expectancy of a male who retires at age 65. Thus, if you retire at age 65, select life with 10 years certain and die at age 70, your survivor will continue to receive the monthly annuity payments for the balance of the period certain (five more years).

The **joint-survivor option** provides benefits for your lifetime and the life of your survivor. A stated monthly amount is paid to you and, upon your death, the same or a lesser amount is paid for the lifetime of the survivor. The joint-survivor option usually is classified as joint and 100 percent survivor, joint and two-thirds survivor, or joint and 50 percent survivor.

The joint-survivor annuity option should be distinguished from a **joint-life annuity**, which covers two or more annuitants and provides monthly income to each of them until one dies. Following the first death, all income benefits cease.

When Do You Want to Get Paid?

Your stages of life usually will determine whether you should buy an annuity that pays immediately or defers payment until a later date. Here's a quick quiz to help you figure out which kind is best for you now.

To Defer or Not to Defer

1) Saving for future retirement is one of my main goals. Yes No

2) I will not touch my principal or interest until I am at least
 59½ years old. Yes No

3) I contribute the maximum deductible amount to my IRA,
 401(k) or 403(b) retirement plan. Yes No

4) I need an investment that will earn tax-deferred interest. Yes No

5) I am retired or very near retirement now. Yes No

6) I have a lump sum of money, and I want to begin drawing
 an income from it. Yes No

7) I want to receive an immediate return from my investment. Yes No

8) I want to receive a steady monthly check for the rest of my life. Yes No

If you answered yes to questions 1 through 4, a deferred annuity may be appropriate for you. If you answered yes to questions 5 through 8, you're more likely to need an immediate annuity.

Source: MetLife

As you can see, whether you want to defer income from an annuity or receive the payments right away usually depends on how close you are to retirement age.

If you still can't decide, you can purchase **split annuities**—one that provides income payments beginning immediately, the other that accumulates a tax-deferred fund to provide income at a later date.

Annuities and Retirement Planning

Most often, the primary purpose of an annuity is to provide **retirement income**. Receiving regular monthly payments from an annuity is a great source of retirement income—beyond what you will receive from Social Security or your pension plan.

If you are planning ahead for your retirement, an annuity may be a good vehicle for you—especially if you are already making the **maximum contributions** allowed to your IRA or 401(k) plan—because it enables you to accumulate money without paying taxes on the earnings right away. You postpone paying income taxes until you withdraw money, typically during retirement, when you may be in a lower tax bracket. Plus, there are no IRS restrictions on the amount of money you can contribute each year to a deferred annuity—since you are contributing after-tax dollars.

Receiving a series of payments from an annuity, instead of a lump sum, allows you to spread the tax liability over several years. Meanwhile, tax-deferred earnings continue to accumulate on the remaining principal and earnings that haven't been distributed.

Another advantage of a deferred annuity is that you can take advantage of **non-taxable transfers**. This means that you can change to a different funding option within your variable annuity without paying taxes on any earnings you've made. The ability to switch without paying taxes lets you change your investment strategy over time, whether you are becoming more conservative with age or simply responding to changing market conditions.

You also can use a deferred annuity like life insurance—to provide a **death benefit** to a beneficiary, without the costs and delays of probate. In addition, if your beneficiary inherits the annuity during the accumulation phase, he or she can simply take over as the new owner of the annuity and continue accumulating funds on a tax-deferred basis. Your beneficiary also could choose to take the cash out of the annuity right away, even if it hasn't reached the distribution stage, without penalty. However, the beneficiary would have to pay taxes on any earnings.

> If you have reached retirement age, an immediate annuity can provide a dependable stream of income for the rest of your life or for a period you select. For this reason, an immediate annuity may be a good place to put a large lump sum of money accumulated through a deferred annuity, a retirement plan or another savings vehicle.

If you and your spouse plan to retire at age 65 and you will have 10 years of mortgage payments left at that time, you may choose to get an annuity with a joint and survivor option and a 10-year period certain. That way, you know you can continue to make the payments. And, if you both die before the guarantee expires, the mortgage could be paid off for your heirs.

Other key features:

- Like life insurance policies, annuity contracts may include **nonforfeiture provisions** to protect you from total forfeiture or loss of benefits if you stop making the required periodic payments—as well as surrender charges, or penalties for cashing in the annuity before the payout period begins.

- Annuities may be purchased on an **individual basis** to help solve individual retirement needs. In this case, the annuitant is the owner of the annuity.

- **Group annuities** often are used to fund an employer-sponsored retirement plan, with the employer as the contract owner. The annuitants, then, are the employees. If an annuitant dies during the accumulation period, the money accumulated will be paid to a survivor.

- A common illustration is the **annual premium retirement annuity contract**, in which the total accumulation is calculated based on an annual premium, an assumed interest rate and retirement age (usually 65).

- During the **accumulation period**, the annuity contract is flexible, in that you may or may not make payments. In addition, you have withdrawal options. The money accumulated can be withdrawn totally, or in part, during the accumulation period.

- Annuities may be used to fund **individual retirement accounts** (IRAs), in which case premium payments may be tax-deductible. But, in this application, there are more restrictions on withdrawals (including tax penalties for withdrawals before age 59).

Shopping Tips

When you are considering purchasing an annuity, compare prospectuses from several companies. Note the types of investment vehicles offered, the interest rates that are guaranteed and the expenses, which can vary widely.

> **Expenses for a fixed annuity usually will be lower than for a variable annuity. With fixed annuities, all of the expenses (such as maintenance and contract fees) have been taken into consideration before the company declares periodic interest rates or determines the payment amount.**

Fees for variable annuities are more complicated. They can include an annual contract charge that covers administrative expenses, surrender fees, and a mortality and expense risk charge (to guarantee the death benefit, the availability of payout options and the level of expenses). A typical mortality and expense risk charge is 1.25 percent. A variable annuity also will charge fees that are deducted daily for management and operating expenses. (The good news is that management expenses for these funds typically are lower than for mutual funds with the same investment objective.)

Independent rating services, such as Morningstar and Lipper Analytical Services, publish reports that compare the fees for variable annuities. While it sometimes pays to pay more, if a contract is too expensive, it could offset any gains you would make from the tax-deferred status.

> **A good rule of thumb: If the expense charges are more than 1.5 percent greater than for a comparable financial vehicle, such as a mutual fund, and your time frame is less than 10 years, an annuity may not be the option for you.**

Remember: You can lose money with a **variable annuity**. If you can't afford to lose a dime, you'll want to limit the annuities you consider to **fixed annuities**—or consider the fixed-interest options of variable annuities.

> **While you may want to minimize your risk and go with a fixed annuity, it is important to note that income payments may not keep pace with inflation. So, you may want to divide retirement savings between fixed and variable options to hedge your bets.**

Remember that deferred annuities are long-term accumulation vehicles. Don't invest any money that you may need sooner, rather than later. If you withdraw income before age 59½, the IRS usually will hit you with a 10 percent penalty—in addition to ordinary income tax. Plus, the company that sold you the annuity may impose its own early withdrawal penalty.

If you think you may want to switch annuities—to adjust your portfolio, respond to changes in interest rates, etc.—be sure to purchase a contract that does not include withdrawal charges if you do make a change. And if your salesperson or broker encourages you to change annuities even though you will be penalized, be sure it's a wise move for you—not a commission-generating ploy. Are the benefits of the new annuity (a higher interest rate, more flexibility) sufficient to make up for the withdrawal charges?

> **You're better off picking a variable annuity that already offers you several funding options, so you don't have to pull your money out and invest it in a completely different annuity. Look for a variable annuity that includes a range of funds.**

Also, if you invested in a stock and held onto it for several years, when you sold it, you would pay **capitals gains tax**, which is 28 percent. If your tax rate will be higher than that when you retire, you may not want an annuity, because earnings from annuities are taxed as ordinary income. The only benefit from an annuity, in this case, would be the tax deferral on earnings. With some other investments, you could be subject to capital gains taxes annually.

Finally, look closely at each company you are considering. An annuity is a long-term investment, and you want the company to be there as long as you need it.

Be especially careful if a company is offering an interest rate for an initial period of time that seems too good to be true. This is much like the credit card offers you get—with a 5.9 percent interest rate for six months, then a 20 percent interest rate forever after. Investigate the underlying interest rate—and the company's viability. Once the **bonus rate** term expires, there's no guarantee that renewal rates will be competitive. Be especially careful if you're switching annuities.

Look into the annuity's **surrender fees**. Usually, the fee for withdrawing your money before the distribution period will decrease over time. See how long these fees are in place—and how high they are. A typical exit fee is 6 percent to 7 percent, decreasing over a period of five to seven years.

For variable annuities, check the track record of the funding options. Look for strong returns over a three- to five-year period—or longer. The history of various funding options can be found through the rating services.

Conclusion

There are few guarantees associated with a variable annuity or other insurance-related investment vehicles. However, if you're close to retirement—

or there already—and would like to shield assets and income from tax, an annuity may be your best tool.

These contracts usually will guarantee that chargeable expenses will not exceed a specific amount or percentage. In addition, they also may guarantee mortality—which means a benefit check will be guaranteed for the life of the beneficiary or annuitant. However, these investment tools do not guarantee the amount of the benefits at retirement, nor do they guarantee principal or interest.

Considerable controversy has raged over the regulatory issue of whether variable annuities are really insurance products or equity investment tools. This is generally true of all investment-type insurance products.

Both the federal Securities and Exchange Commission (SEC) and state insurance departments regulate variable annuities. They are considered securities and have to comply with federal securities laws and regulations, with certain limited exemptions. State insurance departments license insurance companies and agents to sell variable annuities and approve variable annuity contracts, as well as providing other regulatory oversight.

Buying life insurance or annuities as investments may make sense to some people as they plan for their retirement. If you're going to use these tools, though, you should think of them as an addition to your basic income-replacement life insurance coverage. In most cases, the investment-type policies entail a degree of risk—either in what you pay in or what you can take out—that make them a shaky foundation for your essential needs.

Key Questions

1) Does your employer provide an annuity or other insurance-related retirement plan as part of your benefits package?

 Yes No

2) Are you considering purchasing retirement income life insurance policy? Yes No

3) Are you interested in purchasing an annuity? Yes No

4) Are you interested in a fixed annuity, a variable annuity or a combination of the two? _____

5) Do you want to make your payment for the annuity in a lump sum, or would you rather pay over time? _____

6) Do you want to receive the payment from the annuity monthly, quarterly, semi-annually or annually? _____

7) Do you want payments to go to you and your spouse?

 Yes No

8) Do you want to defer the income from an annuity? (Refer to the *To Defer or Not to Defer* chart.) Yes No

9) What are the expenses associated with each annuity you are considering? _____

Who You Are and the Insurance You Need

Clearly, different kinds of insurance—and different amounts—are appropriate at different stages of your life.

If you're young and single and don't own a home, you probably only need automobile insurance and renter's insurance. If you own a boat, a jet ski or a snowmobile, you'll need special insurance policy for them, too.

If you own a home, you certainly need homeowners insurance—although you may opt to purchase dwelling coverage, instead. If you live in an area that's prone to catastrophes—such as earthquakes, floods, hurricanes and tornadoes—you probably also need to add on coverage for losses from these types of natural disasters.

If you are married and have small children, you're a prime candidate for life insurance—and probably also for disability income insurance.

If your employer provides health insurance, life insurance and disability insurance, you may not need to purchase supplemental coverage. If your company does not provide these things, you'll be shopping for individual policies. And if you're a homemaker who is recently divorced or widowed, you've probably just entered the market for health insurance and life insurance.

If you're approaching retirement age, you probably don't need disability income insurance any more, but odds are you'll want long-term care coverage, in case you need help with the activities of daily living, such as dressing, feeding and bathing yourself—and so you can choose whether to receive home-based care or enter a nursing home someday.

Each time certain factors in your life change, it's time to reassess your insurance needs and your current coverage. These factors include:

- your age;

- your marital status;

- your parental status (including whether your kids are grown and self-sufficient);

- whether you own or rent a home (or two—or have income property);

- whether you are employed, and the kind of coverage offered by your employer; and

- whether you work at home or elsewhere (e.g., if you work at home, you may need to add an endorsement to your homeowners policy or purchase a separate home-based business policy).

It's important to keep your coverages current—whether that means letting your insurance company know about an addition to your home or getting a new policy when you buy a boat.

Insurance Has Become Ubiquitous

Whether or not you want to think about insurance, you probably are asked about it fairly regularly. If you go to rent a car, the rental car company probably will try to sell you collision damage waiver insurance.

If you buy a home, the mortgage lender will require you to get homeowners insurance.

When you start a new job, you often have a choice of health insurance plans and group disability plans, as well as the option of participating in a cafeteria plan (which can include coverage for dental care, chiropractor's visits and vision care). If your company changes insurance carriers, you may be asked all these questions all over again.

You may even be asked to buy insurance the next time you plan a vacation—or a wedding.

You've probably also been offered insurance coverage by phone (say, from one of your credit card companies), via the mail and even over the Internet. This direct sales approach to marketing insurance of all sorts is becoming more and more common, as insurance companies try to cut costs by eliminating agents—and their commission—from the sales process. This new approach to insurance sales may make prices more affordable in the long run (or at least keep them level). But it also means that you—as a consumer buying insurance directly from insurance companies—have to know more than ever about these policies.

The good news is: After reading this book, you know enough about the coverages you want and need to ask the right questions—and to buy your insurance any way you see fit. This will be somehting that you find yourself doing more and more as the insurance industry completes its move to a self-service focus.

Good luck.

Appendix 1

Contacts for Consumers

State Insurance Departments

Alabama
Commissioner of Insurance
135 South Union St.
Montgomery, AL 36130
(205) 269-3591 or (205) 269-3595

Alaska Division of Insurance
P.O. Box 110805
Juneau, AK 99811
(907) 465-2515
E-mail: insurance@commerce.state.ak.us

Arizona Department of Insurance
3030 N. Third St., Suite 1100
Phoenix, AZ 85012
Phoenix Area: (602) 912-8444
Tucson Area: (520) 628-6371
Statewide: (800) 325-2548

Arkansas
Insurance Commissioner
1123 South University, Suite 400
University Tower Building
Little Rock, AR 72204
(501) 686-2900

California Department of Insurance
Consumer Services Division
300 South Spring Street
Los Angeles, CA 90013
(800) 927-HELP

Colorado Division of Insurance
Commissioner of Insurance
1560 Broadway, Suite 850
Denver, CO 80202
(303) 894-7499

Connecticut
Insurance Commissioner
P.O. Box 816
Hartford, CT 06142
(203) 297-3900

Delaware Insurance Commissioner's Office
Rodney Bldg.
841 Silver Lake Blvd.
Dover, DE 19903
(302) 739-4251 or (800) 282-8611

District of Columbia
Superintendent of Insurance
613 G St. NW, 6th Floor
Washington, DC 20001
(202) 727-8000 or (202) 727-7434

Florida Department of Insurance
200 E. Gaines St.
Tallahassee, FL 32399
(904) 922-3100 or (800) 342-2762

Georgia
Insurance Commissioner
2 Martin Luther King Jr. Dr.
Floyd Memorial Building
704 West Tower
Atlanta, GA 30334
(404) 656-2070

Hawaii
Insurance Commissioner
P.O. Box 3614
Honolulu, HI 96811
(808) 468-4644, ext. 2790, or (800) 548-5450.

Idaho Department of Insurance
700 W. State St.
J.R. Williams Building, 3rd Floor
Boise, ID 83720
(208) 334-2250 or (800) 721-3272
SHIBA (Senior Health Insurance Benefits Advisors), 208-334-4350

Illinois Department of Insurance
Director of Insurance
320 W. Washington St., 4th Floor
Springfield, IL 62767
(217) 782-4515 or (217) 782-7446
E-mail: director@ins084r1.state.il.us

Indiana
Commissioner of Insurance
311 W. Washington St., Suite 300
Indianapolis, IN 46204
(317) 232-2385 or (800) 622-4461

Iowa Insurance Division
Lucas State Office Building, 6th Floor
Des Moines, IA 50319
(515) 281-5705

Kansas Insurance Department
420 SW Ninth St.
Topeka, KS 66612
(913) 296-3071 or (800) 432-2484

Kentucky Department of Insurance
P.O. Box 517
Frankfort, KY 40602
(502) 564-3630 or (800) 595-6053

Louisiana Department of Insurance
950 N. Fifth St.
Baton Rouge, LA 70804
(504) 342-5900 or (800) 259-5300 or -5301

Maine Bureau of Insurance
35 State House Station
Augusta, ME 04333
(207) 582-8707

Maryland Insurance Administration
525 St. Paul Pl.
Baltimore, MD 21202
(410) 468-2000 or (800) 492-6116

Massachusetts Office of Consumer Affairs and Business Regulation
1 Ashburton Pl.
Boston, MA 02108
(617) 727-7780
E-mail: ask@consumer.com
Massachusetts Property Underwriting Association
 (FAIR Plan): (800) 392-6108

Michigan Insurance Bureau
Commissioner of Insurance
P.O. Box 30220
Lansing, MI 48909
(517) 373-9273

Insurance Division of the
Minnesota Department of Commerce
133 E. Seventh St.
St. Paul, MN 55101
(612) 297-7161

Mississippi Insurance Department
 P.O. Box 79
Jackson, MS 39205
(601) 359-3569 or (800) 562-2957

Missouri Department of Insurance
P.O. Box 690
Jefferson City, MO 65102
(573) 751-4126 or (800) 726-7390

Montana
Commissioner of Insurance
126 N. Sanders
Mitchell Building, Room 270
Helena, MT 59601
(406) 444-2040 or (800) 332-6148

Nebraska Department of Insurance
941 O St., Suite 400
Lincoln, NE 68508
(402) 471-2201 or (800) 833-0920

Nevada Division of Insurance
1665 Hot Springs Rd., Suite 152
Carson City, NV 89706
(702) 687-4270 or (800) 992-0900, ext. 4270
Las Vegas Office:
2501 E. Sahara Ave., Suite 302
Las Vegas, NV 89158
(702) 486-4009 or (702) 486-4007

New Hampshire
Insurance Commissioner
169 Manchester St.
Concord, NH 03301
(603) 271-2261 or (800) 852-3416

New Jersey Department of Banking and Insurance
P.O. Box 325
Trenton, NJ 08625
(609) 292-5360 or (800) 446-SHOP
Auto and Homeowner Insurance Shopping: (800) 446-SHOP
Reporting Insurance Fraud: (800) 373-8568
Individual Health Coverage Program Information: (800) 838-0935
Small Employer Health Benefits Program Information: (800) 263-5912

New Mexico
Superintendent of Insurance
P.O. Drawer 1269
Santa Fe, NM 87504
(505) 827-4592

New York State Insurance Department
25 Beaver St.
New York, NY 10004
Consumer Services: (212) 480-6400
Albany Office:
Empire State Plaza
Agency Building No. 1
Albany, NY 12257
Consumer Services: (518) 474-6600

North Carolina
Commissioner of Insurance
P.O. Box 26387
Raleigh, NC 27611
(919) 733-2032 or (800) 662-7777

North Dakota
Commissioner of Insurance
Capitol Building, Fifth Floor
600 East Blvd.
Bismarck, ND 58505
(701) 224-2440 or (800) 247-0560

Ohio Department of Insurance
2100 Stella Ct.
Columbus, OH 43215
(614) 644-2658 or (800) 686-1526
Ohio Senior Health Insurance Information Program: (800) 686-1578

Oklahoma Insurance Department
P.O. Box 53408
Oklahoma City, OK 71352
(405) 521-2828 or (800) 522-0071

Oregon

Insurance Commissioner

440-1 Labor and Industries Building

Salem, OR 97310

(503) 378-4271, (503) 378-4636 or (503) 378-4484

Insurance Consumer Advocate/SHIBA: (800) 722-4134

Information(503) 947-7984

Consumer Assistance Unit (503) 947-7984

Pennsylvania Insurance Department

1326 Strawberry Square

Harrisburg, PA 17120

(717) 787-2317

Rhode Island

Associate Director and Superintendent of Insurance

233 Richmond St.

Providence, RI 02903

(401) 277-2223

South Carolina Department of Insurance

P.O. Box 100105

Columbia, SC 29202

(803) 737-6140 or (800) 768-3467

Office of Consumer Services: (803)737-6150

South Dakota Division of Insurance

118 W. Capitol

Pierre, SD 57501

(605) 773-3563

Tennessee

Commissioner of Insurance

500 James Robertson Pkwy.

Nashville, TN 37243

(615) 741-2241 or (800) 252-3439

Texas Department of Insurance
333 Guadalupe
Austin, TX 78701
(512) 463-6515 or (800) 252-3439
Mail - P.O. Box 149104,
Austin 78714-9104
Report Fraud (512) 475-4989 or (512) 475-1772

Utah
Commissioner of Insurance
3110 State Office Building
Salt Lake City, UT 84114
(801) 538-3800 or (800) 439-3805
Consumer Service (801) 538-3805

Vermont Division of Insurance
Commissioner of Banking, Securities and Insurance
State Office Building
120 State St., Drawer 20
Montpelier, VT 05602
(802) 828-3301
Consumer Assistance line (802) 828-3302

Virginia
Commissioner of Insurance
1200 Jefferson Building
1220 Bank St.
Richmond, VA 23219
(804) 371-9741 or (800) 552-7945

Washington Office of the Insurance Commissioner
P.O. Box 40255
Olympia, WA 98504
(206) 753-7301 or (800) 562-6900
http://www.wa.gov/ins

West Virginia
Insurance Commissioner
2019 Washington St. East
Charleston, WV 25305
(304) 558-3394 or (800) 642-9004

Wisconsin Office of the Commissioner of Insurance
P.O. Box 7873
Madison, WI 53707
(608) 266-0103 or (800) 236-8517
E-mail: ocioci@mail.state.wi.us

Wyoming
Insurance Commissioner
Herschler Building
122 W. 25th St.
Cheyenne, WY 82002
(307) 777-7401

Nationwide Information Resources

Insurance Information Institute
110 Williams St., 4th Floor
New York, NY 10038
(212) 669-9200
National Insurance Consumer Helpline: (800) 942-4242

National Consumers League
815 15th St. NW, Suite 928
Washington, DC 20005
(202) 639-8140

National Insurance Consumer Organization
121 N. Payne St.
Alexandria, VA 22314
(703) 549-8050

U.S. Office of Consumer Affairs
Consumer Information Center
Pueblo, CO 81009
Write to Dept. 636B to receive a free booklet called *What You Should Know About Buying Life Insurance*.

National Flood Insurance Program
Federal Insurance Administration
(202) 646-4623
or
(800) 638-6620

Index